ONCE UPON A DIAMOND

PRINCE DIMITRI

ONCE UPON A DIAMOND

A FAMILY TRADITION OF ROYAL JEWELS

FOREWORD
CAROLINA HERRERA

INTRODUCTION
FRANÇOIS CURIEL

TEXT
LAVINIA BRANCA SNYDER

PHOTOGRAPHY
MARK ROSKAMS

RIZZOLI
NEW YORK

New York · Paris · London · Milan

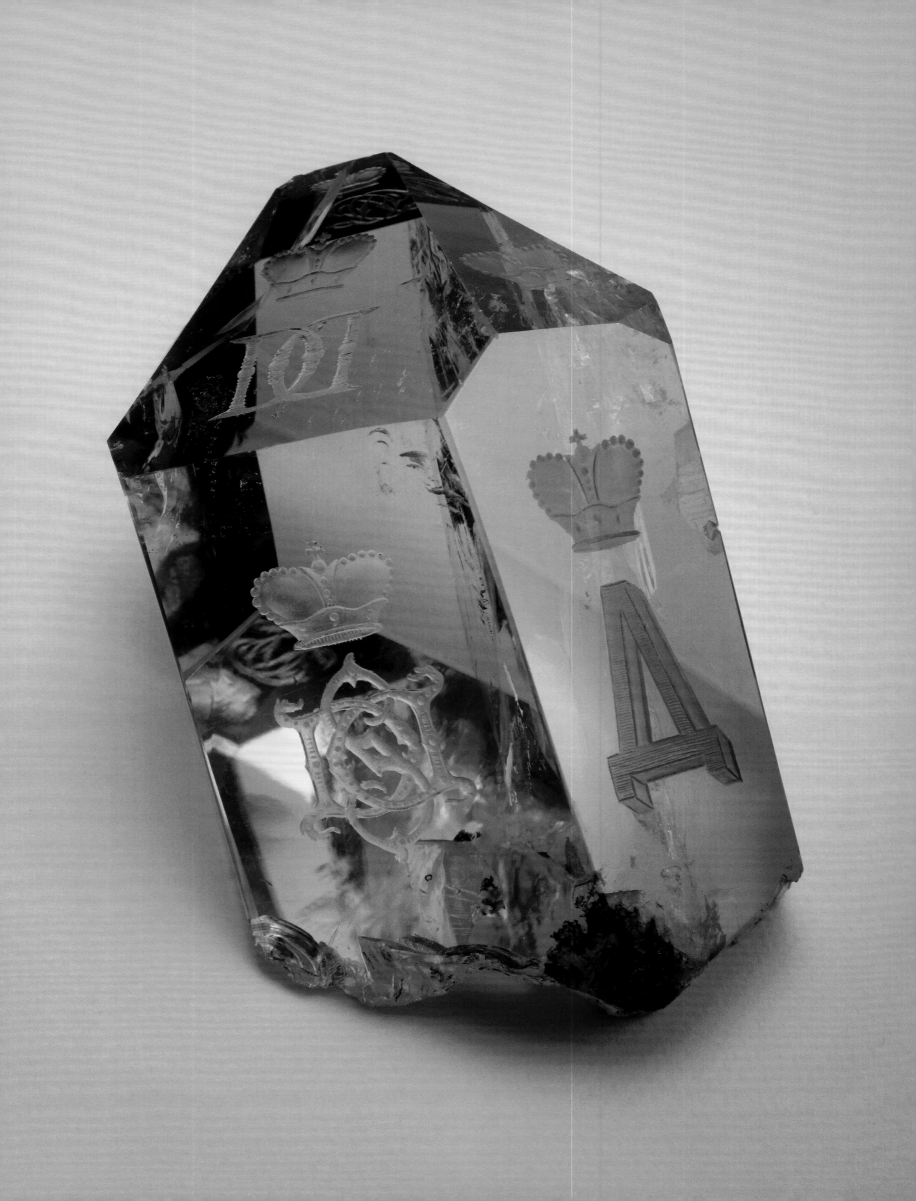

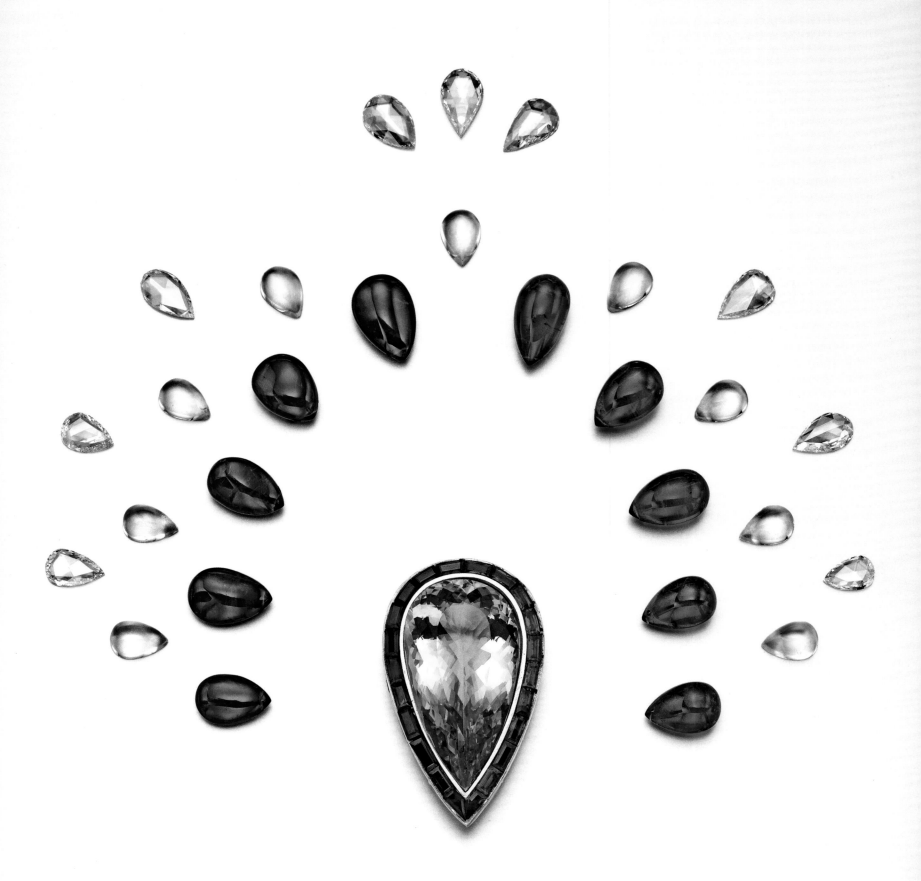

Dimitri has a fantastic eye for the sensuality in jewels, for the exotic luxury found in the diamonds of India, as well as in their emeralds, rubies, sapphires, and ropes of magnificent pearls. He has inherited his exquisite taste from his ancestors—the emperors of Russia, the kings of Europe, and the satraps of the wild and noble hills of Yugoslavia, for he is the prince.

Prince Dimitri of Yugoslavia once told me that he loved jewelry so much that for him, even the smallest and simplest jewel is a work of art; and when you read this book you will discover the imagination and fantasy of all the splendor of his world. Have fun!

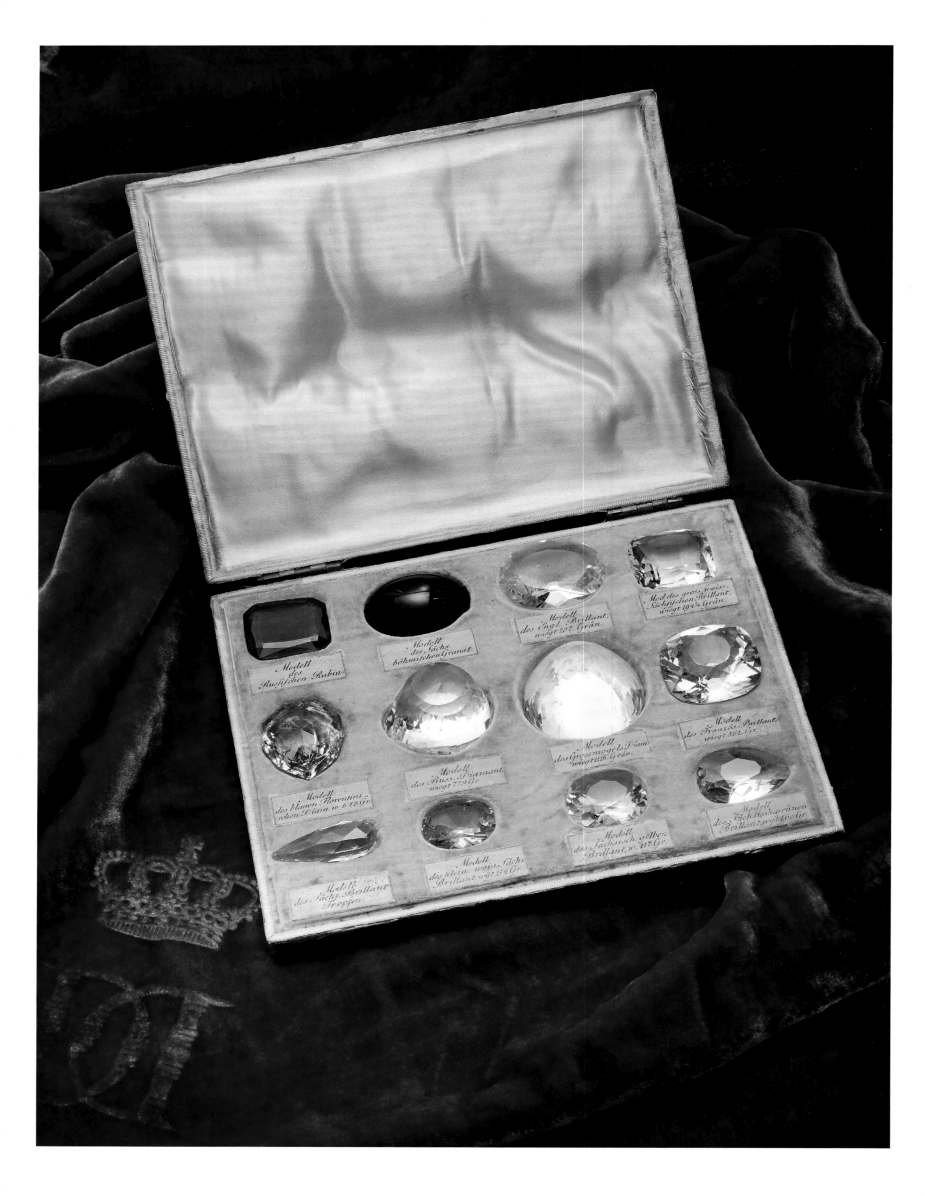

INTRODUCTION

I have known Dimitri for over thirty years. He is cultivated, gallant, talented . . . and royal.

European royalty is an intricate network with many alliances, often formed through marriages. Dimitri is an heir to this tradition, which made him a descendant of many of the grandest names in European history: Catherine the Great, Louis XIV, Charlemagne, the Medicis, and the Greek, Danish, Italian, Belgian, and Yugoslavian royal houses.

To most, European history is either a school subject, fascinating read, or food for imagination; for Dimitri, however, it is the true story of his extended family and his personal memories.

And those memories include jewels from royal collections; the finest and rarest created in a different era, classic but timeless, opulent and elegant. In the political context, the magnificence of jewels symbolizes power. In the artistic sense, their beauty reflects infinite human creativity as well as perfection in craftsmanship, and royals have long been the foremost patrons of these divine pursuits.

Growing up surrounded by the best jewels that civilization could offer, Dimitri's eye was already exquisitely trained as he began his enduring career. As a jewelry artist, he draws heavily from his family, his memories, and the zeitgeist of a bygone yet glorious age for inspiration.

He brings romance and reality to the modern day with iconic pieces that are contemporary and sophisticated, yet relevant and very wearable; an aesthetic that is aristocratic yet approachable.

Just like the Prince Dimitri I know.

— *François Curiel*

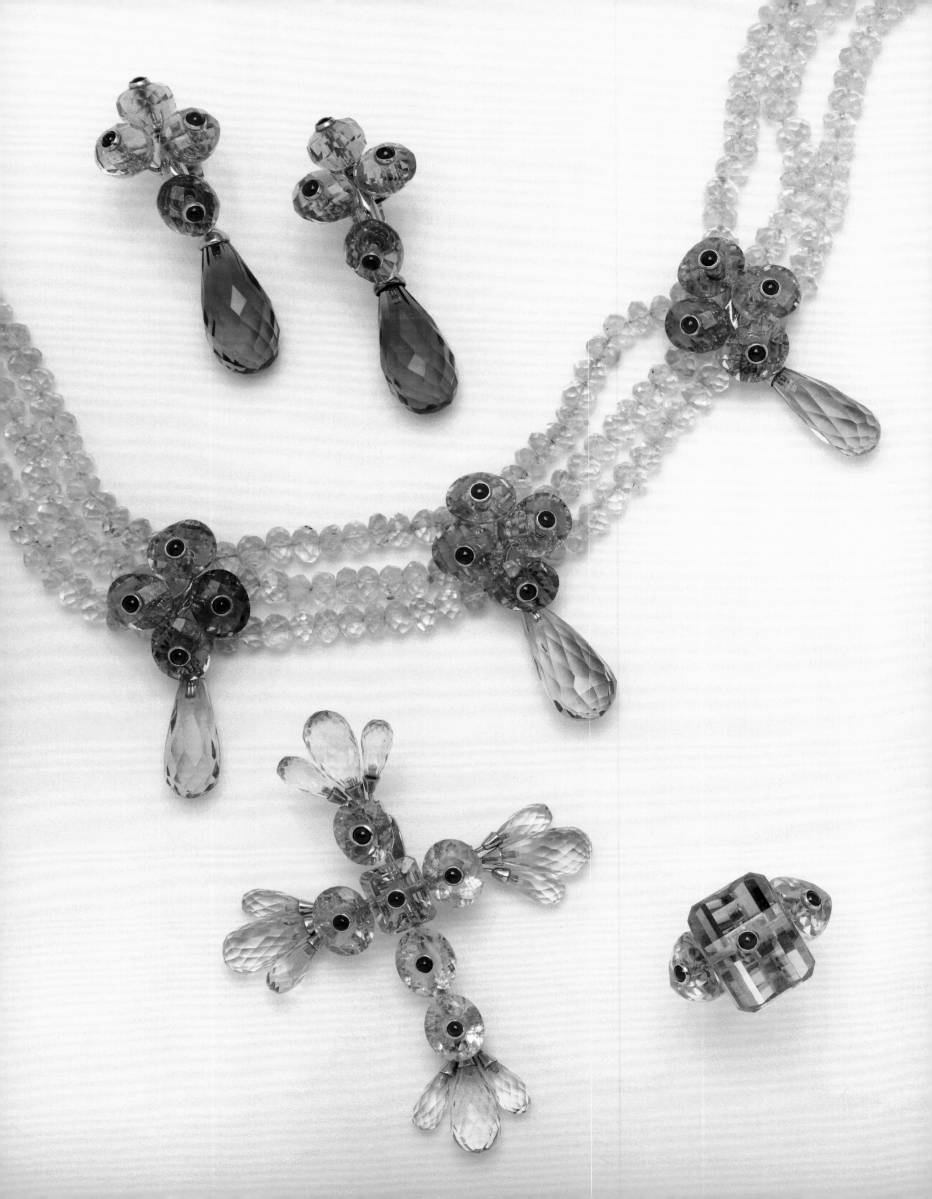

PREFACE

In the past months, Prince Dimitri of Yugoslavia shared some of his fondest memories of childhood, as well as the many stories passed down through the generations. The attentive recipient of untold secrets of his noble lineage, he remembers it all. It is all with him.

It would be hard to uncover any family whose history was more deeply affected by the twists and turns of geographic fate, the idiosyncrasies of its larger-than-life characters, or the vagaries of history than the family of Prince Dimitri.

History books are filled with the extraordinary changes and political upheavals that took place in the hundred years that culminated with World War II. Here, instead, we share, through intimate stories and fabled jewelry collections, how that period of history felt, and how it appeared through the eyes, the loves, and the lives of Prince Dimitri's ancestors and family members.

The magnificent gems and jewels that filled Prince Dimitri's childhood and fueled his imagination were the light and the colors that framed the excited conversations held in a garden, or the whispered confidences he received quietly in the corner of a palace reception room. This is his family's story, told by the jewels and the personal photographs of these princesses and queens, his ancestors. This is the fertile ground into which his own creativity blossomed and which instilled in him a lifelong love of stones.

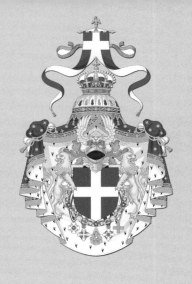

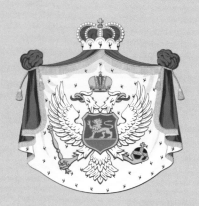

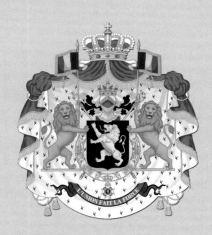

Vittorio Emanuele II of Savoy
King of Italy

siblings

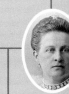

Grand Duke
Konstantin Nikola

siblings

Amedeo I
Duke of Aosta

Umberto I
King of Italy

Margherita of Savoy
Queen of Italy

Princess Marie
of Hohenzollern
Countess of Flanders

Prince Philippe
of Belgium
Count of Flanders

Princess Alexandra
of Denmark
Queen of England

King George I
of Greece

Grand Duchess
Constantinovna o
Queen of Gre

siblings

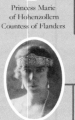

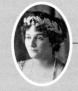

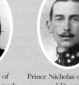

Prince Jean
Duke of Guise

Isabelle d'Orleans
Duchess of Guise

Helene d'Orleans
Duchess of Aosta

Emanuele Filiberto
Duke of Aosta

Vittorio Emanuele III
King of Italy

Elena of Montenegro
Queen of Italy

Duchess Elisabeth
in Bavaria
Queen of Belgium

Albert I
King of Belgium

Princess
Marie Bonaparte
Princess of
Greece and Denmark

Prince George of
Greece and Denmark

Prince Nicholas of
and Denmas

Henri d'Orleans
Count of Paris

Isabelle d'Orleans-Braganza
Countess of Paris

Umberto II
King of Italy

Marie-José of Belgium
Queen of Italy

Prince Paul
of Yugoslavia

Prince Michel
of Bourbon-Parma

Maria Pia of Savoy
Princess of Yugoslavia

Prince Alexander
of Yugoslavia

Prince Dimitri
of Yugoslavia

Prince Michel
of Yugoslavia

Prince Serge
of Yugoslavia

Princess Hele
of Yugoslavia

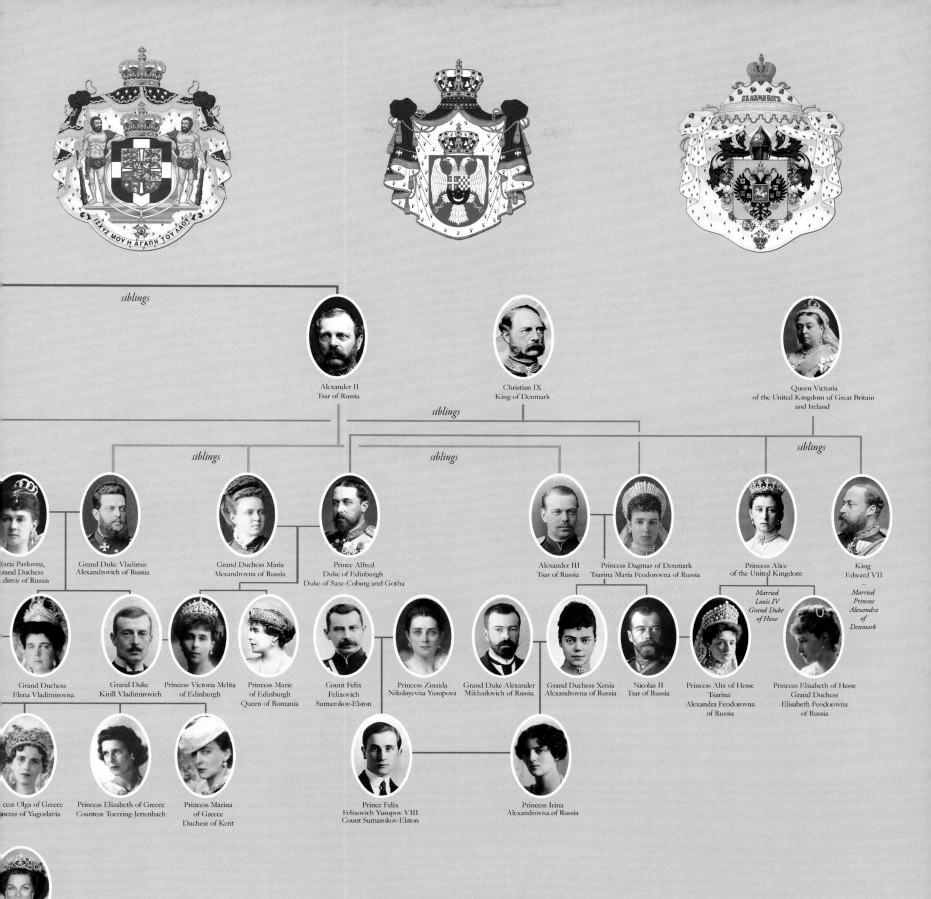

siblings

Alexander II
Tsar of Russia

Christian IX
King of Denmark

Queen Victoria
of the United Kingdom of Great Britain
and Ireland

siblings

siblings

siblings

siblings

...aria Pavlovna,
...rand Duchess
...dimir of Russia

Grand Duke Vladimir
Alexandrovich of Russia

Grand Duchess Maria
Alexandrovna of Russia

Prince Alfred
Duke of Edinburgh
Duke of Saxe-Coburg and Gotha

Alexander III
Tsar of Russia

Princess Dagmar of Denmark
Tsarina Maria Feodorovna of Russia

Princess Alice
of the United Kingdom

*Married
Louis IV
Grand Duke
of Hesse*

King
Edward VII

*Married
Princess
Alexandra
of
Denmark*

Grand Duchess
Elena Vladimirovna

Grand Duke
Kirill Vladimirovich

Princess Victoria Melita
of Edinburgh

Princess Marie
of Edinburgh
Queen of Romania

Count Felix
Felixovich
Sumarokov-Elston

Princess Zinaida
Nikolayevna Yusupova

Grand Duke Alexander
Mikhailovich of Russia

Grand Duchess Xenia
Alexandrovna of Russia

Nicolas II
Tsar of Russia

Princess Alix of Hesse
Tsarina
Alexandra Feodorovna
of Russia

Princess Elisabeth of Hesse
Grand Duchess
Elisabeth Feodorovna
of Russia

...cess Olga of Greece
...ncess of Yugoslavia

Princess Elizabeth of Greece
Countess Toerring-Jettenbach

Princess Marina
of Greece
Duchess of Kent

Prince Felix
Felixovich Yusupov VIII
Count Sumarokov-Elston

Princess Irina
Alexandrovna of Russia

...incess Barbara
...Liechtenstein

...ince Dushan
...of Yugoslavia

This is a representation of how the people included in the book are connected to Prince Dimitri.

It is not a comprehensive family tree.

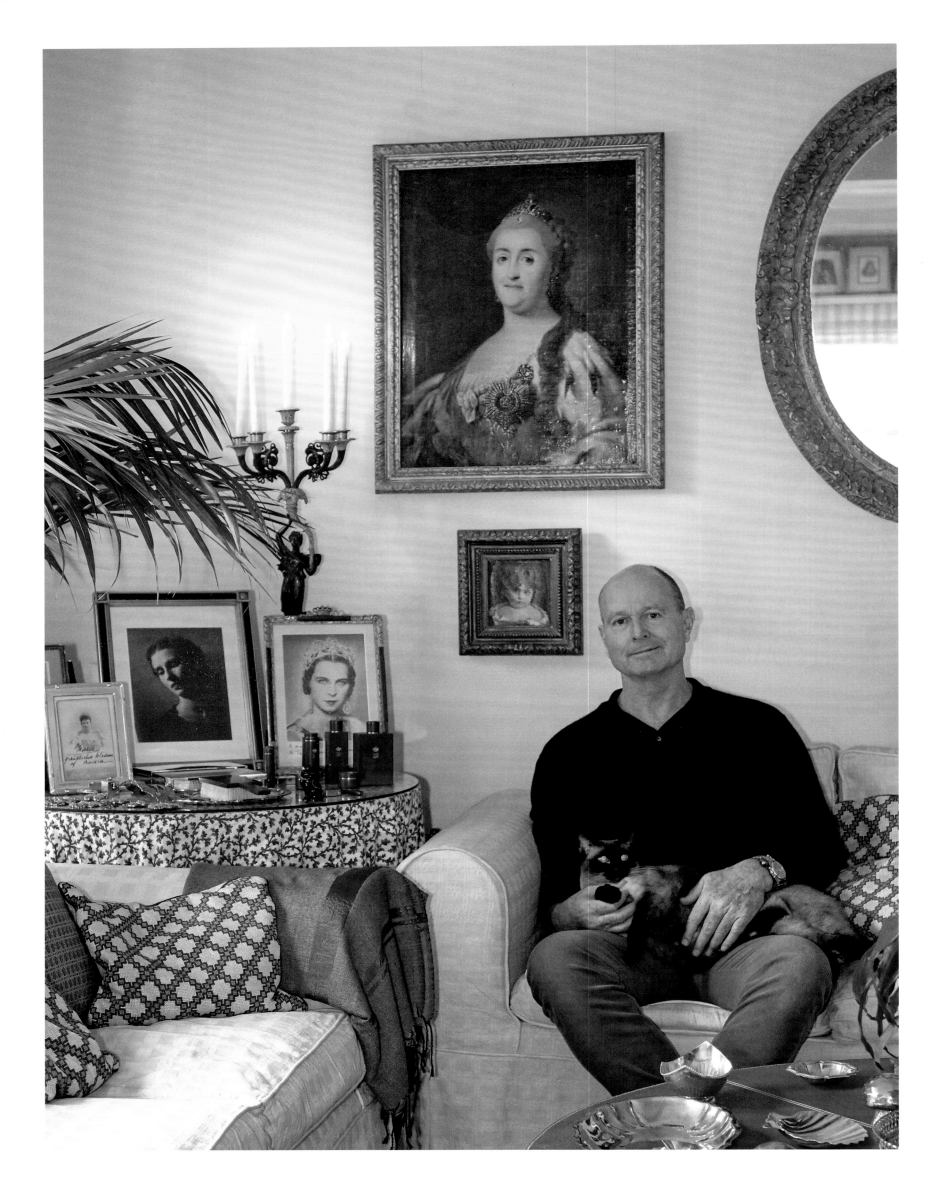

I read somewhere that "gems are the flowers of the mineral kingdom and flowers are the gems of the vegetable kingdom."

Living for beauty, it was so obvious, that as I was reading this, it felt like it was coming from my own heart. My whole life, I worshipped beauty. All beauty. Spiritual, intellectual, musical, material, human, animal, vegetable, mineral.

At a young age I discovered Greek and Roman mythology, fascinated by their cult of beauty and intriguing stories that rang so true as they showed various facets of the human character. All that was very useful; it opened my mind to culture as it gave me the ability to immediately recognize the characters of most paintings and sculptures from the Renaissance on, as well as Greek statues and their later reproductions such as the ones in the park of Versailles where I lived with my family.

More than useful, it was an unending source of that rarest of pleasures, the esthetic emotion you feel when a masterpiece stirs the soul and frees you from the stream of compulsive thinking by gently taking you back to your true home, the eternal present, basking in stillness and beauty.

I felt the same thing from a young age with the intense fascination I had with stones, gems, and jewelry.

I was mesmerized by my mother's and grandmother's jewels, especially the emeralds. When my mother would get ready to go out, I would inspect them from every angle, fascinated by every gem, every pearl, even the color of the metal and its patina.

When we stayed with my grandparents in the summer there were endless visits from relatives. I remember vividly as they appeared for dinner like celestial visitations wearing every gem imaginable. These aunts, one more beautiful than the other, always let me look at their jewels and told me their history. Later on, during the year I would see them in various magazines which was always such fun as I would sometimes recognize their jewelry and admire their fabulous tiaras.

If I saw a jewelry store, I had to go in. Place Vendôme in Paris, the land of magic for me, was a source of endless joy as I stopped in front of every shop, staring at every single jewel on display.

The most memorable experience of all was the Meli Bank in Tehran. My mother took me there to see the legendary crown jewels, many from Mughal times. Room after room full of them. There were mountains of diamonds and loose stones, swords, saddles, vases, and boxes all made of gems. Here was the most fabulous globe on earth, made of 75 pounds of gold and 51,366 precious gems, next to it was the 17th century Shah Jahan peacock throne set with 26,733 precious stones, the empress's coronation robe, also entirely covered in gems . . . The cave of Ali Baba! I was so obsessed that I had to go back three days later!

In 1984 I joined Sotheby's jewelry department in New York and studied gemology. I appraised jewelry for 20 years, seeing fantastic things all year long.

Later on, I discovered design when I helped a friend remount his cufflinks. It gave me an idea that led to a first collection and a few more as well as many one of a kind pieces illustrated here in this book.

To those who listen even stones speak . . . so I explored every culture in history, as well as unusual materials and turned them into my own style of jewelry, my gift of beauty to those who wear them.

Cultural appropriation? Absolutely! I went back to ancient Greece and designed things based on sacred geometry and from there, on to explore the middle ages, India, China, Africa, Russia, the art deco period . . . everything . . .

Culture is humanity's patrimony as the great artists of the renaissance taught us.

Dimitri

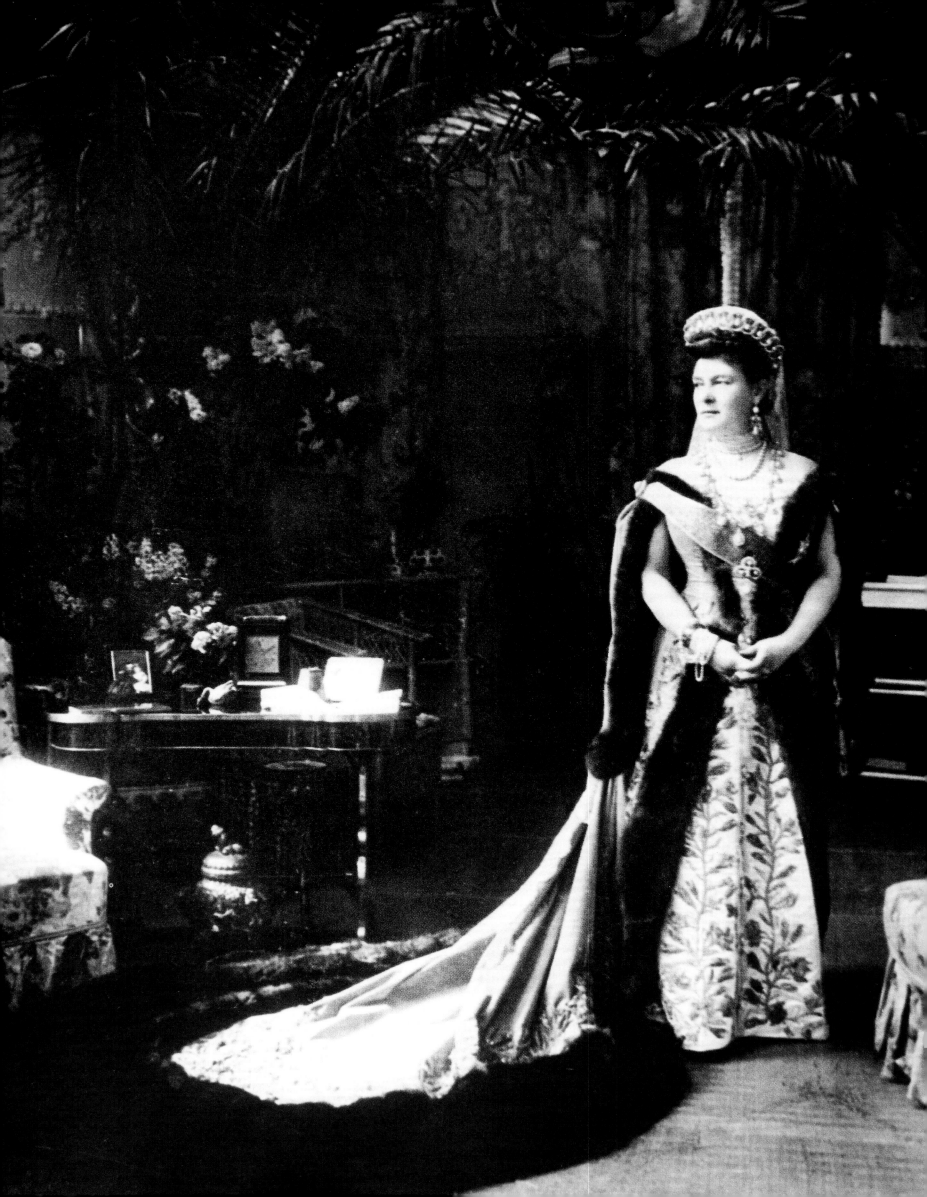

The Grand Duchess Vladimir
and her
Legendary Collection

In 1874, the twenty-year-old German duchess, Marie of Mecklenburg-Schwerin, married the Grand Duke Vladimir Alexandrovich of Russia, the senior grand duke of the House of Romanov and the son of Emperor Alexander II.

It had taken three years for Grand Duke Vladimir to persuade his brother, Tsar Alexander III, to permit their union, as Marie had refused to convert from Lutheranism to Russian Orthodox.

This, despite the fact that even before her marriage, Marie had a Romanov heritage: she was a great-granddaughter of Grand Duchess Elena Pavlovna of Russia. To honor her, Marie adopted the name Maria Pavlovna after her wedding in St. Petersburg.

Soon after her marriage, the Romanov court jeweler, Bolin, created a tiara for her featuring interlocking diamond circles, set in gold and silver, with hanging pear-shaped pearl drops. The piece, perfectly suited to her new position, became known as the Vladimir Tiara. Today, the Vladimir Tiara is part of the private colletion of her Majesty Queen Elizabeth II.

In the portrait facing, the Grand Duchess Vladimir dons several medals, bows, and a sash that punctuate her status and embellish her sable trimmed dress. In the photograph she is also seen wearing the Vladmir Tiara, pearl necklaces and earrings, as well as a large coiled snake brooch as the centerpiece of her devant de corsage (jewelry worn on the center panel of a dress's bodice).

As the newest member of the imperial dynasty, the Grand Duchess needed her own set of formal jewels to meet the elaborate standards of the Russian court. The wedding gift from the groom's father was a rectangular emerald that had once belonged to Catherine the Great and weighed 107 carats.

From that very first 107-carat emerald, the Grand Duchess Vladimir's jewel collection continued to grow, as did her connoisseurship of fine gems. Thus began her lifelong pursuit to acquire the most lustrous pearls and precious stones she could find—gems that she then set in exquisite tiaras and all manner of glittering adornments crafted by the best jewelers of her time. Her acquisition of extraordinary stones, or ones with an important provenance, became two hallmarks of her collecting style, as did the purchase of magnificent jewelry pieces such as a splendid pearl and diamond rivière necklace or a legendary sapphire and diamond tiara.

Grand Duchess Elena Vladimirovna

Grand Duchess Vladimir bore four children during her marriage: Grand Duke Kyril, Grand Duke Boris, Grand Duke Andrei, and Grand Duchess Elena; all the while her social influence continued to expand, until the day her extravagant circle came to rival that of any other Romanov, including that of Tsarina Alexandra, who was married to Tsar Nicholas II.

By protocol, she was the third lady of Russia, behind the two tsarinas, Alexandra, and Empress Maria Feodorovna. At the Florentine Renaissance–inspired Vladimir Palace on the Neva River, the Vladimir court became the center of the intellectual, artistic, diplomatic, and social life of St. Petersburg and the setting for prestigious concerts and balls. The Grand Duke Vladimir, himself an erudite and cultured man, was a patron of Diaghilev's Ballets Russes and the avant-garde.

After the tsar had liberated the serfs in 1861, there was a hope that the Russian Empire could outflank the rising social discontent that was sweeping through Europe in convulsive political revolutions and bloodshed.

As early as 1881, beyond the walls of the imperial palaces, there were politically driven assassinations and famine-driven street riots. Despite the intensifying violent protests and the passing of her husband in 1909, the grand duchess

Grand Duke Vladimir Alexandrovich

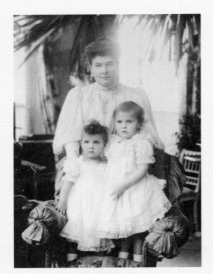

Grand Duchess Vladimir with Princesses Olga and Elizabeth

continued to live as though her enchanted world would not end: all was glamour and divertissement in the highest circles of the Russian nobility.

In the summers, the grand duchess hosted her daughter Elena and her granddaughters Princess Olga, Princess Marina, and Princess Elizabeth in St. Petersburg.

Prince Dimitri recalls: "My grandmother, Princess Olga, told me about the Grand Duchess Vladimir's octagonal jewelry room in her St Petersburg palace. The room was surrounded with cabinets lined in blue velvet that held her extraordinary collection.

"In the cabinets of this jewelry room were displayed her many jewels and parures of every color of precious stone. The most fabulous Burmese rubies, mountains of sapphires and emeralds, Golconda diamonds, pearls of unimaginable size and quality, every semiprecious stone that existed, hundreds of daytime rings, bracelets, brooches, and pendants.

My grandmother told me how, when staying with the grand duchess, she and her sisters, were often asked to 'help' her choose what jewels they thought she should wear that night. When the task had been completed, the grand duchess always made it clear that she could not have managed without their help and thanked them profusely, making them feel loved and very important!"

While life seemingly went on as normal within the palace walls, discontent grew ever louder, both within and outside the Romanov court, as Tsar Nicholas II and Tsarina Alexandra became more and more reclusive due to the illness of their only son, the Tsarevich Alexei Nikolaevich.

In the streets, years of famine and misery of the Russian people, and the relentless agony of World War I, struck the fatal blow to the Russian monarchy.

In 1917, the streets erupted in the revolution that brought down the old world order in a final convulsion of bloodshed and revenge. After the abdication of the tsar in March of that year, Grand Duchess Vladimir left St. Petersburg for Kislovodsk in the Caucasus, hoping to return to St. Petersburg at a safer time. Even after the tsar had abdicated and his entire family had been arrested, the grand duchess and her family remained in Russia, holding on to the hope that

the Romanovs could regain power.

This outcome never materialized. It was only thanks to a valiant and trusted friend, Albert Stopford, who came to visit her in the Caucasus, that she was able to recover the jewelry left behind in the city.

During Stopford's visit, the grand duchess revealed to him how to find the jewels that were hidden in a secret room in the palace. It was 1917, and despite the fact that the Bolsheviks occupied St. Petersburg, Stopford had left her with a promise that he would succeed in this dangerous mission.

Per their daring plan, he dressed as a workman and, with the help of a loyal servant, he entered the palace in the middle of the night. He found the place where the jewelry was hidden, wrapped all he could carry in old newspapers and put them in two bags, which he later managed to smuggle out of Russia. A few days after, the Vladimir Palace was ransacked and all else was lost.

All dreams for the restoration of the monarchy were lost after the riots and Bolshevik looting of palaces in St. Petersburg intensified and the tsar's family was assassinated.

Prince Dimitri recounts how he was told that it was only after two long years, in 1919, in the depths of the Russian winter, that the Grand Duchess Vladimir finally agreed to leave Russia having lost all hope that the monarchy would return.

The grand duchess and her family set off in bitter subzero temperatures on a 30-mile (50-km) journey—in an open carriage—to the nearest working railway station, where her personal train was waiting.

From there, her journey to escape the revolution took her from the Caucasus to the Black Sea and beyond. They took with them a young Countess Stroganoff, who was nine years old and whose mother was too ill to leave the country.

Decades later Countess Stroganoff shared with Prince Dimitri what took place on the train during their escape from Russia: "At one point, the train was stopped by a mob. They demanded to see the Grand Duchess and wanted to know where she was going . . . everyone feared for their lives.

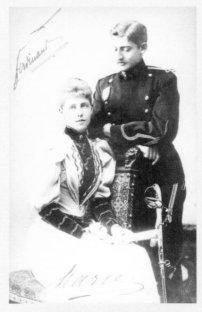

Queen Marie of Romania, a granddaughter of Tsar Alexander II, with her husband King Ferdinand of Romania

"Her Imperial Highness decided to keep them waiting and had her lady in waiting announce that she was ready to grant them an audience. She appeared very slowly, smiling, welcoming them, and thanking them for their kindness and loyalty. They were so struck by her magnetism that they calmed down. A polite conversation followed as she asked them all sorts of questions about their lives. And they left peacefully. I lived in adoration of the grand duchess."

The tsar's sister, Grand Duchess Olga, was at the train station when Grand Duchess Vladimir and her entourage finally arrived at the Black Sea port city and described the encounter thus: "I was amazed that she arrived in the city on her own train, accompanied by her retinue, and remained a grand duchess to her fingertips. When even generals were happy if they could find a carriage and an old nag to go to a safe place, she set off on a long trip on her own train. For the first time in my life I gave her a kiss with pleasure." In 1920, Grand Duchess Olga became the last Romanov to leave Russian soil.

Grand Duchess Vladimir never saw her jewels again. She passed away in September 1920, in her favorite spa town of Contrexéville in France. According to her will, the jewelry collection was bequeathed to her children. It was said to be the largest jewelry collection in private hands at the time, and indeed was sold by her children over the decades to support their lives in exile.

In 2008, a collection of cufflinks, cigarette cases, and jewelry was discovered in the archive room of the Swedish foreign ministry, having been deposited at the Swedish Legation in St. Petersburg for safekeeping before she left.

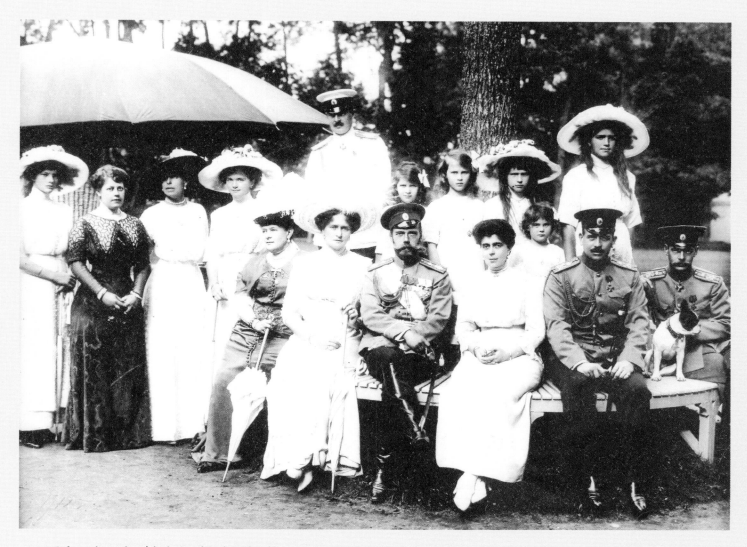

Left to right standing & back: Grand Duchess Olga of Russia; Princess Nanette of Mecklenburg- Schwerin; Grand Duchess Victoria Melita Feodorovna of Russia; Grand Duchess Tatiana of Russia; Grand Duke Kirill Vladimirovich of Russia; Princess Elizabeth of Greece (later Countess Toerring); Princess Olga of Greece (later Princess of Yugoslavia); Grand Duchess Anastasia of Russia; Princess Marina of Greece (later Duchess of Kent); Grand Duchess Maria of Russia.

Left to right seated: The Grand Duchess Vladimir of Russia; Empress Alexandra Feodorovna of Russia; Nicholas II, Emperor of Russia; Grand Duchess Elena Vladimirovna of Russia; Grand Duke Boris Vladimirovich of Russia; Grand Duke Andrei Vladimirovich of Russia.

The Vladimir Tiara

The Romanov Court jeweler, the House of Bolin, was commissioned to fashion the Vladimir Tiara in 1874. It consists of fifteeen interlocking diamond circles, each encasing its own suspended, drop-shaped pearls. It was both a spectacular feat of technical skill and a visual incarnation of feminine elegance.

The grand duchess can be seen wearing the tiara in a number of portraits over the years. In these portraits she wears it both in its original design, seen here, and in its closed-circlet form, without the backing row of curved diamonds and pearl drops.

After the family fled Russia, the grand duchess's tiara was sold to Queen Mary by her daughter, the Grand Duchess Elena. The tiara is now in the collection of Queen Elizabeth II and was modified by the House of Garrard in 1921, at Queen Mary's behest. This was done to accommodate the Cambridge emerald teardrops in the British monarch's collection.

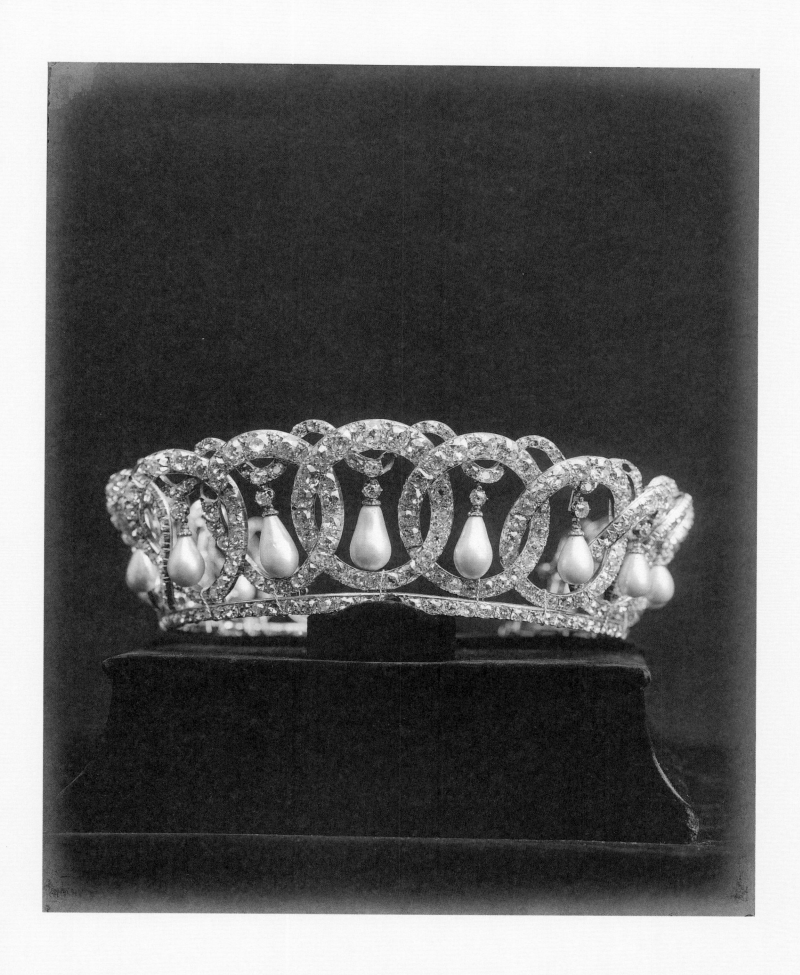

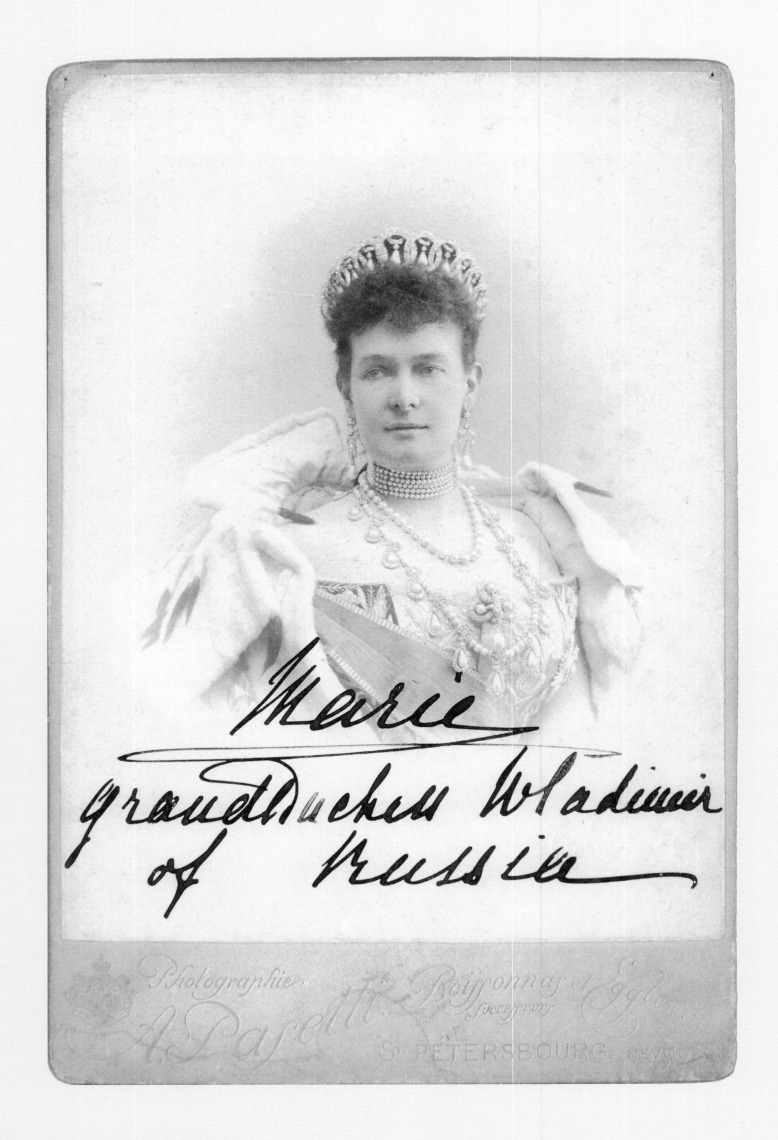

Marie
Grandduchess Wladimir
of Russia

The Vladimir Tiara Portrait

Many of her most remarkable stones and jewels are still beguiling the world: jewels such as the Vladimir Tiara, which she wears in this portrait together with the famous diamond pearl rivière necklace. The Grand Duchess Vladimir's vision and ambition, expressed through her impeccable taste and her extravagant collection of jewels, are now the stuff of legend.

The photo, taken sometime after 1902, is credited to Frederick Boissonnas and Fritz Eggler; who had bought the studio of the famous court photographer Pasetti in St. Petersburg and is signed "Marie Grand Duchess Wladimir of Russia."

The Leeds Cartier Tiara

The Vladimir Tiara was the inspiration for an entire line of jewelry designed by Cartier. The Cartier Leeds Tiara features a pear-shaped center diamond weighing 21.60 carats. The diadem design of intertwining diamond circles features alternating hanging pendants of diamonds and drop pearls.

Cartier made the diamond-loop Leeds Tiara in 1913 for Nancy Leeds. The extremely wealthy American, widowed at the age of thirty, inherited millions from her husband William Bateman Leeds, known as the "Tin King." Nancy Leeds became one of Cartier's most valued clients and she married Prince Christopher in 1920, becoming Princess Anastasia of Greece and Denmark.

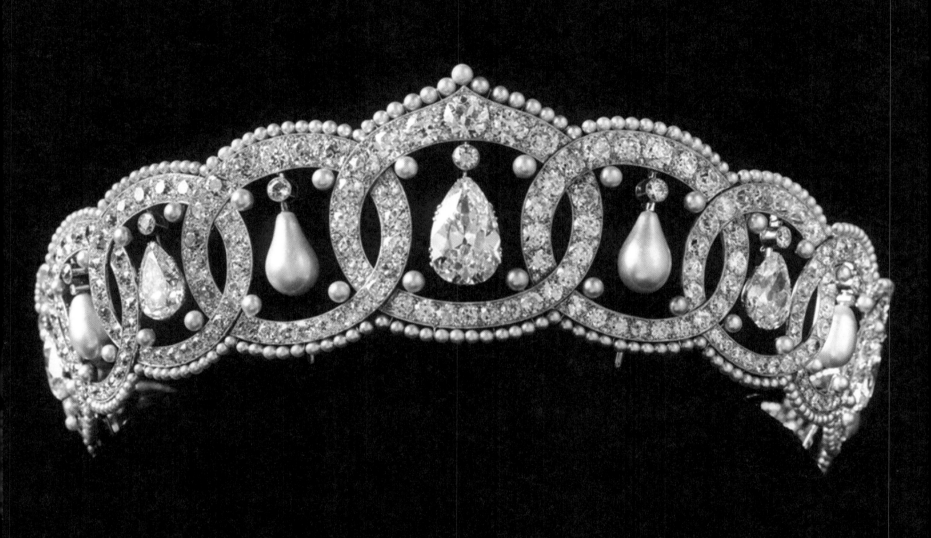

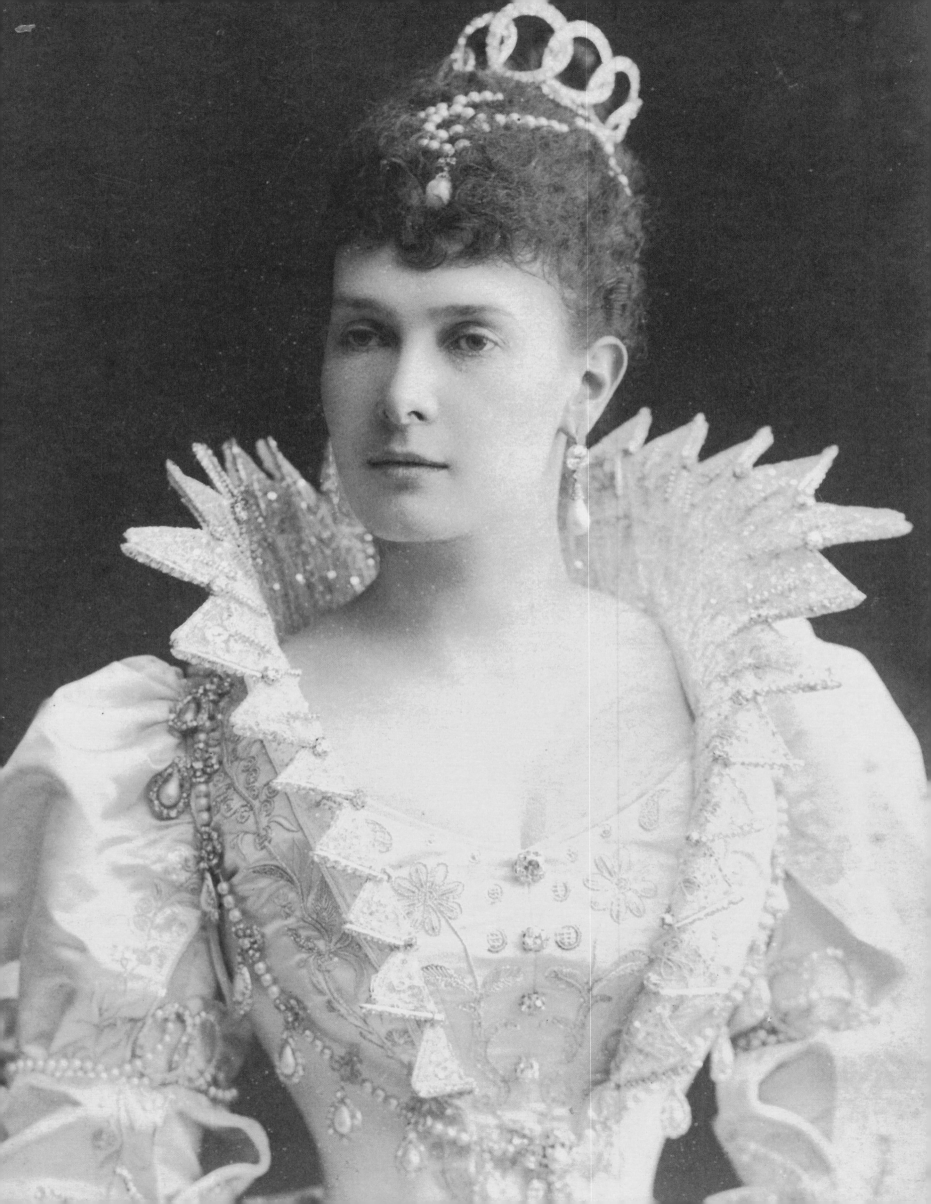

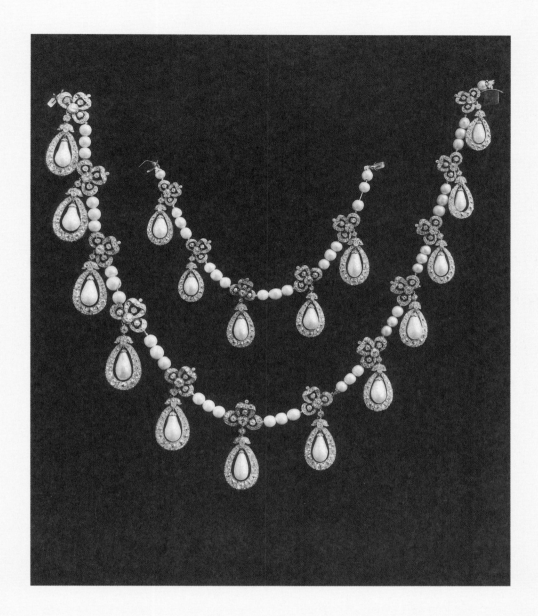

Diamond & Pearl Rivière Necklace

This diamond and pearl rivière necklace is highlighted with seventeen pear-shaped pearl pendentifs. The diamonds are mounted in a silver "à jour" (open-backed) setting soldered in gold.

The grand duchess's pearl rivière necklace is almost identical to one that was part of the jewelry documented in the 1925 Fersman catalogue of imperial jewels—a striking, visible reminder of the grand duchess's social position.

Although no specific jeweler is credited, Fersman describes the imperial piece as a "fine specimen of the jeweler's art of the middle of the XIXth century."

Grand balls took place in the tsar's Winter Palace in St. Petersburg, or at the palaces of other aristocrats. They were very popular, and preparations, for the entertainment as well as the guests' attire, were extravagantly elaborate and took weeks. In this photograph, a young grand duchess is seen wearing the pearl and diamond rivière necklace and the famous Vladimir Tiara—both seemingly born to complement her striking ball gown.

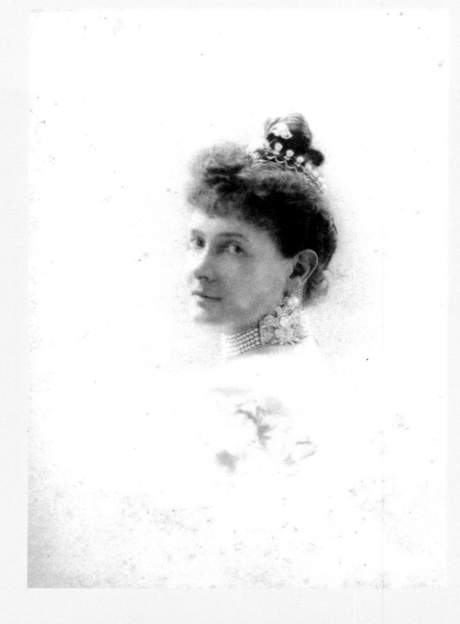

Pearl & Diamond Choker with Imperial Eagle

The Grand Duchess Vladimir, shown wearing the Imperial Eagle *collier de chien* (choker) made by Cartier in 1900.

The photograph is undated but is thought to have been taken in Paris by Otto Wegener. Known simply as Otto, the photographer was a favorite of the Russian and the French aristocracy, the new wealthy elite, and prominent artistic and literary figures. Among the many famous photographic subjects who frequented his studio were Marcel Proust, Isadora Duncan, and Edith Wharton.

The Grand Duchess Vladimir's Imperial Eagle *collier de chien*, was executed by Cartier in 1900, in platinum with pavé diamonds, pearls, and her own larger oval diamonds.

The piece is intended to wrap the neck entirely in 6 rows of pearls, while highlighting the lady's profile with diamond pavé imperial eagles.

The double-headed eagle became the definitive centerpiece of the coat of arms of Russia during the reign of Ivan the Great in the fifteenth century. The longest-reigning Russian ruler in history had tripled the size of its territory and chose this imperial symbol to underscore his dominion over the Near East and the West. Its use in Russia was abolished during the Russian Revolution in 1917.

In 1993 the double-headed eagle was reinstated as the symbol for Russia, although the eagle on the present coat of arms is golden rather than the imperial black.

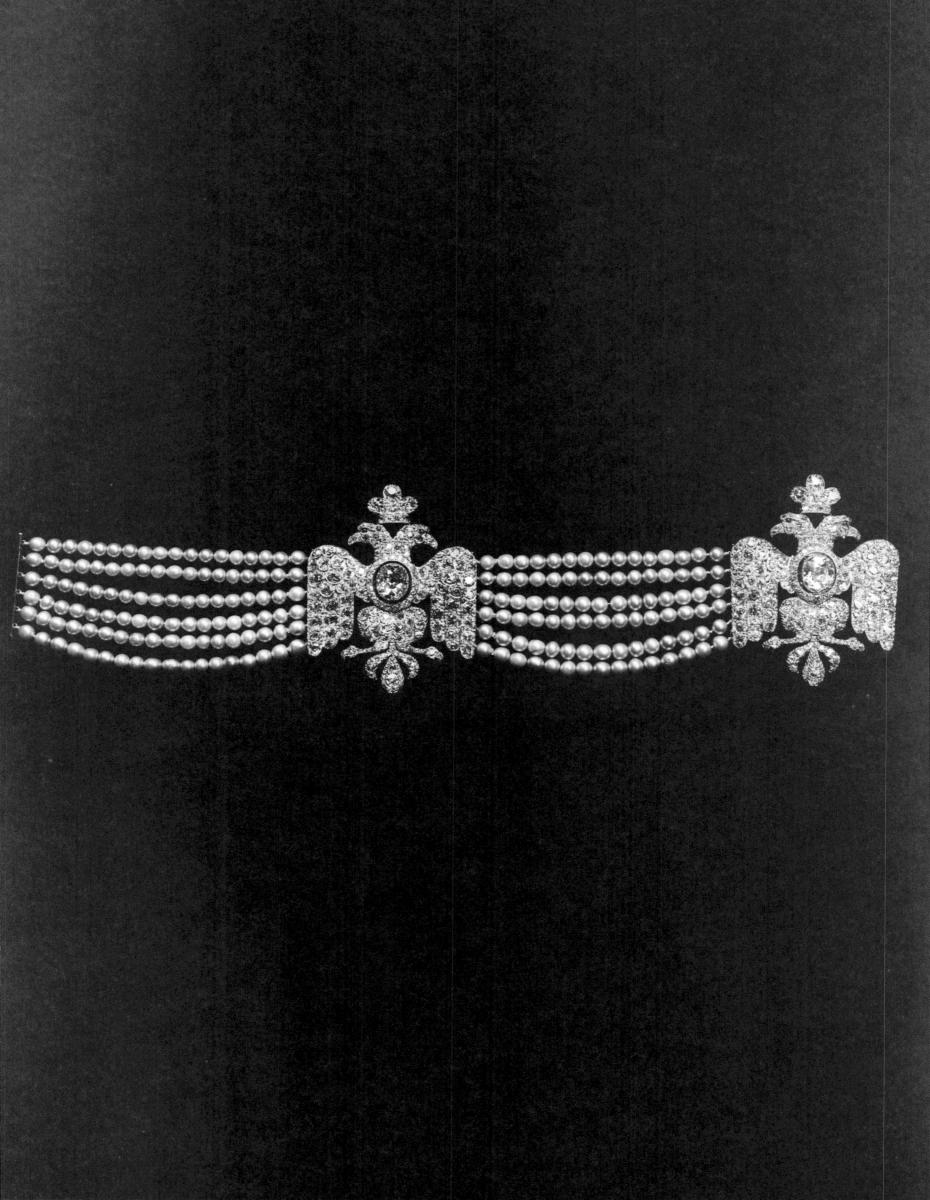

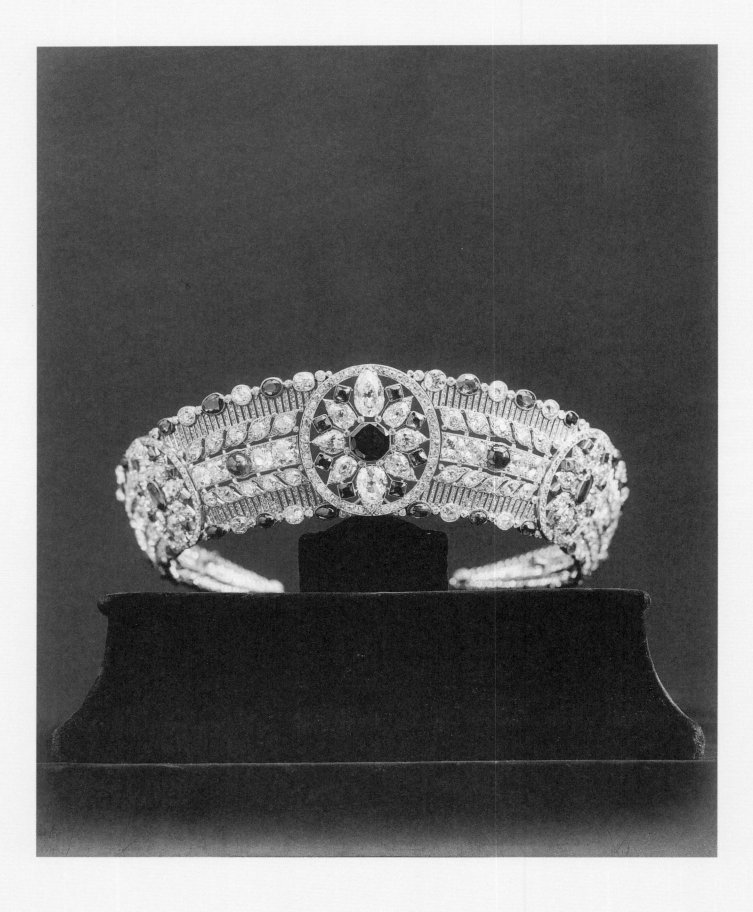

Ruby Tiara by Cartier

In 1908, Grand Duchess Vladimir's acquisition of a 5.22-carat ruby, which had once belonged to Joséphine de Beauharnais, inspired the commissioning of the resplendent Cartier diamond Kokoshnik Tiara that featured the important ruby as its centerpiece.

The tiara was later sold back to Cartier during the Russian Revolution and subsequently acquired by Mrs. Nancy Leeds (when she was Princess Anastasia of Greece and Denmark). She purchased the jewel as a wedding gift on the occasion of her son, William B. Leeds Jr., marrying Princess Xenia of Greece.

Diamond & Pearl Pin

This pin, belonging to the Grand Duchess Vladimir, depicts a stylized coiled snake. It is set with diamonds and pearls.

The popularity of snake jewelry in the Victorian era is said to have begun when Prince Albert proposed to Queen Victoria with a snake ring. Snake jewelry reached its peak in popularity in the mid-nineteenth century and was equated with love, wisdom, and eternity. The snake was depicted on a plethora of jewelry including rings, bracelets, brooches, and necklaces.

A fine example of a very similar Russian coiled-snake brooch was created by the Russian Court jeweler, House of Bolin, in gold with red cabochon eyes, a sapphire cabochon head, and rendered in the same distinctive three-loop contortion.

Grand Duchess Vladimir is seen on the right, in a photo in its original Fabergé leather frame with her cypher in diamonds and rubies. She is wearing the spectacular diamond and pearl coiled-snake brooch as the centerpiece of her devant de corsage, in a rather formal portrait that highlights the medals, bows, and sash that punctuate her off-the-shoulder sable fur-trimmed dress; her kokoshnik is adorned with the famous pearl and diamond rivière necklace.

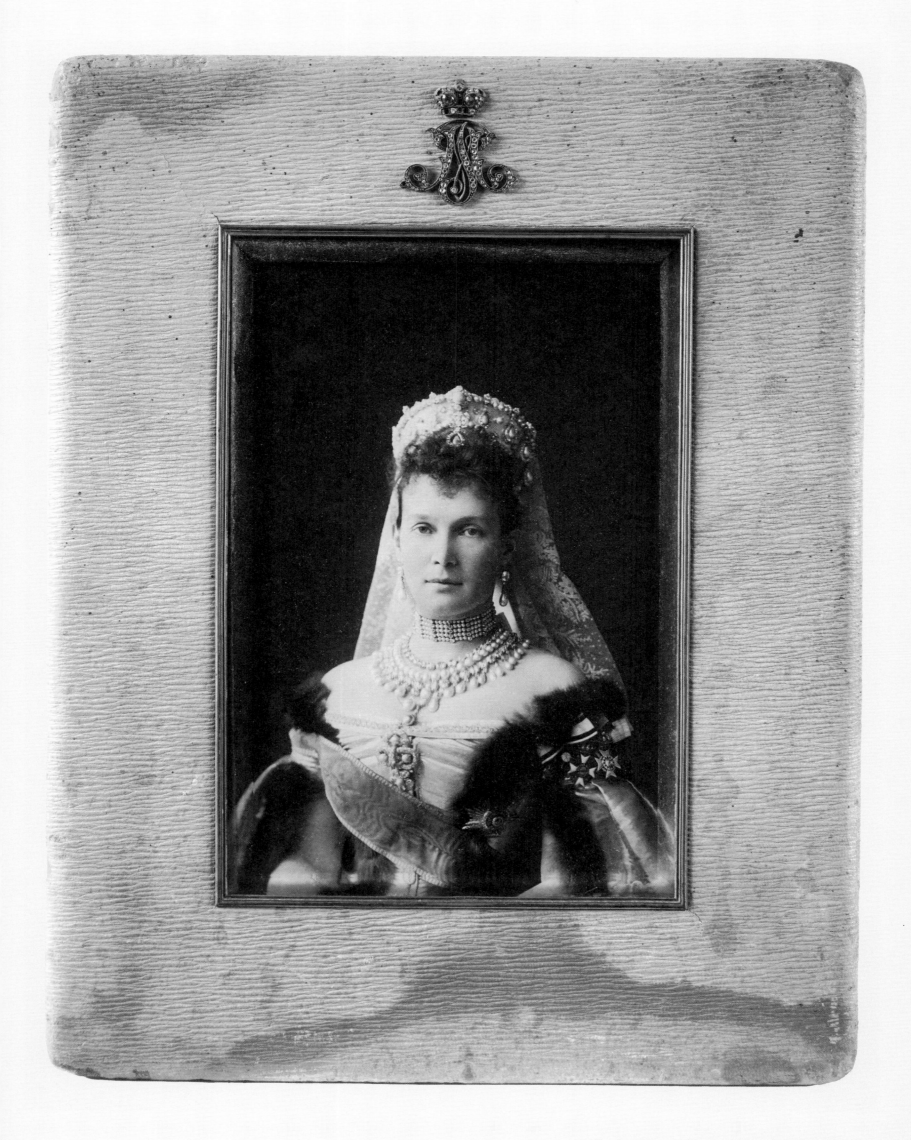

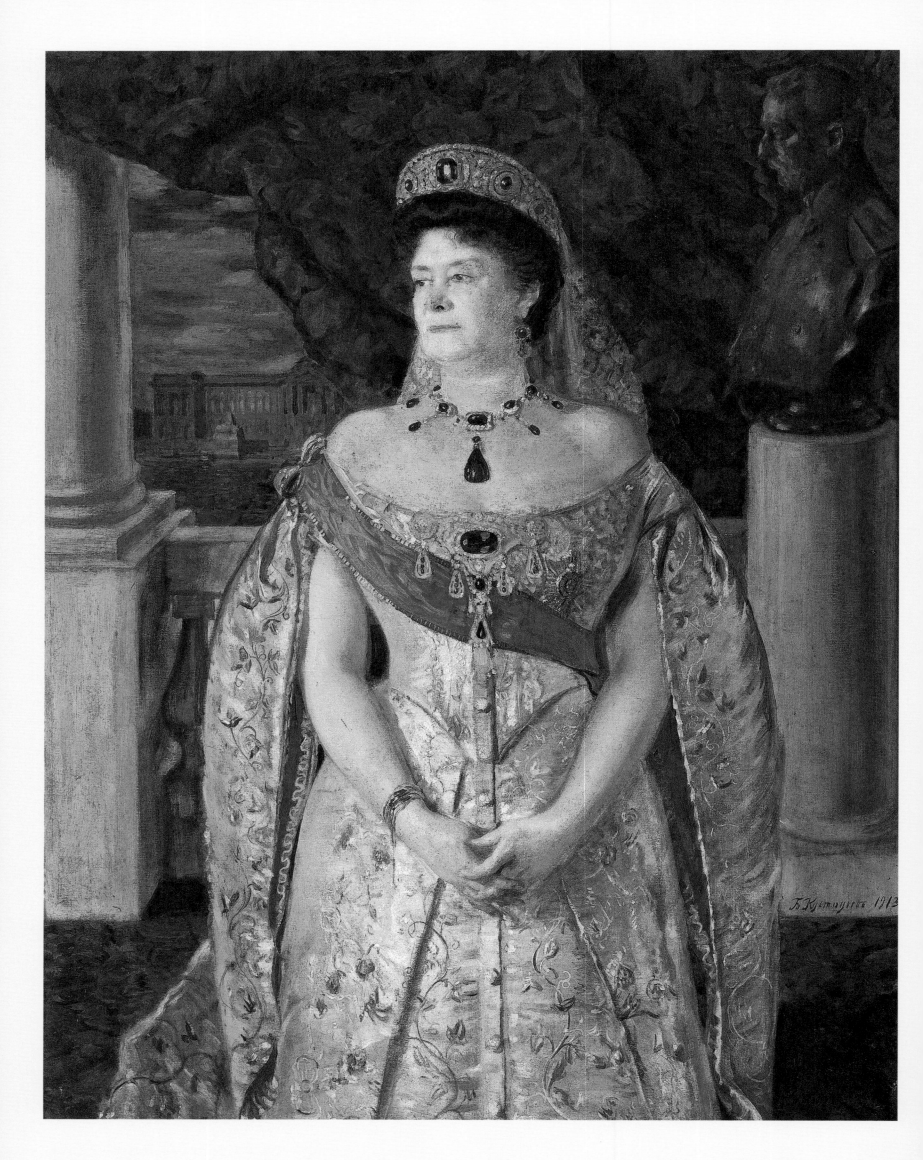

Sapphire & Diamond Kokoshnik and Agraffe

This 1913 Boris Kustodiev portrait of Grand Duchess Vladimir, wearing her famous sapphire parure that includes the tiara, the necklace, and the devant de corsage, is a visual expression of the lady's formidable resiliency.

Despite the Russian Revolution of 1905, with its waves of mass peasant unrest, worker strikes, and military mutinies—and the passing of her husband in 1909—the grand duchess maintained a grand personal aura and a lavish lifestyle.

Kustodiev captures the grandeur and grace of the grand duchess in this portrait, as she poses before the Imperial Academy of Arts in St. Petersburg, symbolic of her lifelong involvement with the arts.

Sapphire & Diamond Devant de Corsage

This archival photo shows the sapphire devant de corsage (or stomacher) of Grand Duchess Vladimir, which was made by Cartier in 1910 reusing imperial stones.

This splendid piece is comprised of diamonds and cabochon sapphires, as well as a spectacular center stone: a 162-carat cushion-shaped sapphire.

In 1913, Boris Kustodiev painted the Grand Duchess Vladimir wearing the jewel set with sapphires. Later the devant de corsage (stomacher) was reset with pearls by the grand duchess, and it was part of the jewels rescued after the revolution.

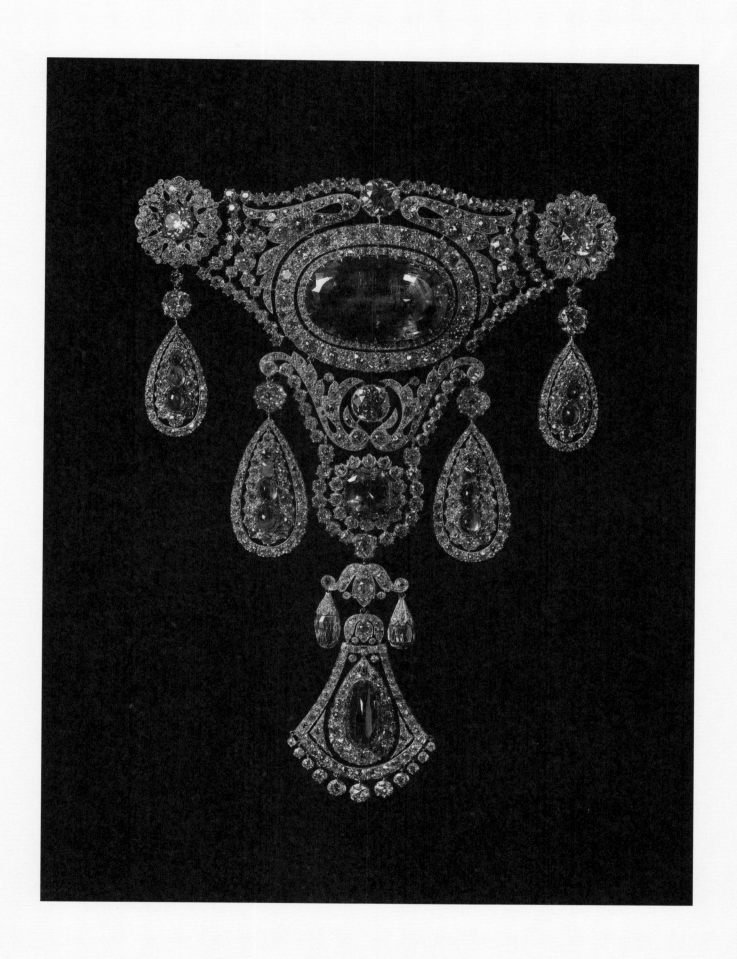

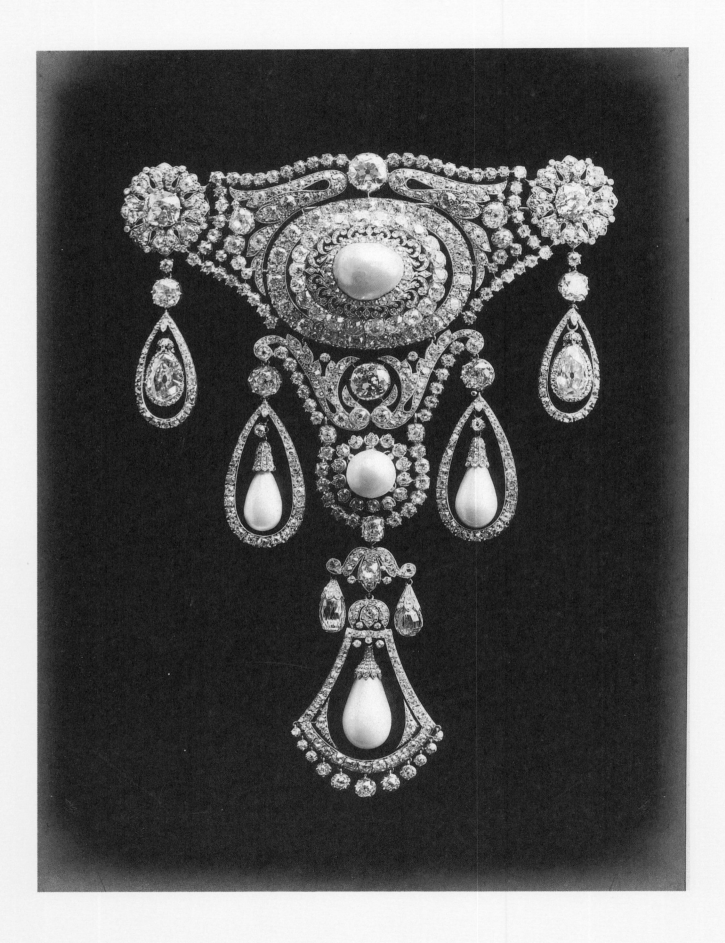

Pearl & Diamond Devant de Corsage

This image of a Cartier Devant de Corsage is from a photographic album of jewels that were the property of the Grand Duchess Vladimir. The album is part of the collection of photographs in the Cartier Archives library. This brooch is the same Sapphire & Diamond Devant de Corsage created by Cartier in 1910. Here set with pearls.

This is just one of the pieces of the grand duchess's jewel collection that were left behind when, for safety, she moved her family to her estate in the Caucasus in 1917.

An Englishman named Albert Stopford salvaged her jewels later, when in a feat of true friendship, he returned to St. Petersburg and was able to smuggle her entire collection out of the country just before the Vladimir Palace was seized and ransacked by the Bolsheviks.

Years later, in London, where he had placed the jewels in a bank safe, Stopford was able to reunite the jewels with the Grand Duchess Vladimir's family.

Diamond Bow Brooch

Grand Duchess Vladimir's large Edwardian double-bow devant de corsage is a fine example of the new lightness allowed by advances in platinum fabrication.

The strength of platinum made it possible to create jewels that resembled "petit point" (needlepoint embroidery) and allowed the jeweler to mount stones in minimalist settings.

Here we can see the millegraining technique (edges of fine beading) made possible by the use of platinum. The border of delicate balls balanced on the edge of the bow give the piece a softer, lighter look than had ever been possible before.

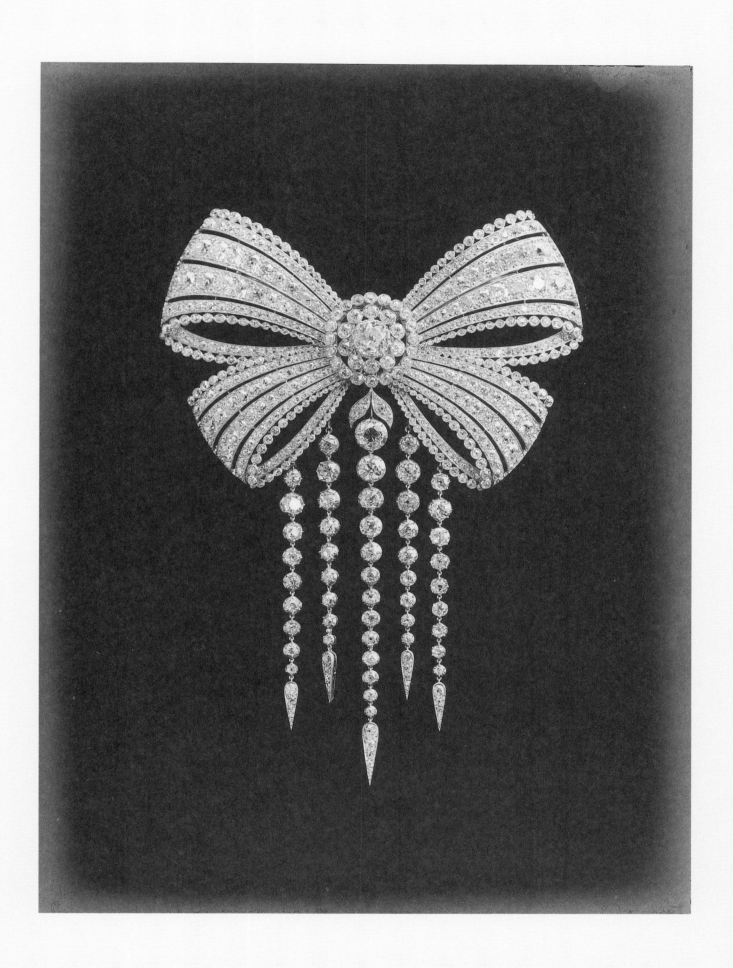

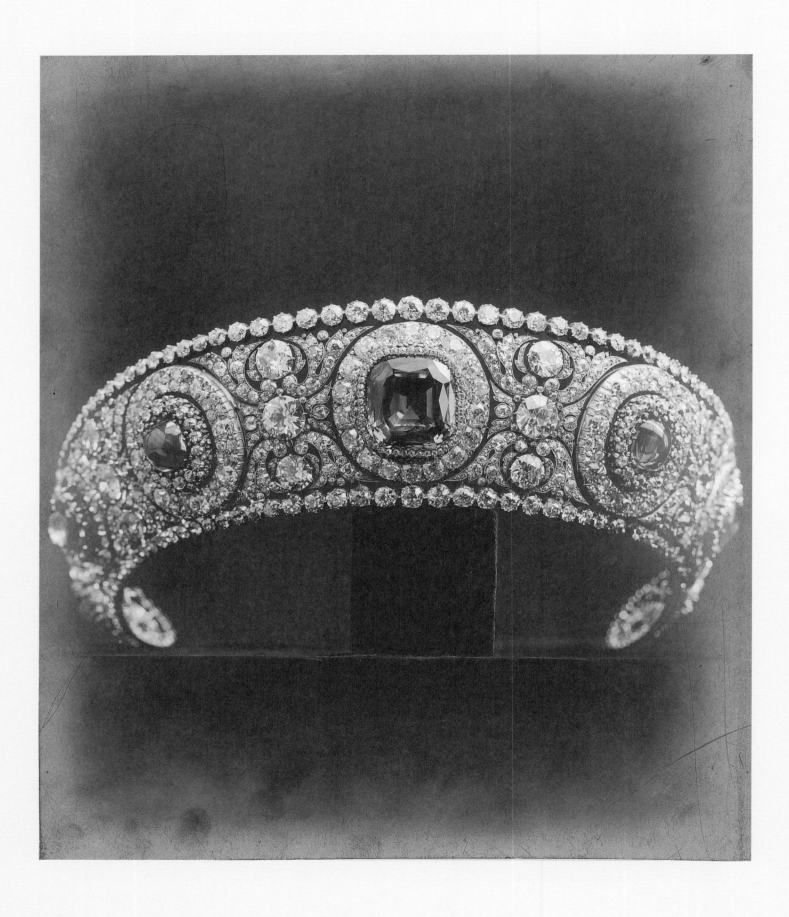

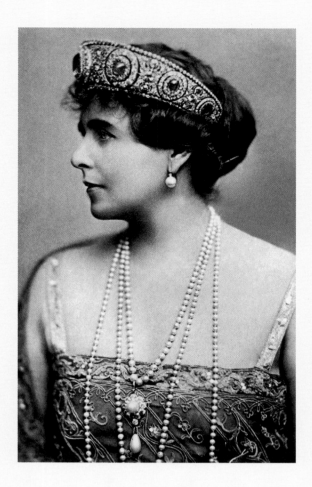

Sapphire & Diamond Kokoshnik

This sapphire Kokoshnik Tiara was originally made by Cartier in 1909 for the Grand Duchess Vladimir. The striking tiara is set with diamonds, as well as six cabochon sapphires. Its dominant design feature is a 137.20-carat faceted, cushion-shaped sapphire, set in a double row of diamonds that were repurposed by the grand duchess from an earlier headpiece. The cabochons had belonged to Empress Alexandra Feodorovna of Russia.

The Grand Duchess Vladimir's son, Grand Duke Kyril, and his wife Princess Victoria Melita, known as "Ducky," inherited the sapphire Kokoshnik Tiara. The couple sold the piece to Ducky's sister, Queen Marie of Romania, in 1921 or early 1922, to help support their life-style in exile.

Although grateful for the chance to own such a beautiful piece of jewelry after she had lost all of hers, Queen Marie was saddened that her sister and husband had to resort to such measures to ensure their survival after the Russian Revolution had left their entire family without any means of support.

Queen Marie of Romania is seen above wearing the sapphire and diamond Kokoshnik Tiara.

"Known as Aunt Missy to her family, she was a first cousin to Grand Duchess Elena," recalls Prince Dimitri. "She sat down at the negotiations table at the Treaty of Versailles in 1919 and obtained 30 percent more territory for Romania than it had before the war!"

The Kokoshnik Tiara, and other pieces, she purchased in the 1920s to replace her own jewelry. During World War I, Queen Marie had sent her jewelry to Russia for safekeeping in the hopes that the treasures would be safe from wartime destruction and loss.

However, after World War I ended, the Russian Revolution swept the country and her jewels were lost along with that of most of the Russian aristocracy.

The Sapphire & Diamond Sautoir

The Queen of Romania sapphire is among the five largest in the world. The first reference to this 478.68-carat sapphire was in 1913 by Cartier. At the time, the gemstone, of Sri Lankan origin, was added to an existing necklace. This sautoir was Cartier's most valuable item when it was exhibited in 1919 in San Sebastian, Spain, at the Hotel Maria Cristina.

Later, Cartier designed a new necklace in a striking, elegant and modern Art Deco aesthetic to hold this legendary sapphire. It was a sautoir made in platinum with geometric forms that were set with diamonds. A design that offered the striking blue sapphire as the focal point of this extraordinary jewel.

In 1921, King Ferdinand of Romania purchased the sautoir from Cartier, as a gift for his beautiful consort, Queen Marie who was a granddaughter of both Queen Victoria of Great Britain and Tsar Alexander II of Russia.

A year later, in 1922, when King Ferdinand and Queen Marie ascended to the throne, she wore her sapphire necklace.

Here, in a photograph from the Cartier historical photographic archives, we see the necklace, as worn by Queen Marie of Romania.

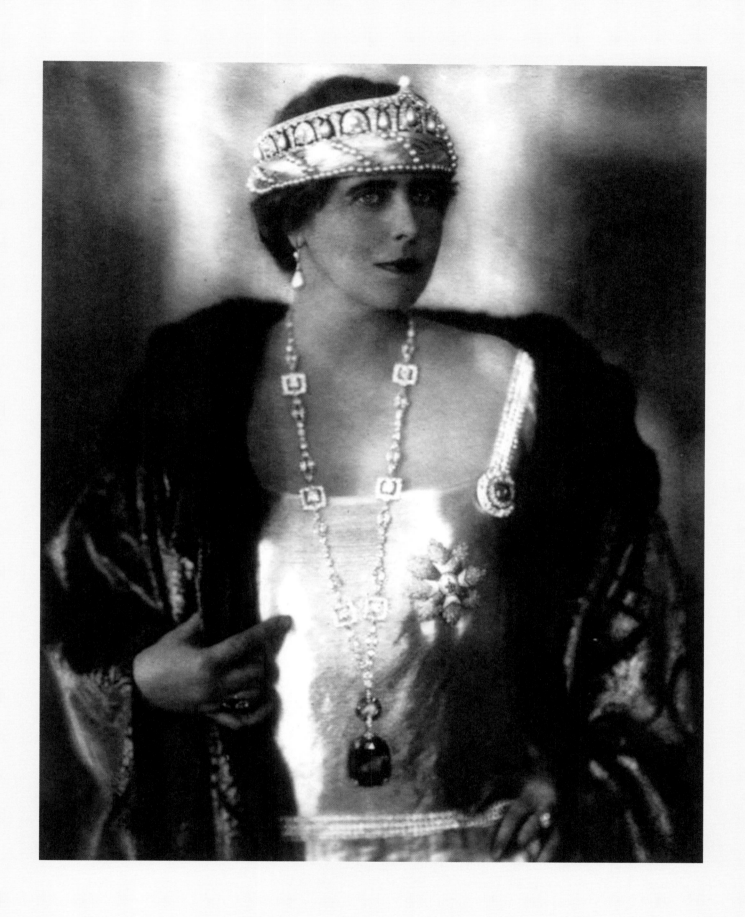

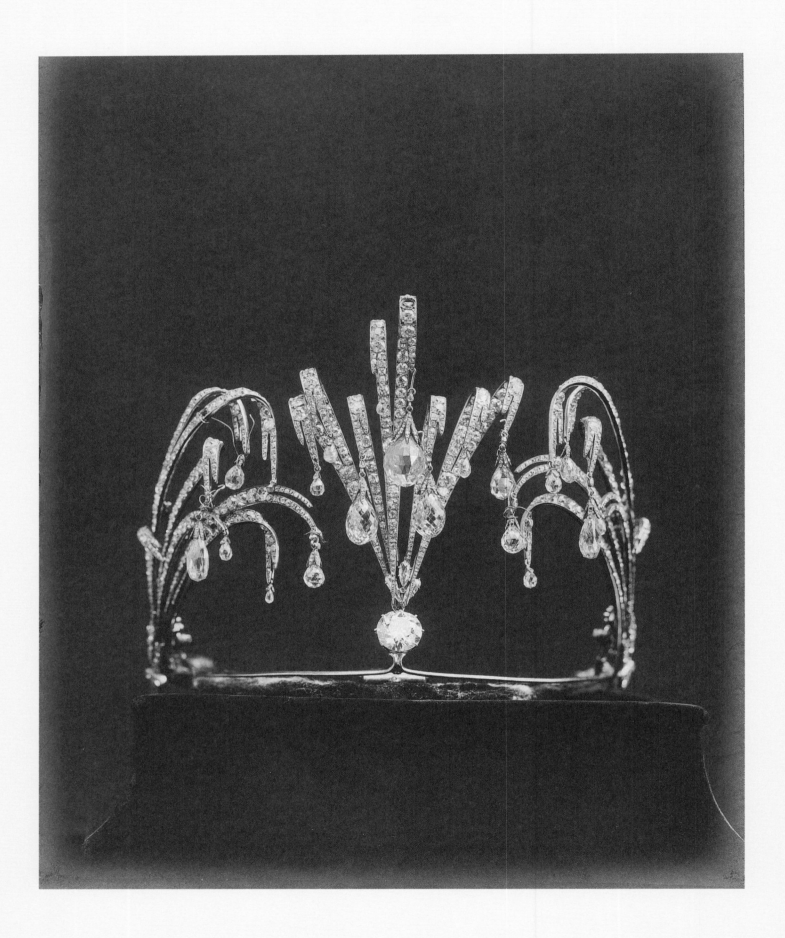

The Waterfall Tiara

The fairy-like platinum Waterfall Tiara, created by Joseph Chaumet in 1899, was a gift from the Grand Duke Vladimir to the grand duchess on their twenty-fifth wedding anniversary.

The diamond briolettes are secured so that they vibrate slightly with every movement of the head. The overall design suggests a multitude of sprays of water set with calibrated round diamonds. These delicate arched structures support the hanging briolettes that reflect the ambient light, just as water does.

The total weight of this extraordinarily fine example of Chaumet's mastery of tiara design is comprised of diamonds that weigh in excess of 75 carats. In 1904, Chaumet made a similar tiara with a different central diamond for Princess Henckel von Donnersmarck.

Emerald Hexagonal Necklace

This spectacular collection of emeralds is set in a necklace that featured a very large center hexagonal stone and eight rectangular stones, as well as pear-shaped emerald pendeloques.

It was worn by the grand duchess at many court functions as well as balls. After she died, the necklace was sold, and in the 1930s it became part of the collection of Edith McCormick Rockefeller. The Rockefeller heiress reimagined their presentation and had the stones set in a long Art Deco sautoir with diamonds. A hexagonal stone hangs at the bottom.

Following Rockefeller's death, the sautoir holding the Grand Duchess Vladimir's emeralds was sold to Cartier. In 1935, Barbara Hutton acquired the famous jewels and later had the stones set side by side, in their third incarnation, as a beautiful diamond and emerald necklace transformable into a tiara.

That incarnation was the last one in which the grand duchess's emerald collection was set in its entirety in one necklace, as Van Cleef later acquired the set and sold the stones off individually. The quality was such that when one of the smaller stones was sold in the 1980s at Sotheby's, it fetched a world-record price per carat.

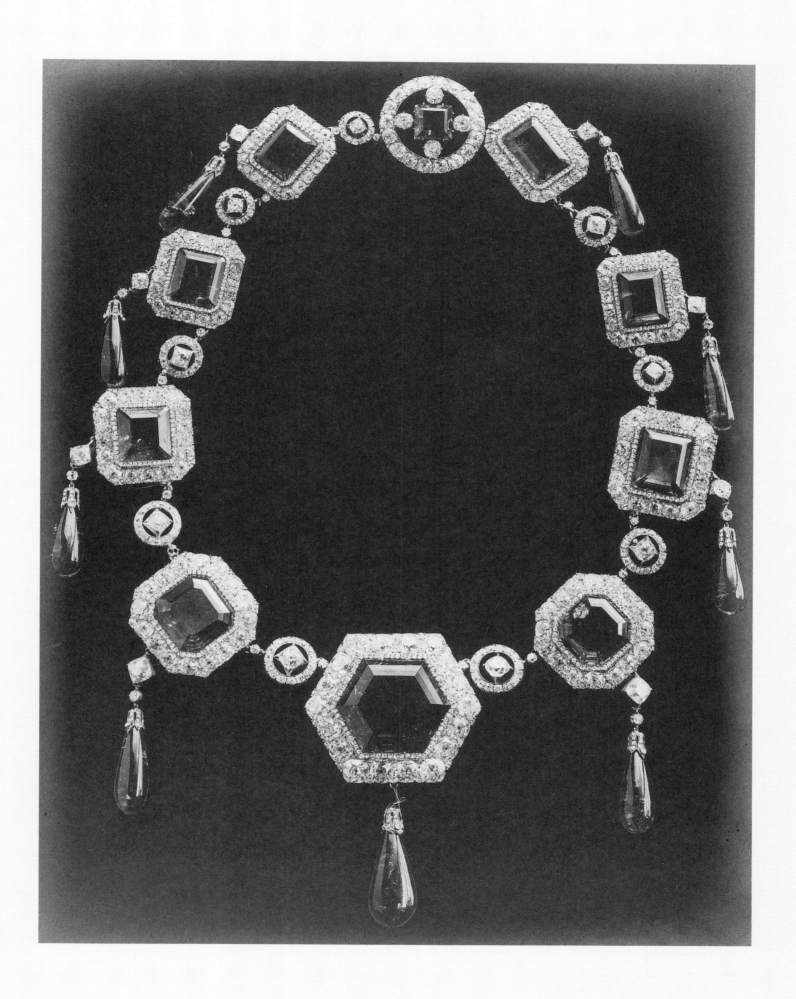

Marie

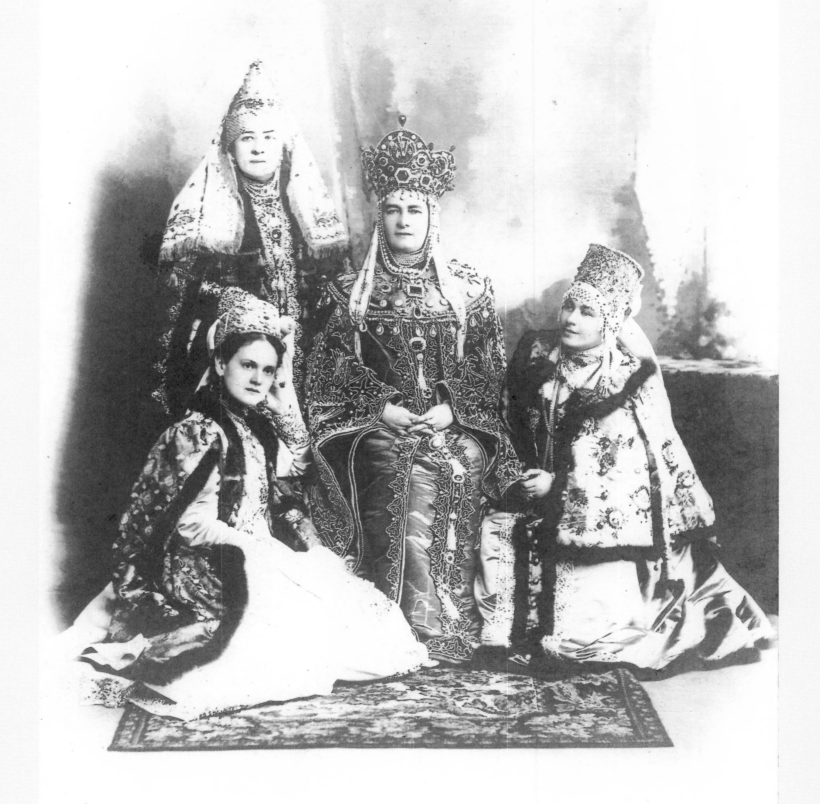

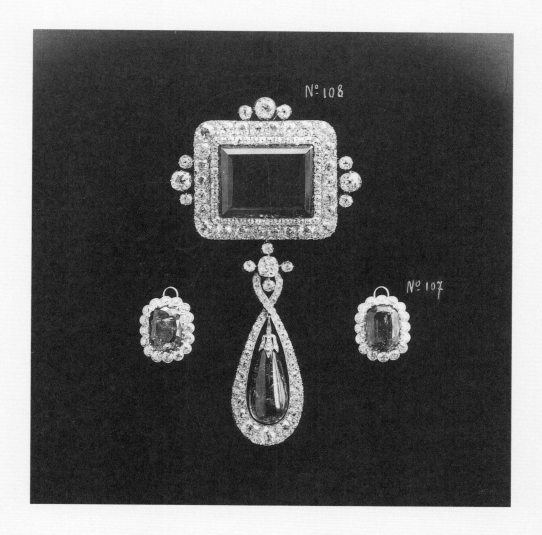

Grand Duchess Vladimir at The Boyar Costume Ball

The Grand Duchess Vladimir *(center)* in a photograph taken at the 1903 costume ball given by Nicholas II to celebrate the 290th anniversary of the House of Romanov.

Per its theme, the Russian aristocracy arrived fabulously attired in seventeenth-century Russian national dress from the pre-Europeanization era. Ladies wore traditional sarafans and kokoshniks bedecked with the most extravagant jewels imaginable.

In this photograph, the grand duchess is wearing the boyarynya dress of a noblewoman of medieval Russia.

The Boucheron Waterfall Tiara and her magnificent emerald parure, which includes the necklace, are worn here as adornments to the kokoshnik, while the large emerald brooch *(above)* is worn on her chest below the many rows of pearls that encircle her face below the kokoshnik. Her pearl and diamond rivière necklace can be seen across her chest beneath the emerald brooch.

Emerald Sautoir

The pear-shaped Vladimir emerald seen here is 75.61 carats, and was recut from the legendary 107.67-carat rectangular gem that had been part of the Russian imperial crown jewels for over one hundred years and was once owned by Catherine the Great.

Tsar Alexander II gifted the emerald parure (set of jewels), including the agraffe brooch with the 107-carat emerald centerpiece and the necklace, to Grand Duchess Vladimir on the occasion of her wedding to his son, the Grand Duke Vladimir in 1874.

In 1920, after her passing, the emerald was bequeathed to her son Grand Duke Boris. He sold it to Cartier in 1927. Cartier remounted the rectangular Vladimir emerald into a diamond sautoir and later modified the design of the piece further by incorporating a diamond necklace purchased from the Payne Whitney family.

In 1954, on the recommendation of the gem dealer Raphael Esmerian, it was decided to recut the rectangular Colombian stone to improve its clarity. The result was an exceptionally high-quality pear-shaped emerald of 75.61 carats. The stone was reset and Raphael Esmerian purchased that necklace in 1971.

Today, the Vladimir emerald is set in a contemporary necklace design that features a detachable 2¾-inch (7.1-cm) pendant. In this most recent incarnation, the emerald is surrounded by round, pear, and marquise-cut diamonds that match the stones used in the necklace.

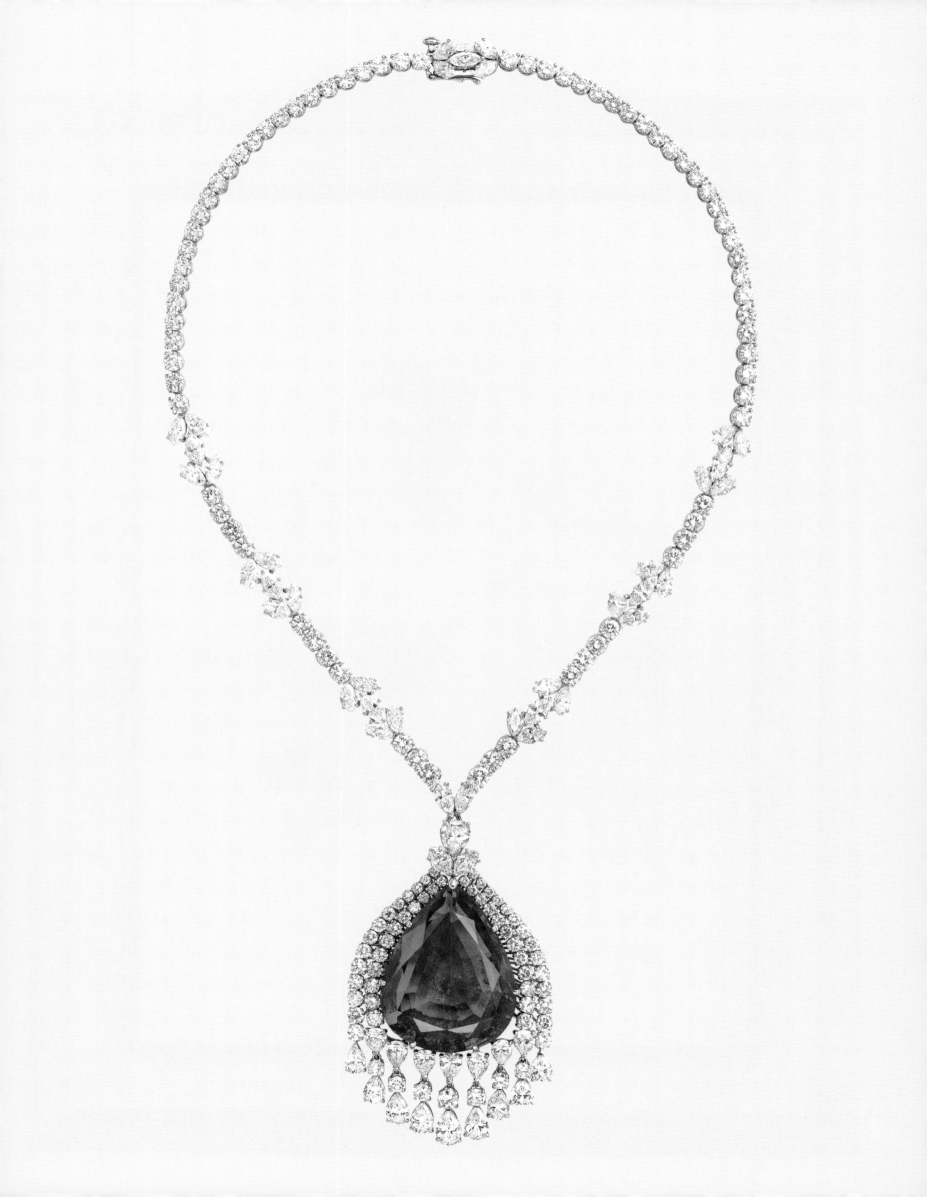

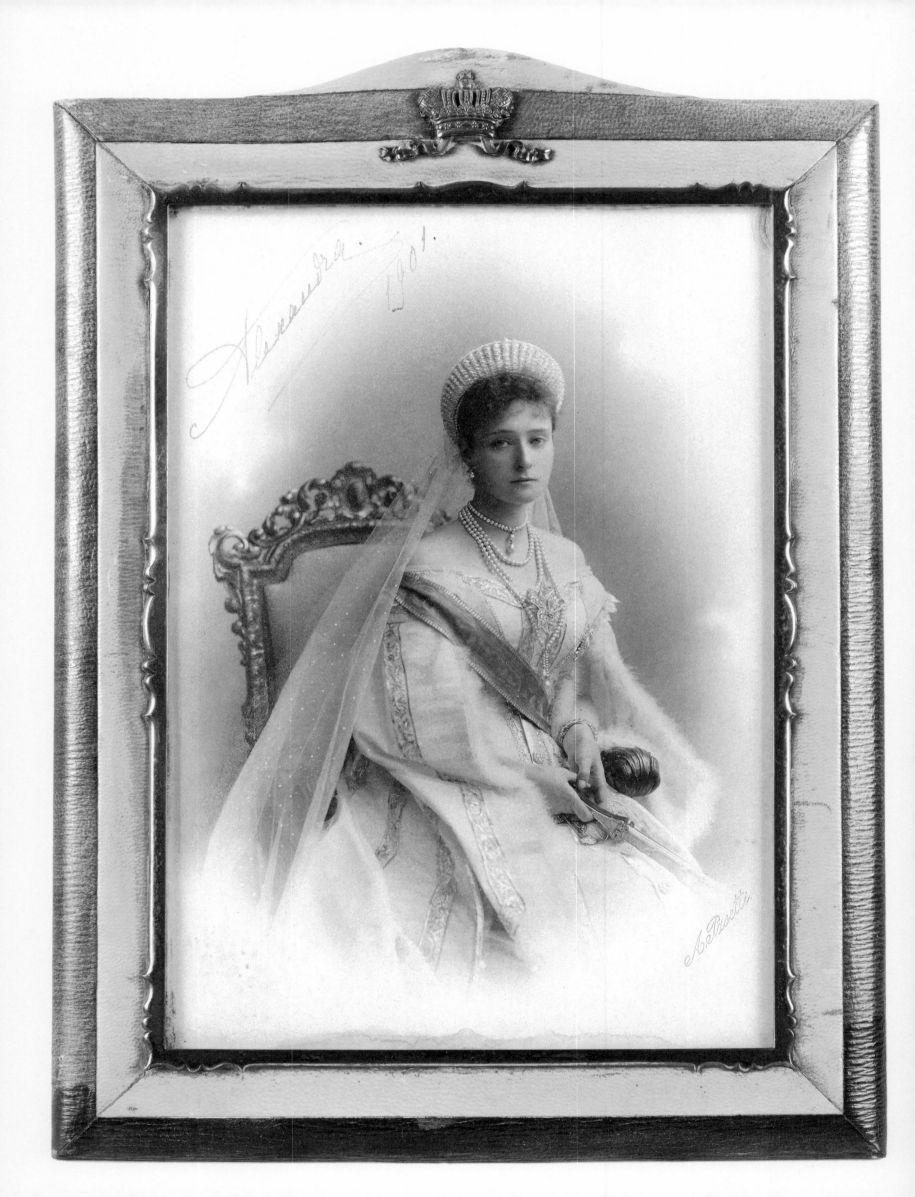

The Magnificent Jewels
of the
Russian Imperial Court

In February 1927, *Illustrated London News* carried an article that read: "A sale of great historic interest is announced to take place at Christie's on Wednesday, March 16, when some magnificent jewelry that formed part of the Russian State jewels will be put up for auction. . . ."

The article listed 124 lots that were being sold to support the new Soviet state; among them was the imperial Russian nuptial crown, a diamond choker, as well as "a diamond tiara designed as wheat-ears and foliage."

With that sensational, but rather matter-of-fact, statement, the entire world was invited to witness the final chapter of the Romanov dynasty and the end of the Russian Empire.

The nexus of that remarkable treasure dated back to Tsar Peter the Great's 1719 decree establishing the "Diamond Fund." This fund was comprised of important state regalia, exquisite jewelry, and rare gems that were added to by every generation of monarchs, and worn by members of the imperial family. The collection was housed in the Diamond Room in the Winter Place, in St. Petersburg, under the care of the Lord Stewards.

The Empress Maria Feodorovna, the wife of Alexander III, is seen above right, wearing the diamond fringe tiara and the famous 475-carat Golconda diamond rivière necklace that is set with large round diamonds and pear-shaped diamond pendeloques.

The collier d'esclave (a necklace that sits under the neck) is formed by a string of twenty-one cushion-shaped diamonds mounted on a channel, which is held together by silk threads to make the necklace more flexible.

Suspended from this structure are fifteen antique, pear-shaped diamonds, each surmounted by a much smaller diamond. The central stone in the string is about 32 carats, while the central pear-shaped diamond is 26 carats.

The mineralogist Alexander E. Fersman, in his elaborately detailed 1925 catalogue of the imperial jewels, explains that

Tsar Nicholas II

Catherine the Great, who exhibited a particular interest in diamonds, had contributed a vast majority of the items to the Diamond Fund, including the Great Imperial Crown made for her coronation in 1762 by the court jewelers Georg Friedrich Ekart and Jérémie Pauzié.

The Romanov dynasty was Europe's most powerful. Their empire comprised land holdings that covered one-sixth of the earth. Their many imperial palaces and country estates were unparalleled in their grandeur; their gem, gold, and jewelry collections were legendary—all reflecting the power that they projected and the vastness of their wealth.

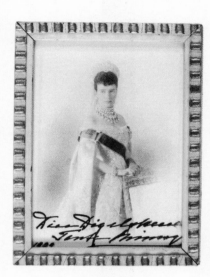

Empress Maria Feodorovna

In 1881, the first political tremors began to weaken this edifice of power. A burst of revolutionary violence brought about the assassination of Tsar Alexander II, thus elevating Alexander III and Empress Maria Feodorovna to the throne.

In that moment, fate intervened once again in charting the extraordinary course of this princess's life. The first time occurred in 1864, when Tsarevich Nicholas Alexandrovich, to whom the young Princess Dagmar of Denmark was engaged, suddenly fell ill and died of meningitis. Hers was not a prominent royal family, so her prospects seemed doomed after his passing. Yet, it was not to be so, as the young Tsarevich's last wish was that the princess should wed his brother, the future Alexander III. It seems that both families also thought this match was desirable and so the two married in 1868.

Per Russian imperial tradition, on the day of the wedding, the bride donned an entire set of spectacular regalia that included the Nuptial Crown as well as the nuptial Kokoshnik Tiara. This tiara was set with diamonds of different cuts and sizes and was a reported 1,000 carats; it centered on a rare, pale pink diamond weighing 13.35 carats. In addition to these head coverings, Maria Feodorovna would also be wearing the famed diamond rivière necklace comprised of large, round, and pear-shaped Golconda diamonds weighing 475 carats.

Opposite: Tsarina Alexandra Feodorovna

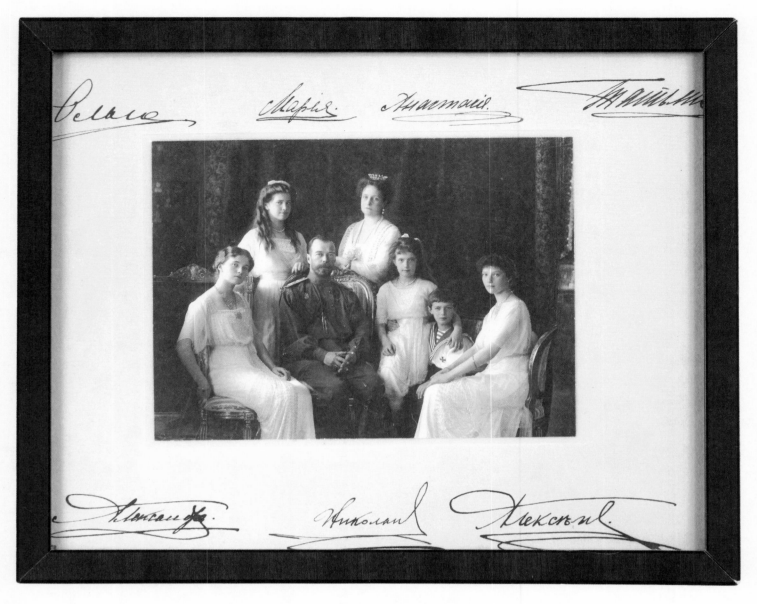

Portrait of the Tsar and Tsarina with their children

Naturally, as behooved an imperial bride, Maria Feodorovna received many gifts of jewelry. One was especially important to her as it came from her beloved sister, Princess Alexandra of Wales, and her husband, the future King Edward VII. It was a brooch that featured a beautiful cabochon sapphire surrounded by two rows of diamonds with an important drop pearl hanging from a collet of diamonds (single round diamonds in a single row).

According to the 1930 sales records of Hennel & Sons, more than sixty years after Maria Feodorovna's marriage, Queen Mary of England purchased the brooch, repatriating the piece to its first home. She bequeathed the brooch to Queen Elizabeth II, whose affection for the jewel is evident by the countless times she has worn it.

A signed photo of the five children of Nicholas and Alexandra

Although Empress Maria Feodorovna and her family were moved out of St. Petersburg, to the Gatchina Palace, for security reasons, she often went to the city to participate in, and organize, balls, official receptions, and other activities that she enjoyed. She did this all while fulfilling her role of wife and bearing six children: Alexander, Nicholas, George, Xenia, Michael, and Olga. It was said that Empress Maria Feodorovna was the most accomplished and elegant empress Russia had ever seen.

In the years of her reign, life was a splendid succession of winter seasons of grand social events and bucolic summers in the Crimea spent with the most celebrated members of the Russian aristocracy. Among them was Princess Zinaida Yusupov, who served as lady-in-waiting to the tsarina.

The Yusupov family was the wealthiest in Russia and its matriarch, Zinaida, was the sole heiress to the family's numerous properties and palaces throughout Russia, including the Arkhangelskoye Estate and the Moika Palace in St. Petersburg as well as a vast collection of paintings, sculptures, and a renowned trove of exquisite jewelry.

In 1887, Princess Zinaida's father entrusted a member of the Fabergé house to go to Paris and purchase, on his behalf, the most famous pearl in the world, known as La Regente. Sold by the French government, the immense collection that made up the French crown jewels included the devant de corsage that held this storied pearl. During this same period, the Yusupovs also purchased Marie Antoinette's diamond pendant earrings.

In November 1894, Tsar Alexander III succumbed to nephritis at the age of forty-nine and died in the arms of Empress Maria Feodorovna. Soon after the passing of his father, Nicholas married Princess Alix of Hesse (who became Empress Alexandra Feodorovna). Although deeply distraught, the Dowager Empress continued to rule St. Petersburg and advise her son Tsar Nicholas II.

Meanwhile, Empress Alexandra dedicated all her time to securing her husband's complete love, trust, and devotion, and giving birth to her children Olga, Tatiana, Maria, Anastasia, and the young Tsarevich Alexander, who suffered from hemophilia.

In the years that followed her marriage, Alexandra's isolation from court grew, while her political power expanded as her husband relied ever more heavily on her advice—a source of concern to the Dowager Empress and discontent to the tsar's military and political advisors.

And yet, outwardly at court, it was the season's social events, such as the 1903 ball, presided over by Nicholas and Alexandra, that seemed to preoccupy the ruling aristocracy.

It was the 1905 February Revolution that truly rocked the foundations of St. Petersburg's aristocracy. Although survived by Tsar Nicholas II, the violent uprising left him a greatly weakened sovereign. Additionally, in its military conflict with the Japanese, Russia suffered multiple military defeats, despite which Tsar Nicholas II chose to remain engaged until the conflict was concluded with a treaty mediated by President Theodore Roosevelt.

That same year, the Empress Alexandra's sister, the Grand Duchess Elizabeth Feodorovna, was devastated when an anarchist assassinated her husband, the Grand Duke Sergei Alexandrovich of Russia, the governor of Moscow and brother of the late Tsar Alexander III.

From that day onward, Elizabeth wore mourning clothes. In 1909, she sold her collection of jewels and other valuable possessions. With the proceeds she founded the Convent of Saints Martha and Mary and became its abbess.

In 1906, Tsar Nicholas met the peasant Grigori Rasputin for the first time. He described the encounter: "He made a remarkably strong impression both on Her Majesty and on myself, so that

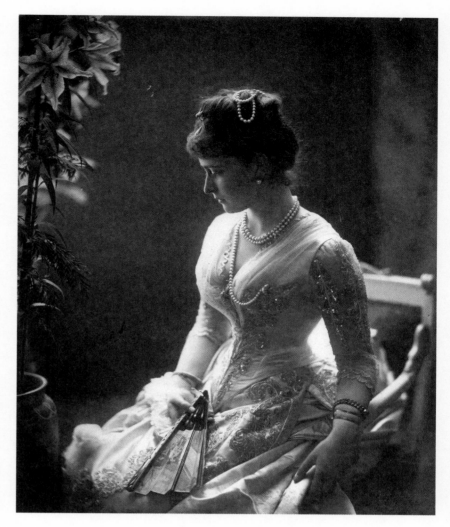

Grand Duchess Elizabeth Feodorovna

instead of five minutes our conversation went on for more than an hour." Thereafter, Rasputin took on the role of spiritual advisor to the imperial couple—encouraging Nicholas in his role as tsar and soothing Alexandra's fears. Much to the dismay of the Russian elite, by the time World War I broke out in 1914, Rasputin was furnishing political advice and suggesting ministerial appointments.

In 1907, when Russia entered into the Triple Entente with France and Great Britain to counterbalance the territorial ambitions of the German-Austro-Hungarian alliance, the fatal political fuse box was lit that led to the undoing of the Romanov dynasty just a few years later.

One of the social highlights of the 1914 season was the wedding of Zinaida Yusupov's son, Prince Felix, to Irina Alexandrovna, the niece of Tsar Nicholas II. Although some in the tsar's family were opposed to the marriage, because Prince Felix had the reputation of being wild, the match had won the endorsement of the Dowager Tsarina Maria Feodorovna, and the couple wed.

As was customary among the ruling elite, the wedding gifts Irina received included countless pieces of magnificent jewelry. When the couple departed on their honeymoon, they stopped off in Paris and entrusted to the jeweler Chaumet the redesign of some of the pieces, including a stunning emerald and diamond parure and a sunburst tiara, both of which would reappear after the revolution.

Just a few months after their wedding, in July 1914, World War I broke out. During the war, Prince Felix hid most of the family jewelry in the Yusupov Palace in Moscow.

The Dowager Empress Maria Feodorovna had taken on the role of president of Russia's Red Cross during the war, while redoubling her efforts to encourage Tsar Nicholas II to banish Rasputin from court—to protect both him and the monarchy's reputation; she was not successful.

By 1916, the situation in Russia became dire, the discontent around the absent Tsar Nicholas II and the ever-growing influence of Grigori Rasputin on the Empress Alexandra had reached a boiling point. Many friends and trusted advisors perceived that Rasputin's influence was so nefarious that unless he was stopped, the Romanovs were doomed.

On December 30, 1916, Felix Yusupov managed to lure the infamous Rasputin to his palace in St. Petersburg. The pretext was a promised meeting with Princess Irina. In the basement of the Moika Palace he and his accomplice, Grand Duke Dimitri, poisoned Rasputin in an effort to save their beloved Russia. His battered and poisoned body was recovered from the Neva River a few days later.

Years later, Felix Yusupov spoke of that night and revealed that the princess was, in fact, in Crimea at the time. He explained that the plot to bring an end to the life of this dreaded monk had been elaborately planned and that he was its perpetrator.

In February 1917, eight days of mass demonstrations against food rationing turned into violent armed clashes with the police and military; on February 27, elements of the Russian army sided with the revolutionaries. Three days later Tsar Nicholas II was forced to abdicate.

After the 1917 revolution had pushed the Yusupov family out of the city, the Bolsheviks came looking for the famed collection. One of the Yusupovs's loyal employees refused to give up the location and was executed, but the jewels were ultimately discovered and confiscated.

On July 17, 1918, Tsar Nicholas II, Tsarina Alexandra Feodorovna, and their five children were executed at the Ipatiev House, marking the end of the Romanov rule. The next day, Alexandra's sister, Grand Duchess Elizabeth Feodorovna, who had served as the abbess of the convent she had founded in 1909, was assassinated in Alapayevsk. Rumors and fear spread far and wide among Russia's nobility.

On July 22, 1918, the Russian government confirmed the demise of the tsar to the world in an aseptic dispatch that read, in part: "The Presidium of the Ural Regional Council decided to shoot the ex-Tsar Nicholas Romanoff."

The news was a devastating blow to the aristocrats and to the loyal government forces that had remained in Russia hoping for a political reversal. Over the course of 1918, some nineteen members of the Romanov family were assassinated. Nonetheless, the Dowager Empress Maria Feodorovna refused to leave.

In July 1918, the Bolsheviks took the Grand Duchess Elizabeth Feodorovna from her convent to the town of Alapayevsk in the Ural Mountains.

Sometime later, the grand duchess, together with a small group of Romanov family members as well as a nun from her convent, Varvara Yakovleva, were brutally assassinated by the Bolsheviks: they were thrown into a mineshaft where grenades were then exploded to execute them.

It is said that the grand duchess had survived her injuries and torn her clothes to make bandages for the wounded before they too died. After the massacre, the White Army regained territory and found the bodies; they carried their caskets to the Church of St. Seraphim of Sarov.

In 1921, Grand Duchess Elizabeth's remains were finally laid to rest in the Church of Maria Magdalene in Jerusalem. In 1981, the Russian Orthodox Church Abroad canonized Elizabeth and in 1992, the Moscow Patriarchate recognized her as Holy Martyr Elizabeth Feodorovna.

Prince Dimitri remembers how Princess Olga of Yugoslavia used to tell how she always knew there was something special about Grand Duchess Elizabeth; many decades after her death there were doubts that her body was still in the coffin in Jerusalem, so it was opened. He recalls her saying: "There she was, intact, seemingly asleep with a serene smile on her face. And a delicate scent of roses floating around her! The undeniable signs of Sainthood."

By April 1919, the Bolsheviks were advancing to the coast and the remaining Romanovs were told they must depart immediately or be killed. Maria Feodorovna was finally convinced to do so after receiving a letter from her sister, Queen Alexandra of England. Together with her daughter, the Grand Duchess Xenia, the Yusupovs, and some thirty other members of the imperial family and household, Maria Feodorovna boarded the HMS *Marlborough*, sent to their rescue by King George V.

As the ship sailed into the Black Sea, blurring the final glimpse of Russian land, it is said that the passengers stood silently while, for the last time, the voices of the Imperial Guard could be heard drifting over the waves singing the Russian imperial anthem. Despite overwhelming evidence, the dowager empress refused to believe that the Bolsheviks had murdered her son, Tsar Nicholas II,

and her beloved grandchildren. Until she died, she held hope that she would see her family again.

Once in exile, Maria Feodorovna lived briefly at the Amalienborg Palace in her native Denmark. It is said that one day, her nephew the king, commented that electricity bills in her wing of the palace in Copenhagen were too high. After taking the matter under advisement, Prince Dimitri reports that: "She had her entire wing of the palace lit up all night!"

In the years that followed Maria Feodorovna's death, in 1928, her daughter, Grand Duchess Xenia, lived in England and supported herself through the sale of her jewels. When Grand Duchess Xenia died in 1960, she bequeathed her two jewelry albums, a souvenir of former times, to her children. The albums sold at auction in 2001 for approximately $250,000.

Although Zinaida Yusupov had lost her family's vast land properties, her many palaces, and their contents, she had been able to bring some of her jewelry into exile, which enabled her to provide for herself during her remaining years. Zinaida was able to retain the legendary Pelegrina pearl that was part of the 1935 Russian Art Exhibition, listed as property of the Yusupov family.

Zinaida Yusupov later bequeathed her collection to her son, Prince Felix and his wife, Princess Irina Alexandrovna, who sold such exemplars as the Marie-Antoinette earrings to Pierre Cartier in 1928. Cartier then sold them to the famed collector Mrs. Marjorie Merriweather Post. In 1964 Post's daughter, Mrs. Eleonor Barzin, gifted the earrings to the Smithsonian Institution.

Prince Felix and Princess Irina lived in Rome until the prince's passing in 1967, after which Princess Irina moved to Paris, where she died in 1974. The whereabouts of the legendary La Regente pearl, a wedding gift from Prince Felix, remained unknown until a private collector sold the pearl at auction in 2005.

Prince Dimitri tells how his grandfather, Prince Paul of Yugoslavia, told him that: "Many years after the assassination, when the Yusupovs visited New York, a society hostess gave a big party for them. She knew the whole story and had instructed her guests never to mention Rasputin, as the subject was taboo. They walked into the room and she proudly announced "Ladies and Gentlemen, I would like to introduce my dear friends Prince and Princess Raspoutoff!"

One hundred years after the revolution took its terrible toll, the Russian jewels and regalia of the Romanov dynasty continue to generate passion and wonder. Of the 773 items officially listed in the Fersman catalogue of imperial jewels in 1925, only some 114 remain in the museums of Russia, the former Soviet Union.

Today, these magnificent gems continue to exhibit their rare beauty in private collections scattered across the globe, on modern monarchs and in the public institutions entrusted with their care. It seems as though these rare masterpieces, symbols of a bygone world, were meant to survive to tell their tales and bear witness to history.

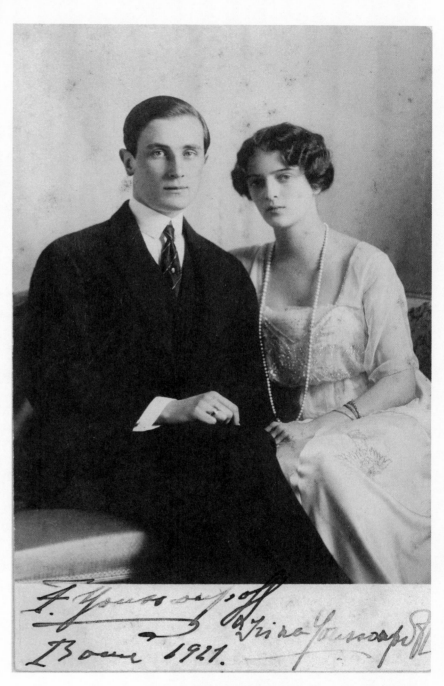

A portrait, dated 1914, of the Princess Irina of Russia and her husband, Felix Yusupov, said to be the handsomest and richest man and yet a rather controversial figure in Russia's high society.

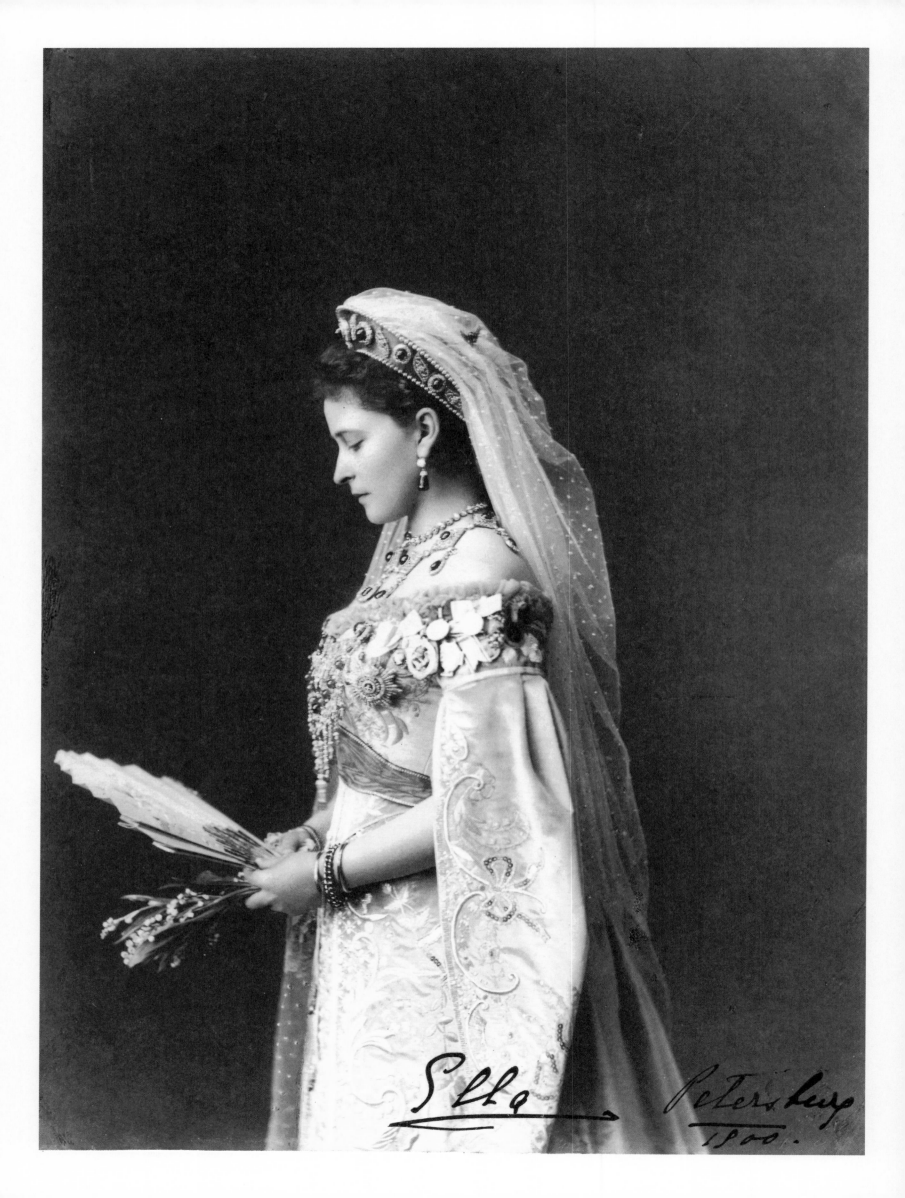

Ella *Petersburg 1900.*

Grand Duchess Elizabeth with Emerald & Diamond Necklace

Grand Duchess Elizabeth of Hesse Darmstadt was the sister of Empress Alexandra. She married the tsar's uncle, Grand Duke Sergei, a rather controversial member of the imperial family.

In this photograph, taken in 1903, the princess is wearing an emerald and diamond necklace composed of lozenge-shaped elements and drops. A very similar necklace is pictured in the 1927 Fersman catalogue. She gave this necklace as a gift to her niece, the Grand Duchess Maria Pavlovna the Younger, whom she took care of after her father was banished by the tsar.

Grand Duchess Elena Vladimirovna with the Russian Nuptial Crown

A photograph of the Grand Duchess Elena Vladimirovna taken at her 1902 wedding, where she wed Prince Nicholas of Greece and Denmark, third son of George I of Greece.

The grand duchess, who was known as Ellen or Helen to her family, is wearing the Russian Nuptial Crown, created around 1844, with 320 carats of large diamonds and 80 carats of smaller diamonds. The crown's cross can be seen rising above the Kokoshnik Nuptial Tiara.

The couple was deeply affected by the Russian Revolution and the subsequent turmoil in Greece, which became a republic. Not only were they forced to abandon their homelands, but they were also constrained by the reduced sums they received as a result. It was Grand Duchess Elena's fabulous jewel collection, as well as Prince Nicholas's own artwork, that were their sources of income.

Living in France, Grand Duchess Elena became deeply involved in charity work for Russian exiles. Having shared the journey into exile with a nine-year-old Countess Stroganoff, she continued to look after the young girl as she had promised to do. Her generosity, it is said, included selling her car so as to be able to put the young countess through school.

Prince Dimitri recounts how the countess explained that she lived in adoration of the grand duchess and named her own daughter after her.

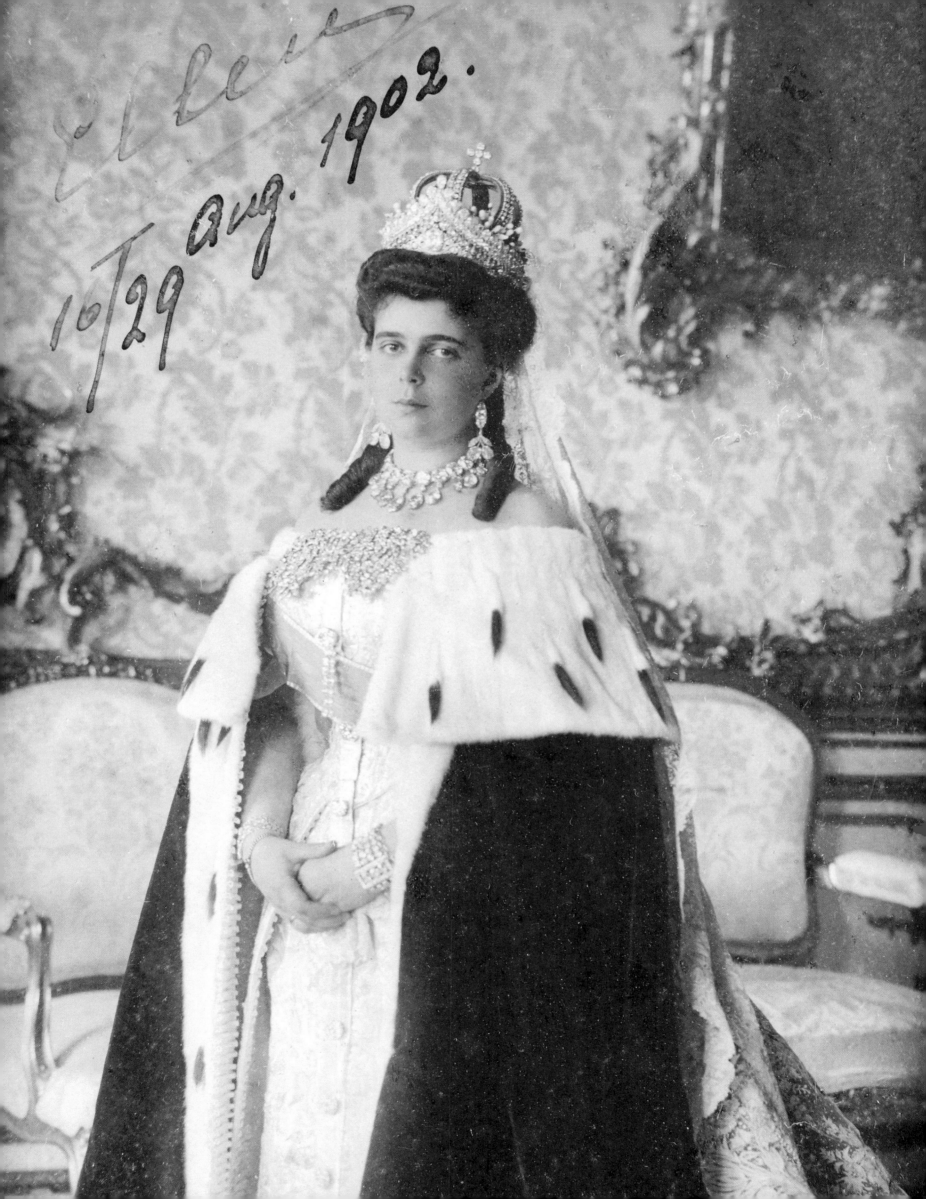

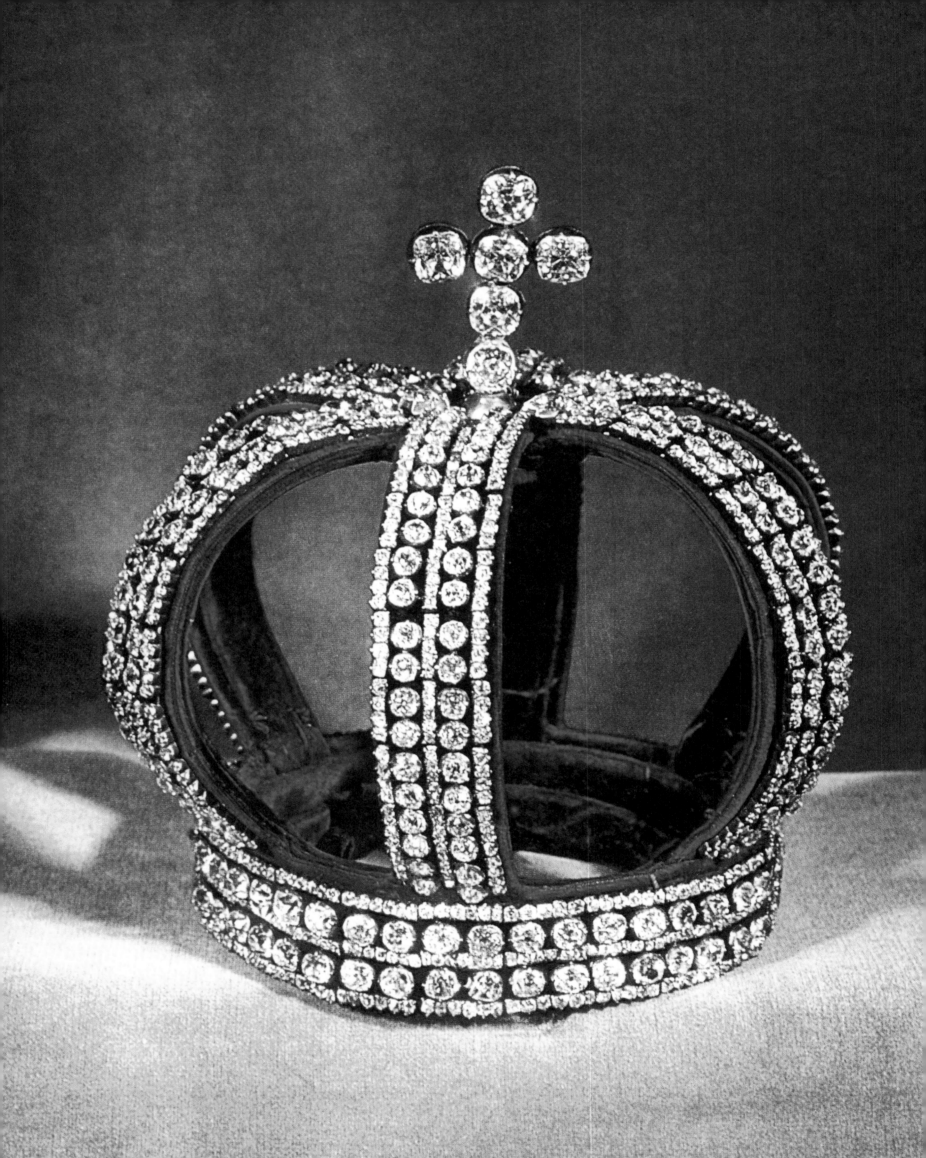

THE NUPTIAL CROWN

The Nuptial Crown was part of the imperial wedding regalia. Its orb-like shape is formed of six silver bands encrusted with approximately 1,535 old-mine diamonds. The diamonds are attached to strips of fabric in rows that have flaps at the bottom, so they can be pinned on the hair. A cross that is composed of six larger old-mine-cut diamonds tops the orb.

All the imperial brides wore the crown together with the Nuptial Tiara, a diadem that was most notable for its central pink diamond weighing more than 13 carats. This rose-colored stone of impeccable quality came from the treasury of Emperor Paul I.

The crown and the tiara were worn by every empress and every grand duchess of Russia the day of their wedding until the revolution, including Tsarina Alexandra Feodorovna at her wedding to Nicholas II in 1894 and the Grand Duchess Elena in 1902.

The Nuptial Crown was sold in 1927 as part of the imperial jewels sale held at Christie's in London. A 1973 bequest of Marjorie Merriweather Post, the crown is now part of the Russian art and jewel collection of the Hillwood Museum in Washington D.C.

Necklace with Detachable Diamond Bow

The diamond, gold, and silver necklace has a detachable diamond bow that can be used as a brooch.

Made in 1760, the necklace is comprised of twenty-five graduated, cushion-shaped brilliant-cut diamonds within a border of old-cut diamonds, all set in silver. The openwork bow is made up of a central floral cluster and surrounding foliate design.

This necklace and bow demonstrate that during the second half of the eighteenth century, jewelry reached a summit of elegant design and technical execution that is still unsurpassed.

Furthermore, jewelry of this period is characterized by the use of light-colored stones set in silver, so that they look pure and colorless.

Preference for white diamonds was also impacted by the fact that the diamond cutters had mastered the technique necessary to finally and fully highlight the beauty of a diamond.

No wonder this period in the history of Russian jewelry artistry is called "the diamond age."

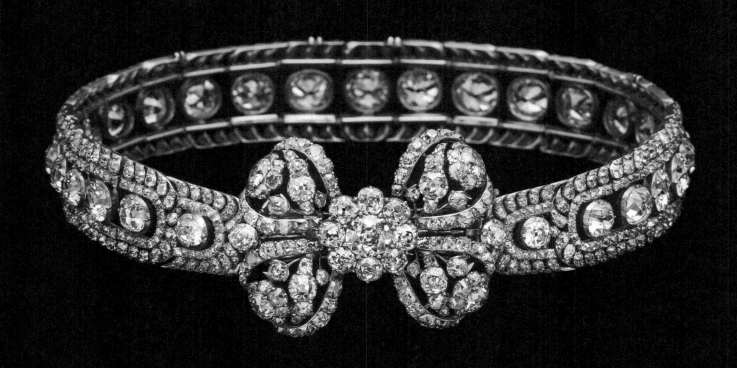

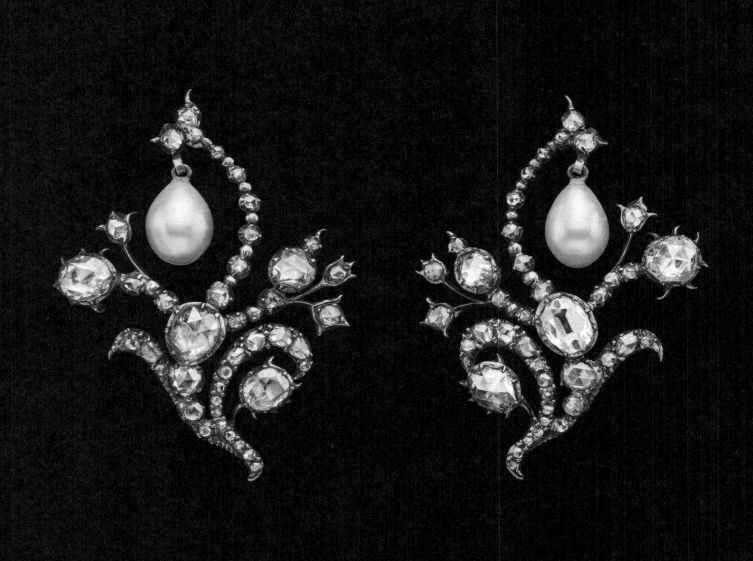

Silver Spray Brooches

For this pair of circa 1740 Russian pearl, diamond, and silver spray brooches, the design includes two scrolling stems with rose- and cushion-shaped old-cut diamonds, and a third stem extending upward to support an ovoid pearl pendant.

Catherine the Great was reputed to be completely enamored with diamonds. These were but two of many ornaments and jewels that the empress could select from her "Brilliant Room." During her reign, she purchased vast numbers of the gems from abroad or from famous St. Petersburg jewelers, such as Leopold Pfisterer, Jerome Pauzier, and Louis Duval.

In addition to her personal love for the gem, presentation jewels were deeply political, as they gave the empress the incomparable aura of majesty. This set her apart from her subjects; it ensured that, whenever she entered a room, everyone present would be awed by her greatness.

Furthermore, since there was almost no limit to what Catherine the Great could afford, her jewels were also grander and more imposing than other monarchs could ever hope to possess.

The Feather Aigrette

This pearl, diamond, and silver aigrette is embellished with three feathers and a diamond flower on a leafy stem tied together by a twisted ribbon. In addition to the shimmering of the stones, the pearl drops also gently swing with every movement of the wearer.

The aigrette was originally an ornament, which could either hold a spray of feathers in the hair or on a hat. The word "aigrette" is derived from the egret, whose feathers were often used with these pieces.

This jewel was part of the imperial regalia stored in the Imperial Treasury of the Winter Palace, which remained intact for more than two centuries. After the 1917 Revolution, a specially appointed commission was tasked with creating a detailed catalogue with photographs that was supervised by the mineralogist Alexander Fersman. Titled *Russia's Treasury of Diamonds and Precious Stones*, it listed no less than 773 items.

The Soviets, through the State institutions of the Antikvariat, began a huge dispersal starting with the 1927 sale at Christie's in London. Other items such as this, which is number 145 in the Fersman catalogue, made their way out of Russia onto the art market independently. Since 1967, the Diamond Fund Exhibition at the Kremlin has displayed the remainder of the jewels.

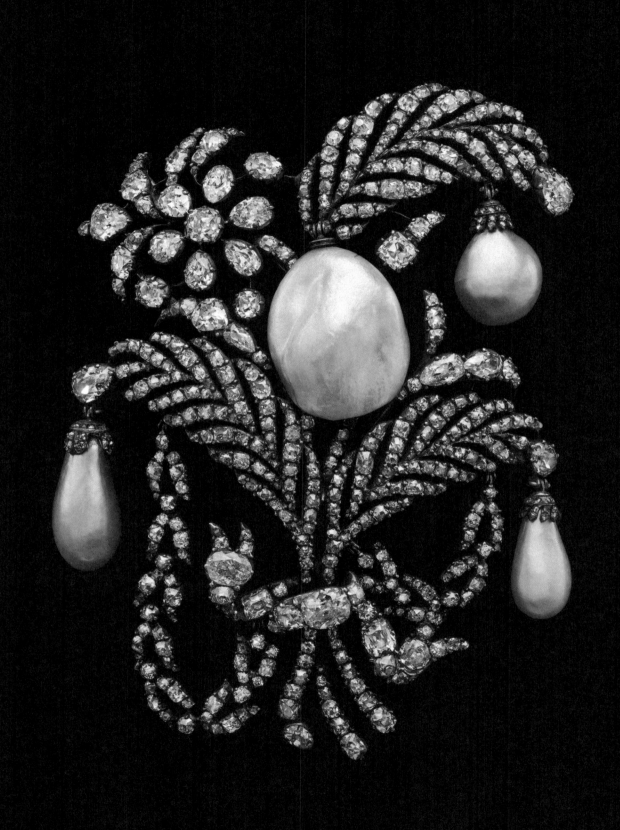

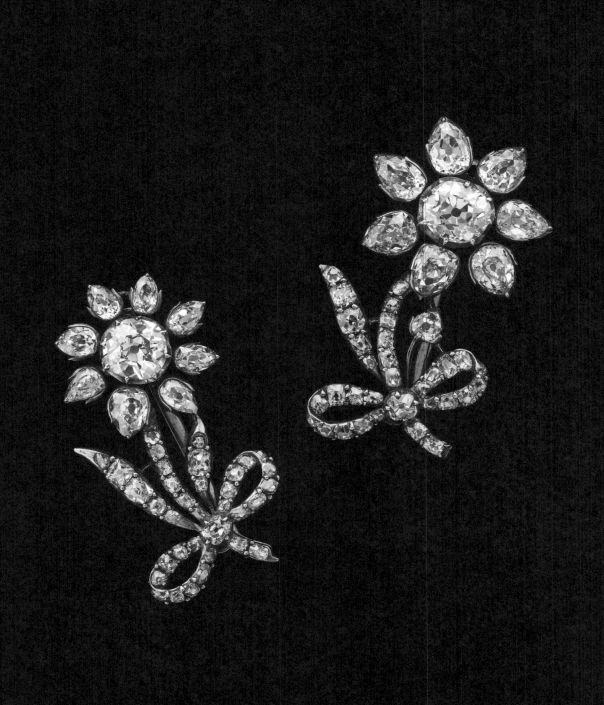

Daisy Brooches

This pair of Russian silver and diamond floral sprays circa 1780 are part of a collection of diamond flowers that were sewn on Catherine the Great's coronation dress.

Each flower is made up of seven petals set with pear-shaped diamonds around a cushion-shaped brilliant-cut diamond. The flower is presented at the end of delicately bowed stems made of brilliant-cut diamonds. The base is tied with a ribboned bow constructed on a closed-back silver setting.

Dress ornaments were placed either on the kokoshnik or the dress to enhance their sparkle. In a drawing dated 1874, Empress Maria Feodorovna is depicted wearing these flower ornaments.

The sketch was drawn on the occasion of the wedding of Tsar Alexander II's daughter, Maria Alexandrovna, to Queen Victoria's son, Prince Albert, the Duke of Edinburgh.

It is said that because Queen Victoria could not be present at her son's wedding, she sent an artist who made various sketches documenting the festivities for her.

Flower Bouquet Brooch

A pair of Russian diamond, sapphire, silver, and gold-mounted sprays. The flower bouquet is an example of decorations for the ceremonial dress of the empress. Typical of mid-eighteenth-century jewelry and distinguished by joyful colors, this fancy asymmetrical design is an exquisite example of artful craftsmanship.

Each brooch is a single stem tied with a bow-knot. The stems end in sapphire and diamond buds and are embellished with diamond leaves and flowers with sapphire centers.

The jewelry of the mid-eighteenth century made up a large part of the collection in the Diamond Fund that the Soviet government sold in 1927 at Christie's in London and then continued to dispose of, over time, to raise money to pay for arms and grain.

In addition to these and other jewels and works of art of imperial provenance, the government also sold important pieces confiscated from other aristocratic collections.

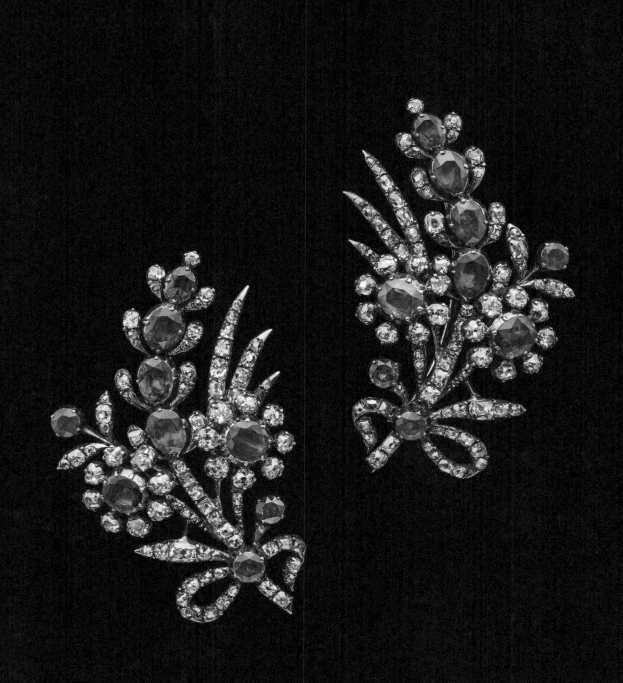

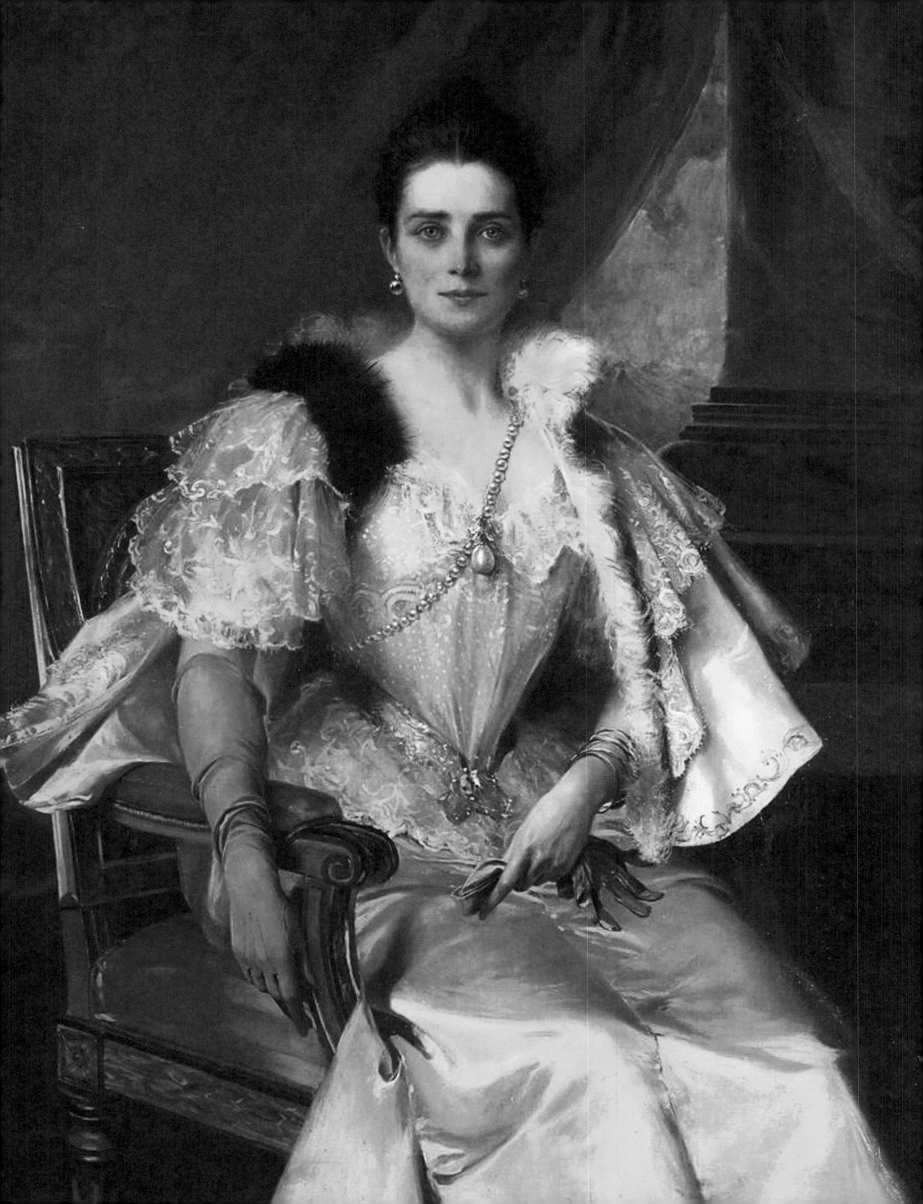

La Regente

La Regente was a gift from Emperor Napoleon I to his second wife, Marie-Louise, in 1811, and originally set in a tiara. La Regente, also known as La Perle Napoleon, originally weighed 346.27 grains (337 old grains) and is the fifth largest pearl in the world.

It is suggested that the name La Regente refers to the fact that both empresses who made use of the pearl, Marie-Louise in 1813 and Eugénie de Montijo in 1870, acted as regents in the absence of their husbands. Or perhaps not, it's one of the mysteries surrounding this beauty.

The pearl was sold in 1887 by the French government when, for political reasons, it divested itself of the French crown jewels. According to the 2005 Christie's catalogue in which La Regente was sold: "Fabergé had shown the auction catalogue to Prince Nicolas Yusupov, who was interested in the enormous pearl weighing 337 old grains and wanted to give it to his only daughter, Princess Zinaide."

During the Russian Revolution, the pearl is believed to have escaped the fate of many other Yusupov jewels that were stolen from their palace and later sold by the Soviet government. Or not. This part of its history remains obscure . . .

It is known that the pearl was in private hands when it was lot 385 and sold at auction by Christie's in New York on June 16, 1987, although at the time the name La Regente was not associated with the item for sale.

This 1893 portrait of Princess Zinaida Yusupov was painted by the renowned French artist François Flameng.

Princess Zinaida, the only child and sole heir of the Yusupov family, wears a sumptuous dress and a long pearl sautoir necklace featuring La Regente, the pearl she received as a gift from her father.

La Regente is one of the world's most magnificent natural pearls, as well as the most expensive single pearl ever sold, fetching a record price of $2.5 million at Christie's in November 2005.

The striking oil painting was entered into the Hermitage collection in 1946.

Marie Antoinette Earrings

These pear-shaped diamonds, which weigh 14.25 and 20.35 carats respectively, once belonged to Queen Marie Antoinette of France. While the circumstances by which Marie Antoinette's diamond earrings left her possession may never be known with certainty, the earrings appear to have stayed in the French royal family. In 1853, as a wedding gift, Napoleon III gave Empress Eugénie a pair of earrings with large pear-shaped diamonds that are believed to have been the Marie Antoinette earrings.

Empress Eugénie sold her personal jewels from 1870 to 1872, after she was exiled to England. The earrings then became the property of the Princess Tatiana Yusupov. When jeweler Pierre Cartier purchased the diamond earrings in 1928 from the Yusupov family, their authenticity was attested to in an affidavit signed by her daughter Princess Zinaida and her grandson, Prince Felix, stating that the earrings had never been reset in the years that they had been in the family.

Marjorie Merriweather Post acquired the earrings from Pierre Cartier in October 1928. In 1959, Harry Winston, Inc., mounted the diamonds into platinum and diamond replicas of the "original" silver settings for Mrs. Post.

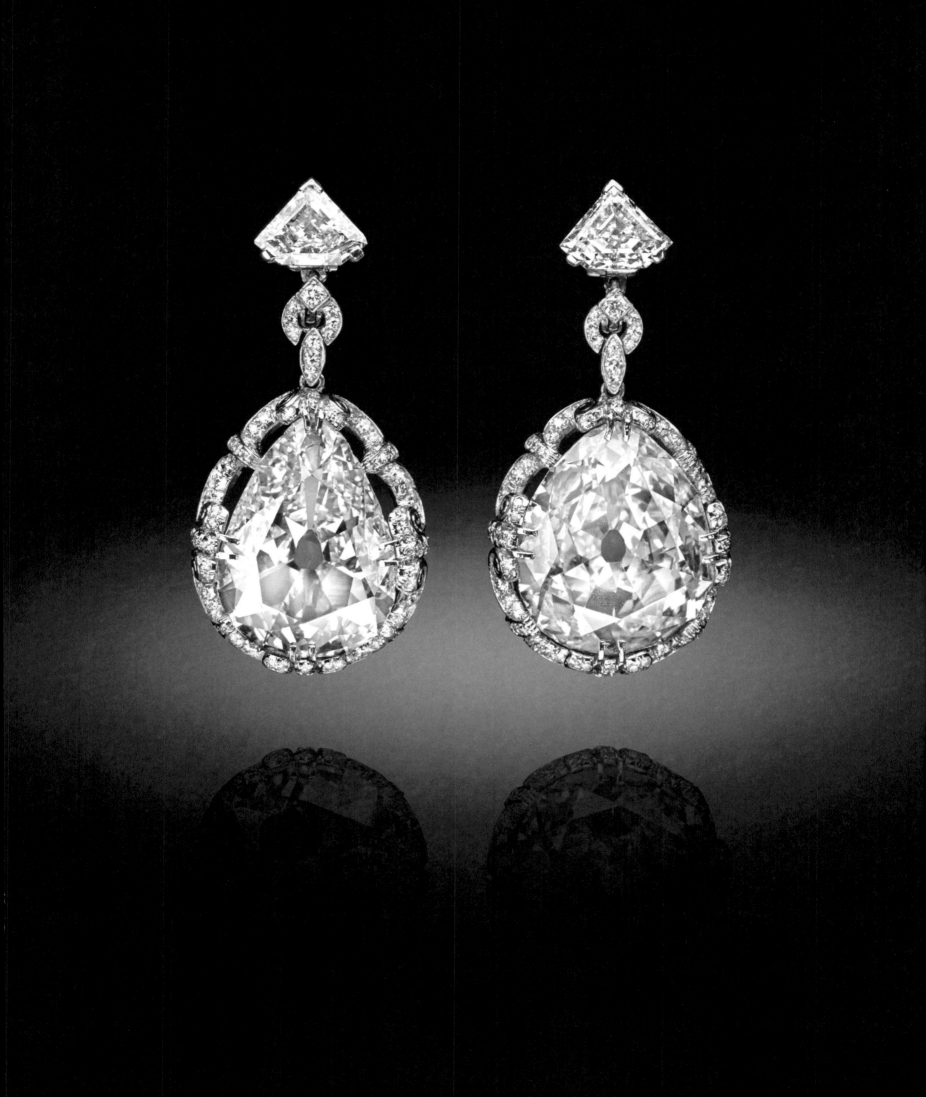

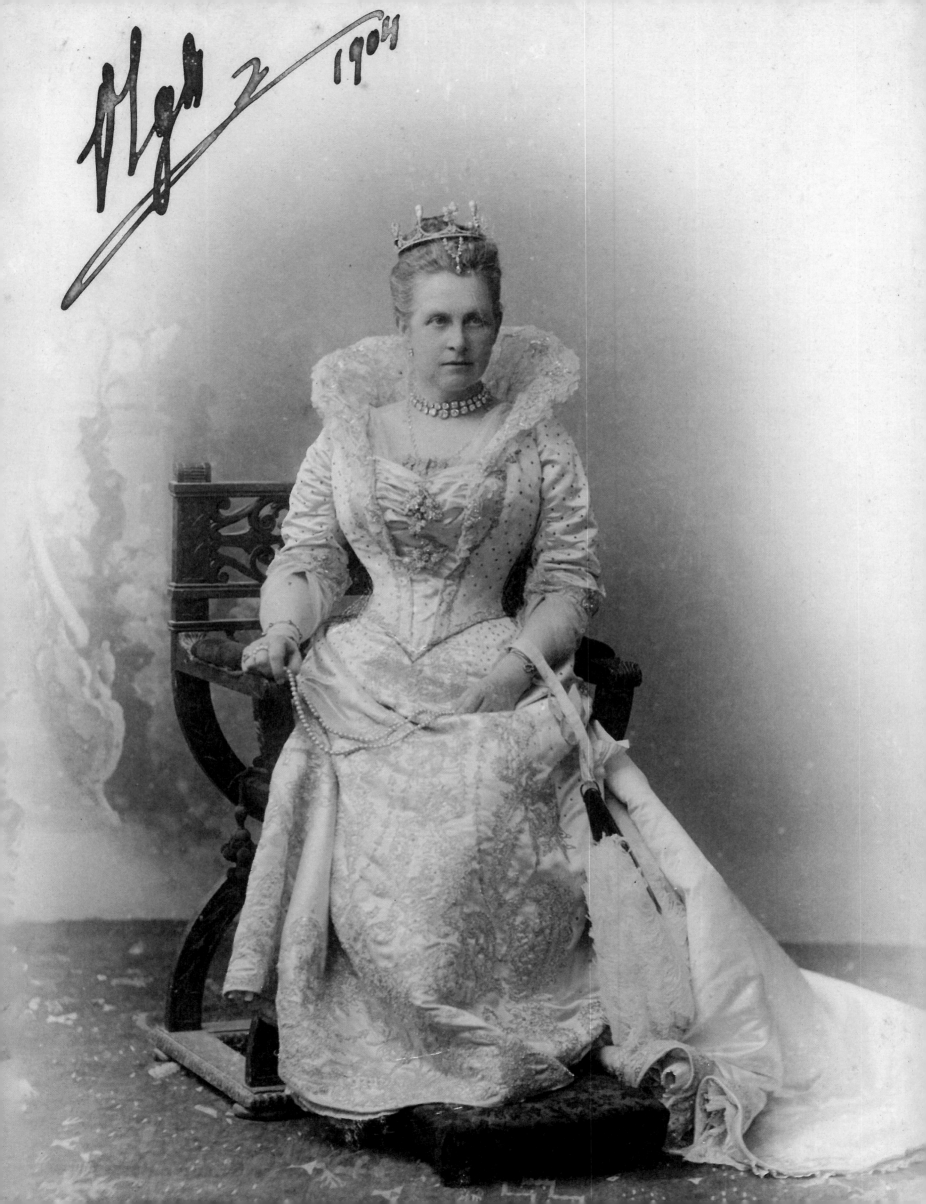

Olga 1904

A Tale of Princesses, Their Tiaras, and Crowns

The Grand Duchess Olga Constantinovna of Russia—pictured on the left in a signed photograph dated 1904—grew up in the Pavlovsk Palace, the architectural masterpiece designed by the Scotsman Charles Cameron for Catherine the Great's son. Since 1796, when Catherine's son ascended the throne as Paul I, Pavlovsk had become the official imperial residence. Grand Duchess Olga's father was Grand Duke Konstantin Nikolayevich of Russia, the younger brother of Tsar Alexander II, and her mother, the Grand Duchess Alexandra, was the former Princess Alexandra of Saxe-Altenburg.

It was there, at the age of fifteen, that she was introduced to King George I of Greece with whom she would fall in love and soon marry. Prince Dimitri recalls the story told by his grandmother, Princess Olga, who was named after the grand duchess; about how the grand duchess prepared for her departure to her new kingdom: "She brought all her dolls and teddy bears with her, along with the most fabulous jewels, like only the Romanovs had . . ."

Her husband to be, King George I of Greece, born Prince William of Denmark, was charming and very handsome, and the favorite brother of his sisters Empress Maria Feodorovna of Russia and Queen Alexandra of England. Prince Dimitri tells of how Prince William learned that he had acceded to the throne when he was still a cadet in the naval academy and living quite a spartan life: "One day he left home with a sardine sandwich wrapped in newspapers. When he unwrapped it, he read the big news of the day: that he had been appointed king of Greece at the age of seventeen! He said: 'Nobody told me.'"

On September 17, 1863, the young prince sailed to Greece with two Danish aides. The reception by the Greek people was fantastic—in part because his father, the king of Denmark, had insisted that Queen Victoria give Corfu and the Ionian Islands back to Greece. King George I immediately understood that Greece's future depended on its relationship with the great powers. He turned to Russia, the great protector of Greece, and to his sister Empress Maria Feodorovna to secure his future and that of his new kingdom. This was

the political calculus that had led him to search for his Queen among the Russian grand duchesses, the twist of history that introduced him to his future Queen, the young Grand Duchess Olga Constantinovna.

Their wedding had completed a formidable set of alliances for George's Danish family, which had risen from relative obscurity to rule the Kingdom of Denmark in 1863. Their marriage was a warm and close one that lasted some fifty years and produced seven children.

In 1902, their third son, Prince Nicholas of Greece and Denmark wed Grand Duchess Vladimir's daughter, Elena, at the imperial palace at Tsarkoye Selo. For her wedding, as was the Romanov custom, Elena donned the entire imperial wedding regalia that included the Nuptial Tiara and Crown. The wedding gifts she received from her mother included a diamond kokoshnik tiara, especially designed for the occasion, a splendid diamond fringe tiara, an emerald parure, a large diamond brooch shaped like a ribbon, as well as other jewels.

After moving to Athens, the Grand Duchess Elena and her husband, Prince Nicholas of Greece, welcomed the birth of their first daughter in 1903. She was named Princess Olga, in honor of her grandmother. A year later Princess Elizabeth was born and, finally, in 1906 Princess Marina.

Prince Nicholas's brother, Prince George of Greece and Denmark, courted Princess Marie Bonaparte. She was heir to a very large fortune inherited from her mother's side of the family, who were real estate developers, and descended from the family of Napoleon Bonaparte; the match was ideal. After securing the approval of both parents, Princess Marie and Prince George were married in 1907; thereafter she was known as Princess Marie of Greece and Denmark.

Prince Dimitri fondly recalls the memorable impact she had on him: "Known as Aunt Mimi in the family, she married my great grandfather's brother, known as Uncle Goggy." She was intellectual, independent, eccentric, afflicted by phobias, and a hypochondriac.

She left for Vienna to study with Sigmund Freud and became his right hand, writing numerous books on sexuality and becoming a leading authority in her field at the time.

"She interviewed murderers in prisons to study the causes of violence. Thanks to her fortune, she was able to look after her

King George I of Greece

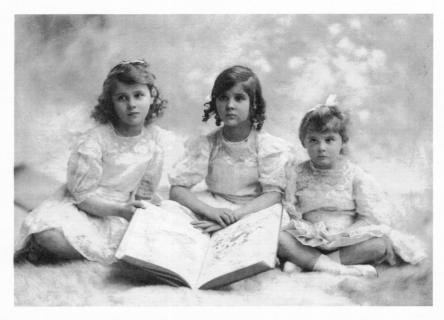

Princess Olga, Princess Elizabeth, and Princess Marina of Greece and Denmark

impoverished Greek relatives during their exile and chartered a plane to smuggle Freud out of Vienna to London when the Nazis wanted to arrest him," remembers Prince Dimitri.

"My mother told me that when my twin brother and I were born, she came to the clinic, stormed into the room, and immediately instructed the nurse 'unpack all that,' examined our little bodies 'down there,' and with a big smile exclaimed, 'Perfect! Perfect!' and stormed right out to the howls of laughter of everyone in the room."

During these years, Nicholas and Elena and their three young daughters traveled to Russia by train and spent summers in the company of Elena's mother, the Grand Duchess Vladimir, and their extended family in their palaces in St. Petersburg and on the Crimean Peninsula. Princesses Olga, Elizabeth, and Marina of Greece and Denmark enjoyed countless adventures in the company of their cousins, the daughters of Emperor Nicholas II.

All seemed destined for decades of prosperity and stability. At times George's sister, Alexandra Queen Empress and Edward VII of England, who had ascended to the throne after the death of Queen Victoria, also joined the family.

In the summers before the 1917 Russian Revolution, Grand Duchess Elena and the three young princesses would travel by train from Greece to the Russian border, where the Grand Duchess Vladimir's train would be waiting for them.

This change of transport was required in Russia, because the train tracks were of a different width than the rest of Europe. It is said this was to discourage foreign invaders.

Princess Olga, the eldest of Elena's three daughters, described the adventure as: "Enchanted journeys in unimaginable luxury."

She explained that "the train had numerous carriages: one for the sitting room, one for the study and bedroom, another for guest bedrooms, one for a formal dining room followed by the pantry and kitchen (with a French chef in it) and staff headquarters.

The inside of the carriages were all in precious woods, silk, velvet, taffetas, and the most comfortable furniture and beds possible."

Instead of the promised continuity, the world would soon begin a paradigm shift that would only be completed some forty years later, after the end of World War II. In the intervening decades, the world of the European aristocracies was marred by violent spasms that punctuated the decline of hereditary monarchies and the rise of elected governments of the modern era.

For the Grand Duchess Olga, Queen of Greece, and her extended Greek royal family, the upheaval began in 1913, with the brutal assassination of her husband, the king. Soon after his death, she returned to her native Russia to support her country in the war effort after the outbreak of World War I; Queen Olga set up a military hospital in her brother's Pavlovsk Palace.

In 1917, Prince Nicholas of Greece and his wife, the Grand Duchess Elena, and the three princesses, were forced into exile following the overthrow of King Constantine I. The family moved throughout Europe, with the young girls, staying with various members of their exiled extended family at times.

Queen Olga's grandson was installed as King Alexander of Greece shortly thereafter. However, Alexander's reign did not last long. His premature death in 1920 from an infected monkey bite saw Queen Olga appointed regent until King Constantine's return one month later.

After a series of elections, plebiscites, and political reversals, the 1922 defeat of Greece in the Greco-Turkish War created a new crisis and once again Queen Olga, her son Nicholas and daughter-in-law Grand Duchess Elena, and the three princesses were exiled.

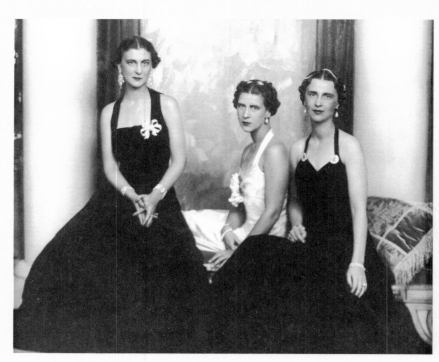

Princess Marina, Princess Elizabeth, and Princess Olga in the 1930s

A year later, in 1923, the eldest of the three sisters, Princess Olga, married the dashing Prince Paul of Yugoslavia, with the Duke and Duchess of York as witnesses. A most cultured and handsome man, her new husband spoke seven languages and had attended Oxford, where he met Elizabeth Bowes Lyon, who remained one of his closest friends. At her wedding, Princess Olga wore many of the jewels that her mother Grand Duchess Elena had received from her own mother, the Grand Duchess Maria Pavlovna, as wedding gifts.

Three years after the wedding, Queen Olga passed away. With her death, the last vestige of the imperial life that the family had known in Russia was gone forever.

In January 1934, Princess Olga's sister, Princess Elizabeth, married Count Carl Theodor of Törring-Jettenbach. As a gift from her mother, she received the famed Vladimir Fringe diamond tiara and wore it to secure her veil at her wedding. It is said her beauty and radiance was such that it eclipsed the sparkle of her remarkable tiara. However, the sense of possibility and joy brought about by the wedding was short-lived.

On October 9, Princess Olga's family was once again forced to reckon with political events well outside their control, when a terrorist killed King Alexander of Yugoslavia, the cousin of Prince Paul. He was shot while he was on a state visit to France. Princess

Olga had experienced this tragic death as a terrifying premonition in a dream. Prince Dimitri recalls how she had begged the king not to go, but to no avail. "So she kissed him goodbye in tears, knowing she would never see him again."

Two months later, the youngest of the three sisters, Princess Marina, married the fourth son of King George V, Prince George Duke of Kent, in a formal ceremony in Westminster Abbey that was broadcast around the nation and abroad with new radio technology. She wore a white and silver brocade dress designed by Molyneux, with a diamond rivière choker necklace and the fringe diamond tiara that she received from the City of London, which held the delicate veil that trailed behind her as she walked.

Soon after, Princess Marina, now the Duchess of Kent, undertook her new royal duties, demonstrating a deep sense of commitment that would define the rest of her life. Over time, she became the patroness of several organizations, charities, and hospitals. She also grew close to her mother-in-law, Queen Mary, with whom she would usually spend time while her husband was off performing his own royal duties.

What followed from 1935 onward was a decade marked by widespread economic crises, shifts in European political alliances, and, finally, the start of World War II, which engulfed the world. The

Prince and Princess Paul of Yugoslavia

family was in turmoil and suffered many losses.

Soon after the October assassination of King Alexander I of Yugoslavia, Princess Olga's husband, Prince Paul, the king's first cousin, was appointed regent.

In a strategic bid to avert what he perceived as a catastrophic alliance for Yugoslavia, in 1941 Prince Paul, in his capacity as regent, signed a neutrality pact with Germany. "He was hoping to avoid the fate he most feared: the widespread destruction of his beloved Yugoslavia and the deaths of close to a million of his fellow compatriots," remembers Prince Dimitri.

Just two days later, a coup d'état against the regent took place in which King Alexander's young son, Peter, was declared king of Yugoslavia. Prince Paul and Princess Olga were deported and arrived with their children in her native motherland of Greece, where they became guests of King George II. Within days, the German armies invaded the country, overwhelming the Yugoslav army and what he feared came to pass.

Princess Marina trained as a nurse and joined the civil nurse reserve. In 1942, her husband, the duke of Kent, was killed in an airplane crash while on active service with the Royal Air Force. From exile, Princess Olga heard the news and returned to be with her sister.

Although the war had finally ended, Princess Olga and her family could not go home, as Yugoslavia had fallen to the communists in 1945. Prince George of Greece and his wife, Princess Marie Bonaparte, possessed great wealth and stepped in to help members of the Greek royal family. The family of Princess Olga settled in Switzerland and then in Paris and Italy, where Paul had inherited the Villa Demidoff at Pratolino.

During those years spent in Tuscany, Princess Olga was happy and always welcomed by Marina, Duchess of Kent, and the rest of the British royal family. At the coronation of Elizabeth II, Princess Marie Bonaparte and her husband Prince George of Greece, joined the duchess of Kent and represented their nephew, King Paul of Greece.

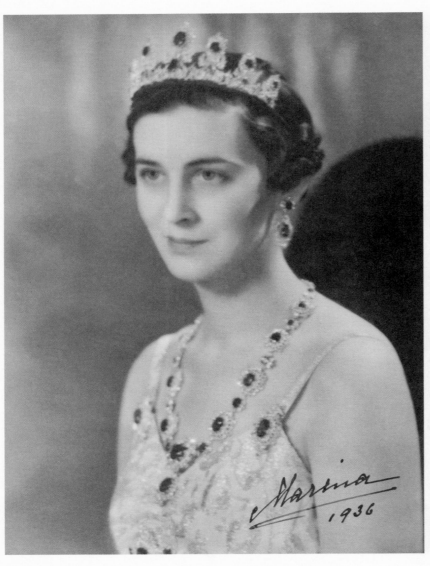

Princess Marina wearing the Cambridge sapphires

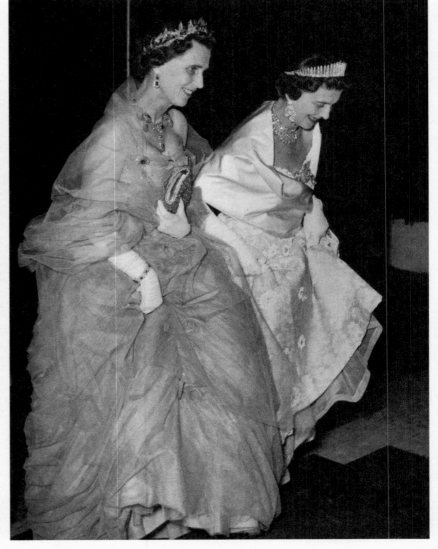

Princess Olga and Princess Marina

Until 1968, Princess Olga's young grandchildren would spend the summer with her and Prince Paul at their Villa Demidoff, the Medici residence in Tuscany whose gardens had been designed during the Renaissance by Buontalenti. She would spend her days in their company organizing all sort of activities for them.

The highlight of the summer was the full moon night, when she would wake the children and bring them to her balcony to watch the full moon with her binoculars.

Prince Dimitri recalls: "Of course, we always imagined seeing things like UFOs or comets. For days after we would talk about this, and she never tired of hearing it over and over again. Growing up it was like having Mary Poppins as a grandmother; she adored children, was kind, cozy, and protective of us grandchildren, and we loved her dearly!"

The two Cecil Beaton photographs below were taken in the garden of the villa where many joyous summers spent with his grandmother punctuated Prince Dimitri's childhood.

Over the next few years Princess Elizabeth passed away, then her mother Grand Duchess Elena, followed by her sister Marina, Duchess of Kent, Princess Marie Bonaparte, and, finally, Princess Olga's husband, Prince Paul of Yugoslavia in 1976. Prince Dimitri was devastated when the news of his passing reached him; he adored his grandfather. The hard blow only softened by the love of his grandmother Princess Olga and her retelling the key events of their lives.

In the days and months that passed, Prince Dimitri recalled and marveled at the vastness of their stories and found comfort in the realization that, in their final years, they had made peace with their extraordinary lives—and would be together once again.

Princess Olga and four of her grandchildren. Standing are Prince Dimitri, Prince Michel of Yugoslavia and Catherine Oxenberg. Christina Oxenberg is on her lap.

H.R.H. Princess Maria Pia

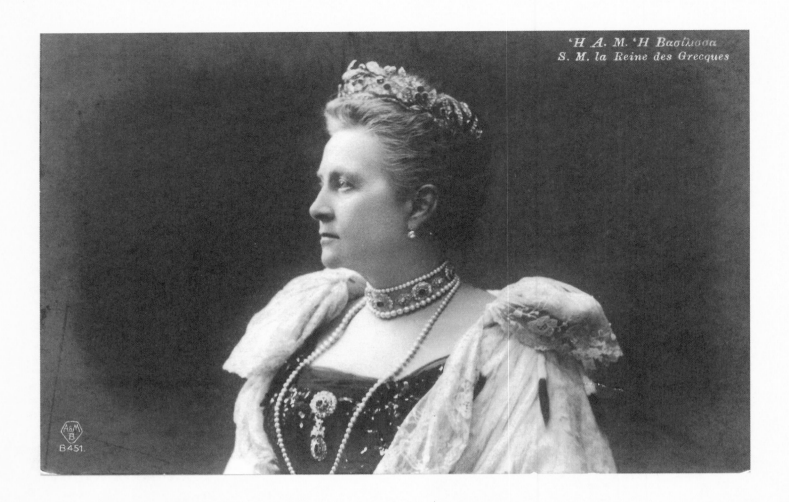

'H A. M. 'H Βασίλισσα
S. M. la Reine des Grecques

LAUREL WREATH TIARA

The elegant Laurel Wreath Tiara is made from rubies set into a delicate asymmetrical, freeform design. It is also known as the Greek Ruby Tiara, whose original owner was Grand Duchess Olga, Queen of Greece, seen above.

The tiara is part of the Royal Greek ruby parure that includes a magnificent ruby and diamond necklace, two brooches, and matching earrings. After Queen Olga's death, the tiara was bequeathed to her son, Prince Nicholas, and worn by his wife, Grand Duchess Elena. On several occasions prior to 1956, their daughters, Princess Olga, married to Prince Paul of Yugoslavia, and Princess Marina, Duchess of Kent, wore the tiara.

Featured on the cover of this February 1940 *Tatler* is an elegant photographic portrait of Princess Olga, who is wearing the parure and tiara. The parure and the Laurel Wreath Tiara came to be owned by Queen Frederica of the Hellenes and, in 1964, was presented to the bride of King Constantine II of Greece, Queen Anne-Marie, as a wedding gift from his family.

The Tatler

Vol. CLV. No. 2017. London, February 21, 1940 POSTAGE: Inland 1½d.; Canada and Newfoundland 1½d.; Foreign 2d. **Price One Shilling**

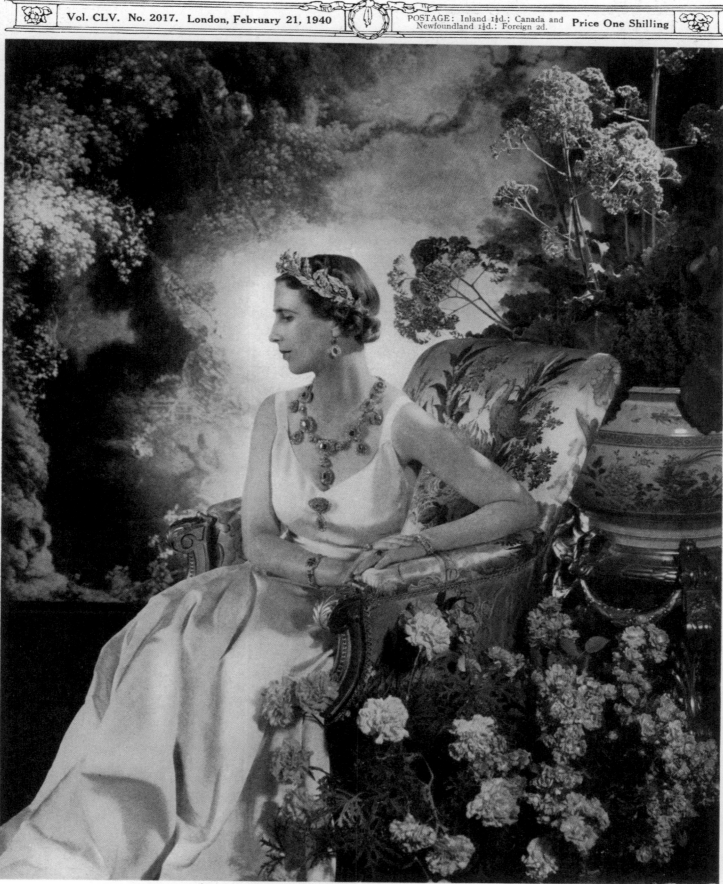

Cecil Beaton

H.R.H. PRINCESS PAUL OF YUGOSLAVIA

A beautiful portrait study of the Consort of the Regent of Yugoslavia. H.R.H., the former Princess Olga, is a sister of H.R.H. the Duchess of Kent and the eldest of the three daughters of Prince Nicholas of Greece. She was married to Prince Paul in 1923. It was in 1934 that Prince Paul was appointed Regent of Yugoslavia during the minority of the young King Peter who succeeded on the assassination of King Alexander in Marseilles in 1934

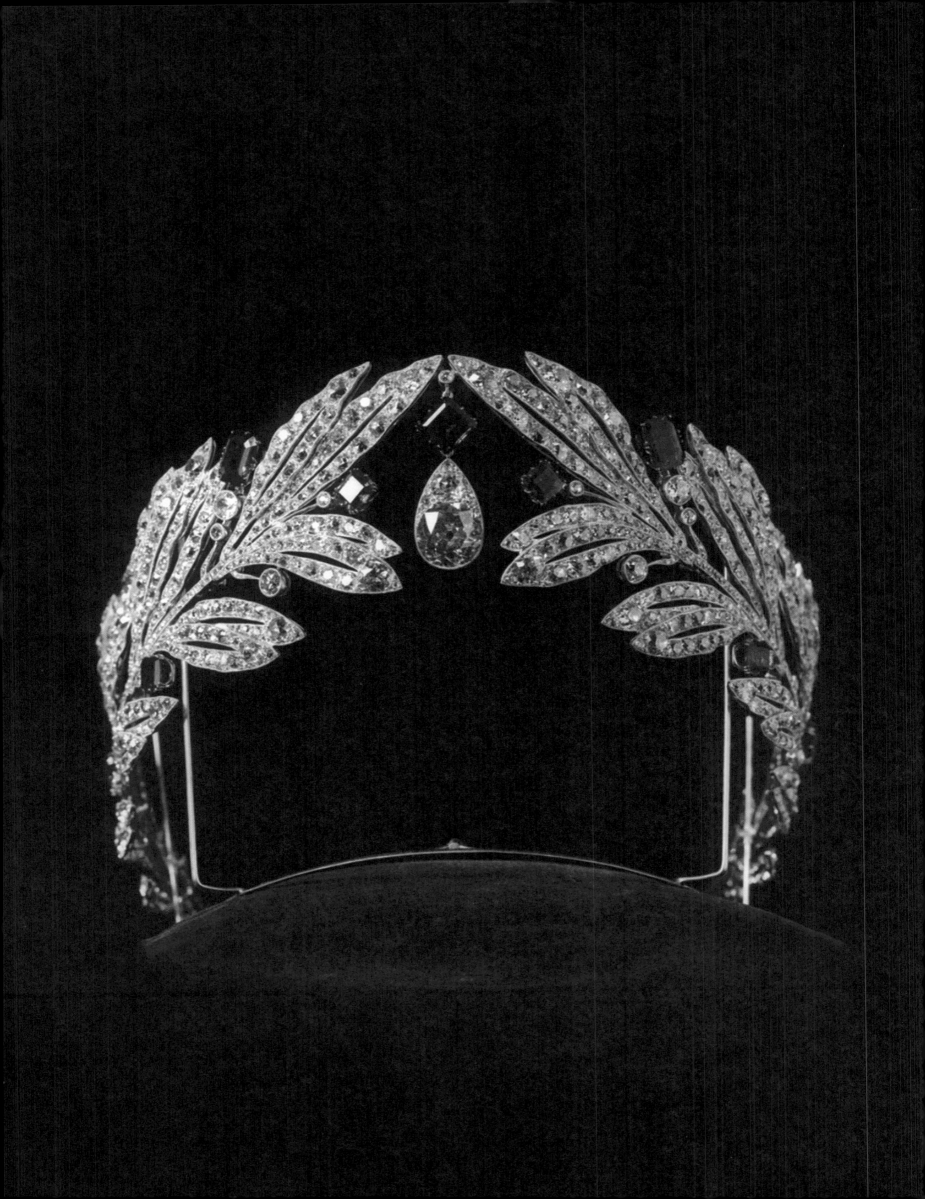

Olive Leaf Diamond Tiara

The Olive Leaf Tiara, made up of diamonds, is one of several pieces of beautiful wedding jewelry commissioned from Cartier by Princess Marie Bonaparte for her 1907 wedding to Prince George of Greece and Denmark, one of the sons of King George I of the Hellenes.

The tiara is made of platinum set with emeralds and diamonds. Diamond olive leaves have eleven emerald "olives," which could be swapped out for diamonds. In the center of the tiara is a pear-shaped diamond pendant set with a large, circular cut diamond, smaller stones, and a step-cut emerald, all hanging freely.

In this 1953 photograph of Prince George and Princess Marie of Greece taken at the Coronation of Queen Elizabeth II, the Princess wears the Olive Leaf Tiara embellished with a diamond star centerpiece. Standing on the right is their daughter, Princess Eugénie of Greece and Denmark and her husband Raimondo, Prince della Torre e Tasso.

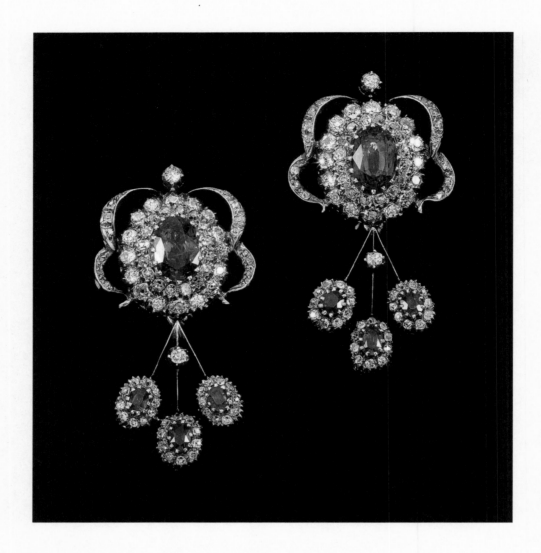

Sapphire Parure of Princess Eugénie of Greece and Denmark

This important necklace and earring suite once belonged to Princess Eugénie of Greece and Denmark. She is shown on page 89 wearing it at the coronation of Queen Elizabeth II in 1953. It is designed as a chain of eleven clusters, each set with an oval sapphire within a cushion-shaped diamond border framed by diamond swags.

The front of the necklace is further highlighted with three detachable drops, each set with an oval sapphire within a border of cushion-shaped diamonds. Each drop cluster is also topped by a diamond ribbon bow motif holding three sapphire and diamond attachments.

The pair of matching earrings is mounted in gold and silver, and show French assay marks and maker's marks by Mellerio. The Mellerio family from Valle Vigezzo, founded the firm in 1613 under the patronage of Marie de Medicis.

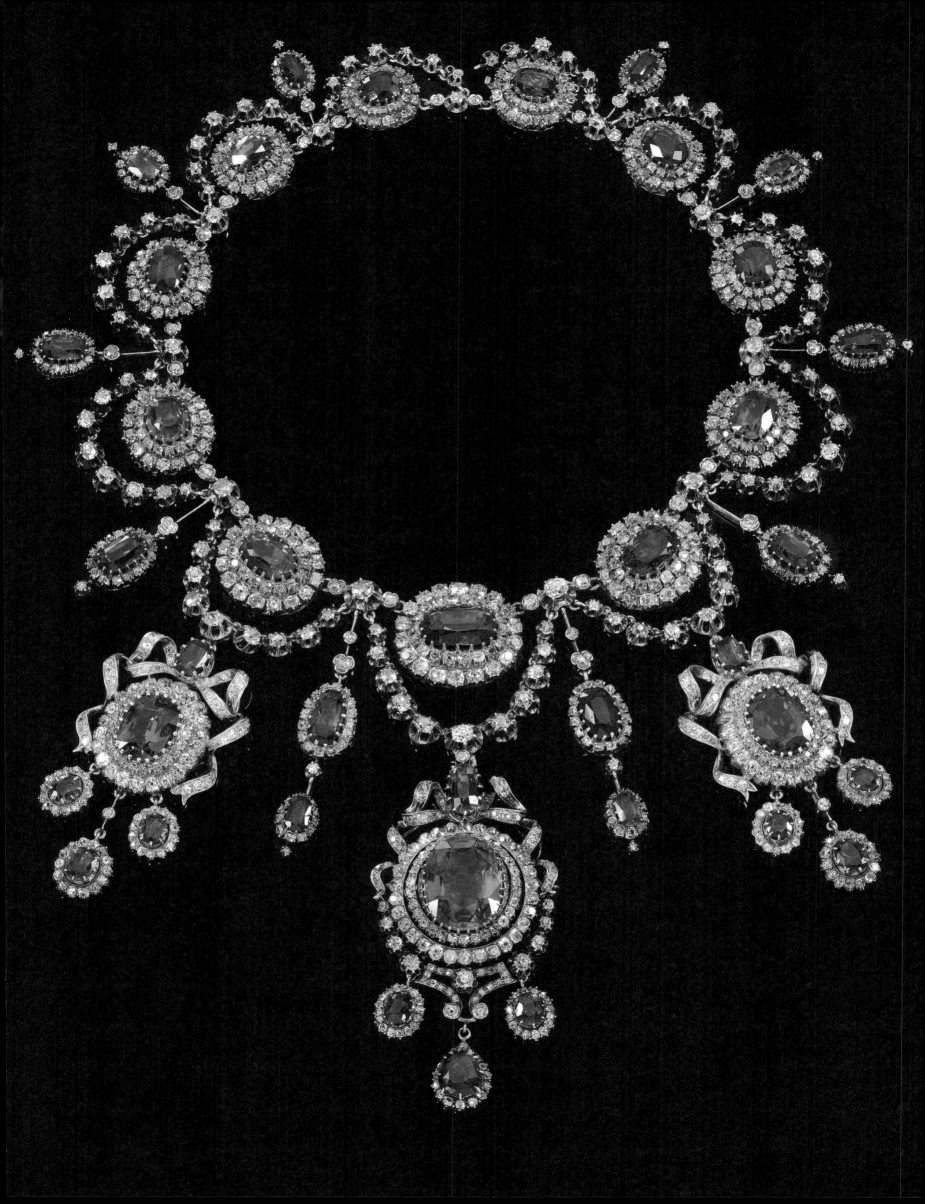

Princess Marie Bonaparte and the Olive Leaf Diamond Tiara

The tiara is comprised of two branches of olive tree leaves arranged in a classic laurel-leaf wreath design. The composition is both a nod to Greek history and the tradition of brides wearing olive wreaths, which dated back to ancient Greece, as well as to her imperial Napoleonic heritage. In the photograph, Princess Marie Bonaparte is seen wearing the tiara with the branches lying flat on the sides of her head.

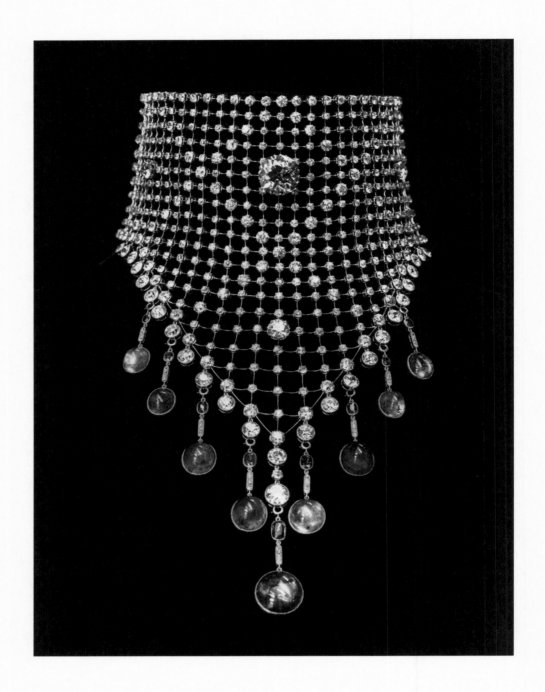

Résille Cartier Necklace

The platinum collier résille shown here was made by Cartier in 1904 for Queen Alexandra of England. The term "collier résille" comes from the French word résille, which translates as "net" or "netting." The design seen here above featured detachable gem drops. The exquisite Cartier résille necklace was altered for Queen Mary of England in 1926 and last seen in public worn by her in the 1930s.

Queen Alexandra of England often wore résille, high-collar-style necklaces, as can be seen in this formal seated photographic portrait, signed "Aunt Alix 1913." Born Princess Alexandra of Denmark, she was the sister of Empress Maria Feodorovna of Russia (Princess Dagmar of Denmark) and of King George I of Greece (Prince William of Denmark).

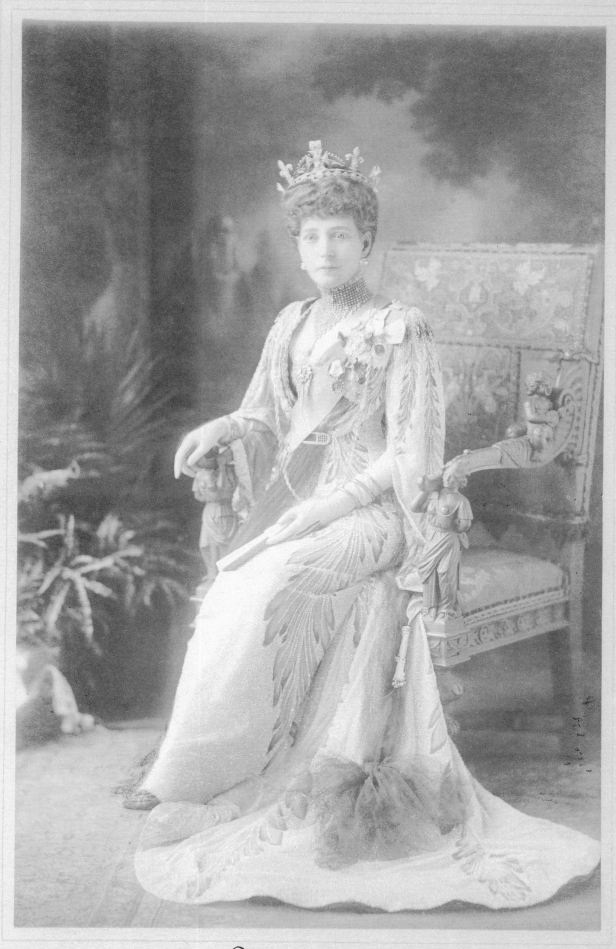

Aunt Alix 1913.

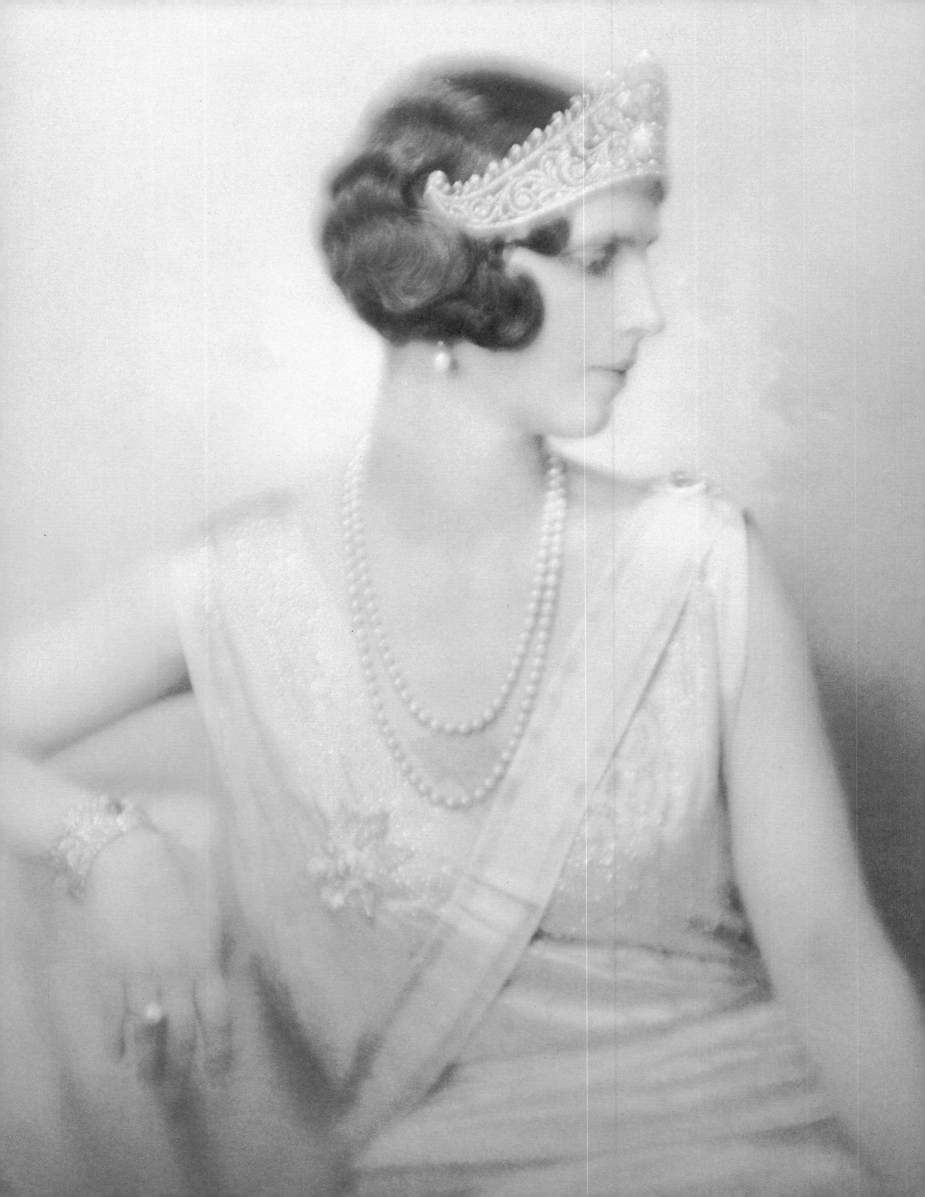

The Diamond Kokoshnik Tiara

In 1902, Grand Duchess Elena, daughter of the Grand Duchess Vladimir, received a magnificent diamond kokoshnik tiara as a gift from her mother when she married Prince Nicholas of Greece and Denmark.

In this lovely photograph from 1927, Princess Olga is seen wearing the tiara which Grand Duchess Elena gifted to her on the occasion of her marriage to Prince Paul of Yugoslavia in 1923.

She continued to wear it on many occasions during the inter-war years. In 1960, Princess Maria Pia of Savoy (Prince Dimitri's mother), who had married Princess Olga's son, Alexander, wore the tiara to the wedding of King Baudoin of Belgium.

One of the most distinctive designs for a tiara, it is an interpretation of the Russian traditional female headdress, called a kokoshnik. Emperor Nicholas I demanded that all the ladies who appeared at his court wear a kokoshnik. The ladies naturally complied and subsequently began to decorate their headdresses with jewels—and thus the jeweled kokoshnik tiara made its appearance.

Princess Marina with the City of London Tiara

Princess Marina of Greece and Denmark was given the elegant City of London Tiara as a gift on her wedding to the Duke of Kent. The gift was a wonderful demonstration of the affection that her future British home would show this princess in the decades that followed and was very similar to the Vladimir Russian Fringe Tiara.

In fact, both tiaras feature diamond fringes and spikes, but the position of the spikes on the Vladimir Fringe makes it appear to have a thicker base and its fringes are farther apart than the City of London Tiara.

Princess Marina, Duchess of Kent, would become one of the most beloved members of the British royal family and gave decades of service to her new nation.

She wore the City of London Tiara on numerous occasions, including in February 1957, when she wore it as she read a speech on behalf of the queen in the National Assembly in Ghana, granting independence to the Gold Coast.

Marina
Nov. 29 - 1934

Princess Elizabeth wearing the Vladmir Fringe Tiara

The original owner of the Fringe Tiara was Grand Duchess Vladimir, whose husband was the son of Tsar Alexander II, brother of Tsar Alexander III, and the uncle of Tsar Nicholas II.

The Grand Duchess Vladimir, Princess Elizabeth's grandmother, was known to have one of the most extraordinary collections of jewelry. Including the diamond Fringe Tiara that was a favorite design of the Russian imperial family and owned by nearly every Romanov lady.

The Vladimir Fringe Tiara has remained in Elizabeth's branch of the family, and continued to serve as a wedding tiara. Elizabeth's daughter, Helen, wore the tiara when she married Archduke Ferdinand of Austria in 1956, and their daughter, Sophie, also wore the tiara when she married Mariano Hugo, Prince of Windisch-Graetz, in 1990.

The tiara was used most recently at a family wedding in 2005, when Elizabeth's grandson, Archduke Maximilian, married Maya al-Askari.

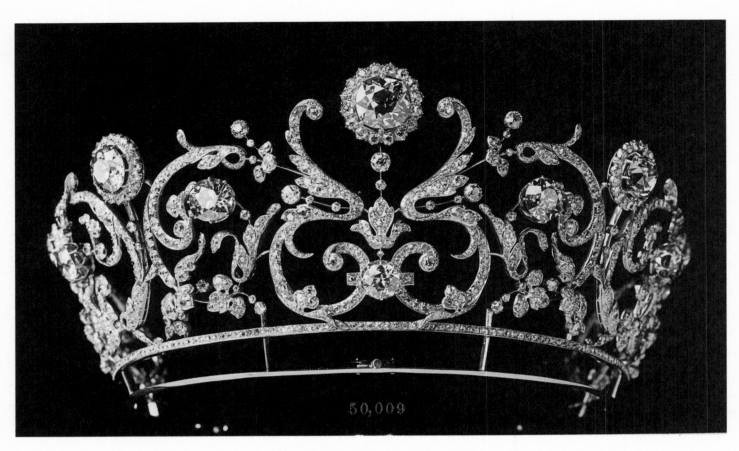

The Boucheron Tiara without diamonds around the bottom.

CECIL BEATON PORTRAIT OF PRINCESS OLGA

Princess Olga is seen in a 1939 photographic portrait by Cecil Beaton, signed and dated 1940. The princess is wearing Boucheron's glittering diamond tiara featuring diamond swags culminating in a large diamond centerpiece. This spectacular piece was executed in 1907 for Princess Maria Pavlovna Abamelek-Lazarev. In its original design it rested on the head with the jeweled swags rising from an invisible base.

In the official biography of the noted photographer, author Hugo Vickers recounts how Cecil Beaton photographed Princess Olga of Yugoslavia and that she showed the results to Queen Elizabeth and "encouraged her to send for Beaton."

According to Vickers, Mr. Beaton, already a celebrated fashion photographer with a successful career at *Vogue*, arrived at Buckingham Palace two days later. Beaton's photographs of the royal family, taken from the 1930s to the 1960s, are said to have shaped the public image of the British monarchy.

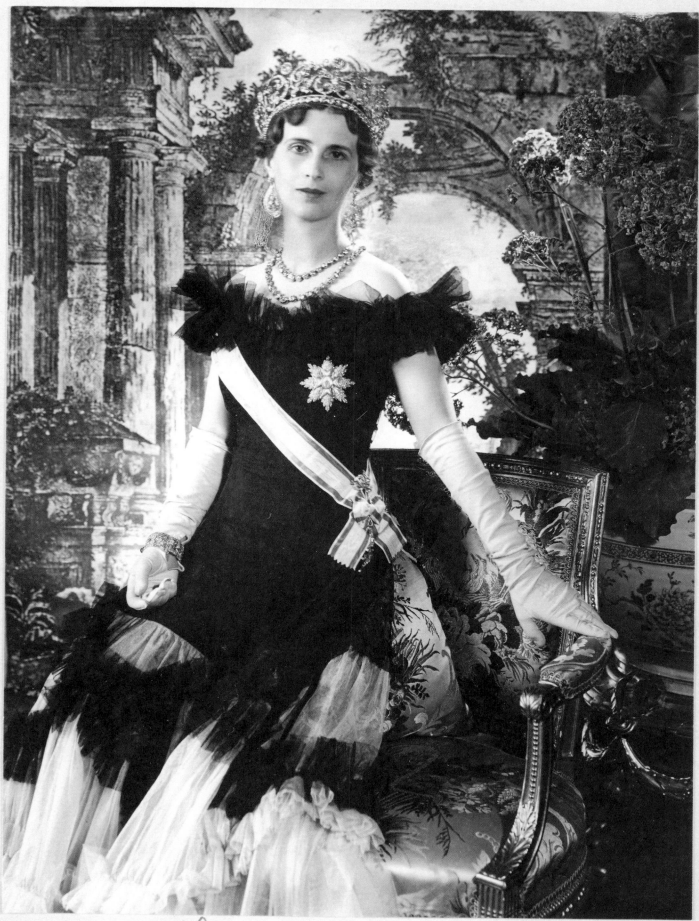

Olga 1940 Beaton

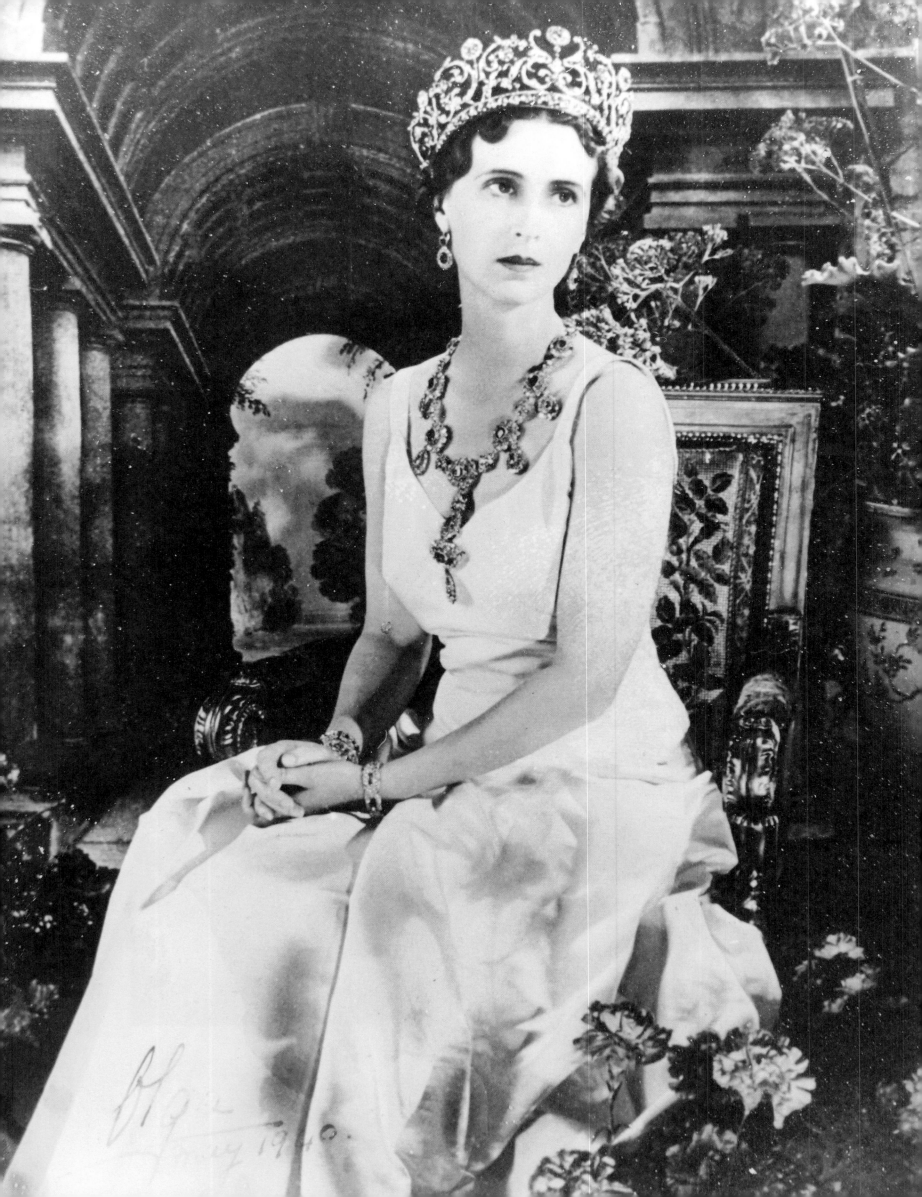

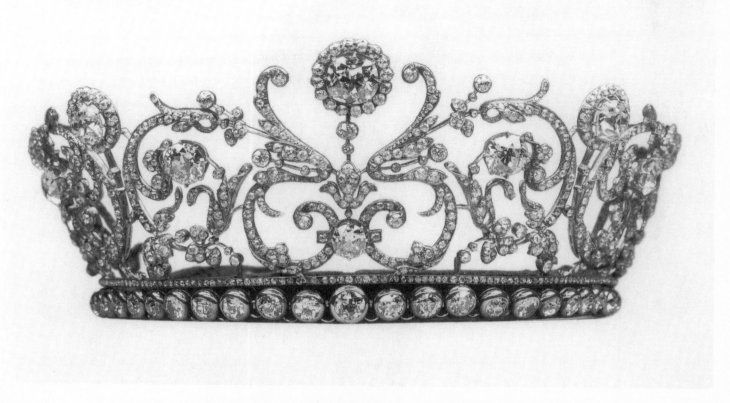

The Boucheron Tiara with the diamond base worn by Princess Olga.

PRINCESS OLGA WITH BOUCHERON TIARA

The Princess Abamelek-Lazarev gifted the elaborate Boucheron tiara to her nephew, Prince Paul of Yugoslavia. He in turn gifted it to his wife, Princess Olga, who wore it on many occasions.

Soon after receiving this gift, Princess Olga had the piece modified with the addition of a removable base made of a row of faceted diamonds, redefining the proportions of the piece and making it a more important diadem.

In this signed 1940 portrait, Princess Olga wears the redesigned Boucheron Tiara with an elegant low-necked white gown, and Queen Olga's ruby necklace and earrings that together convey a striking and romantic image of the princess.

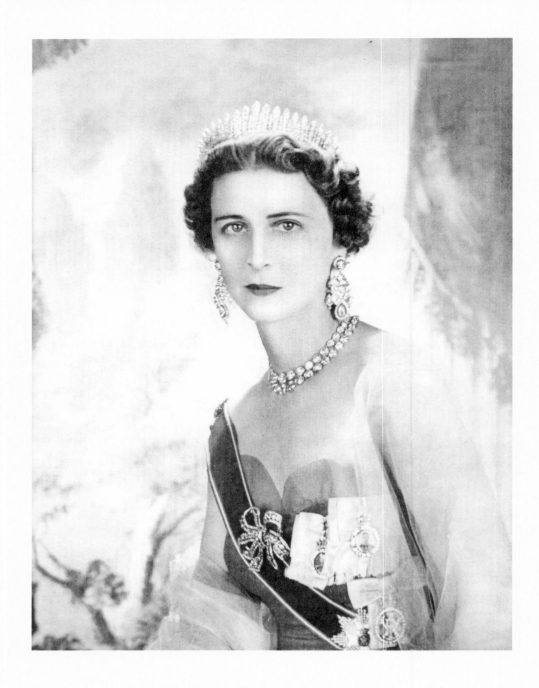

Diamond Bow Brooch

In 1902, the Grand Duchess Vladimir gave the Bow Brooch to her only daughter, Grand Duchess Elena, when she married Prince Nicholas of Greece and Denmark. Grand Duchess Elena gifted the brooch to her daughter, Princess Marina, when she married Prince George, Duke of Kent.

The silver-topped gold and diamond brooch features the naturalistic design of a double-ribbon bow centered by an oval-shaped diamond. The jewel, of Russian origin and dated around 1850, has a central diamond weighing approximately 3.50 carats. Numerous pear-shaped and old-mine-cut diamonds, totaling approximately 38 carats, are set with smaller old-mine and rose-cut diamonds weighing approximately 64 carats.

In 1949, Cecil Beaton photographed Princess Marina, Duchess of Kent, in Kensington Palace. In this portrait, as was her usual custom, she wears her Diamond Girandole earrings, the City of London Tiara, and the Russian diamond Bow Brooch.

Princess Marina wore the ensemble of these jewels when participating in formal occasions, such as the 1953 coronation of Queen Elizabeth II, as well as when attending other royal events or fulfilling her official duties. The princess was last pictured wearing the Bow Brooch at the State Opening of Parliament in October 1967.

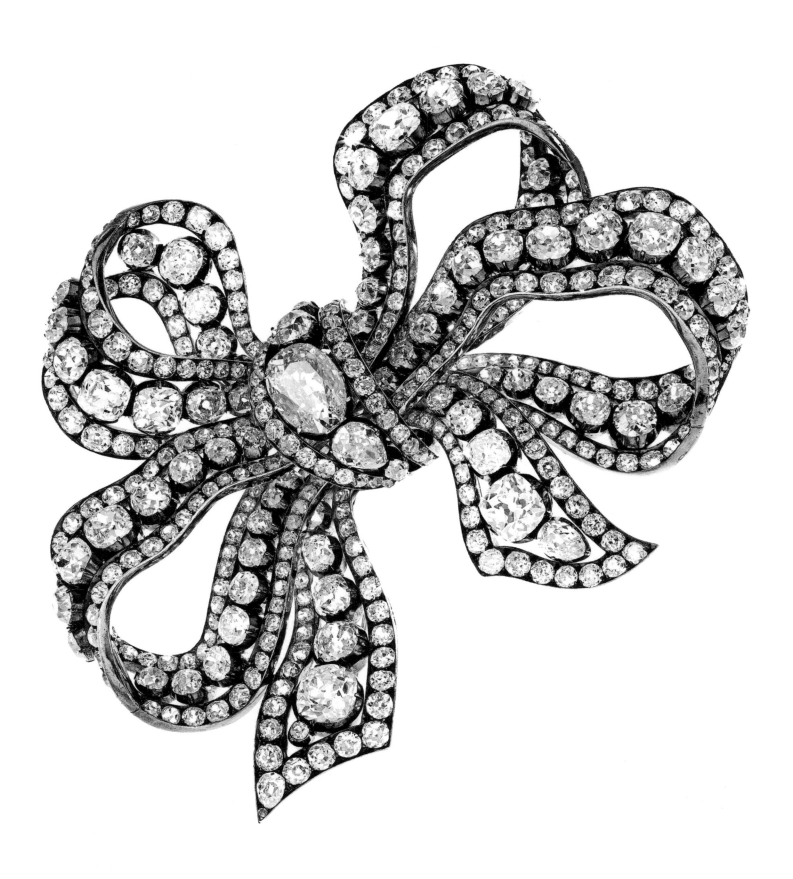

Cecil Beaton

Grand Duchess Elena's Emerald Earrings

This pair of platinum, emerald, and diamond pendant earclips belonged to the Grand Duchess Elena. On the occasion of her wedding, she received the emeralds as a gift from her mother, Grand Duchess Vladimir.

The parure included a brooch set with a round cabochon emerald in a diamond cluster and a magnificent pair of ear pendants with round cabochon emeralds and drops.

At the end of the 1930s, Princess Olga had the earrings redesigned to include the pear-shaped emerald drops surrounded by diamonds.

The two drop-shaped emeralds are suspended from two pointed, round cabochon emeralds. The diamond frames surrounding the emeralds include round, old-mine-, and single-cut diamonds weighing 17.50 carats.

Grand Duchess Elena later divided her jewels among her three daughters, Princess Olga, Princess Elizabeth, and Princess Marina. Princess Olga received these emerald and diamond earrings as a gift.

The Cecil Beaton portrait of Princess Olga wearing the emerald earrings given to her by her mother, Grand Duchess Elena, was taken in 1955, on the day of the wedding of her son Prince Alexander to Princess Maria Pia of Savoy (Prince Dimitri's parents).

Princess Olga and Princess Marina in Athens

Princess Olga of Yugoslavia and her sister, Princess Marina, Duchess of Kent, descending the staircase of the Royal Palace in Athens on the occasion of the wedding of Princess Sofia of Greece and Prince Juan Carlos of Spain in 1962.

Princess Olga *(right)* is wearing Grand Duchess Elena's diamond kokoshnik tiara, a diamond necklace, emerald pendant earrings, and an emerald brooch of the same provenance.

The Duchess of Kent *(left)* is wearing the sapphire parure known as the Cambridge Sapphires. The parure was Queen Mary's wedding gift to her goddaughter, Princess Marina of Greece and Denmark, upon her marriage to Mary's son, Prince George, Duke of Kent.

The Family Albums *of the* Grand Duchess Elena Vladimirovna

Grand Duchess Elena

These photographs were taken by Grand Duchess Elena, Princess Nicholas of Greece, who shared a passion for photography with the Tsarina Alexandra. Her dedication to the medium is well documented in these, her private and previously unpublished photographic journals.

Over several decades she photographed her family, the Greek, Russian, German, and Italian royal families, and conserved these images in numerous albums that the Grand Duchess Elena bequeathed to her family.

Alix et moi.

January 1900, Tsarskoe Selo
Grand Duchess Elena and Alexandra Feodorovna, Empress of Russia

Gd Dss Vladimir

Tatoi Palace, Greece
Grand Duchess Vladimir

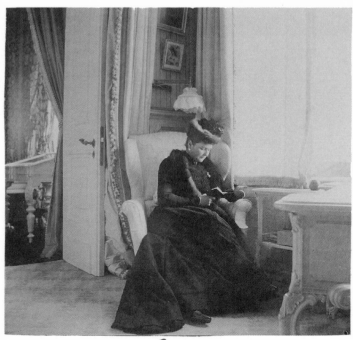

Alix.

January 1900, Tsarskoe Selo
Alexandra Feodorovna, Empress of Russia

Tatoi June 1903

June 1903, Tatoi Palace, Greece
Prince Nicholas and Princess Olga

Princess Nicolas of Greece

June 1903, Tatoi Palace
Prince and Princess Nicholas and Princess Olga

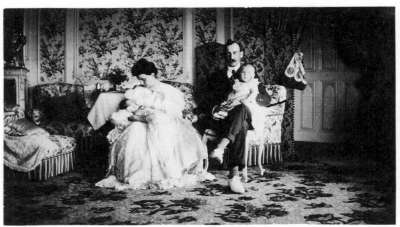

Elizabeth *Olga*

1904
Prince Nicholas and Princess Elena of Greece
with Princess Olga and Princess Elizabeth

1904
Baby Princess Olga

daughters of the russian Emperor
O. in the middle

Peterhof 1904

1904, Peterhof
The four daughters of Emperor Nicholas and Empress Alexandra
and a baby Princess Olga

Maman.

Maman, Sacha Yourievsky + moi.

Mam. Bron Steenpacht, Mme de Peters Michette Rüdiger.

Maman + Etter.

Zousoff + Maman.

Zousoff, Maman, Michette + Verinka.

Spring in Beaulieu-sur-Mer in France

Top row:
H. Legg - I. Greville - A. Davidson - Duke of Portland - Cl. Brocklehurst - Queen - Lord de Grey - Duke of Devonshire - Lord Valetort - Miss Knollys - Col. Fenwick - Sir D. Robyn - Vicar - Lord Dalmeny - ? - Lord Revelstoke - Victoria - John Ward - Lady Gosford - D of Manchester. A. Victor - Arthur Sassoon.

Bottom row:
A. Crusada - Lord H. V. Tempest - Emilie Ysnaga - D of Devonshire - Lady deGrey - King E. Ms Sourval, D of Portland - Mrs Sassoon - Mrs ncolly Sneyd.

18 Nov 1905 Sandringham

November 1905, Sandringham
King Edward is seated in the center, and his niece Grand Duchess Elena is on his left

Imp. William

1905, Corfu
William II, German Emperor and King of Prussia

1905, Corfu
King George I

November 1905, Windsor Park
Seated at the right of King Edward is Grand Duchess Elena

Διάβασις Πηνειού-

Ἐπίσκεψι εἰς Καλαμπάκαν. 15 Μαΐου 190

(my father) Pce Nicholas

1906
Prince Nicholas of Greece and members of the Royal Guard

Théâtre du Grand Casino in Contrexeville, France

The 1906 Intercalated Games or 1906 Olympic Games celebrated in Greece

King George I of Greece (middle right)

King George I of Greece and King Edward VII (bottom right)

on the Acropolis.

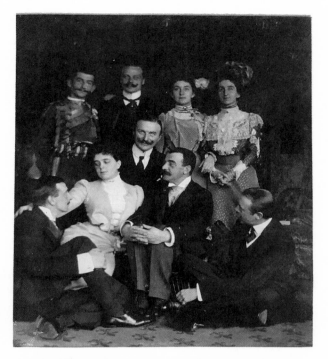

*Militsa and Anatasia of Montenegro married
the Tsar's cousins Grand Duke Peter Nikolaevich
and Grand Duke Nikolai Nikolaevich*

*Athens
King Victor Emmanuel III and King George I*

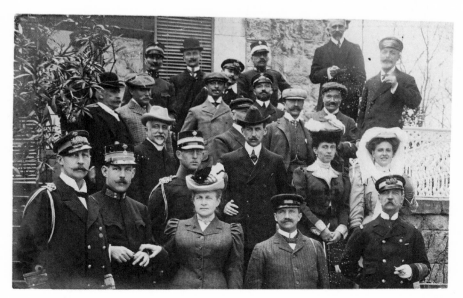

*Greek royal family gathering
In the front row, Queen Olga, King Victor Emanuel III, and King George*

St. Moritz - Engadine
25th July - 20th August 1907.
Villa Languard.

1907, St. Moritz, Engadine

view from our window.

Villa Languard and Badrutt Palace Hotel

Venice gondolas

1907

Prince Nicholas in a theatrical performance at the Greek royal palace

*Prince Nicholas, Grand Duchess Elena, and Grand Duchess Vladimir
visiting the village of Domrémy in France, the birthplace of Joan of Arc*

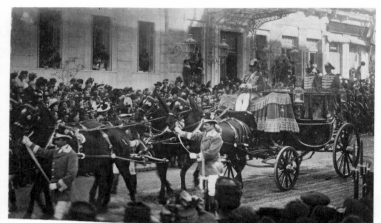

the bride.

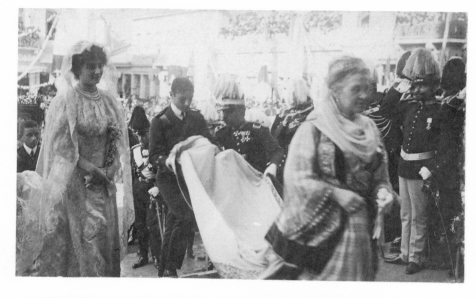

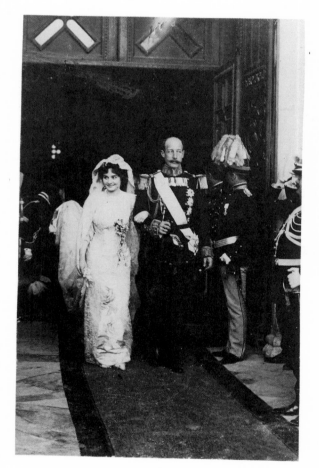

sitta

George's wedding.
29th Nov. 1907.
Athens.

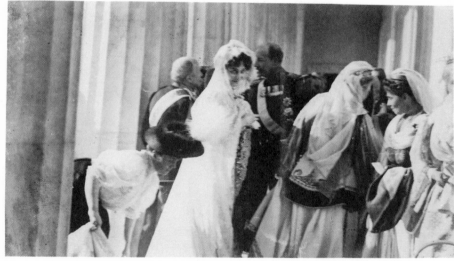

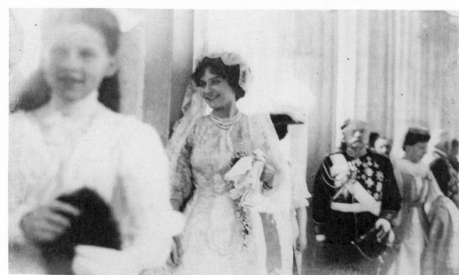

1907, Athens

The wedding of Prince George and Princess Marie Bonaparte

The bride and Queen Olga of Greece (top right)

The future Queen Helen of Romania and the bride (bottom right)

January 1900, Alexander Palace at Tsarskoe Selo

Grand Duchess Elena and Alexandra Feodorovna,
Empress of Russia (left)

Grand Duchess Elena and Princess Victoria
Melita of Great Britain (right)

Appraisal of the Jewelry Belonging to Her Imperial Highness Grand Duchess Elena Vladimirovna

The following pages are a selection from a previously unpublished and hand-painted jewelry notebook, which features close to one hundred pieces of jewelry. The inventory ranges from gold bangles to belt buckles to rings, earrings, necklaces, brooches, pendants, and hat pins as well as a gold thimble and a watch.

Many of these strikingly modern designs are adorned with briolets and round diamonds, pearls, turquoise, coral, and any number of colored precious stones.

Of particular note is N. 69, a rivière diamond choker featuring thirty-nine diamonds and N. 80, a gold and diamond brooch comprised of a sapphire carved to resemble a turtle shell.

Estimation

des
Bijoux
de

Son Altesse Impériale

Madame la Grande Duchesse
Hélène Wladimirowna

Dessiné par
J. Koechli fils

No 1. 1 Collier de 4 rangs
368 Perles
Crochets en diamts
Fermoir composé de
7 Perles 8 13/32 cts
6 Diamts 24/32 .
108 Roses.

" 2 1 Collier chaine en or
9 pend en corail

" 3 1 Collier
Oeufs

" 4 1 Collier corail

" 5 1 Médaillon en émail
Camée & diamts
Chaine en perles & or

Nᵒ 11 1 Bracelet

" 12 1 Bracelet

" 13. 1 Bracelet

" 14. 1 Broche en or
3 Saphirs
3 Diamᵗˢ

" 15. 1 Broche
5 Turquoises
Roses

N° 16. 1 Broche

" 17 1 Broche
 Rubis
 Diamts

" 18 1 Broche en argt oxydé

" 19. 1 Broche en or
 Diamts
 roses

" 20 1 Broche
 1 Saphir
 2 Diamts

" 21 1 Broche

No 22 1 Locket
 Rubis
 Diamts

" 23 1 Locket
 1 Rubis
 Diamts

" 24 1 Locket
 1 Grenat
 Diamts

" 25 1 Locket

" 26 1 Locket
 Grenats
 Diamts

No 27 1 Broche & pend
 2 Turquoises
 Roses

" 28 1 Médaillon en or
 3 Saphirs
 1 Diamt

" 29 1 Croix
 4 Émeraudes
 Diamts

" 30 1 Oeuf
 1 Rubis
 Roses

" 31. 1 Oeuf

a

b

Nᵒ 32 1 Montre & chaîne

" 33 1 Porte-monnaie en or
 3 Rubis
 3 Saphirs
 3 Diamᵗˢ

" 34 1 Encrier de voyage en or

" 35 3 Epingles
 3 Diamᵗ briolettes
 1 rub, 1 saph, 1 diamᵗ

" 36 1 Breloque

No 37 1 Dé en or

" 38 1 Médaille en argt

" 39. 1 Monnaie en cuivre
 1 Diamt

" 40 1 Bracelet

" 41 1 Broche en or
 1 Perle
 Roses

N⁰ 75 1 Broche
1 Saphir étoilé
Diam⁰⁰

" 76 1 Broche monnaie & émail
5 Rubis
Roses.

" 77 1 Broche
3 Emeraudes
Diam⁰⁰

" 78 1 Broche
1 Calcedone
4 Rubis
Roses

" 79 1 Broche
1 Calcedone
1 Rubis
Roses

No 59 1 Locket
 1 Saphir foc
 Diamts

" 60 1 Broche
 3 Saphirs
 Roses

" 61 1 Bracelet, montre en or
 8 Diamts

" 62 1 Collier
 Rubis
 Saphirs
 Turquoises
 Perles

" 63 1 Collier en or
 Perles

Nᵒ 69 1 Rivière de 39 chatons
 39 Diamᵗˢ

" 70 1 Bracelet or fin
 2 Diamᵗˢ

" 71 1 Bracelet
 3 Saphirs
 3 Diamᵗˢ

" 72 1 Bracelet et Broche
 5 Perles
 8 Diamᵗˢ

" 73 1 Broche
 2 Emeraudes
 Diamᵗˢ

" 74 1 Broche
 1 Perle
 Diamᵗˢ

Nᵒ 80 1 Broche tortue
 1 Saphir
 1 Diamᵗ pend
 Roses

" 81. 1 Broche Croix de Malte
 en argent.

" 82 1 Broche "Coq"
 Roses
 1 rubis

" 83 3 Broches émail rose
 Diamᵗˢ
 Roses

" 84 1 Broche
 Saphirs
 Rubis
 Diamᵗˢ

Nº 95 1 Epingle de chapeau en or

 96 1 Montre acier oxydé

 97 1 Bracelet
 Diamᵗˢ
 1 Emeraude

 98 1 Chaine en or
 Perles

 99 1 Corail

Tatoi Palace, Greece
Grand Duchess Vladimir and Grand Duchess Elena, Princess Nicolas of Greece

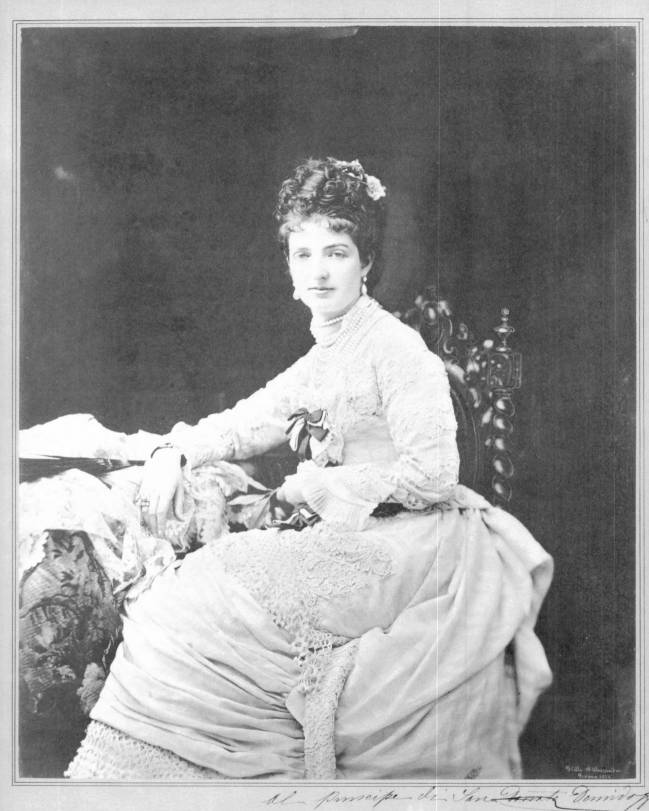

al principe di San Donato Demidoff

Margherita di Savoia

Mosca 19 Luglio 1896

The Three Queens *of* Italy *and* their Storied Gems

In 1861, a national parliament proclaimed the Kingdom of Italy; Victor Emmanuel II was its king. It was the first time that a united Italy would exist since the sixth century, when the Roman Empire broke apart. It was also the beginning of an eighty-five-year reign by the House of Savoy that ended with caskets of jewels hidden in the Bank of Italy and the family in exile.

Seven years after the Italian Kingdom was created, in an atmosphere of national optimism, Margherita of Savoy signed the wedding contract with her first cousin, Crown Prince Umberto, the heir to the Italian throne, in the ballroom of the royal palace in Turin. After the wedding, Umberto and his wife settled in the Palace of Capodimonte in Naples where, a year later, Margherita gave birth to a baby boy, who someday would be king: they named him Victor Emmanuel to honor the founding father of the nation.

As befit her royal role, Margherita (which means "pearl" in Latin), started acquiring jewelry early on and made pearls her signature gem. She understood that a royal personage had to be seen as splendid at all times. Thus, she curated for herself a refined aesthetic and magnificent physical demeanor, anchored by a fashionable wardrobe coupled with priceless jewelry.

Victor Emmanuel II's consort had passed away before unification, so while he was king, it was Crown Princess Margherita who became the de facto first lady of Italy. Her love of pearls, and her

fashion style, created a new industry, as the Italian regional nobles strove to show their sophistication. In her role as first lady, she had a lot of representational duties, which were intended to make the new royal house of united Italy popular throughout the peninsula.

During her official tours throughout the country, Crown Princess Margherita was careful to wear local folk costumes and demonstrate enthusiasm for local customs, traditions, and culture. Gradually, she became a great asset to the House of Savoy, as she deployed her innate ability to create enthusiasm and support for the monarchy through her public appearances.

In January 1871, with the Papal States finally brought under the crown, the unification of Italy was complete and Rome was proclaimed its capital.

Crown Prince Umberto and Crown Princess Margherita settled in the capital. The princess continued to push her political agenda by making her receptions at the royal court the center of Roman high society, and she successfully subdued the opposition to unification within the Roman aristocracy. She also eventually succeeded in making her salon one of the most exclusive and famous in contemporary Europe.

In 1878, Umberto I succeeded Victor Emmanuel II. Over time, he revealed himself as a militarist, who favored spending money on armies rather than social programs. Just four years after his

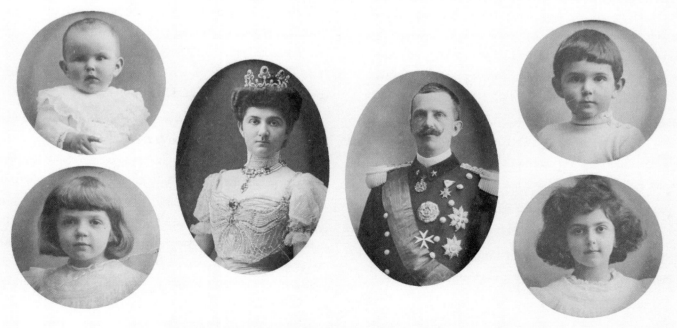

Queen Elena and King Victor Emmanuel III with (clockwise from top left)
Princess Giovanna, Prince Umberto, and Princesses Yolanda and Mafalda

Opposite: Queen Margherita

accession to the throne, he approved the Triple Alliance with the German Empire and Austria-Hungary.

In contrast to her husband, Umberto I, who lacked interest in anything intellectual, Queen Margherita was a natural political strategist, with deep interests in ideas. She was well read in the classics of European literature. Over time, she carved out a voice for herself and became involved in domestic political issues, advocating actively for a strong monarchy.

Time and again during his twenty-two year reign, Umberto I failed to understand the changing economic realities and social circumstances that were buffeting Italy and the world. After surviving two attempts on his life, he was finally assassinated in Monza in 1900. Their son, Victor Emmanuel III, became king after his death.

Victor Emmanuel III would reign during a period when Italy saw the rise and eventual defeat of Italian fascism and suffered the devastation of two world wars. He played a significant role in both: providing political support to the Italian fascists and forging military alliances with the Axis Powers. Both of these stances eventually led to the end of the monarchy and pulled all members of the Italian royal family into the fray.

Victor Emmanuel III's consort, Elena, the daughter of King Nicholas I of Montenegro, had been educated in St. Petersburg and was the goddaughter of Alexander III of Russia. A thoughtful and intellectually curious woman, Elena had been favored by Queen Margherita for her royal blood, yet she was looked down upon by many at court because of the simplicity of her demeanor, and her devotion to her role as wife and mother above all else.

It is said that, at Princess Elena's 1896 wedding, Princess Hélène of France—who had married Victor Emmanuel III's cousin, the Duke of Aosta, a year earlier—described Princess Elena as "La Bergère" (The Shepherdess). Indeed, the rather more glamorous Princess Hélène had been resplendent at her own nuptials, when she wore an array of elegant jewels that included an exquisite emerald fringe necklace she had received as a wedding gift. However, the two women grew to appreciate and understand each other through their many charitable works.

Unlike her predecessor, Margherita, the Dowager Queen Mother, Queen Elena skewed toward a more moderate royal demeanor and appearance; she wore few adornments or important jewelry outside of what was expected at official functions.

In 1904, the Dowager Queen Mother celebrated the birth of her grandson by commissioning an elaborate tiara from the jeweler Musy.

Beginning in 1905, the Duke and Duchess of Aosta resided at the Capodimonte Palace, where the duchess would hold a court that

was said to be so splendid as to rival the prestige of any queen. In contrast, Queen Elena dedicated herself to her subjects. Her impact was widespread: she used her own money to build mountain refuges for mountaineers to shelter in during storms; she gave succor to the survivors of the 1908 Messina earthquake; and she later organized hospitals for the wounded soldiers of war.

In 1902, while Italy was still a signatory to the Triple Alliance with Germany and Austria-Hungary, the Italian government entered into a secret agreement with its nemesis, France. In May 1915, a year after the start of World War I, Italy officially revoked its adherence to the Triple Alliance and declared war on Austria-Hungary, joining the Allied powers in the conflict.

The war struck a devastating blow to the Italian military forces, to its economy, and to the fabric of Italian society. Years of grueling warfare did not result in the hoped for territorial expansion; the military death toll exceeded 500,000 troops, while civilian deaths associated with the conditions of war also numbered 500,000.

During the war the Duchess of Aosta, whose husband, "The Undefeated Duke" had commanded Italy's Third Army, had embraced his homeland as her own. Not only did the Duchess of Aosta work with the Italian Red Cross tending to the injured Italian troops, she also lent her support to Naples's poorest inhabitants. Her dedication earned her the love and respect of the city's population as well as its civic leaders.

In 1918, at the end of World War I, Italy was recognized with a permanent seat in the executive council of the League of Nations, along with Britain, France, and Japan. However, one of the deadliest conflicts in human history had also saddled Italy with enormous debts. The peninsula's economic conditions caused serious social strife, mass emigration, and nourished popular resentment against the government. It also planted the seeds of Italian fascism.

The ideology that underpinned Italian fascism was a mix of Italian nationalism and an ambition to complete what fascists considered the unfinished project of Risorgimento: to usher in the birth of a third Roman Empire. It was also a reaction to the perceived Bolshevik threat that loomed large in European monarchies.

In the aftermath of World War I, Queen Elena saw the immense suffering of her adopted country and thus became evermore devoted to helping its people. The queen was ahead of her time in many ways: she used her celebrity to raise funds for the treatment of diseases; she did not content herself with working as a nurse but also studied and received a degree in medicine; and, finally, weary of the impact of royal excesses on public opinion, she went as far as offering to sell the magnificent crown treasures to repay war debts. Among these treasures was a large diamond floral bow

Marie-José of Belgium

pin adorned with 670 diamonds that Queen Elena wore in her official role at the Coronation of Pope Pius XII in 1939.

"The Kind Queen," as she was known, was twice the recipient of the Vatican's highest decoration for acts of charity, known as the Golden Rose, and Prince Dimitri adds, "There is currently a procedure moving forward in the Church toward her possible beatification."

Despite her ideological and political differences with her consort, Victor Emmanuel III, Queen Elena remained by his side throughout her marriage and fulfilled her duties with the utmost rigor. She bore five children, including a boy, her middle child Umberto, who would grow up and marry a Belgian princess, Marie-José, and become the next king of Italy—if only for a few weeks.

Princess Marie-José, the last queen of Italy, was born Princess of Belgium in 1906 in Ostend, the youngest child of Albert I, King of the Belgians, and Elisabeth, born Duchess in Bavaria.

Marie-José of Belgium, later Queen of Italy, had been sent to school in Florence to learn Italian as a child, where her parents, King Albert and Queen Elisabeth of Belgium, would come to visit her. On one such occasion, the family went to the Santa Maria del Fiore Cathedral for a ceremonial mass in the presence of the Italian sovereigns, the Florentine aristocracy, as well as other dignitaries.

Queen Marie-José told Prince Dimitri a story that occurred after visiting with her parents: "I wanted to take some tangerines back to my dormitory, so I stuffed the fruits in my bloomers. Unfortunately, I took so many that, as I was walking down the nave, the tangerines broke loose and began falling from under my dress, dropping onto the church floor with a thud and rolling around!"

Prince Dimitri recalls her saying that instead of being embarrassed, the young princess thought that this cascade was quite funny and began to laugh. Although her mother, Queen Elisabeth, was not amused, the king got the giggles and was promptly joined by a number of other dignitaries in the church.

When years later she attended her first court ball in 1924, Princess Marie-José was still far removed from power and the Italian throne. Her beauty was widely praised and it is said to have lit up the Belgian night, when she appeared wearing the diamond and antique pearl tiara that had previously been owned by the Grand Duchess of Baden.

In 1929, in Brussels, Princess Marie-José became officially engaged to Crown Prince Umberto, to the delight of her parents, Belgium's king and queen.

A year later, at the wedding of Umberto II and Marie-José, the press enthusiastically reported on the day, describing how Princess Marie-José wore a veil, which was held in place by a "diadem of diamonds and other precious stones set in platinum." The Musy diadem, previously owned by Queen Margherita, was a gift from Queen Elena. In addition, Princess Marie-José wore a Savoy diamond knot necklace and a turquoise and diamond parure.

The day was a triumph for both families, and the ceremony attracted prominent members of the royal families from all over Europe. A short while after the wedding and other official duties had been concluded, Marie-José and Prince Umberto II settled in Naples to begin their new life.

The first of the four children of Crown Prince Umberto II and Princess Marie-José was Princess Maria Pia, who was born in 1934 and baptized in the Palatine Chapel of the Royal Palace in Naples.

Crown Prince Umberto II and Crown Princess Marie-José

The royal classroom in Palazzo Pitti, 1942

Most of the Italian royal family, the Italian court, as well as twenty-four mothers from the city's poorer neighborhoods attended, a testament to the good work Princess Marie-José did for the people of Naples.

After World War II broke out, Crown Princess Marie-José and her children took up residence at the Pitti Palace, where a Montessori-trained tutor schooled the children in the magnificent Renaissance galleries.

During World War II, in addition to her royal duties and being a mother, Princess Marie-José served as Inspector of the Red Cross, tending to wounded soldiers in the palace hospital. A trained concert pianist, she also played the piano in the dormitories of the hospitals. Eventually, several members of the Italian court, political insiders as well as Princess Marie-José, began putting out feelers to the Allies.

One of Prince Dimitri's most heartfelt stories was told to him by his mother, Princess Maria Pia: "In August 1945, my mother returned to the Quirinale Palace in Rome, where my grandfather, King Umberto, had welcomed forty injured war orphans who were living at the Palace.

"The first time she met them, she says she nearly fainted at the sight of the terrible mutilations that the children suffered. But soon enough she found her smile again, and they played together every day. At the palace there were two little carriages, one pulled by a

pony and one by a donkey. So, my mother and uncle used to take the youngest of these children and go around the garden."

He continues: "At the time, she didn't know their exact ages or where they were from, but it was a joy to be with them and see them smile, laugh, and be happy despite the horrors they had endured and their terrible injuries. One of them, whose name was Vittorio, had been blinded when a Nazi soldier had shot him in the head while he was in his mother's arms; the bullet had severed his optical nerve and killed his mother. He always held my mother's hand and had a very special bond with her. She grew very fond of them and to this day she wonders what happened to them when they had to leave."

However, it was only at the end of the war that Umberto and Marie-José began their reign; after Victor Emmanuel III, abdicated in hopes of restoring faith in the monarchy. Just a few weeks following their accession, in June 1946, a contentious national referendum on the institutional form of the state ushered in the Italian Republic and abolished the monarchy. Thus, the House of Savoy's rule over Italy formally ended.

Soon thereafter, Umberto II had a casket containing the Italian Crown Jewels delivered to the Bank of Italy. His parents, Victor Emmanuel III and Queen Elena, flew to Egypt to live in exile. Umberto II, Queen Marie-José, and their family departed for Portugal and Switzerland. They continued to be welcomed at informal events as well as official ceremonies by the royal families of Europe. At these gatherings, Queen Marie-José continued to wear her personal jewels, including a diamond devant de corsage inherited from Empress Carlotta of Mexico, which Marie-José later sold to support her music foundation.

Queen Marie-José's father, King Albert of Belgium, had passed away in 1934 in a tragic mountaineering accident, but her mother the queen lived on to the age of ninety.

Umberto II and Queen Marie-Jose's oldest daughter, Princess Maria Pia, met her future husband, Prince Alexander of Yugoslavia,

Princess Maria Pia standing with children

Princess Maria Pia on the donkey cart

on the Agamemnon cruise organized by King Paul and Queen Frederica of Greece, which reunited many members of the deposed royal families of Europe.

Prince Dimitri recounts, "After the war, in 1954, Queen Frederica of Greece decided to organize a cruise in the Aegean and Ionian Seas on a ship for all the young royals of Europe to meet after the long separation caused by the war. She hoped some would get married.

"That summer one hundred and four royals embarked on the Agamemnon for what would be known as the cruise of the kings, hosted by King Paul and Queen Frederica.

"The cruise lasted eleven days with numerous stops at famous Greek archeological sites and plenty of beach time. My four grandparents were on board and were very close friends since their childhood, having gone through two world wars and the loss of their thrones.

"They were certainly hoping for what happened . . . My mother and father fell in love and were married the following year in Portugal."

They welcomed their first two boys, the twins Prince Dimitri and Prince Michel, in 1958. In 1963, a second set of twins, Prince Serge and Princess Helene, were born.

Prince Dimitri is seen below in 1965 when he was visiting his great-grandmother, Queen Elisabeth, at her home, the Château de Stuyvenberg near Brussels: "I was lucky enough to get to know her and to spend four days with her in Brussels just ten days before she passed and I remember her as a lovely, kind person." When Queen Elisabeth passed away, she left one of her two beloved Stradivarius violins to her great friend, the famous violinist David Oistrakh.

In 1976, the *New York Times* reported that the safe containing the Italian Crown Jewels was finally opened. Representatives of the government attended the formal opening of the vault of the Bank of Italy. With that ceremony, and the photographs that were made available, the public was finally able to view the magnificent Crown Jewels.

In 1983, Queen Marie-José was permitted to return to Italy after the death of her husband, Umberto II. She had been separated from her husband for decades: He had continued to live in Portugal; she spent most of her time in Switzerland, where she passed away in 2001.

More than seventy years have passed since the end of the monarchy in Italy and the fall of the House of Savoy. Yet, to this day, the Crown Jewels remain sequestered in the vaults of the Bank of Italy. Their beauty is hidden from all, while the destiny of these storied gems continues to be unknown.

Participants of the Agamemnon cruise

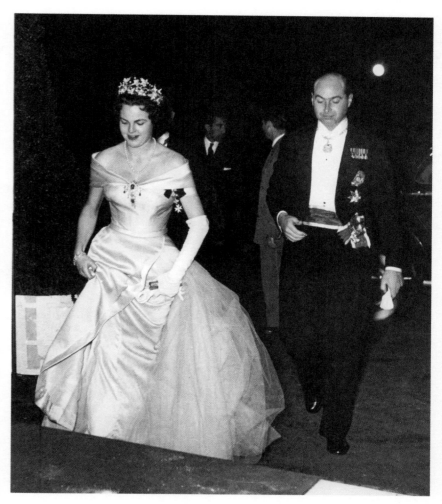

Princess Maria Pia accompanied by Prince Alexander photographed at the ball on the eve of her wedding

Queen Elisabeth and Prince Dimitri

THE JEWELS OF QUEEN MARGHERITA

On January 9, 1878, Margherita became the first queen of Italy when her husband, Umberto I, ascended to the throne following his father's death.

In this early formal portrait of Queen Margherita, she can be seen wearing her pearl-drop tiara with its eleven diamond curled motifs, in addition to other important pieces of emerald and pearl jewelry including her magnificent pearl drop earrings.

The tiara was made for her in 1883 by Musy and was later worn by Queen Elena for a number of important functions.

The diamond and emerald jewels she wears here include the magnificent pearl, diamond, and emerald necklace made by the jeweler Delsotto in Austria, as well as the emerald and pearl brooch designed by Hancock in London pinned here to her devant de corsage.

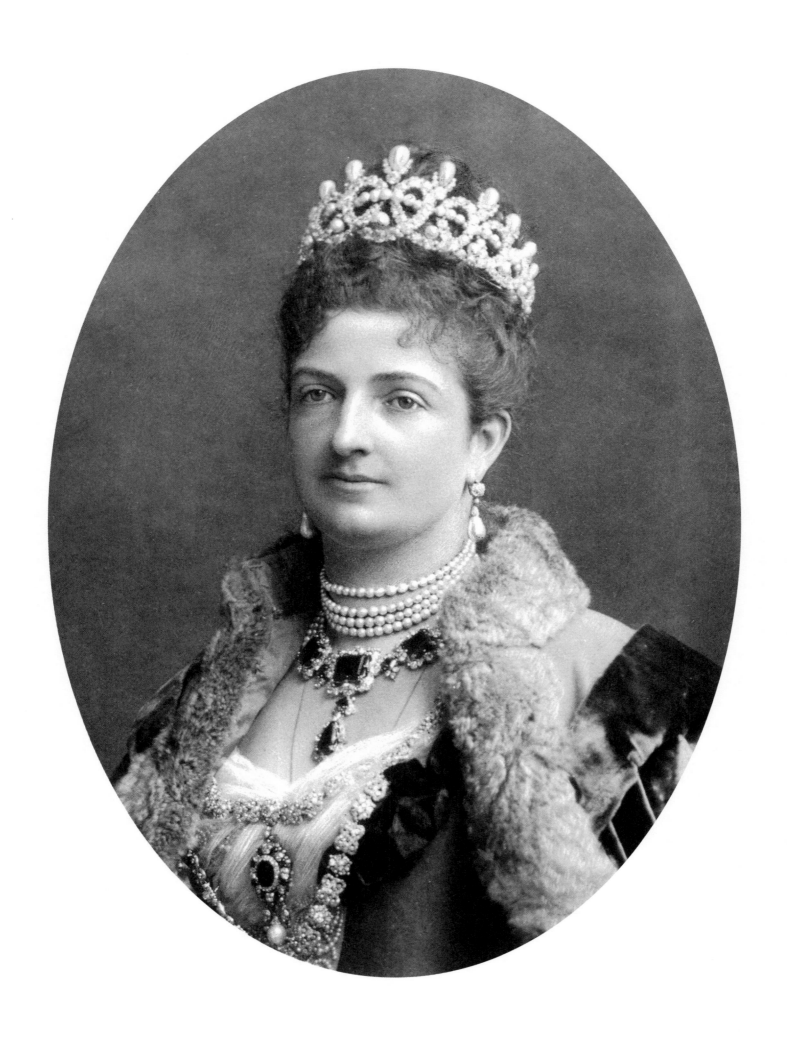

The Pearl Queen

The first queen of Italy, Queen Margherita was known as the "Pearl Queen," for her collection of magnificent pearls that can be seen here adorning her tiara and draped around her neck.

From the time of the Roman Empire, pearls had been a symbol of wealth and status. In the Middle Ages pearls acquired additional significance. They were seen as symbols of authority on regalia, as well as attributes of Christ and the Virgin Mary, symbolizing purity and chastity. By the Renaissance, the meaning of pearls had evolved into an increasingly secular and lavish adornment, used to demonstrate high social rank. In the nineteenth century, the opulence and ceremony enjoyed by the courts of Europe made fashionable pearl necklaces of all lengths, from long sautoir necklaces to many-stranded chokers. The necklaces Queen Margherita wears in the photograph are said to have been the property of her deceased mother-in-law, Archduchess Adelaide of Austria, Queen of Sardinia.

A formidable presence and a much-liked queen, Margherita worked tirelessly for the prestige of the Savoy monarchy. It was a quality that endeared her to her subjects as well as her husband, who is said to have given her most of her pearl collection. These gifts were bestowed on Margherita to show his admiration to a devoted sovereign, but also to be forgiven for his indiscretions.

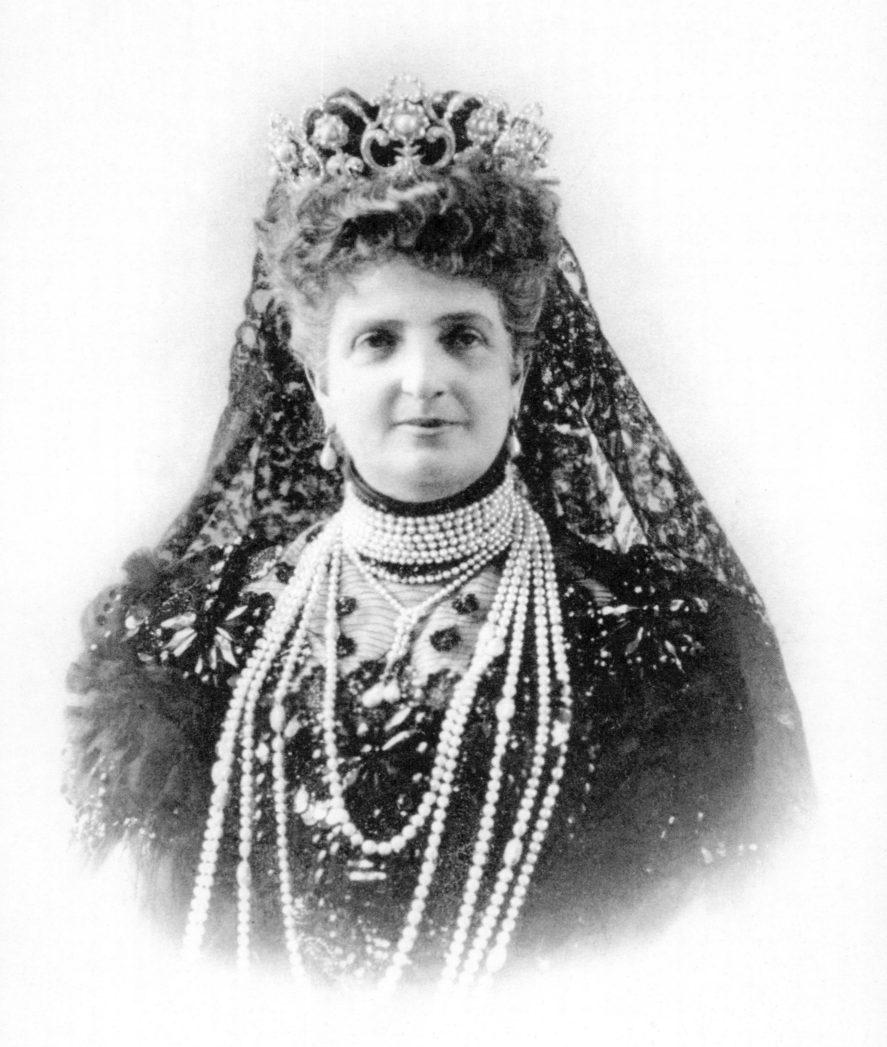

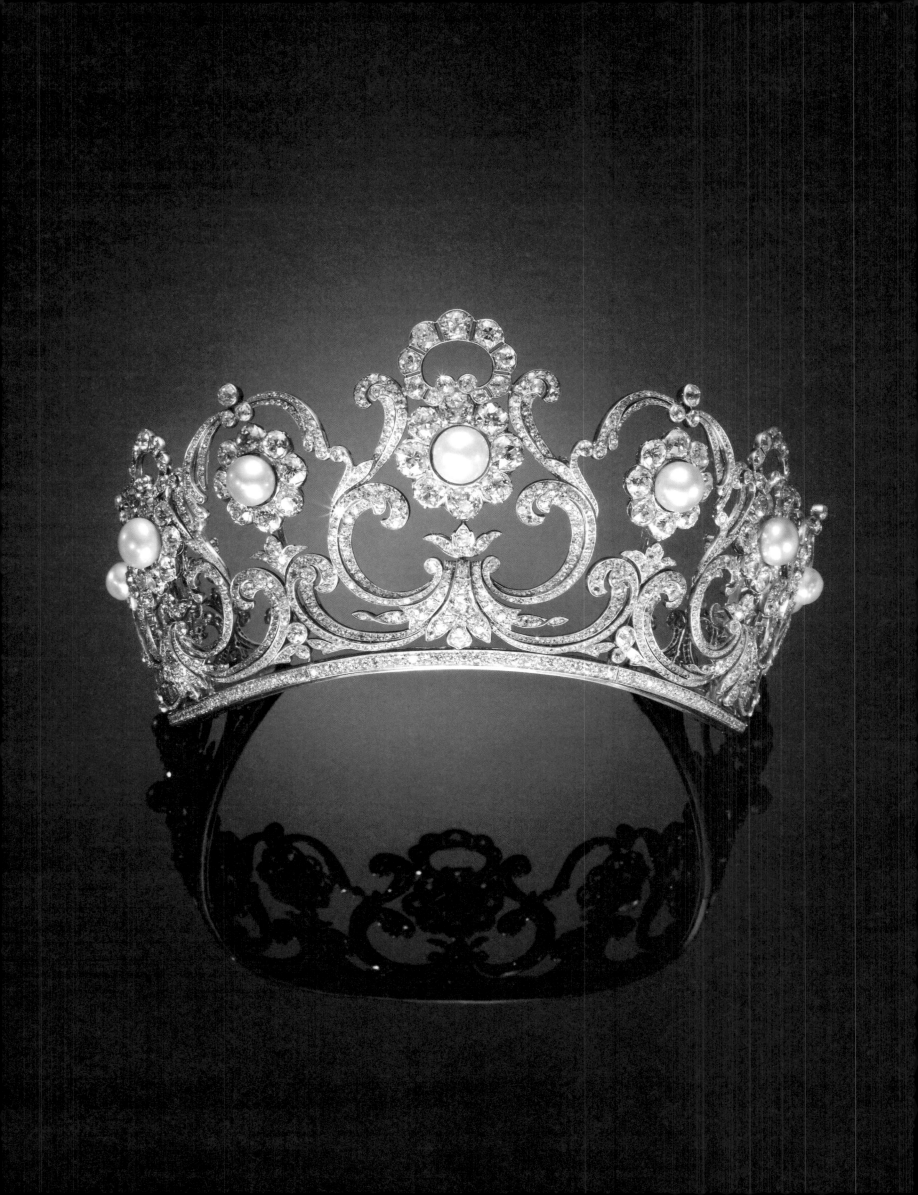

Musy Tiara

Queen Margherita preferred to buy her jewelry in Italy, from such places as Musy in Turin. The queen commissioned this elaborate tiara from Musy to celebrate the birth of her grandson in 1904.

Queen Margherita sent some pieces from her personal jewel collection to Musy to be crafted into this new diadem. This extraordinary piece can be worn in several different ways, as it disassembles to create either a simpler or more elaborate design.

Her grandson, Umberto, was named after Margherita's late husband King Umberto I, who was assassinated in 1900. She wore the tiara in public for his christening and for formal occasions for the rest of her life.

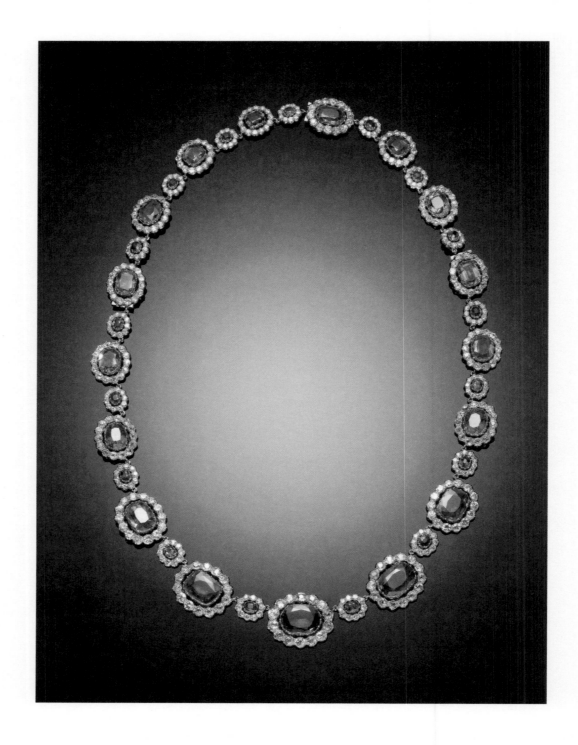

Sapphire and Diamond Necklace

Queen Marie-José is seen here wearing the Musy Floral Tiara and the Petocchi double row sapphire and diamond necklace. Petocchi's design, as seen above, features oval faceted sapphires in a yellow gold mount surrounded by diamonds set in platinum.

Queen Marie-José and King Umberto are photographed in 1962 descending the grand staircase of the Royal Palace in Athens on the occasion of the wedding of then Princess Sofia of Greece and Denmark and Prince Juan Carlos of Spain.

Directly behind the royal couple can be seen King Michael and Queen Anne of Romania, followed by Prince Joseph and Gina of Liechtenstein, and finally Prince Rainier and Princess Grace of Monaco.

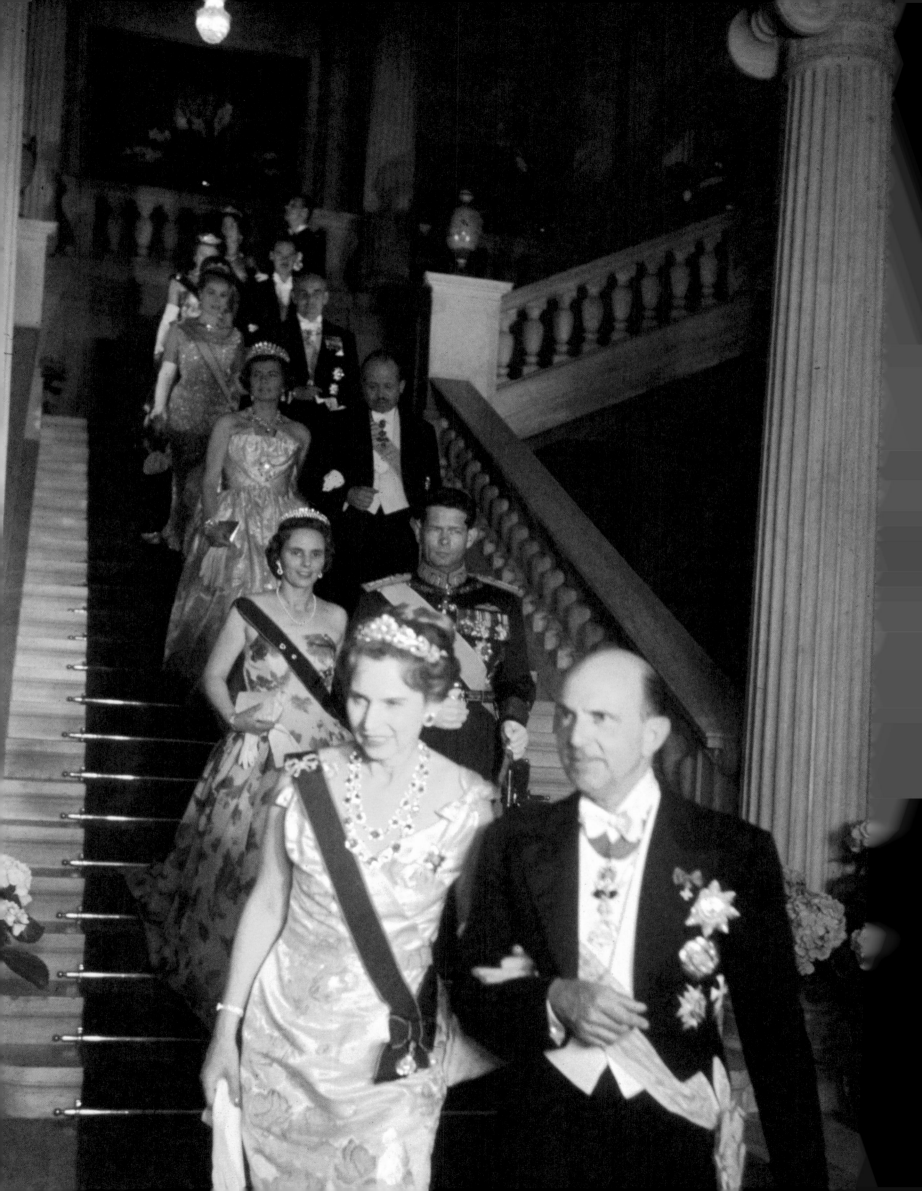

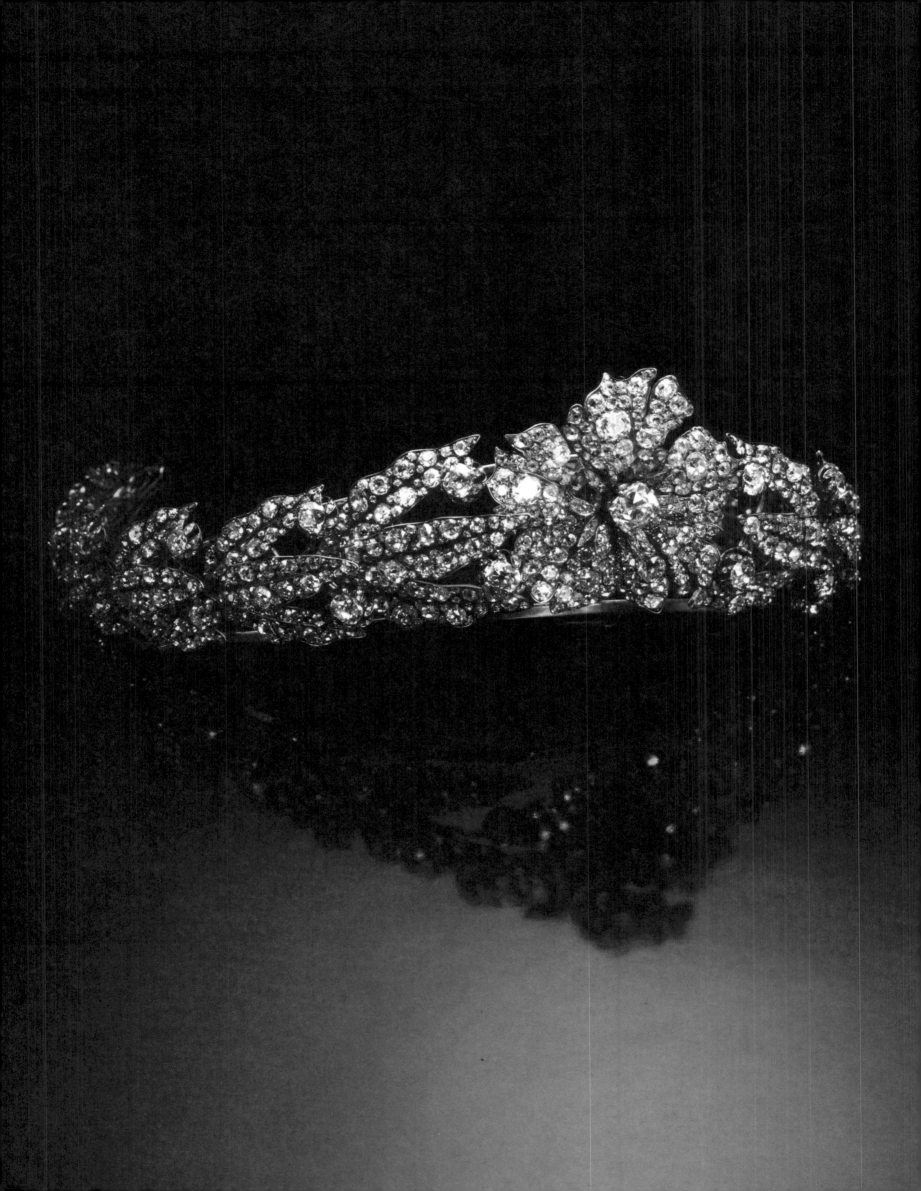

MELLERIO FLORAL TIARA

The floral tiara of Queen Margherita of Italy was among the pieces exhibited by the jeweler Mellerio at the Paris Universelle Exhibition in 1867. Victor Emmanuel II bought the diadem as a gift to his son and heir's future bride, Margherita of Savoy-Genoa.

The wreath's naturalistic design reflects the elegance and style of a Mellerio creation—a jeweler particularly adept at creating jewels with the natural motifs that were so popular at the time.

The choice of a wreath is also a nod to ancient Rome, making this tiara the perfect gift for a future Italian queen consort.

Queen Margherita wore the tiara throughout her life and, subsequently, it was inherited by the members of the Italian royal family and worn by Queen Marie-José even after she and her family were exiled.

Hélène of Orléans' Emerald Necklace

This necklace, comprised of cut diamonds framing a number of larger emeralds, was the property of Princess Hélène of France, Duchess of Aosta, and in 1930 the Marchioness of Cholmondeley bought the piece.

It was part of the parure that was sold by the duke and duchess of Aosta and was dated to the early nineteenth century. The necklace is said to have been the property of the Duchess of Aumale and to have been a gift of her widowed husband to Princess Hélène of France.

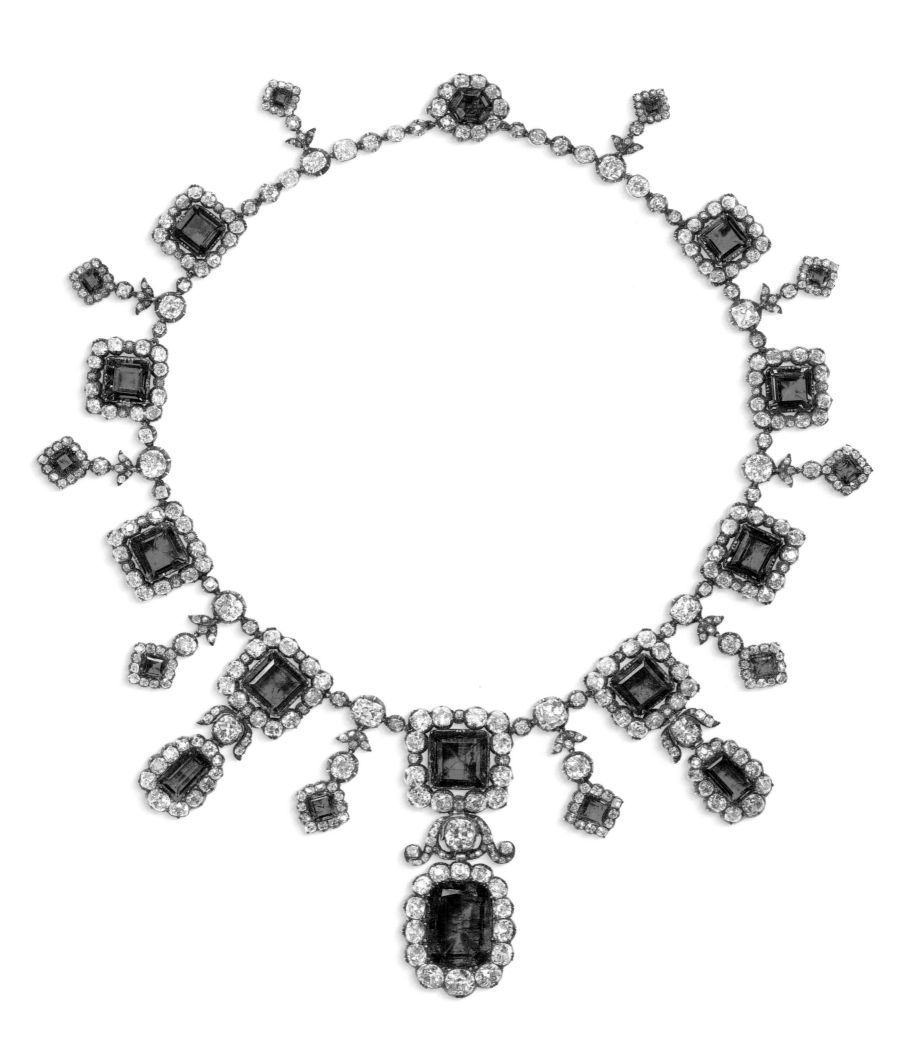

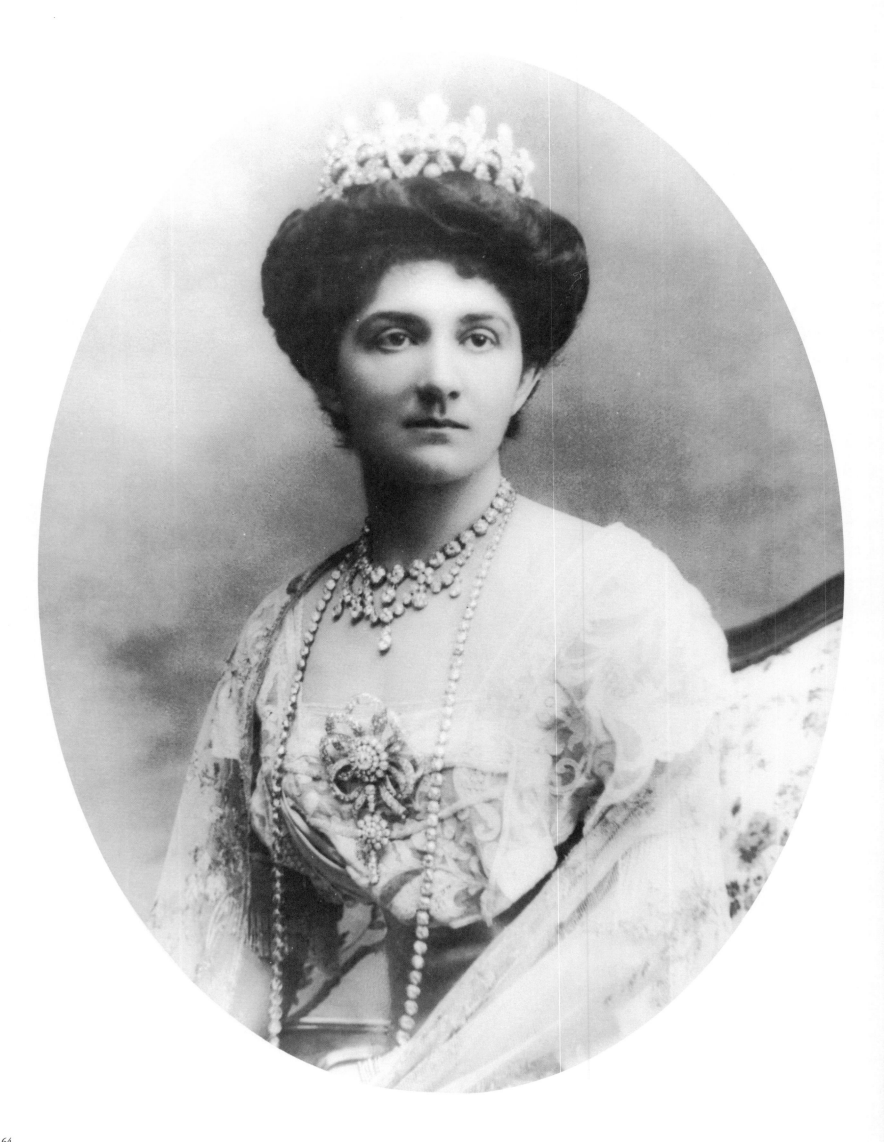

Queen Elena of Italy

Queen Elena's generosity and altruism were not limited to the neediest of her citizens and neighbors as well as the sick; Queen Elena was also instrumental in arranging for safe passage for the Grand Duchess Vladimir when she was escaping from Russia.

After the six-hundred-kilometer train journey the Grand Duchess feared boarding the public ship waiting in port because it was dirty, overcrowded, and would have been submitted to a health inspection once in Constantinople.

So, Queen Elena of Italy sent the ship *Semiramis* to her aid and allowed her to eventually arrive safely in Venice with her entire family. Queen Elena's kindness was absolutely instrumental in saving them, as a typhoid fever epidemic killed everybody on board the intended escape ship.

Countess Stroganoff told Prince Dimitri that on the *Semiramis*, the Grand Duchess was the same powerhouse as ever: "The Grand Duchess Vladimir decided that the corner table in the dining room was hers and told the ladies with her that it was the imperial table. Hence, they were expected to curtsy every time they passed in front of it even if she wasn't there."

Diamond Clips

The house of Chiappe was renowned for its elegant designs and, although perhaps less known today than some other Italian jewelers, it was once considered to be among the best. In 1913, the Italian royal family appointed Chiappe as court jeweler.

The drawings for the platinum and diamond clips feature the Savoy knot and were ordered by Umberto from Chiappe. The company, originally founded in 1886 by the jeweler Filippo Chiappe, was located in Genoa.

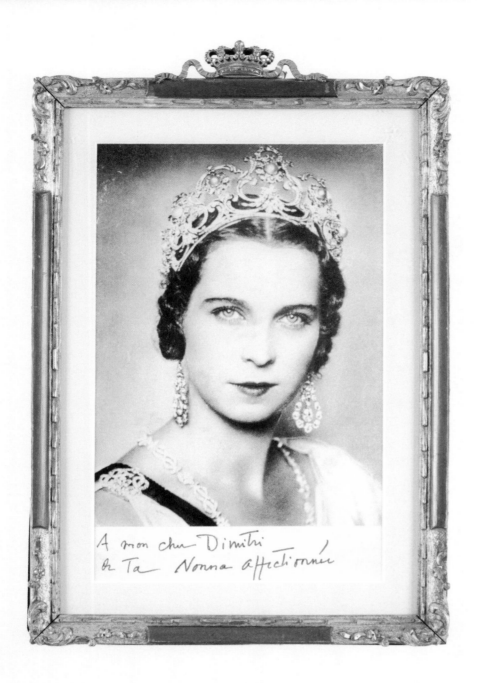

Savoy Knot Necklace

The Savoy knot is the notable symbol seen on the heraldic badge of the royal House of Savoy, founded in 1003.

In this photograph dated 1938, Princess Marie-José wears the Savoy Knot Necklace and other jewels commissioned from Musy by her future husband, the Prince Umberto. She is also wearing the Musy Tiara that was bequeathed by Queen Margherita to her grandson Umberto II. She wore the tiara on her wedding day in 1930.

The delicate diamond link necklace was designed as a succession of flowers and Savoy knots, and was ordered from the Italian jeweler Chiappe by Prince Umberto on the occasion of his wedding to Marie-José of Belgium.

The parure that Queen Marie-José wore on many occasions also included a pair of diamond pendant earrings. The drawing shown here is a preparatory drawing made by the jeweler and submitted to the prince for his approval.

The necklace design culminated in a Savoy knot pendant, and the entire necklace was constructed in such a manner as to be broken apart to form bracelets or to be worn in a shorter choker style.

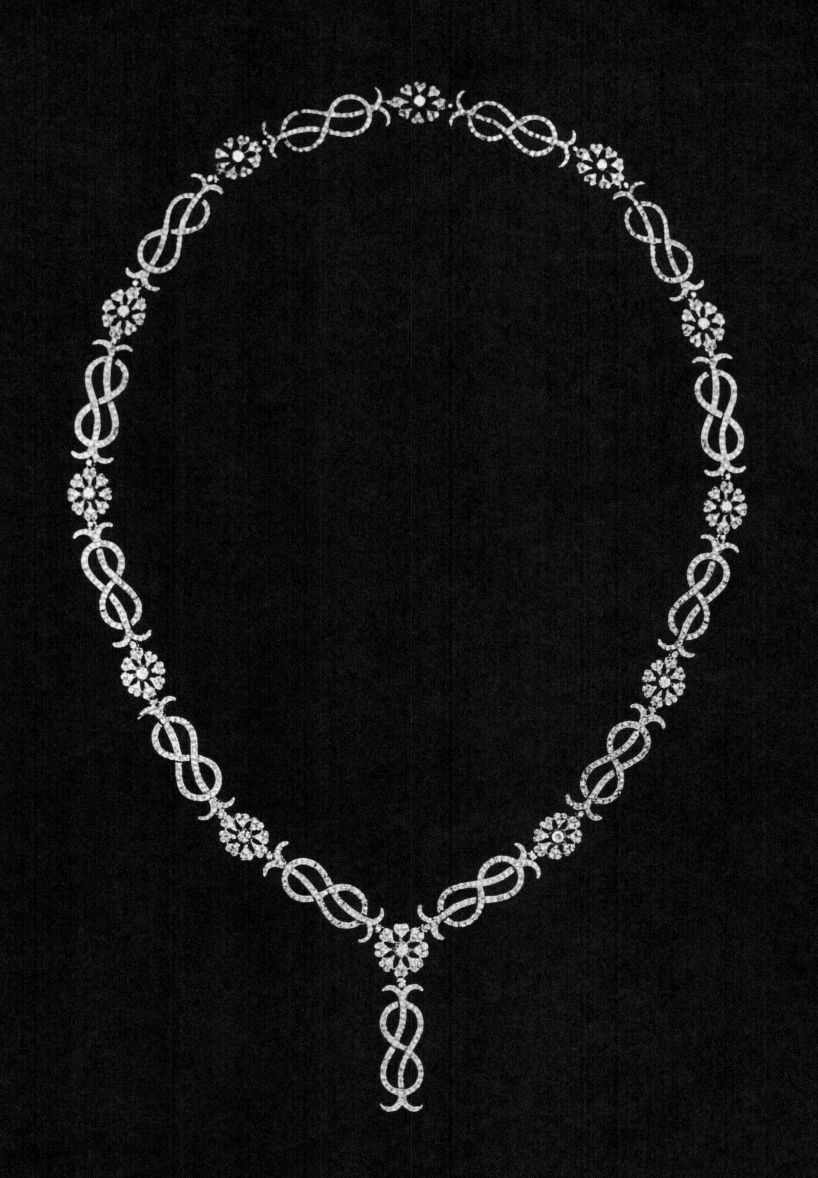

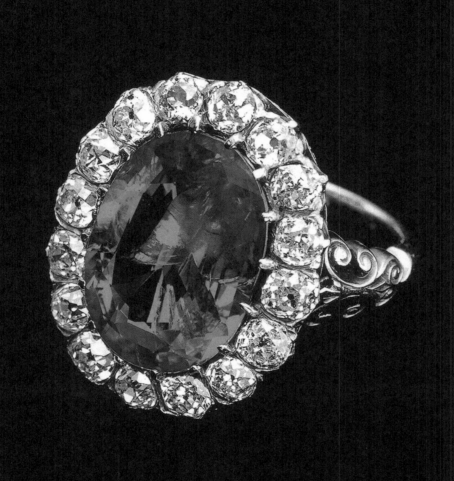

MARIE-JOSÉ'S RUBY RING

This important ruby ring belonged to Queen Marie-José of Italy. Sixteen brilliant old-cut diamonds surround the center stone, which weighs 8.48 carats and is an exceedingly rare Burmese ruby.

The renowned Italian scholar and devoted bibliophile, known as the "king of libraries," Tammaro de Marinis, gifted the ring to Queen Marie-José. He lived in the Villa Montalto near Florence, where he would often entertain the literati of the day.

The custom of gifting jewels to royalty was well established and meant to enhance the prestige of the recipient as the jewels were worn in public. The giver was thus expressing his patriotism and loyalty by presenting such gifts.

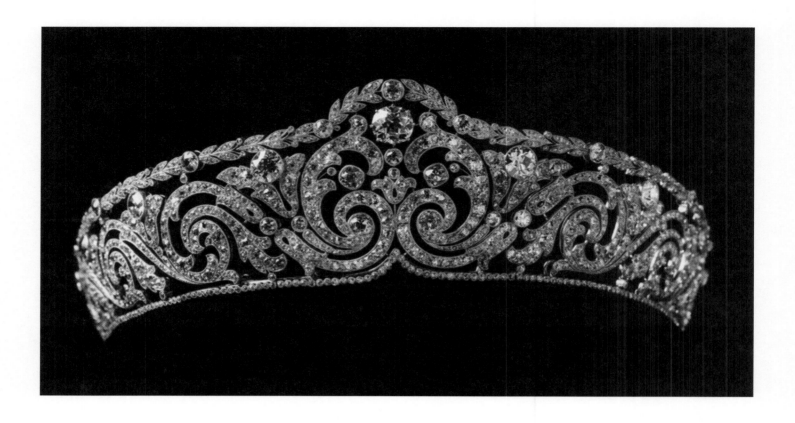

Queen of the Belgians Tiara

The diadem known as the Queen of the Belgians Tiara was made of diamonds and platinum and commissioned from Cartier in their "garland style," in 1910. The year 1911 was a great one for Cartier and the history of the tiara. They held an exhibition in April in London that showcased nineteen tiaras.

This tiara was altered in 1912 by Cartier to be worn as a bandeau. In the 1920s, shorter hairstyles created a perfect new way to highlight the more casual role afforded the fairer sex, while offering an opportunity to wear the tiara in a more modern way—as is seen here in a portrait of Queen Elisabeth of Belgium, the mother of Queen Marie-José of Italy, dated to the 1920s. She continued to wear the Cartier Tiara into her widowhood, including to the wedding ball of her grandson, King Baudouin.

In addition to her role as queen and mother, Queen Elisabeth, the mother of Queen Marie-José of Italy, was also passionate about classical music and an excellent violinist.

Queen Elisabeth met Albert Einstein in 1927, when he attended the Solvay Conference dedicated to physics. A deep friendship was born between them that lasted until he died in 1955. Both passionate violinists, they corresponded over the years and played together on many occasions.

In the mid-1930s, Queen Elisabeth and King Albert extended an official invitation for Albert Einstein to visit them in Belgium, to protect the physicist from possible internment in a concentration camp. Once he arrived, they arranged for him to sail from Antwerp to England, thus saving his life.

A musical competition that Queen Elisabeth helped establish in 1937 to commemorate Eugène Ysaÿe, the Belgian concert-violinist, and friend of the queen, continues to be held in Brussels for young classical violinists, cellists, pianists, and singers. Many great musical talents have been discovered there.

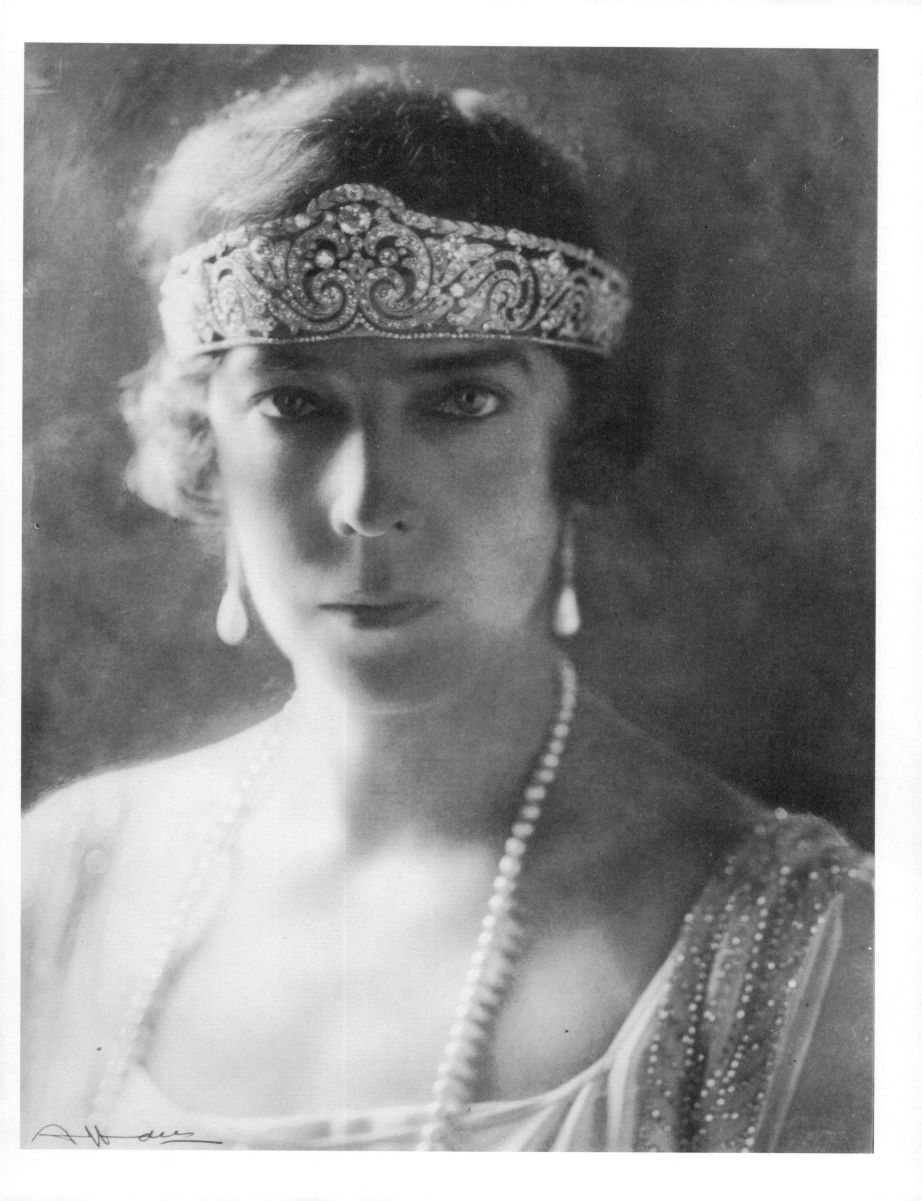

Bébelle

Janvier 1957.

Isabelle d'Orléans-Braganza

Born in 1911, Isabelle d'Orléans-Braganza, HRH the Countess of Paris and great-granddaughter of the Emperor of Brazil, was said to be one of the greatest beauties of her time and, as Prince Dimitri recalls, "She had the most mesmerizing pale blue eyes."

She married Henri d'Orléans, Count of Paris, whose uncle was Prince Emanuele Filiberto, Duke of Aosta, the grandson of King Victor Emmanuel II of Italy.

A force of nature, she bore eleven children; she went fox hunting riding sidesaddle; and she swam in the freezing waters off the coast of Normandy.

The boys always kissed her hand, Prince Dimitri recalls, and the girls always curtsied to her, and they all adored her. Prince Dimitri remembers that he and his twin brother, Prince Michael, would visit the Countess of Paris, their godmother, at her home, the Château d'Eu. He remembers her being enormously generous as well as witty and gifted with a sixth sense.

She loved the occult and sometimes held séances with her numerous guests in attendance and even went ghost hunting with the children late into the night that led to much shrieking with terror and excitement.

He remembers, with a smile, "She loved naughty children as long as they had impeccable manners!"

Sapphire & Diamond Parure of the Countess of Paris

In this photograph, taken in the 1950s, Henri, Count of Paris, and his wife, Isabelle of Orléans-Braganza, Countess of Paris, are seen seated next to each other; the countess is wearing the full sapphire and diamond parure.

The diamond and sapphire parure includes a coronet, a necklace, a pair of earrings, as well as two small brooches and one large one. The pieces are set with faceted Ceylon sapphires ringed with diamonds and set in gold.

It is almost impossible to date the pieces, as none bear the hallmarks of any of the nineteenth century's most respected jewelers, such as Nitot, Bapst, and Marguerite—all of whom often worked for the royal family.

Elements of the parure were modified over time to the tastes of Queen Hortense of Holland, Queen Marie-Amélie of France, and Isabelle of Orléans-Braganza, and finally remained in the Orléans family until 1985.

Despite the numerous modifications and the mystery that surrounds its designer, the set of jewelry is a remarkable tribute to the skills of Parisian jewelers in the early years of the nineteenth century.

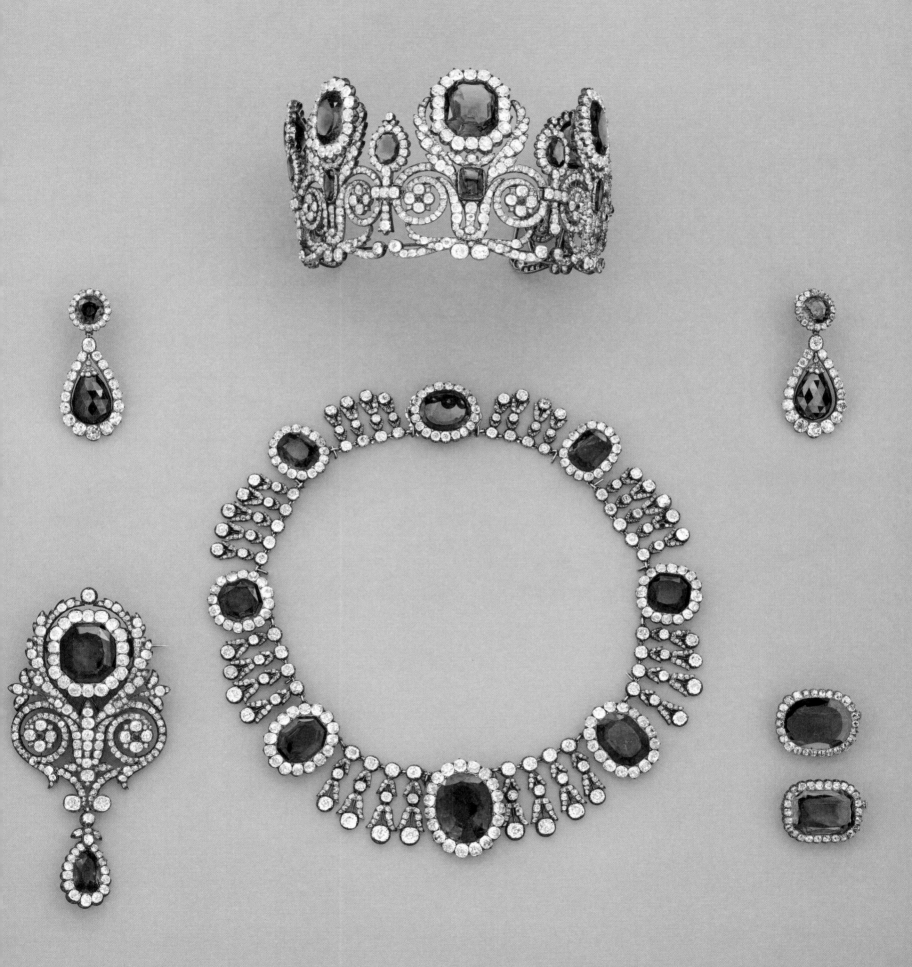

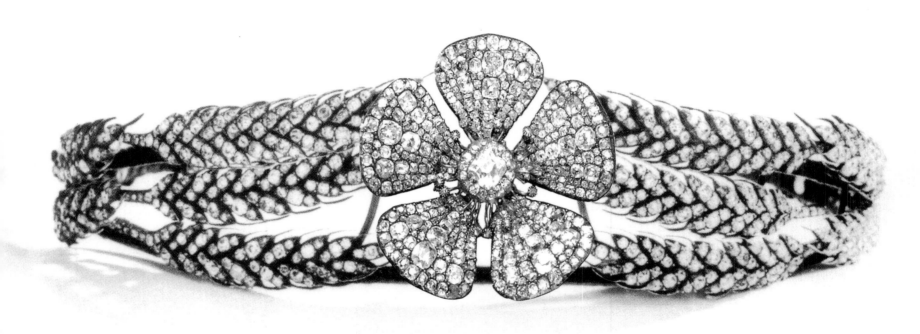

Daisy Tiara

The ten stalks of wheat set with diamonds were pieces that originally belonged to the Duchess of Genoa, mother of Queen Margherita. Later the duchess requested that Musy jewelers create a tiara with the wheat stems and with the addition of a stylized wild rose, also set in diamonds, that would provide the diadem's visual focal point. In 1955, Prince Dimitri's mother, Princess Maria Pia *(above)*, wore the piece when she married Prince Alexander of Yugoslavia.

Musy was originally established in Geneva by Giacomo Musy, who moved its goldsmithing and clockwork shop to Turin, after it was liberated from the French in 1706.

There, in a small area near the royal palace, where the court-appointed House of Savoy suppliers were located, Musy began to grow in fame until it became known and prized by all nobility for its extraordinary craftsmanship.

PRINCESS MARIA PIA

This whimsical fashion photograph from the late 1960s portrays a young Princess Maria Pia, then Princess of Yugoslavia, in which her youthful beauty is perfectly captured for a magazine article.

Her hair is mounted over her head in three chignons and embellished with a number of pieces of jewelry designed by Harry Winston.

Prince Dimitri recalls how he went to the Winston showroom with his mother; while there, he was permitted to touch the gems and jewelry on display.

The result, he remembers, was that he was hypnotized by the light reflecting on the precious metals and in the facets of the diamonds, as well as mesmerized by the depth and the richness of the hues displayed by the countless colored gems.

Thanks to the understanding and generosity of Harry Winston's staff, it was also Prince Dimitri's first glimpse into the fascinating world of gemology—a young manager began to show and explain the differences between Kashmir, Ceylon, and Burmese sapphires.

This was his moment of awakening, and the beginning of a lifelong passion for stones that has inspired the arc of his professional life.

The rest is what came next.

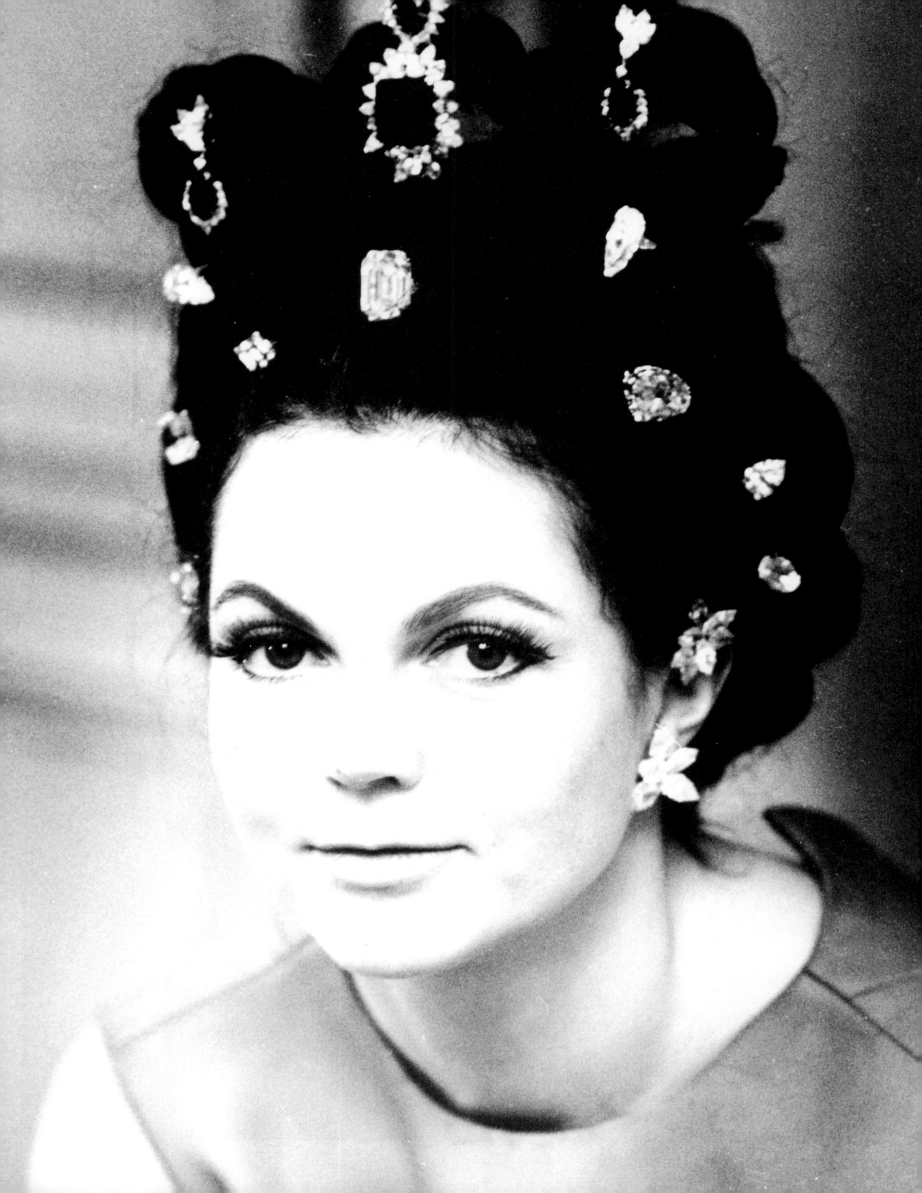

The Jewels and Designs *of* Prince Dimitri of Yugoslavia

The jewels I grew up staring at fascinated me because they possessed this mysterious ability to create a halo of light, an aura of glamour, around the wearer. With these jewels came the privilege of beauty that placed she who wore them above the rest of us common mortals. I was the lucky witness of magic. That feeling always stayed with me and when I design, I try to re-create it.

Proportion is always a key element. After all, the Greeks had invented the "divine proportion," that important difference between static and dynamic harmony. Superlative quality is essential. Details, especially the hidden ones, are fundamental for they convey this marvelous feeling of luxury.

Because I have always found novelty so exciting, I work with unusual materials and color combinations.

There are two types of inspiration: One comes from shapes or even a detail spotted in nature or in decorative arts from different cultures; the other comes from gems themselves.

I love the concept of alchemy, with its fascinating power to change lead into gold, so I enjoy transforming and putting things together and giving them a new life.

There is nothing more satisfying than having a friend confess that she has all this old, unwearable jewelry and to be able to conjure up the alchemical skill to turn it into new adornments that will give her pleasure forever.

— Prince Dimitri

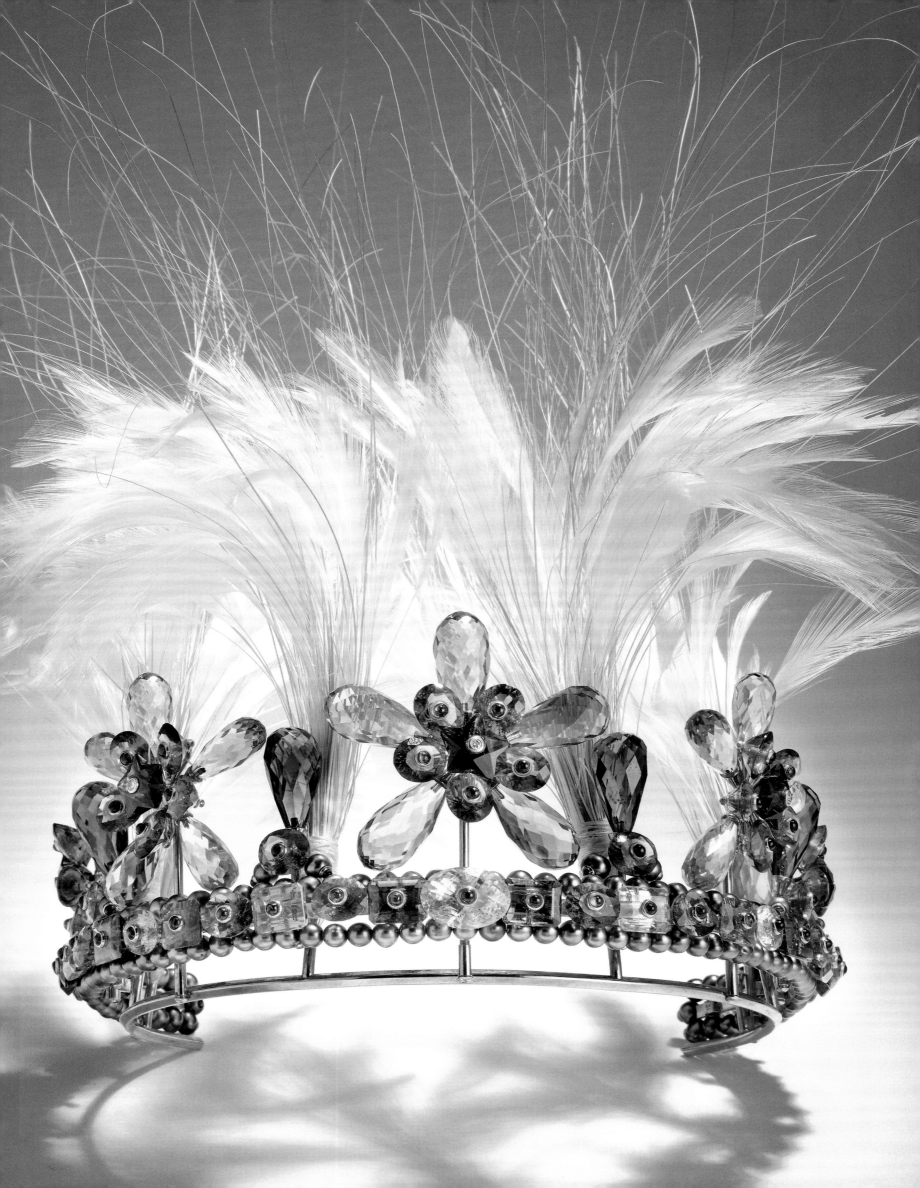

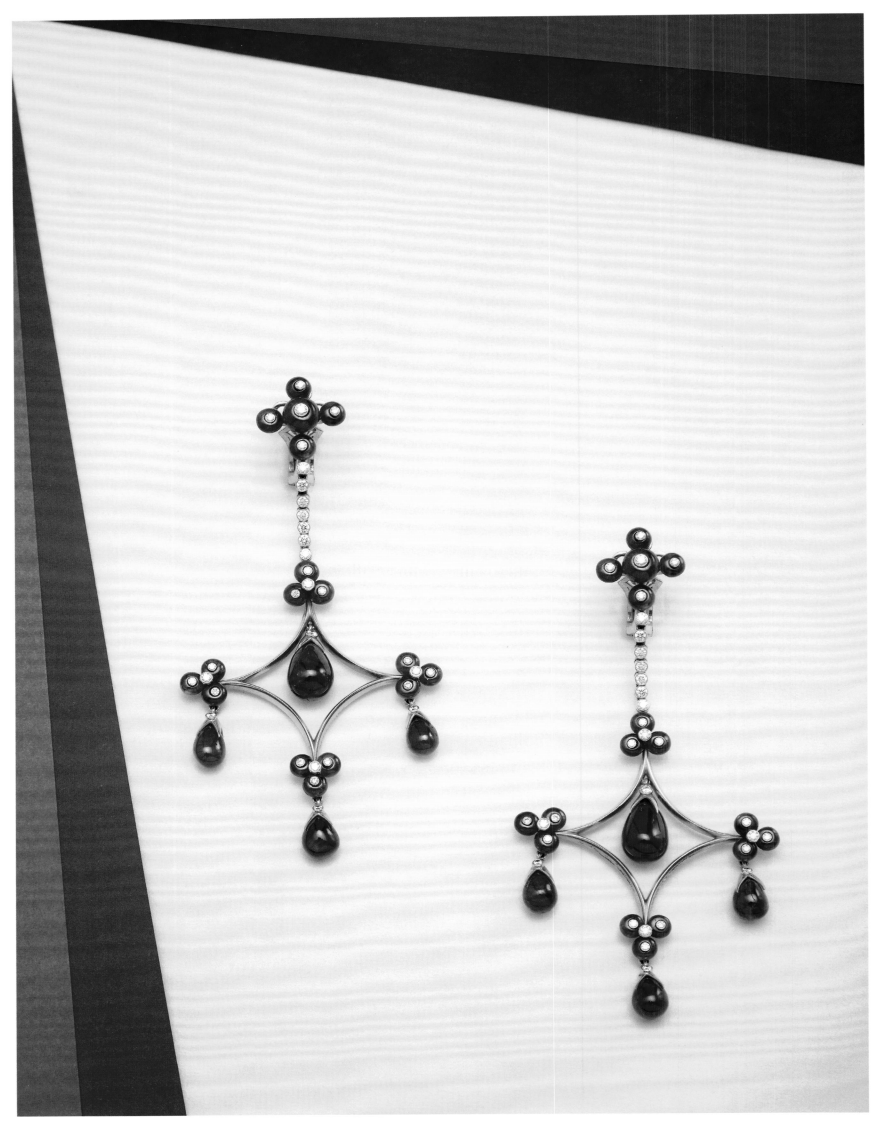

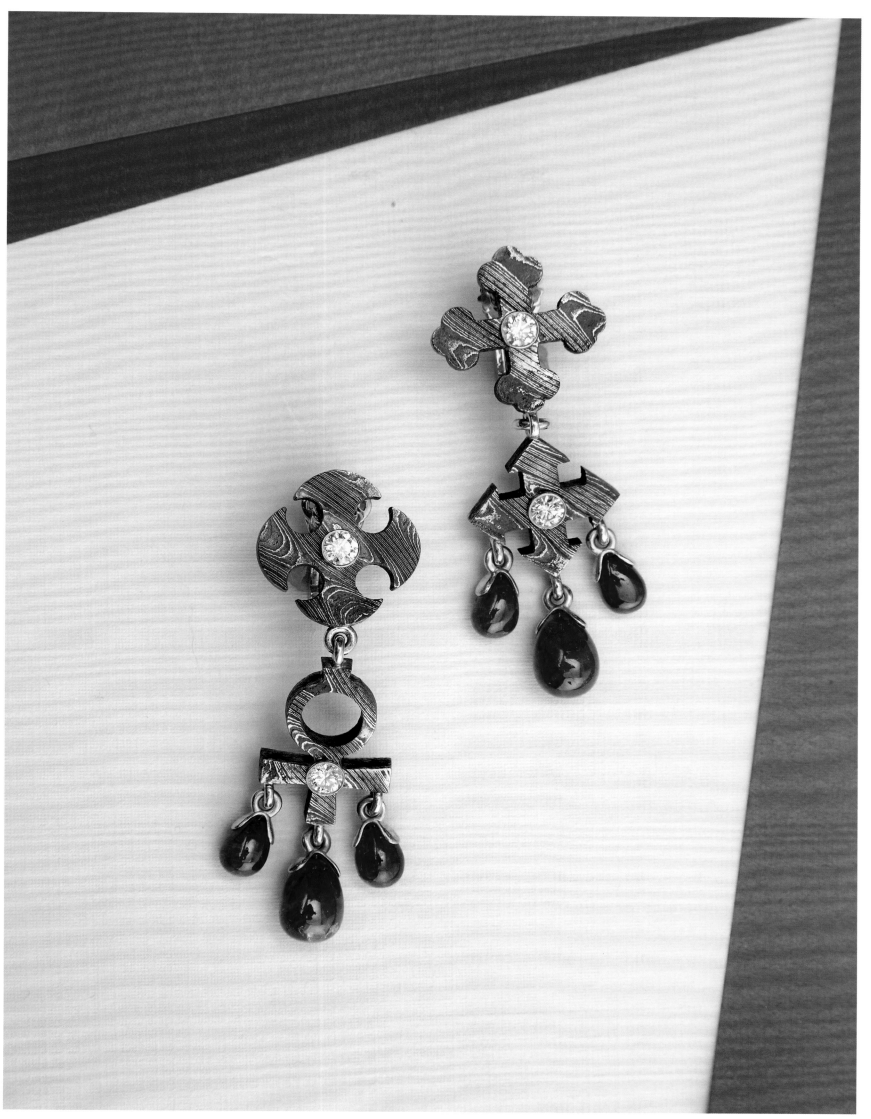

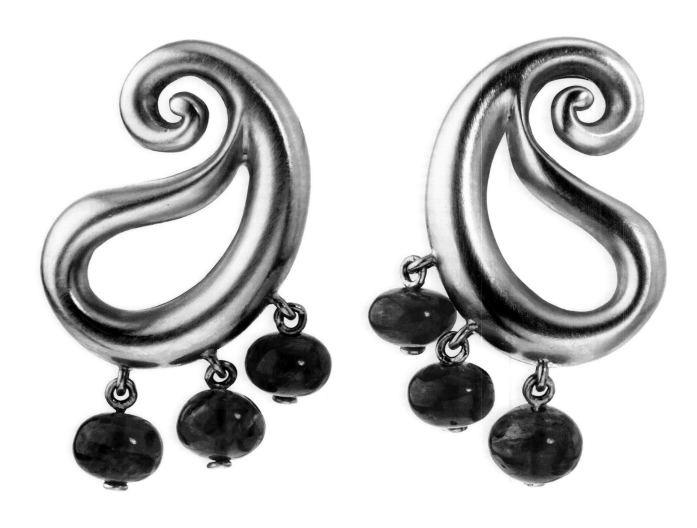

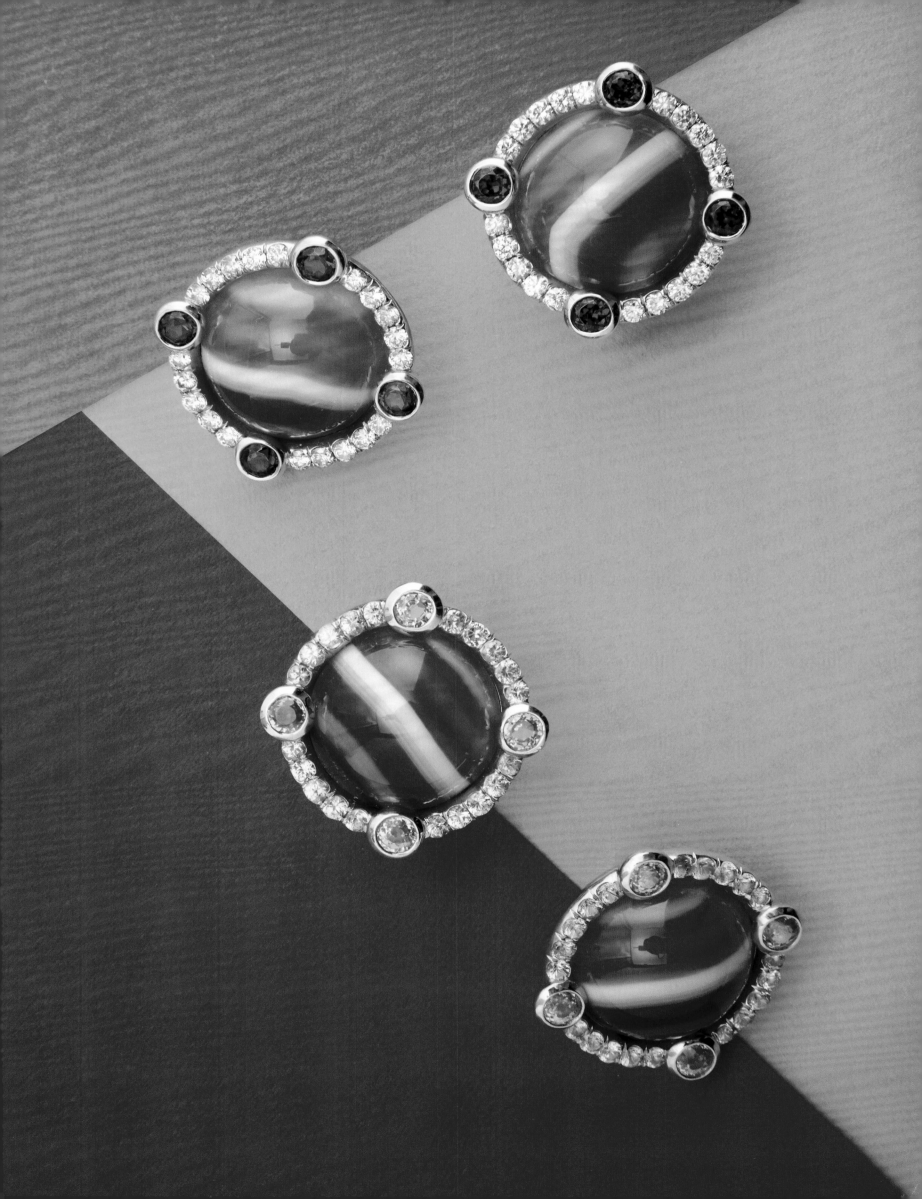

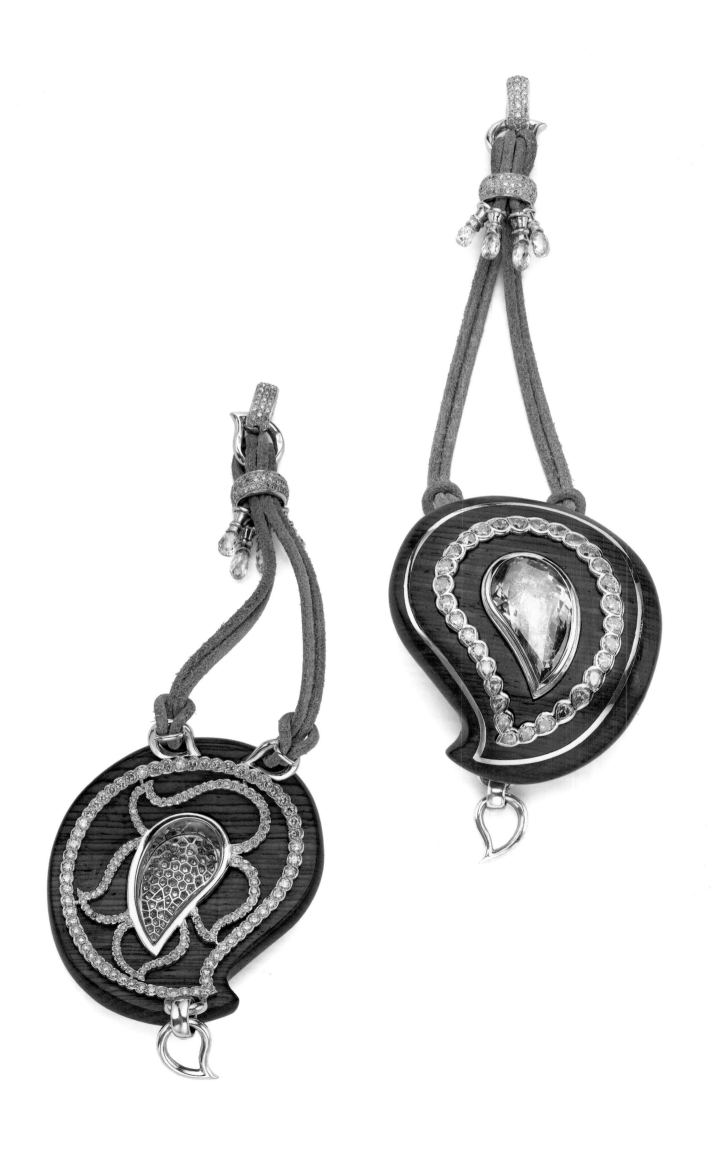

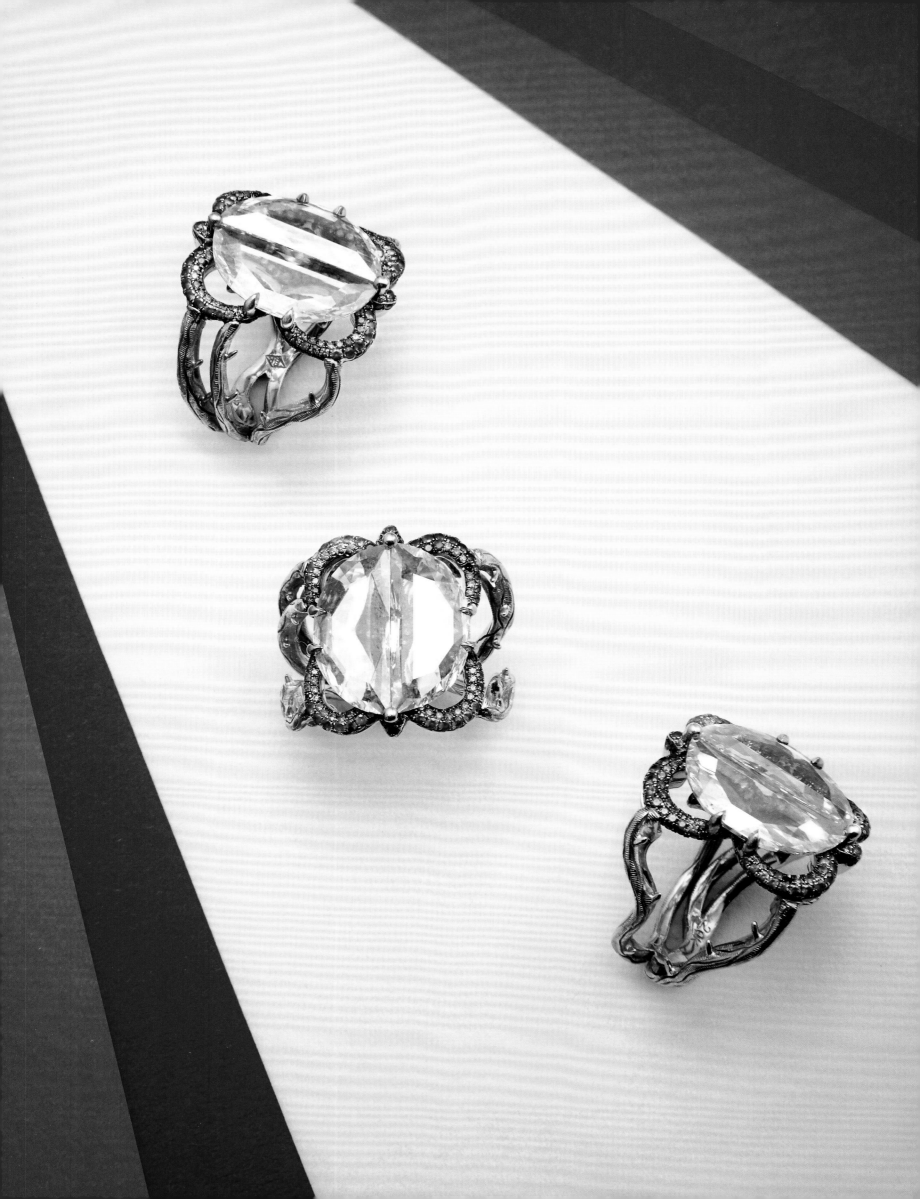

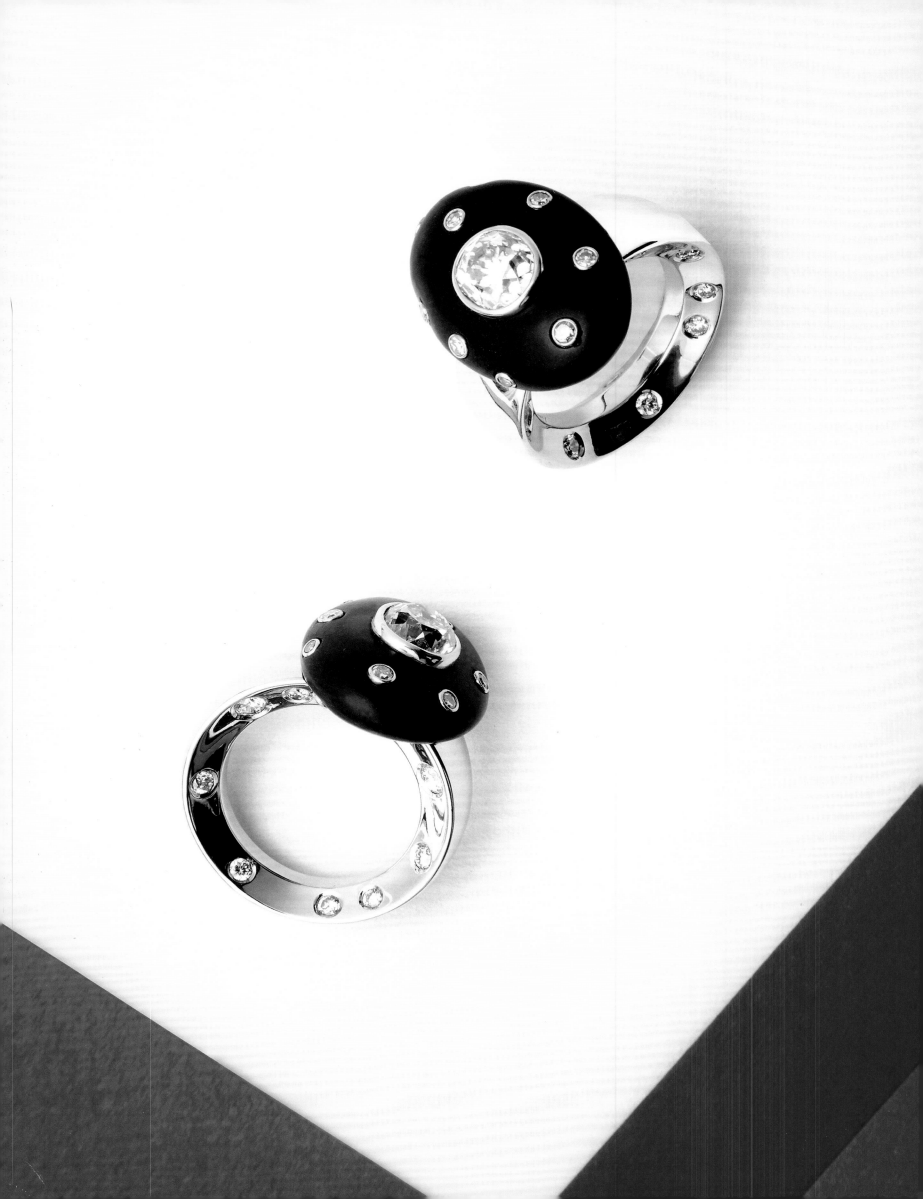

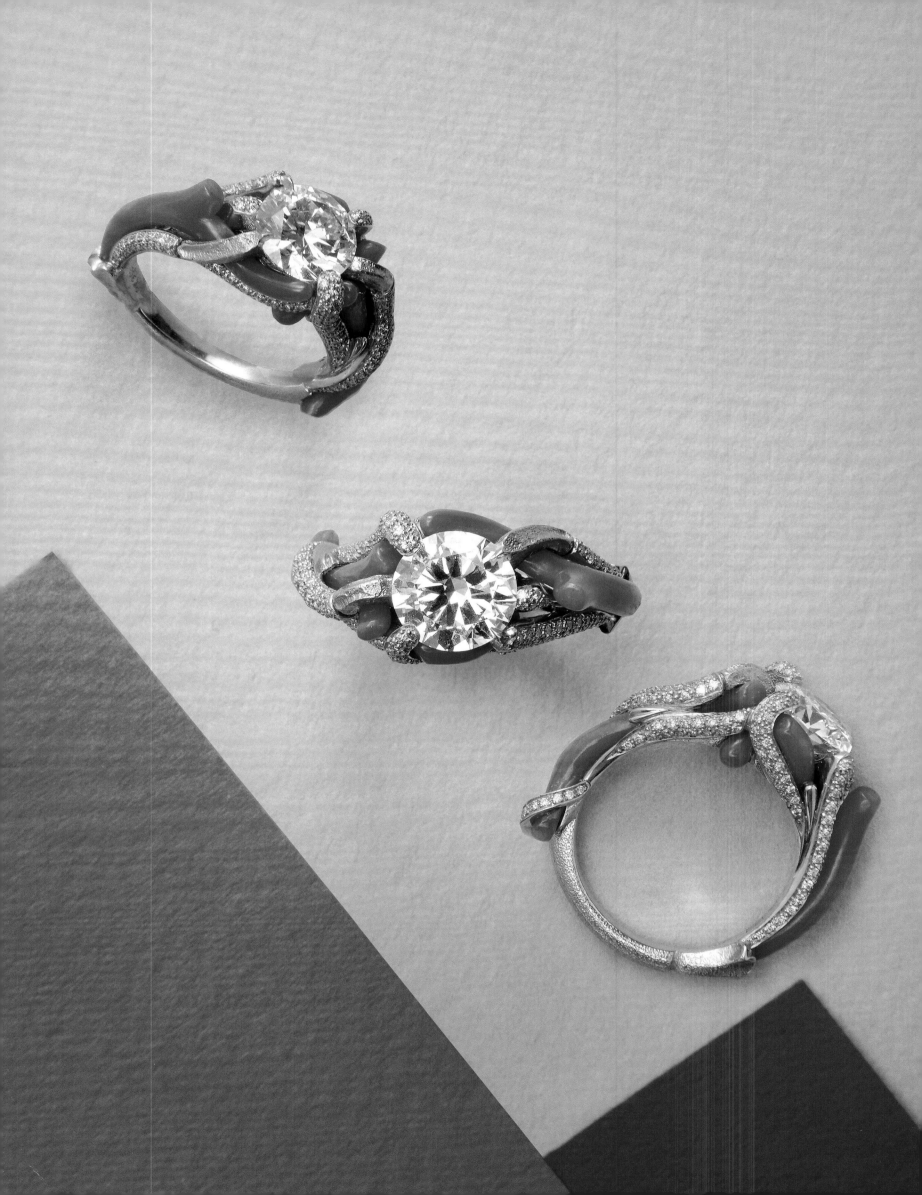

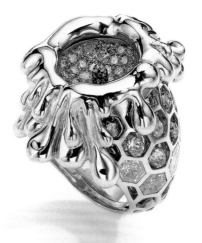

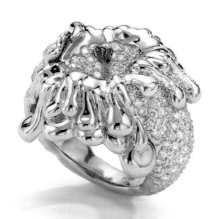

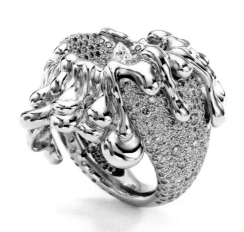

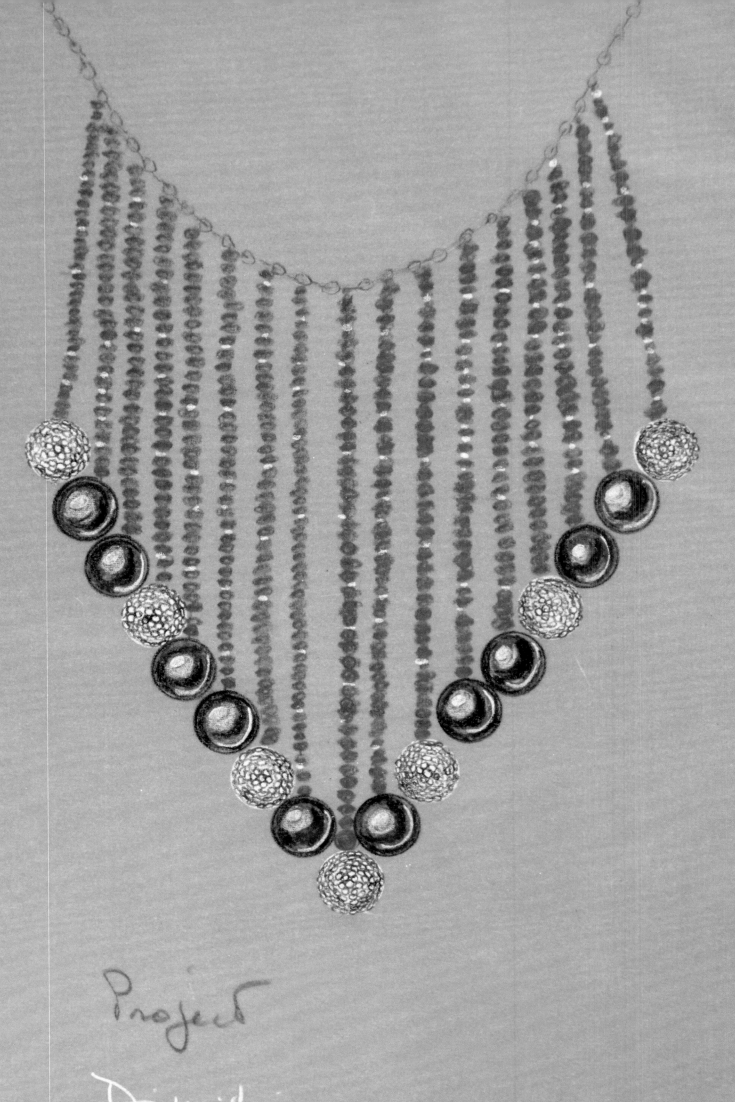

Project

Dimitri

2-13-13

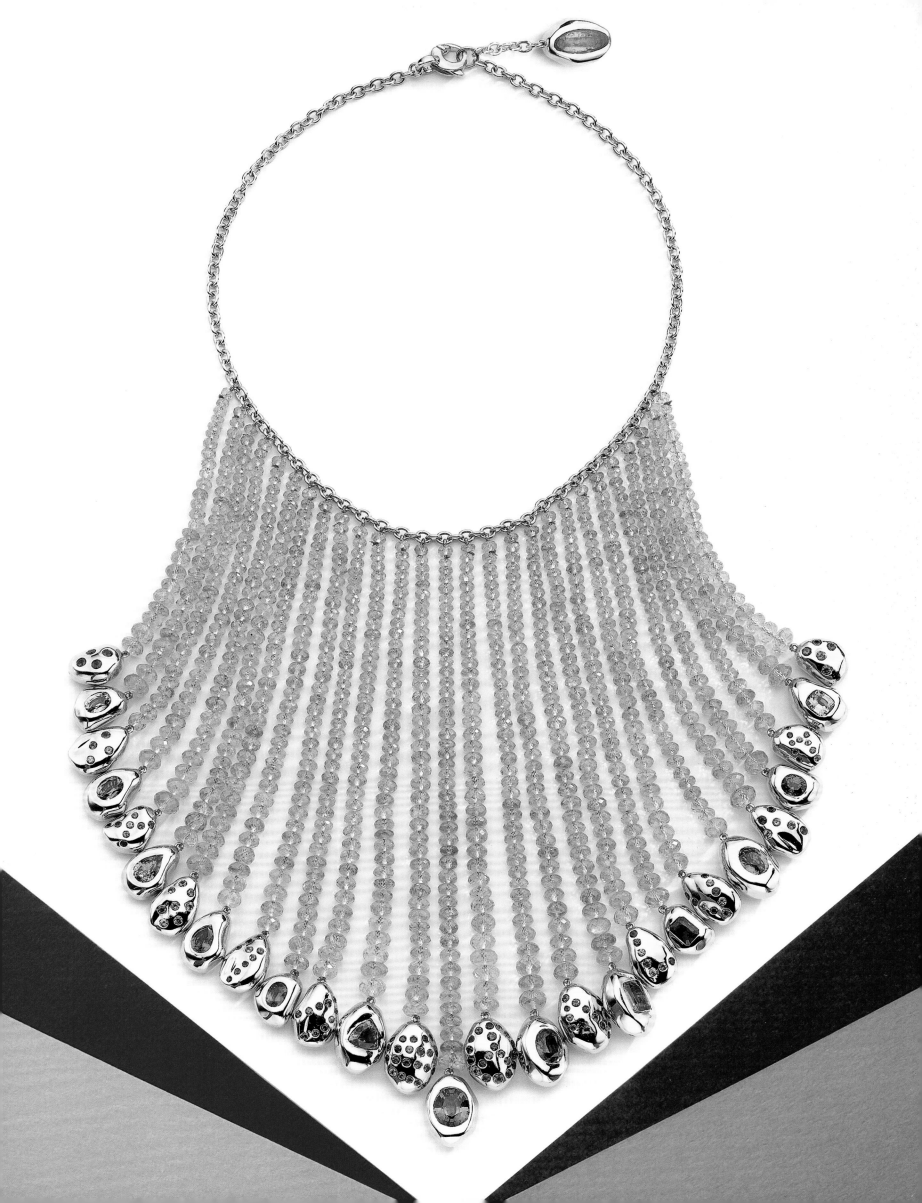

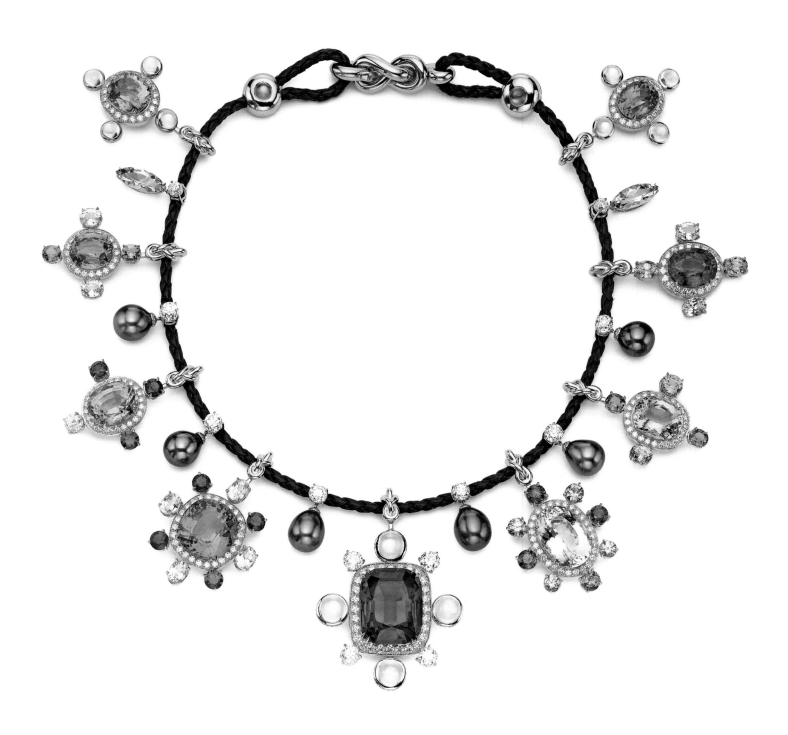

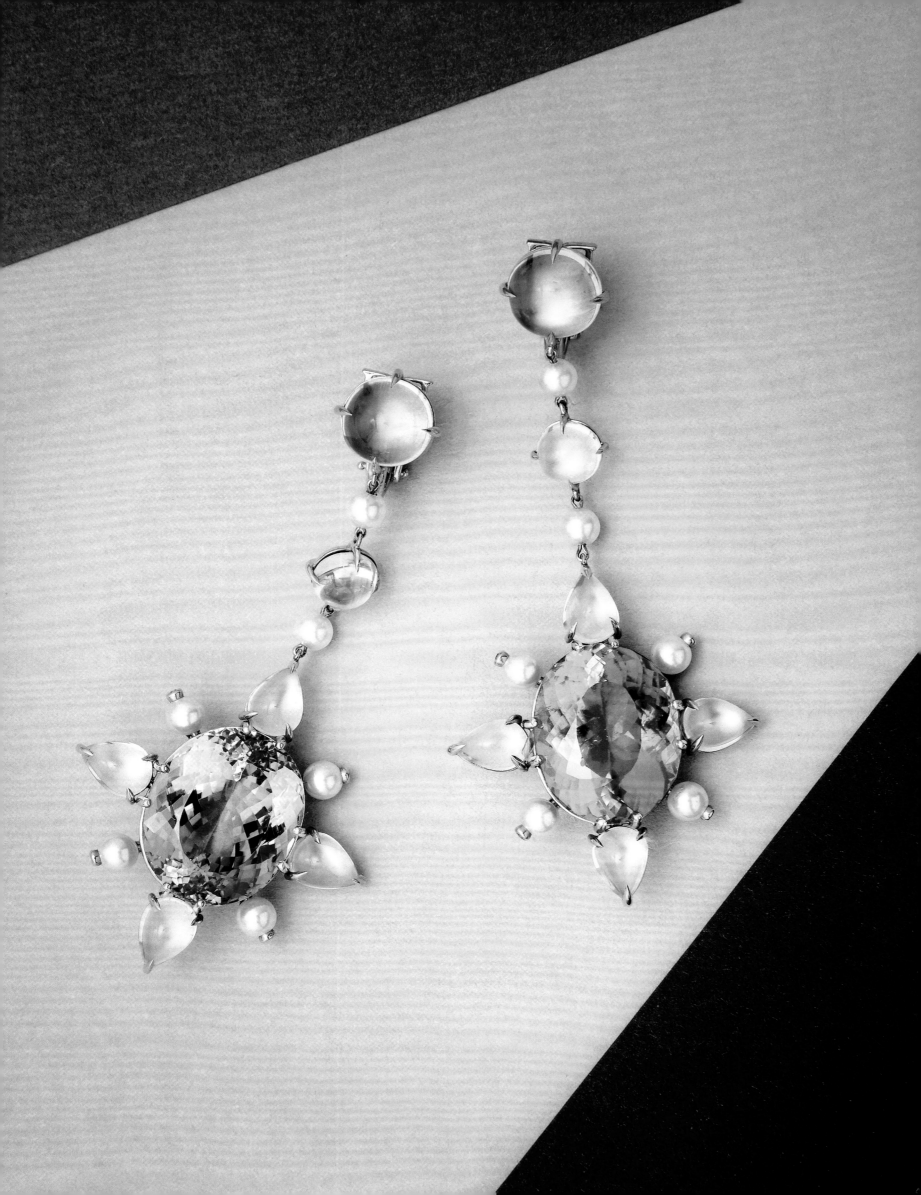

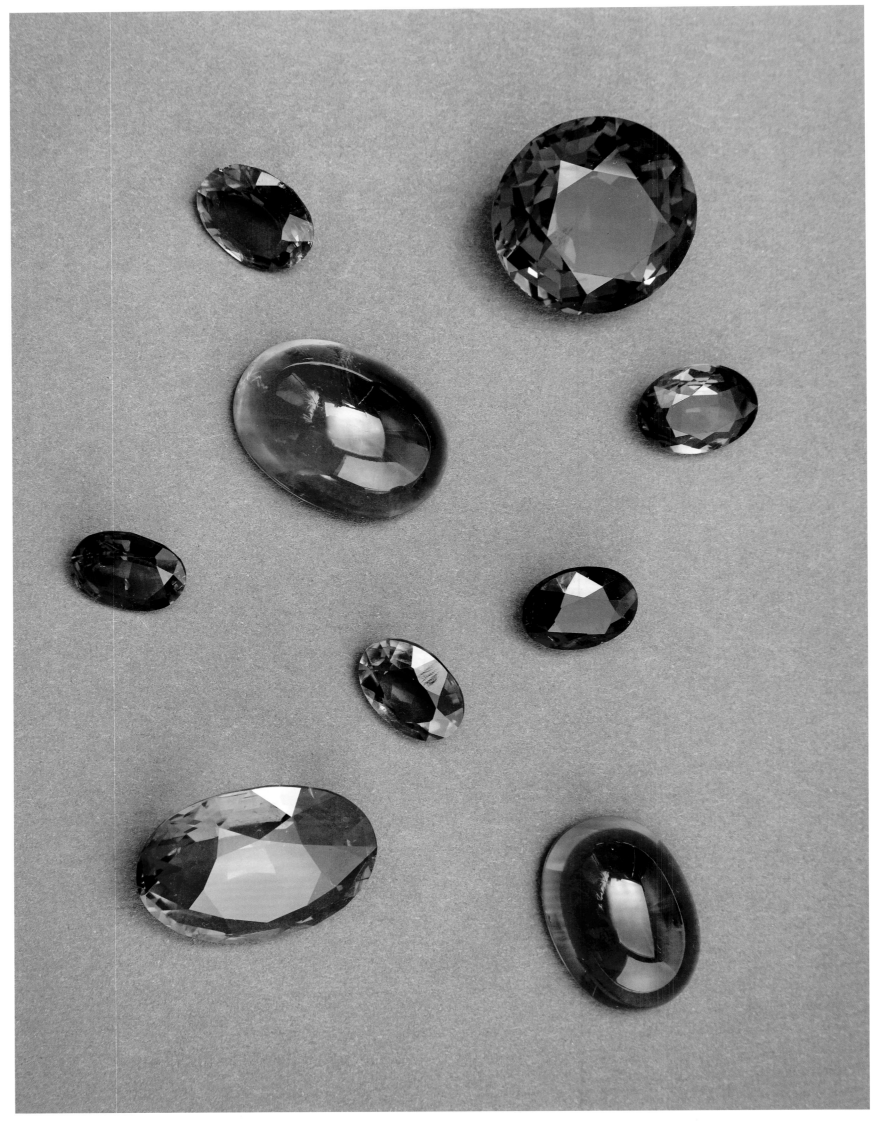

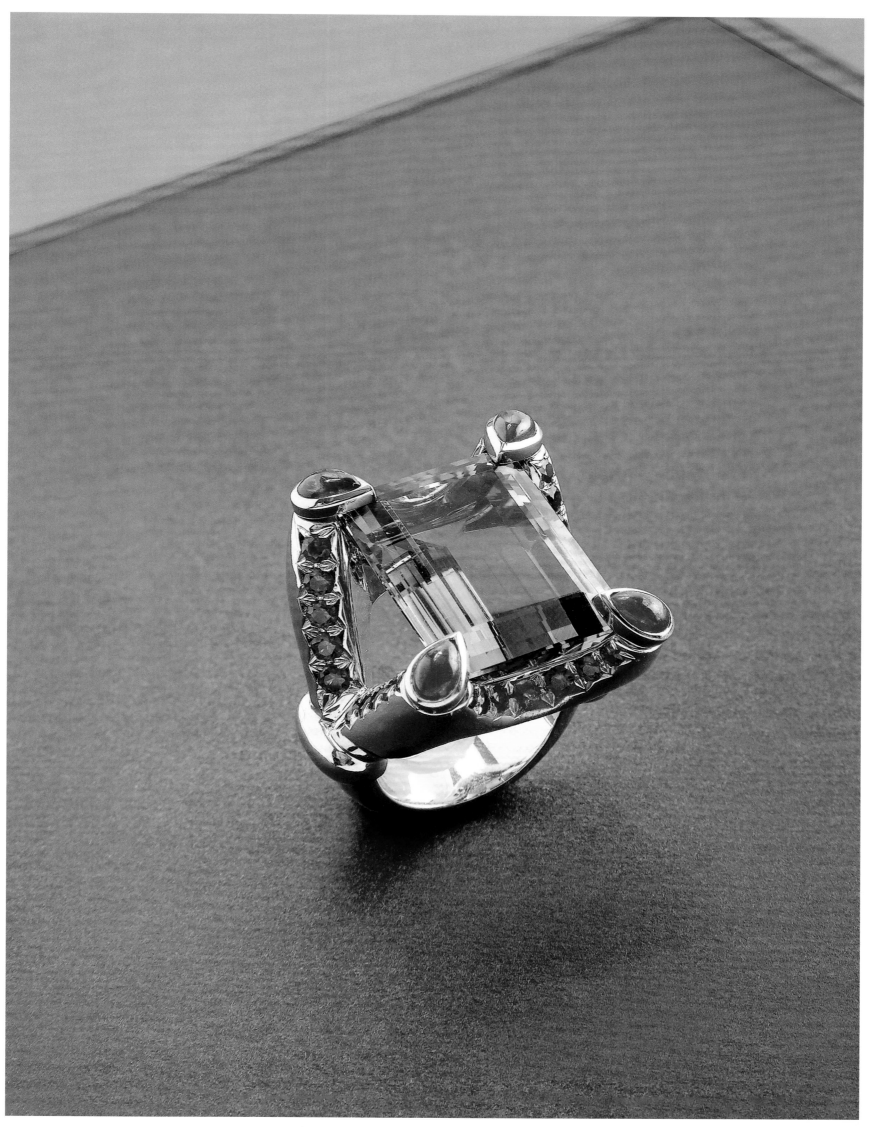

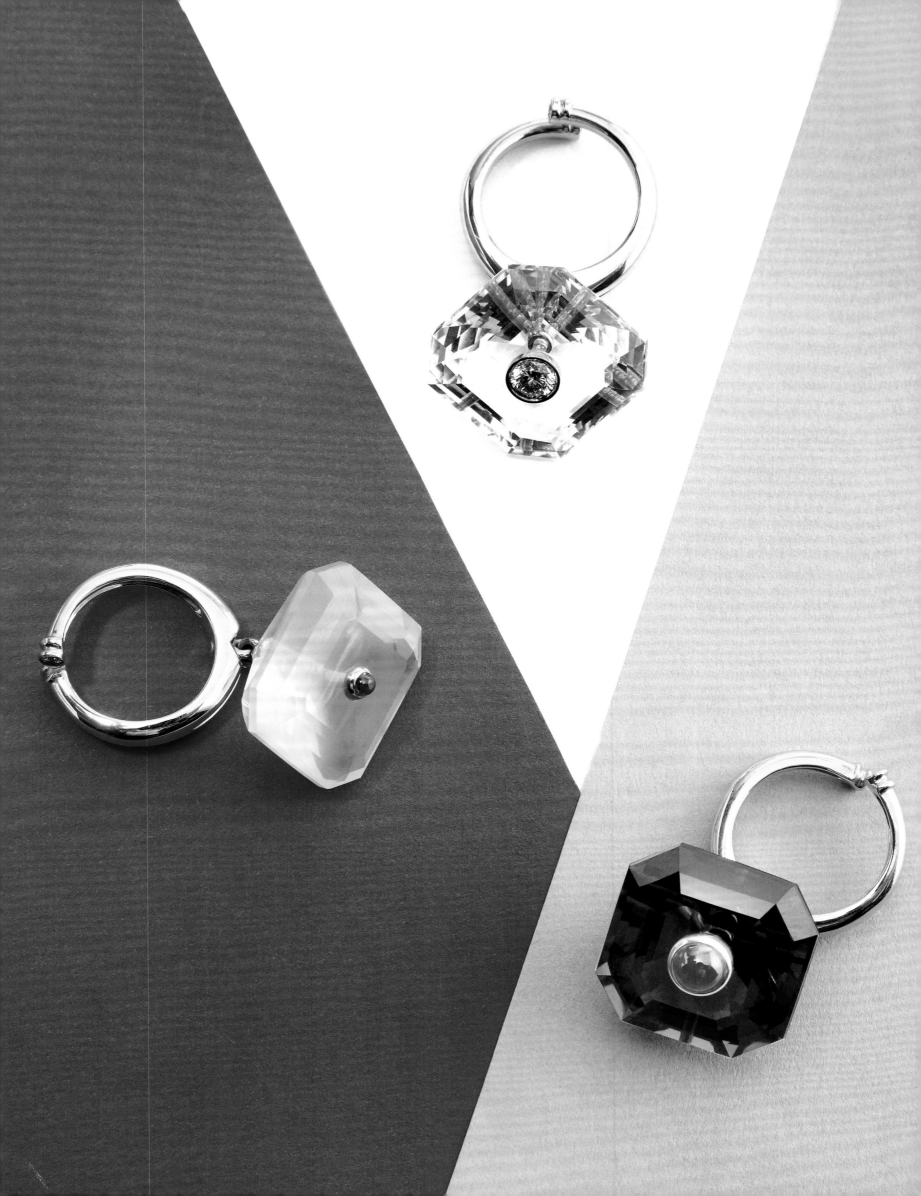

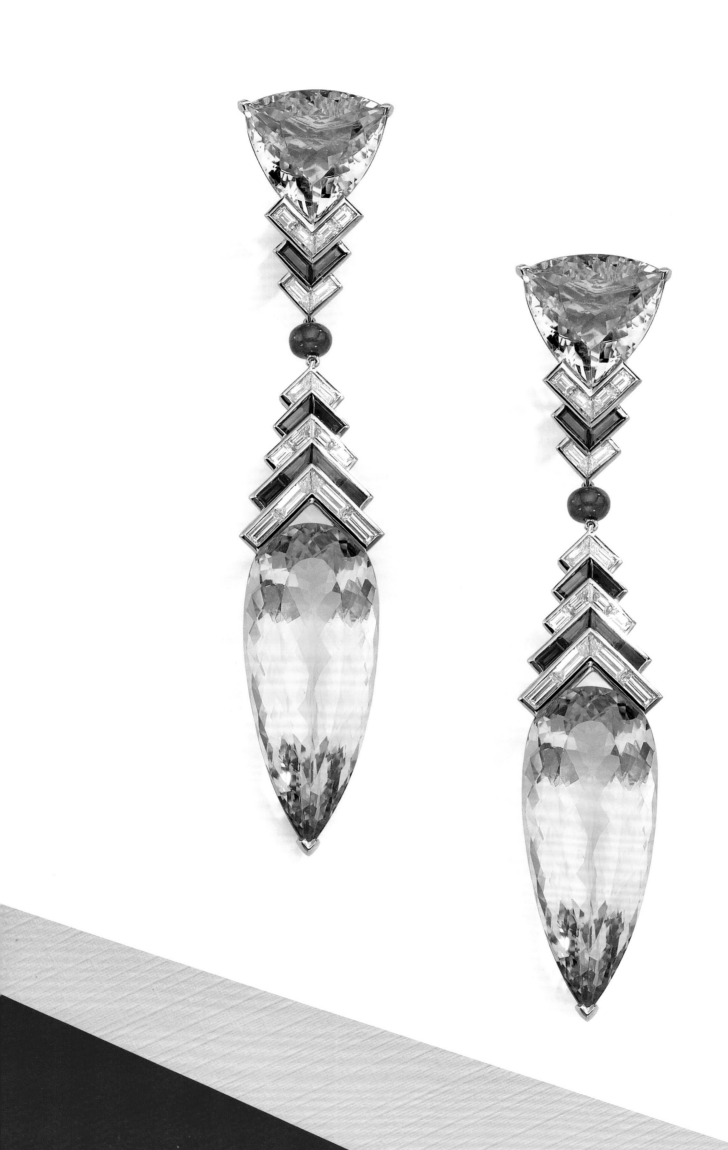

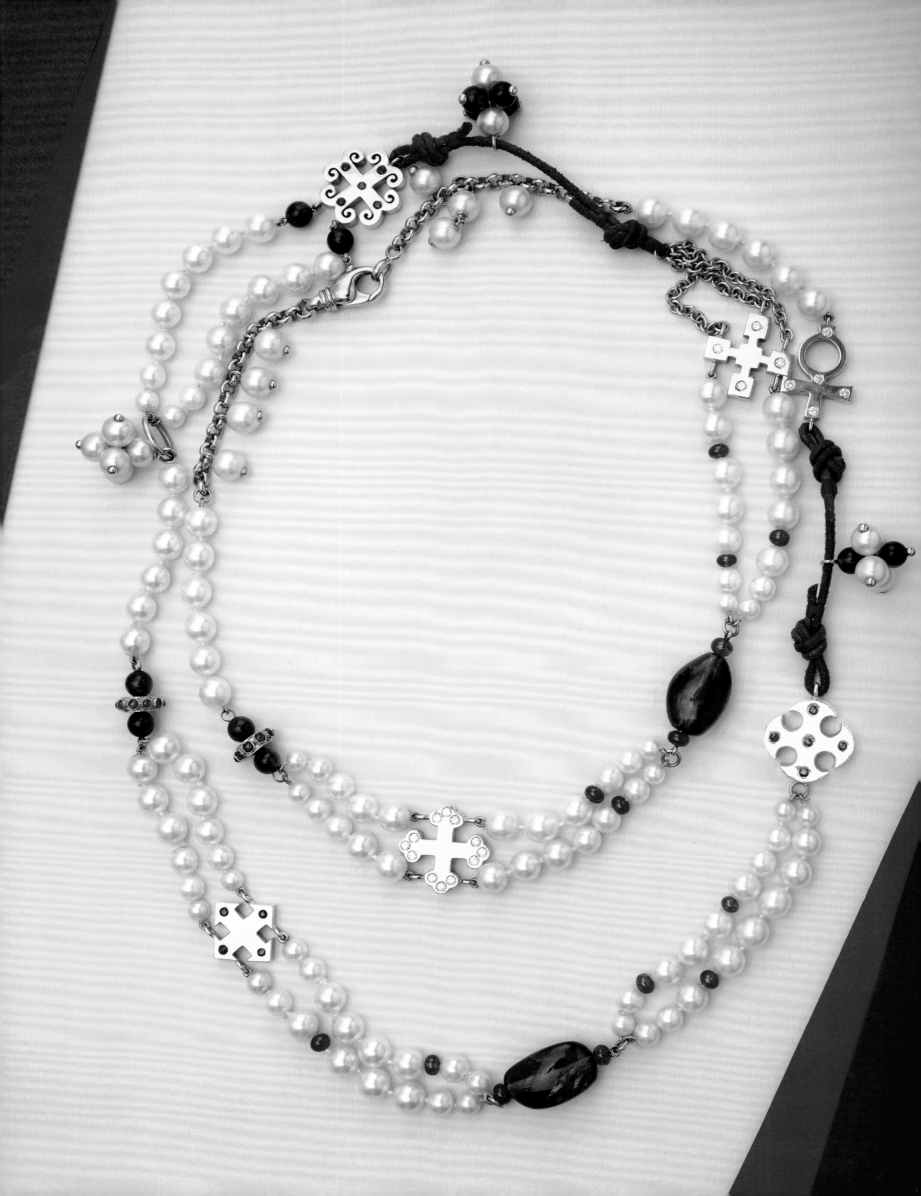

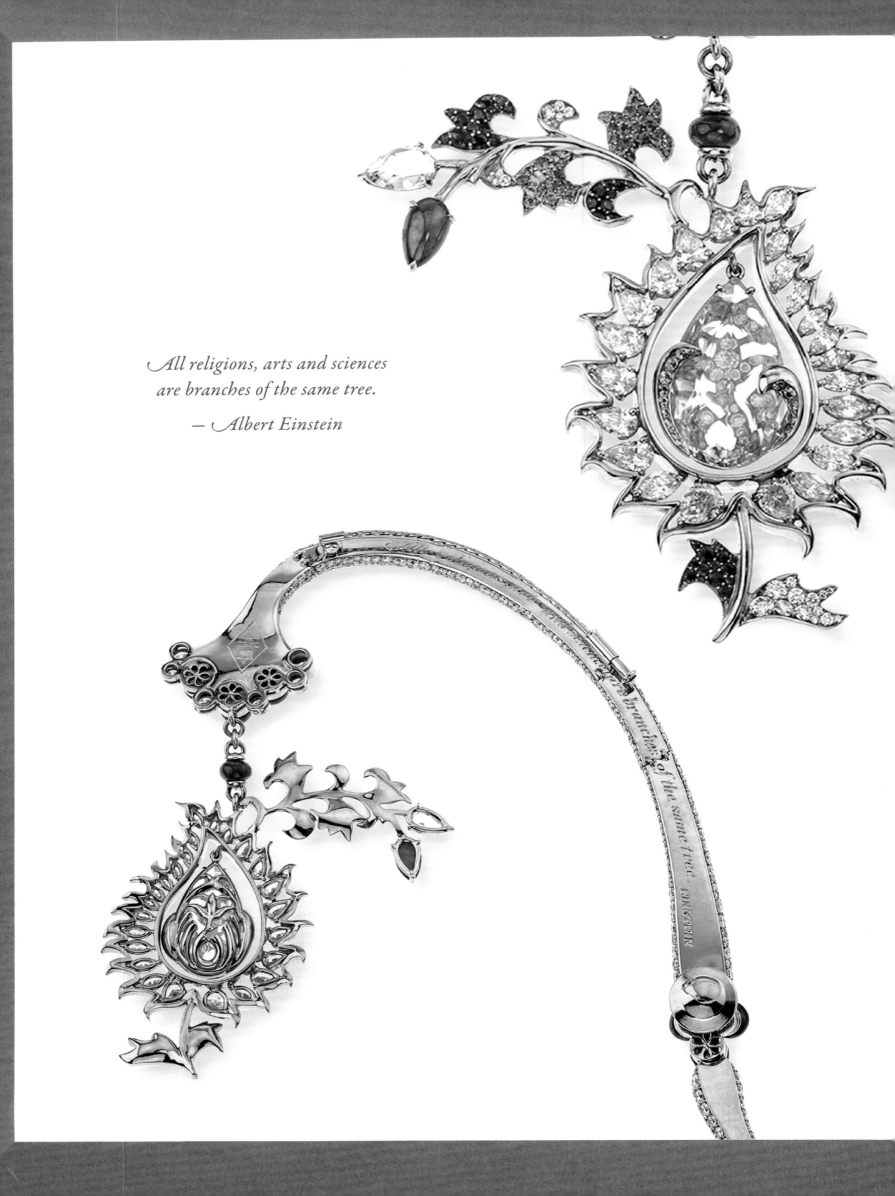

*All religions, arts and sciences
are branches of the same tree.*

— Albert Einstein

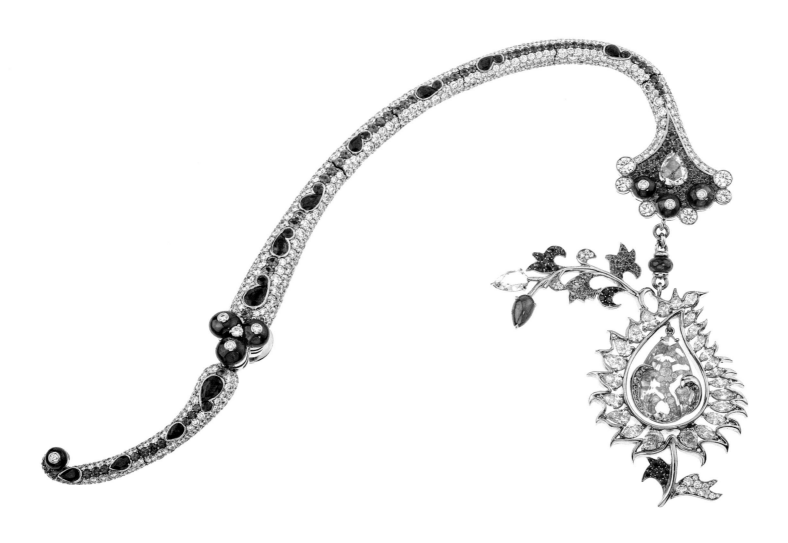

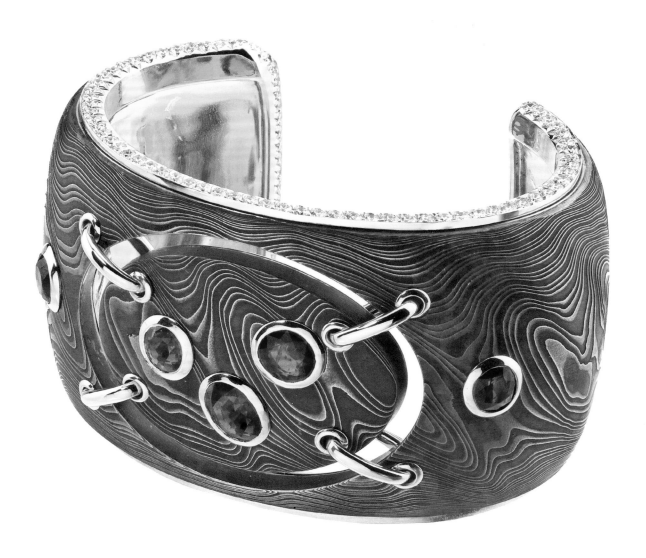

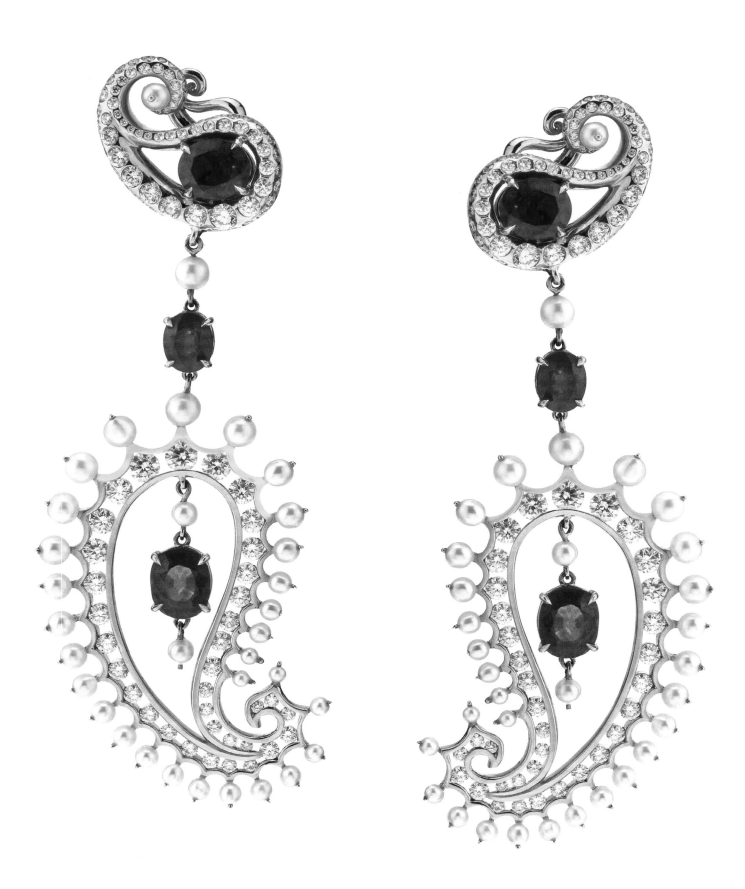

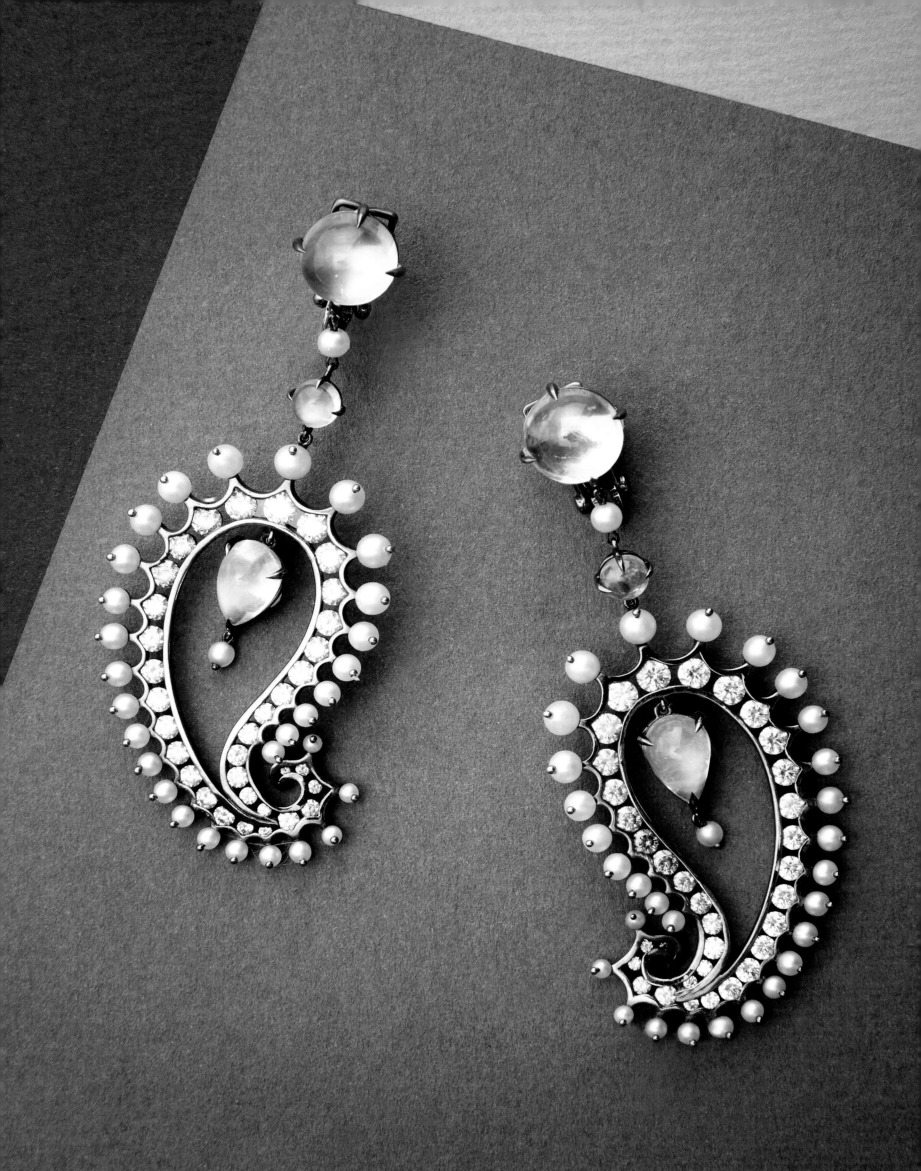

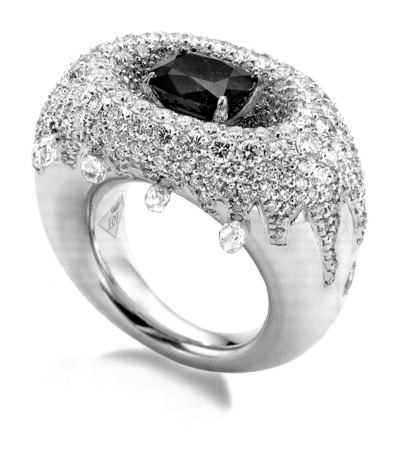

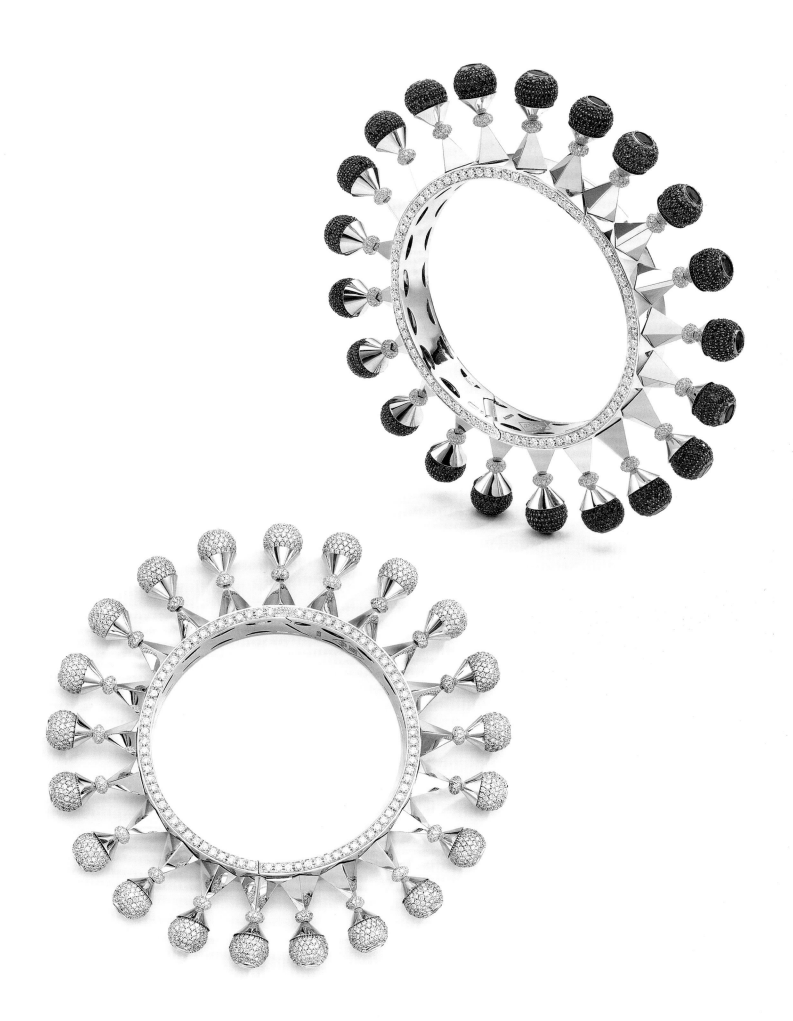

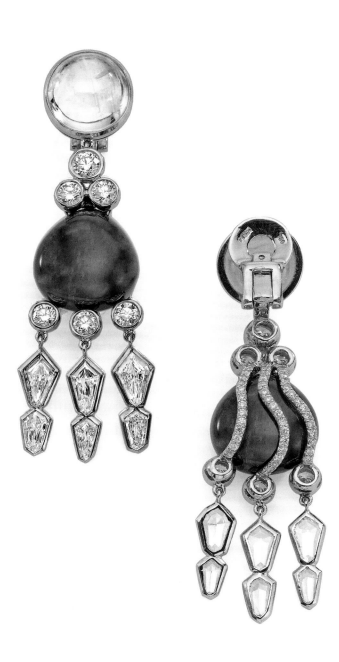

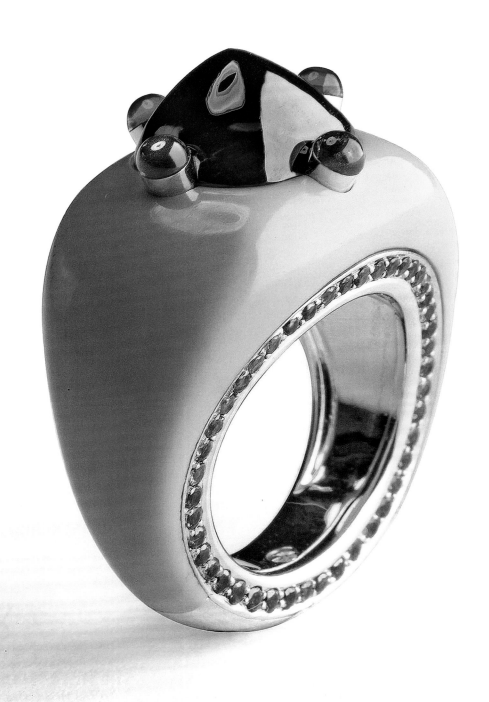

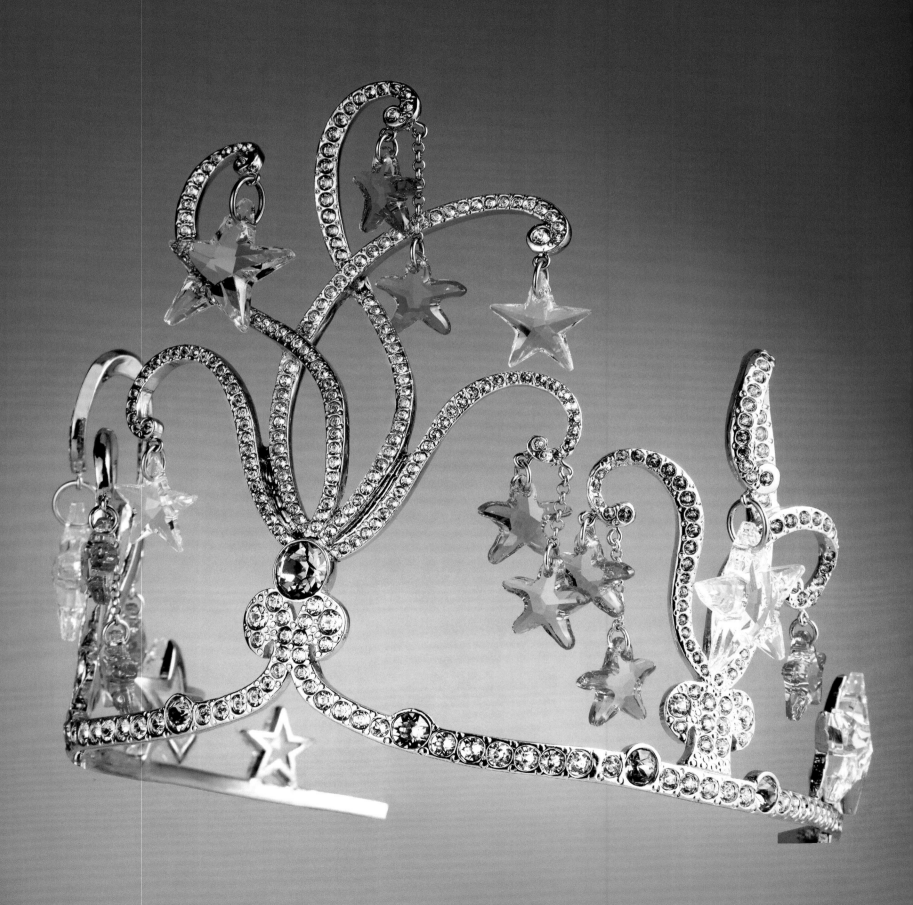

Dimite
10-31-12

All white and AB.

Dimitri

16 - 11

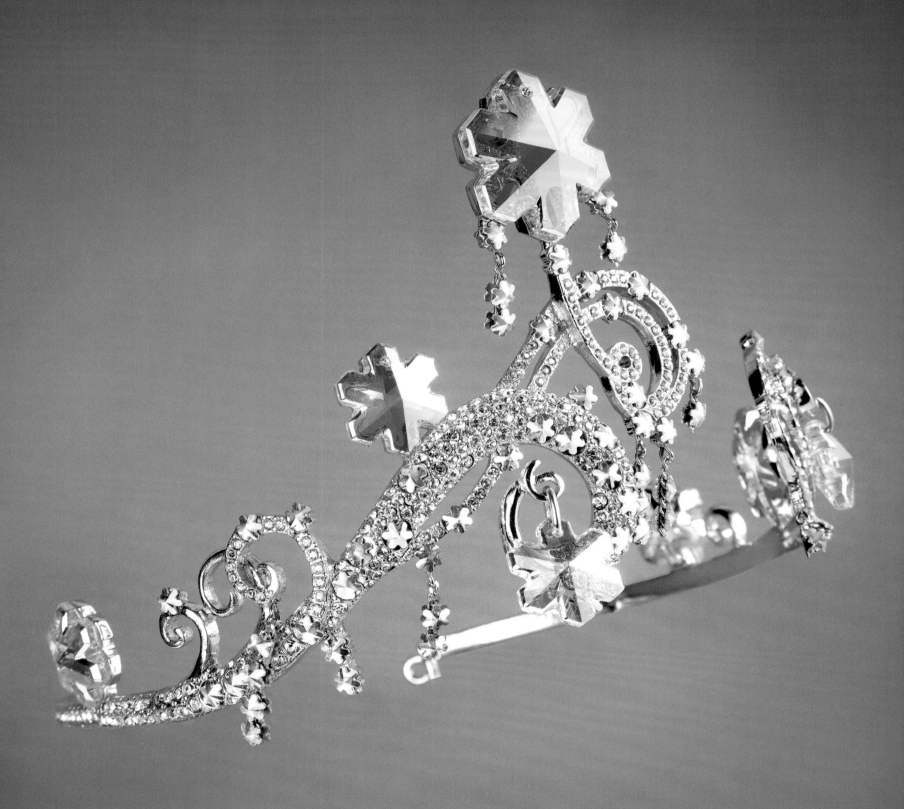

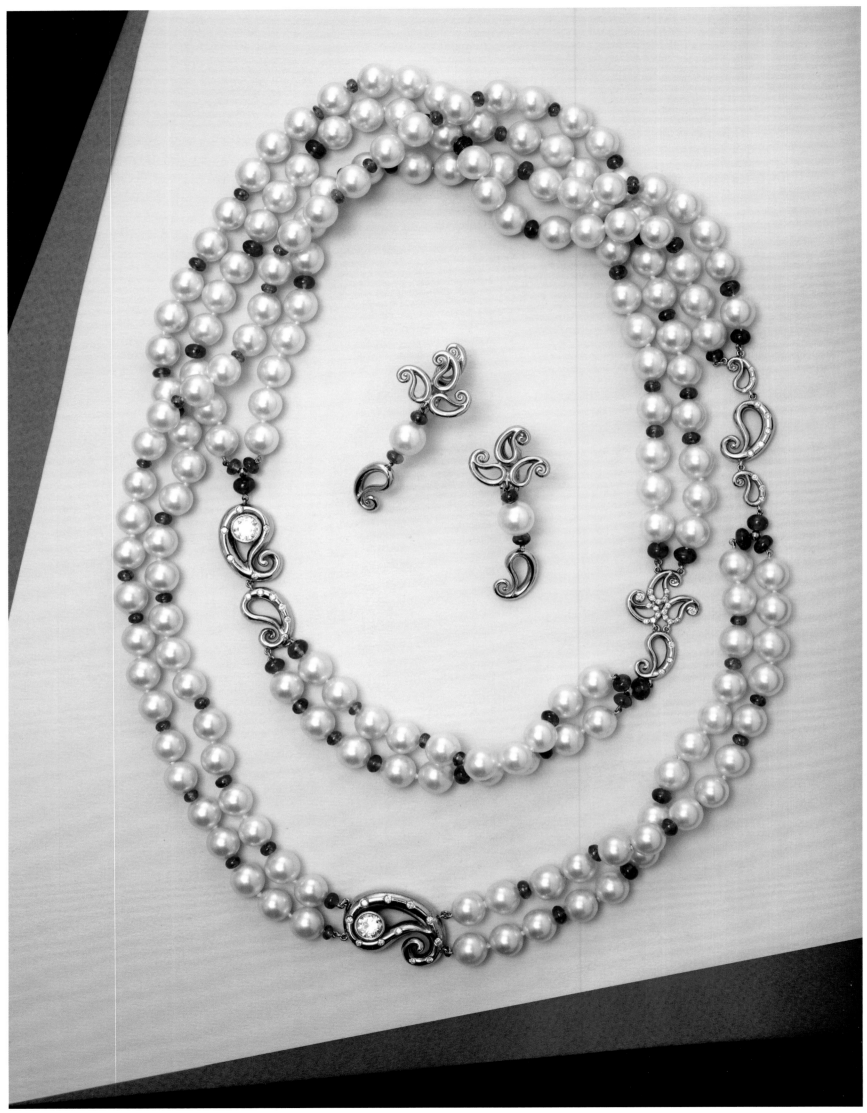

Dilmuti sept 7th 07

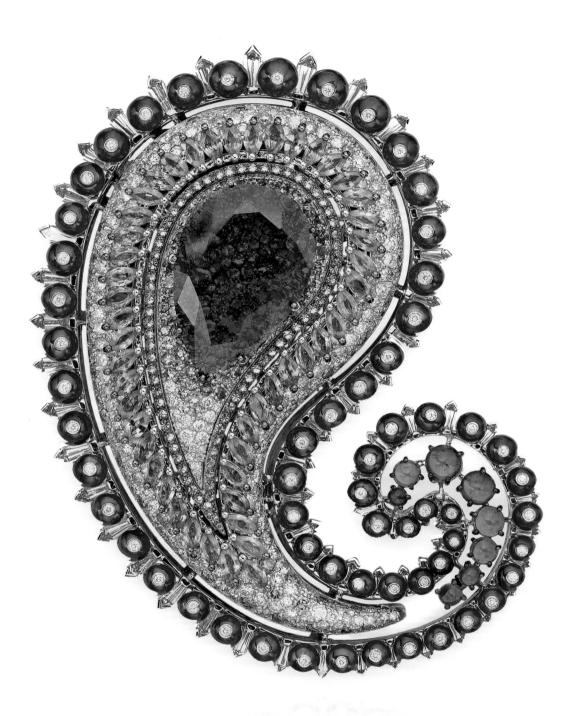

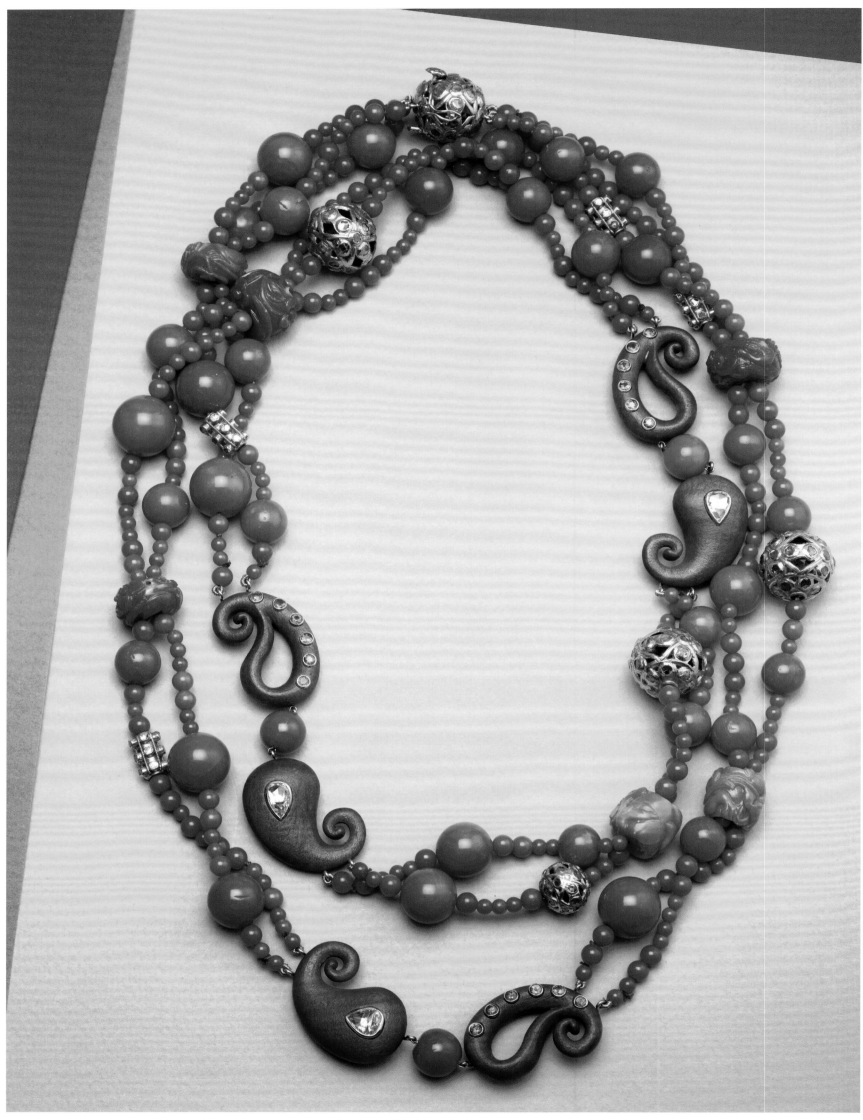

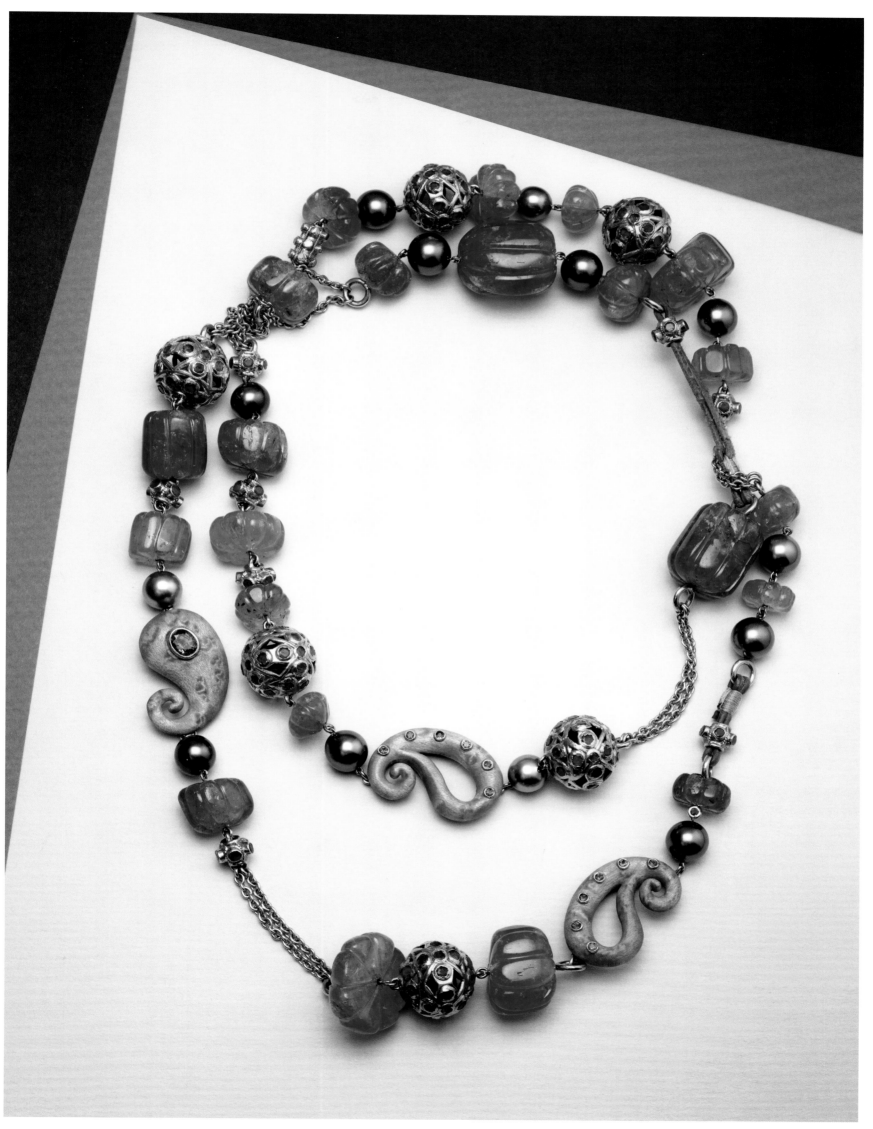

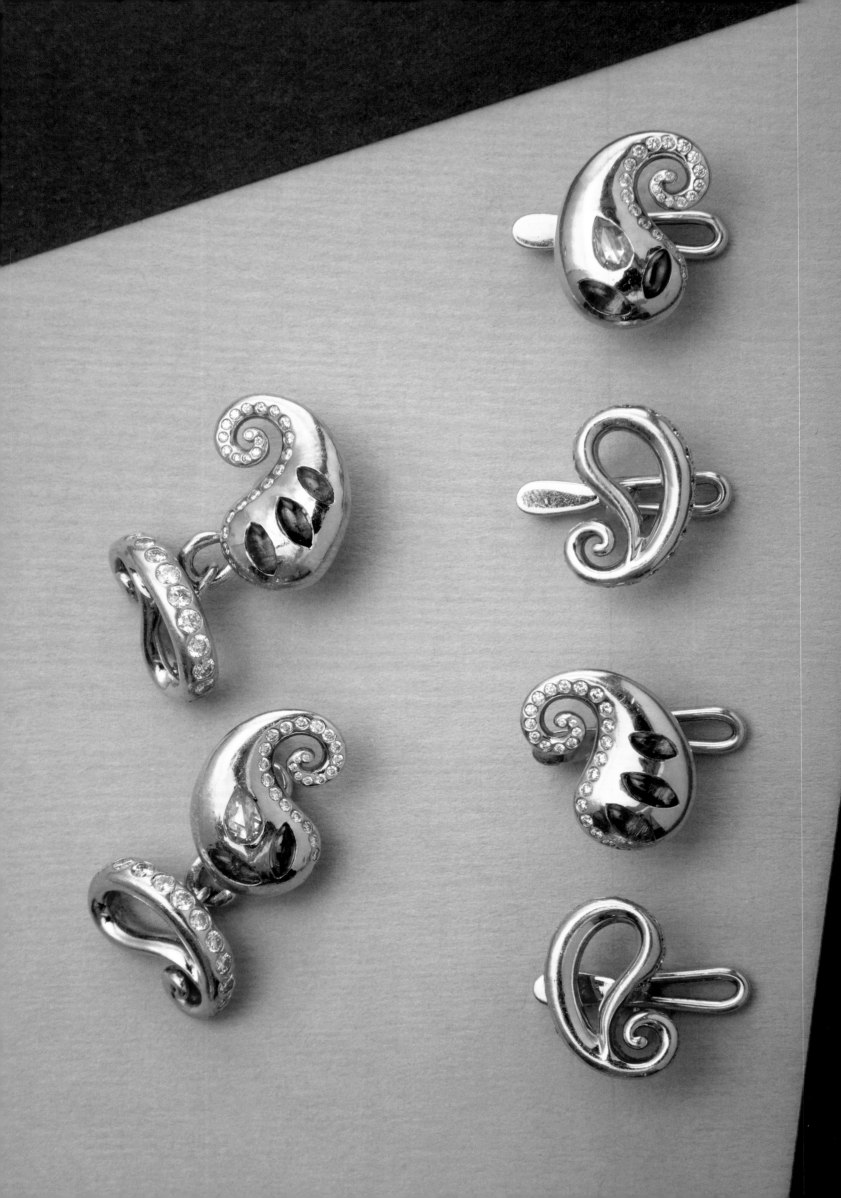

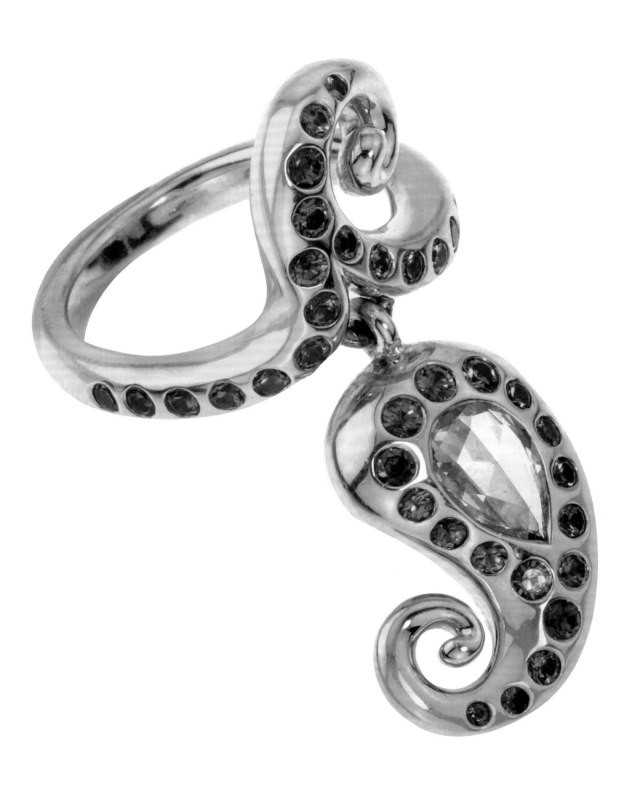

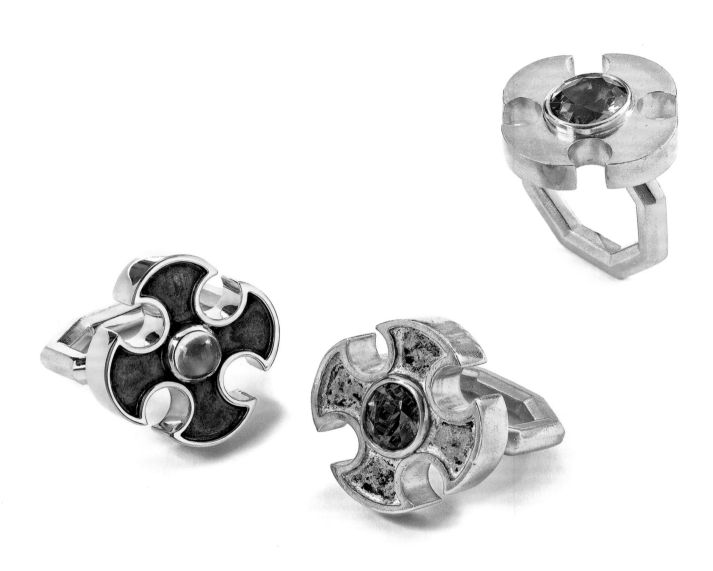

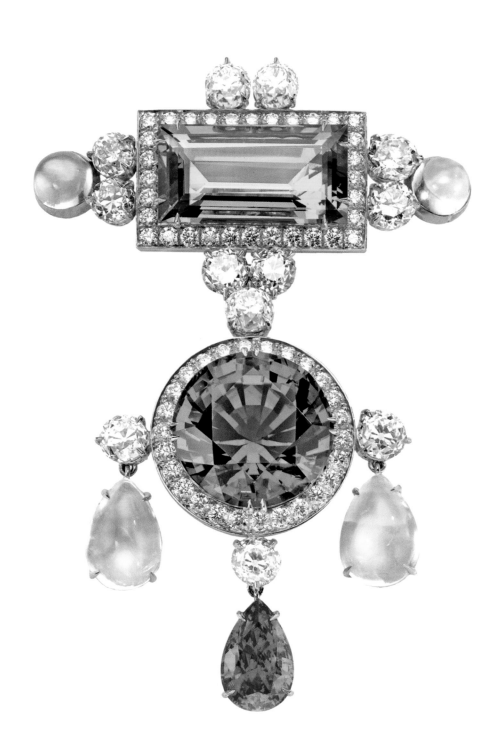

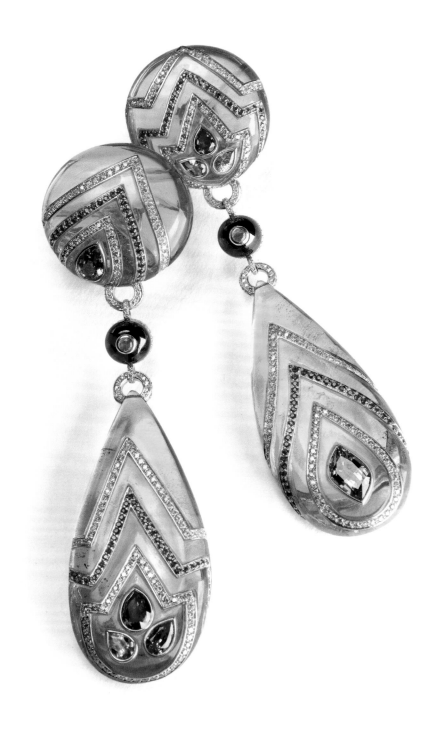

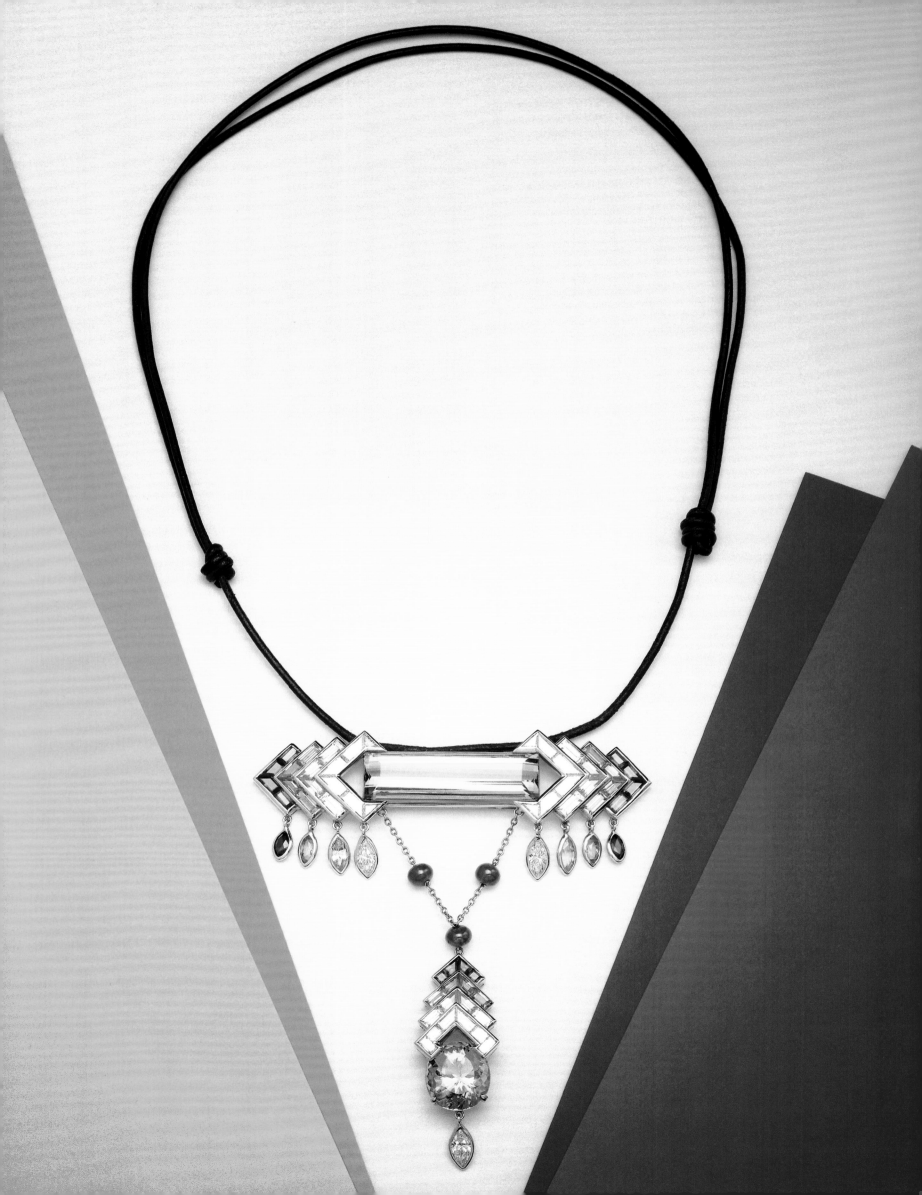

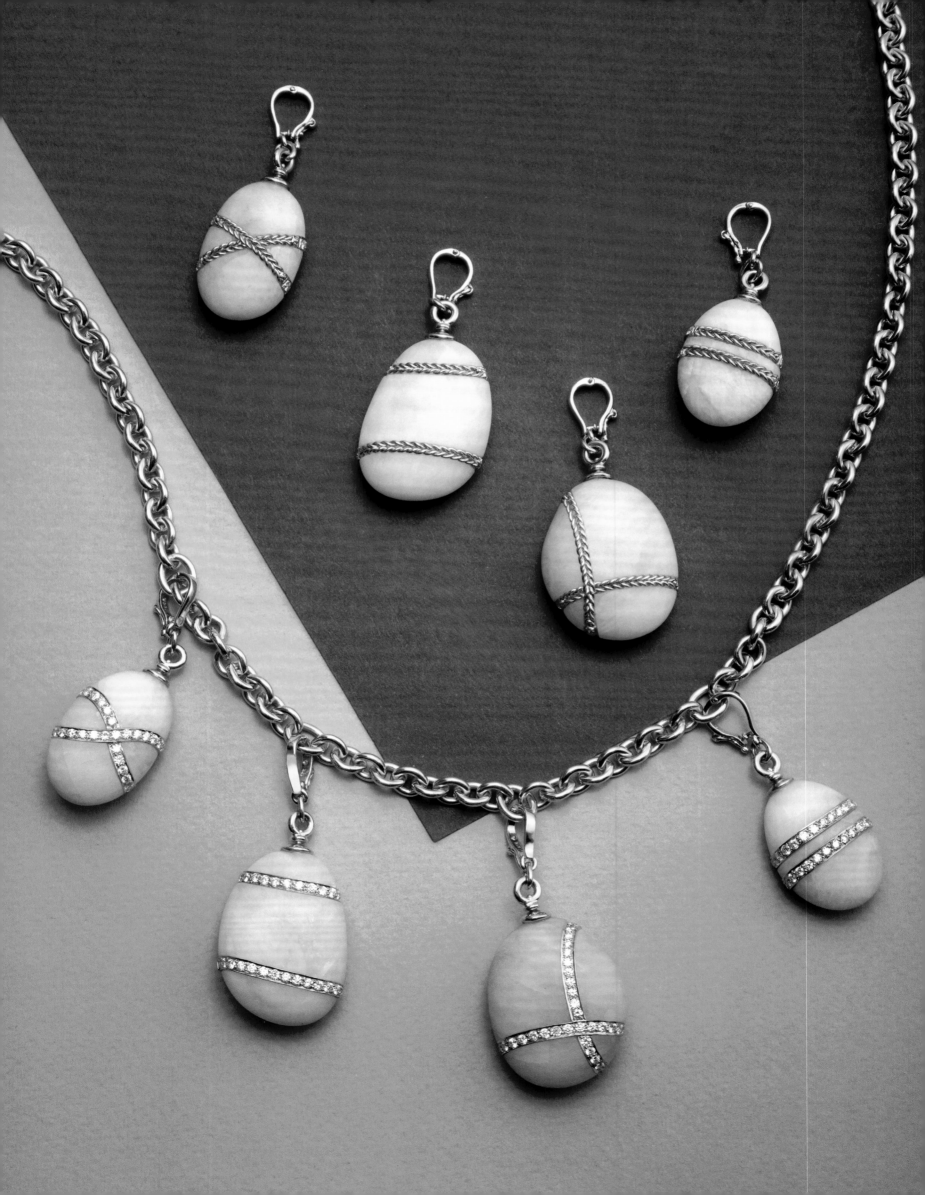

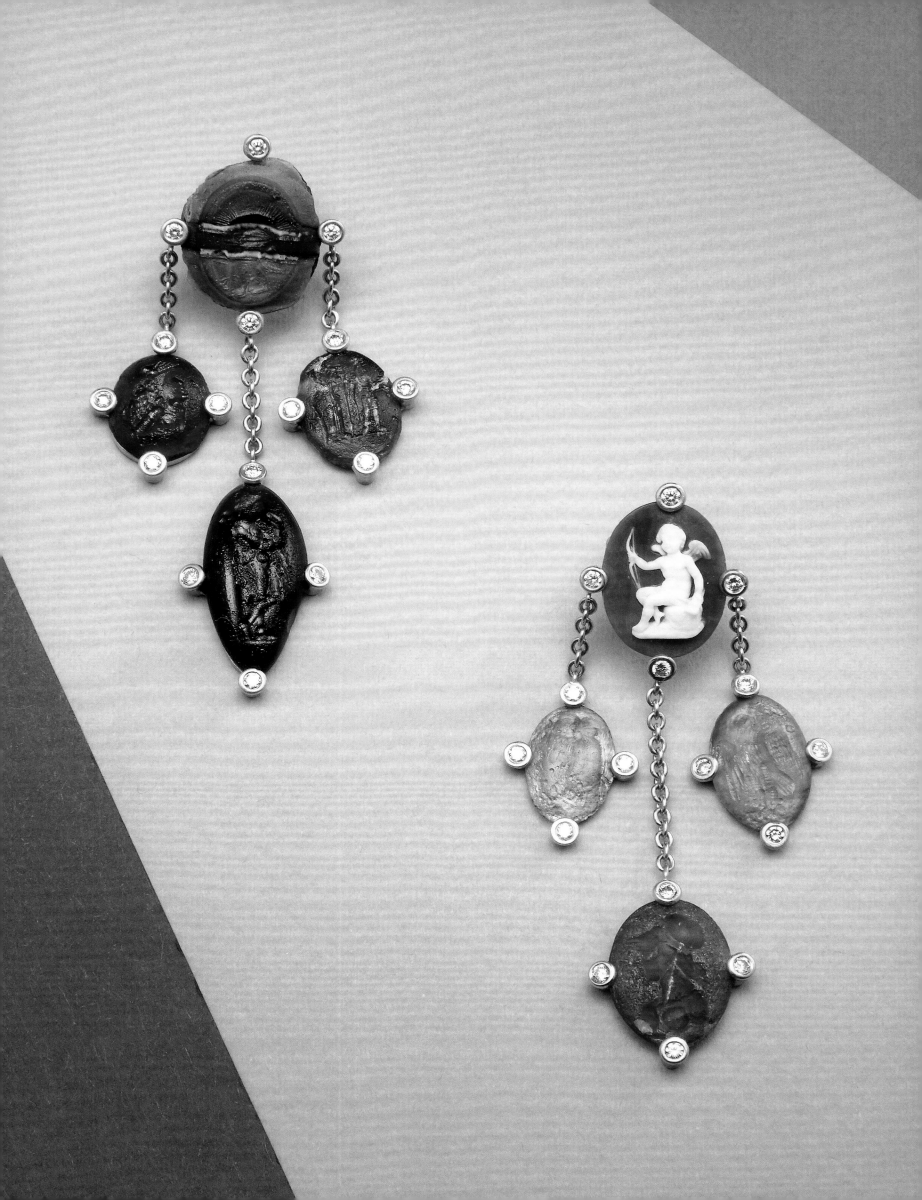

Dimitri

18 mai 2008

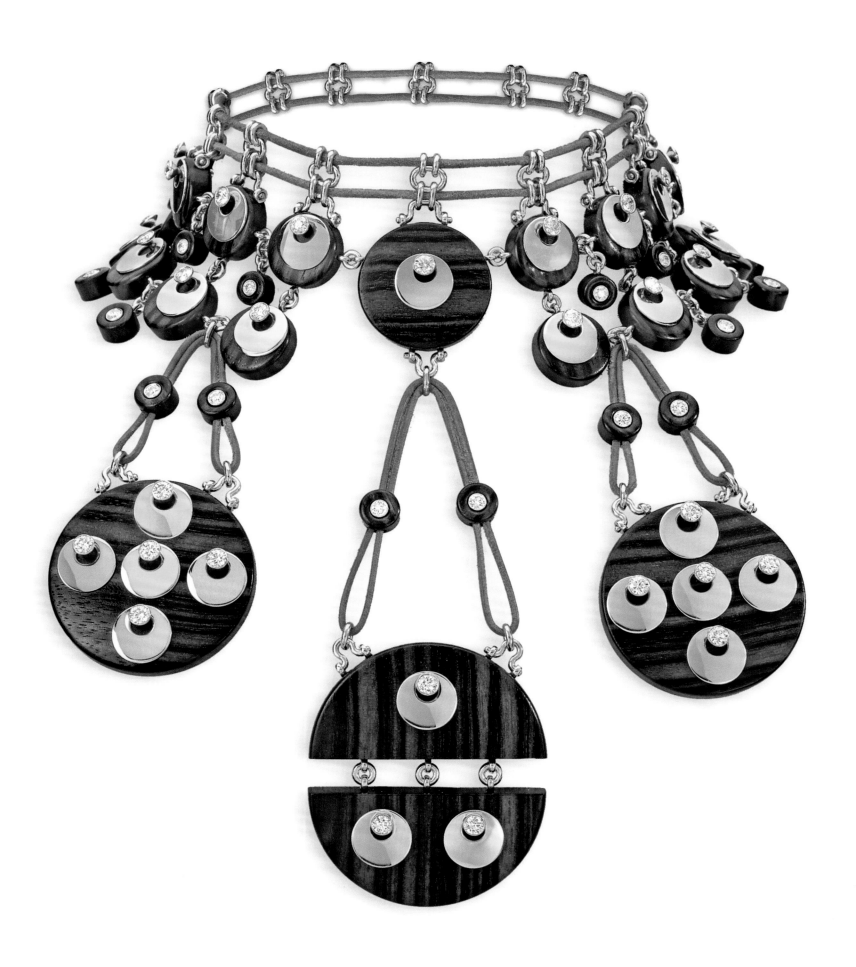

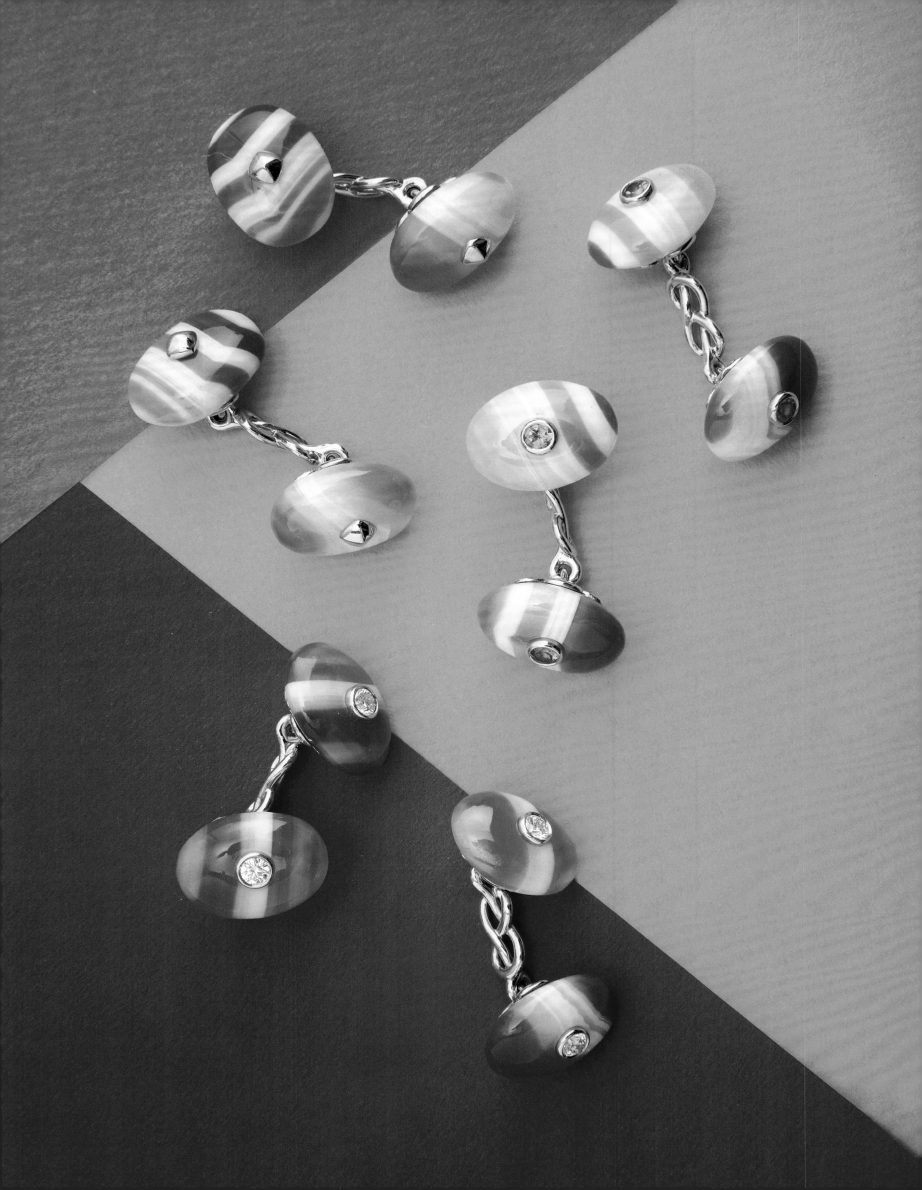

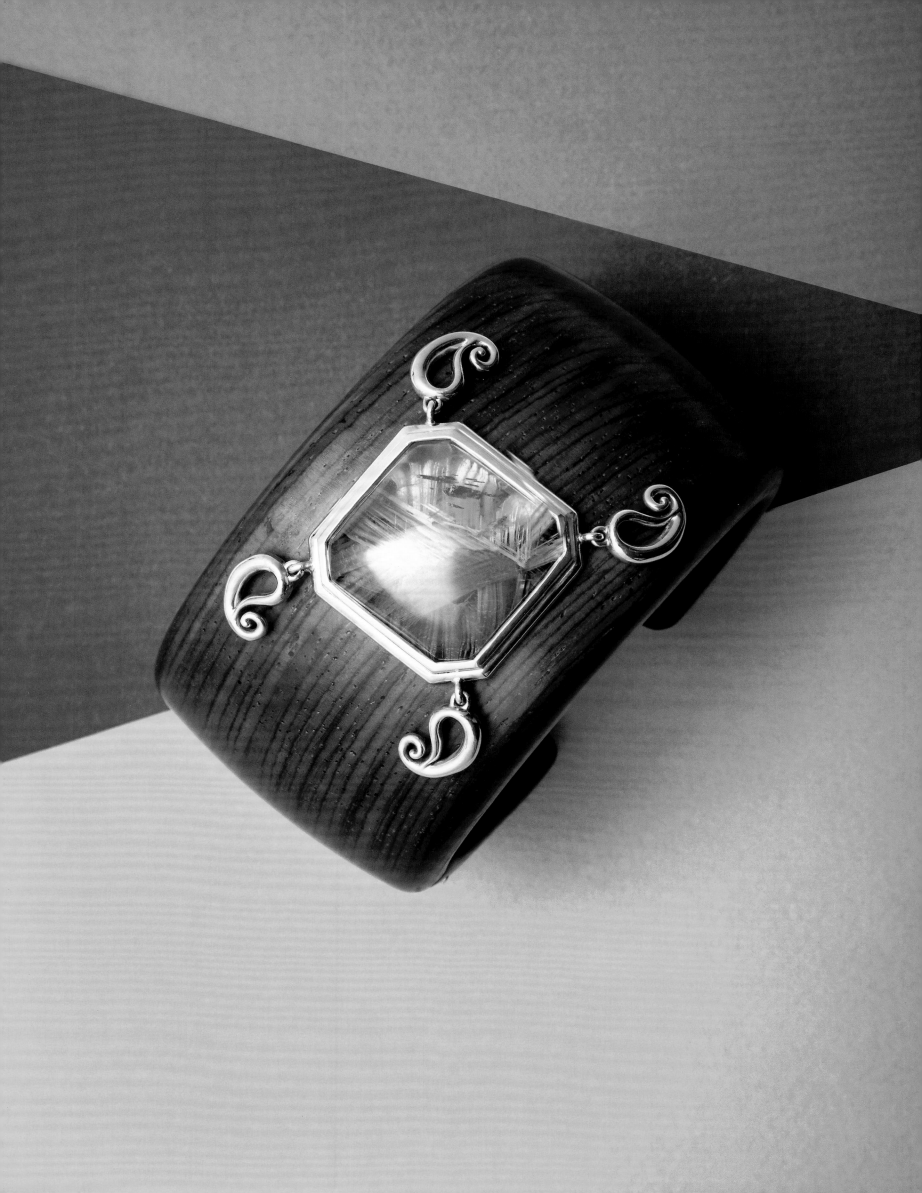

Di la te

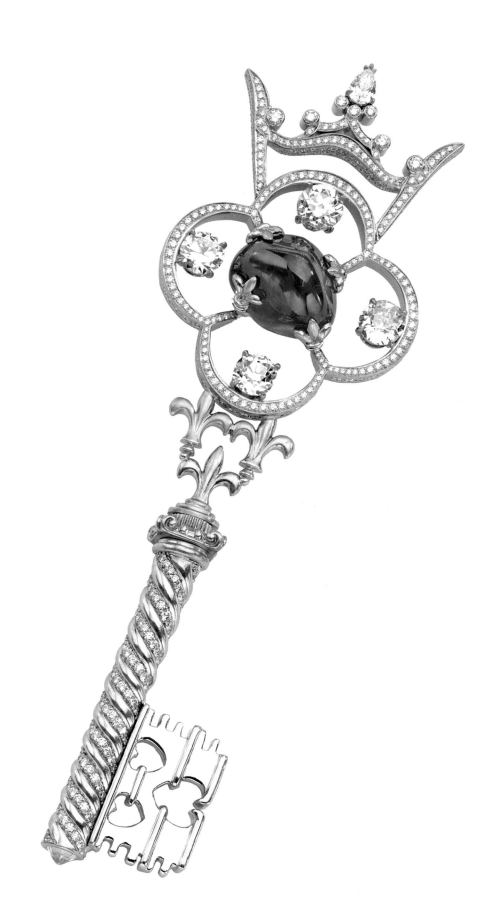

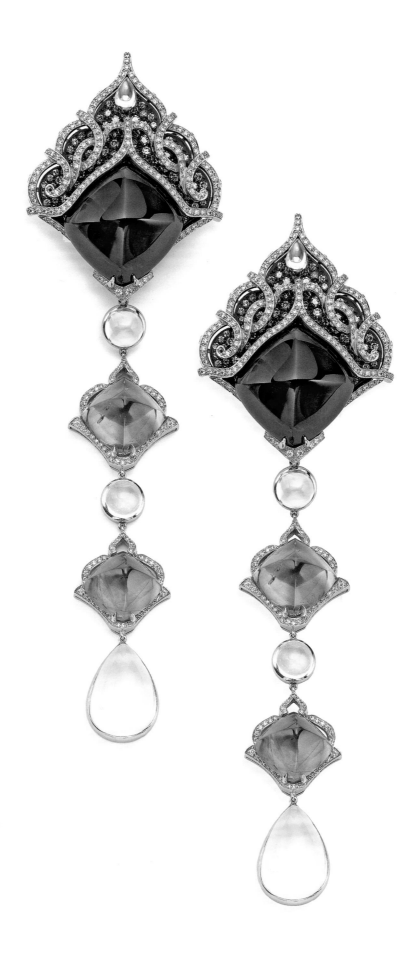

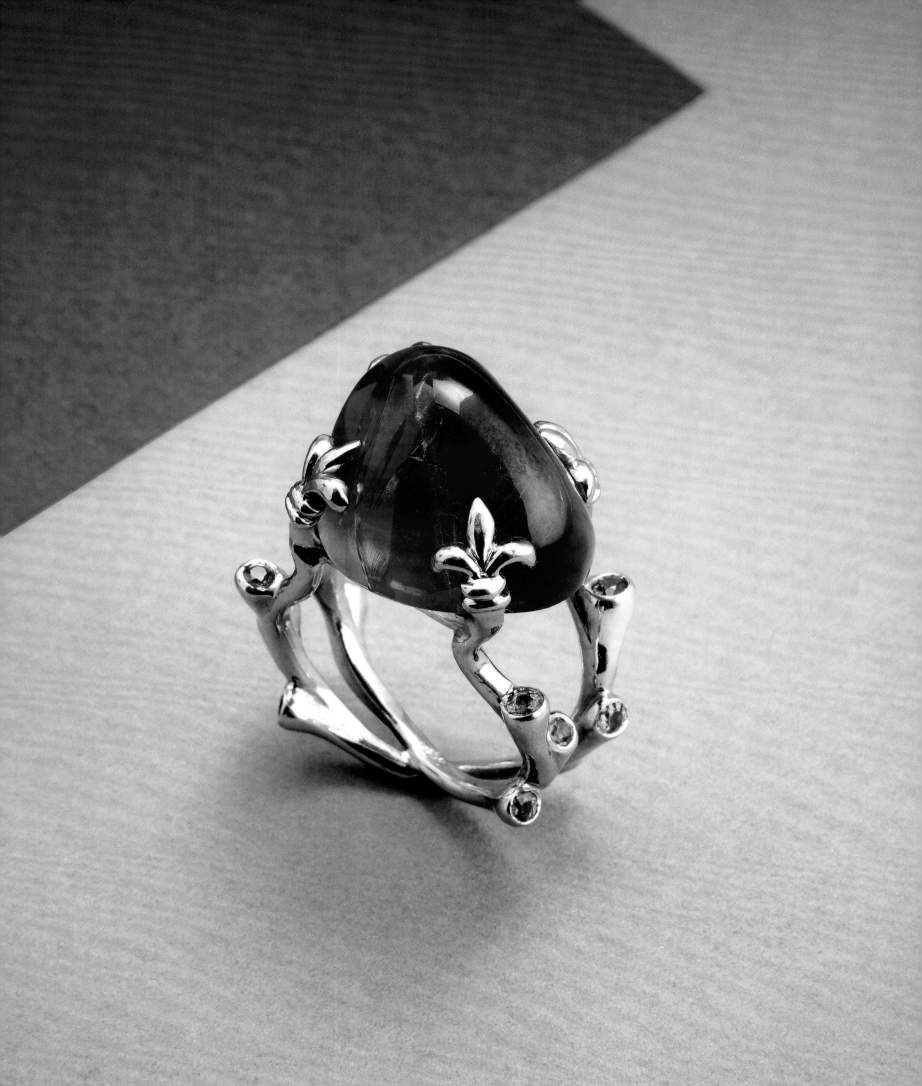

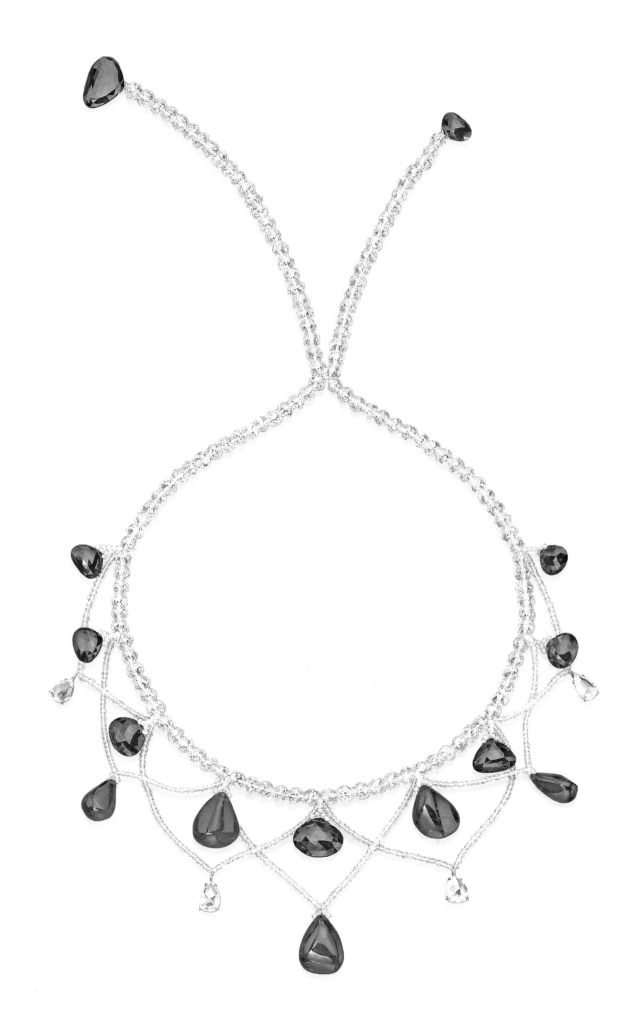

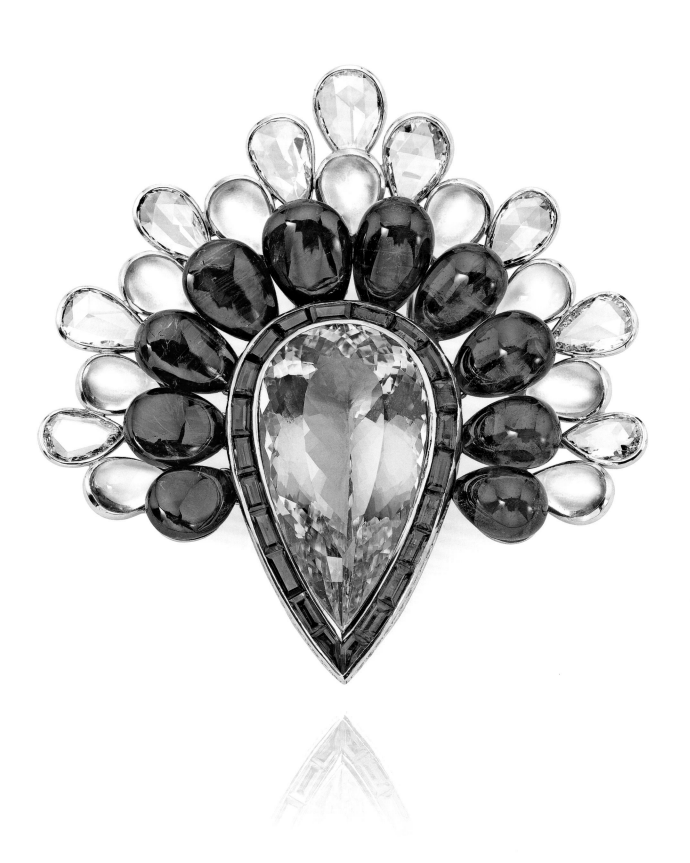

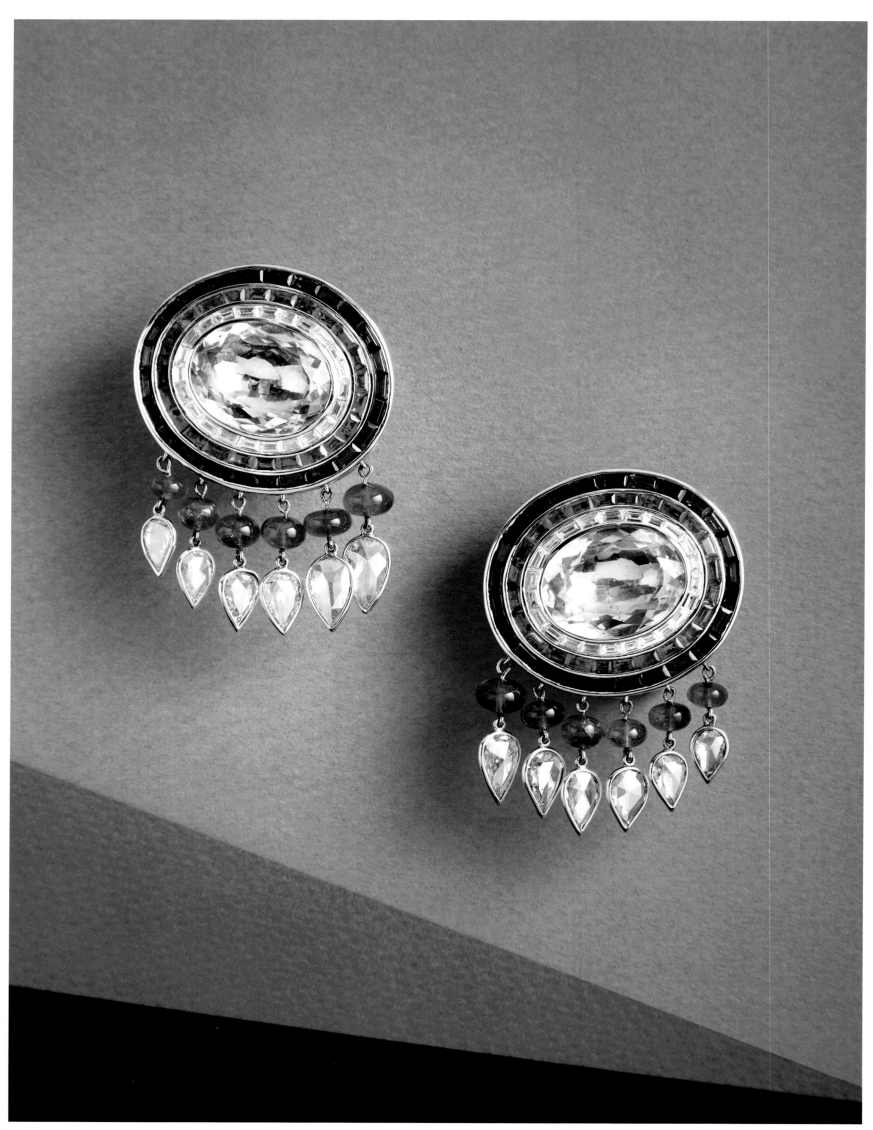

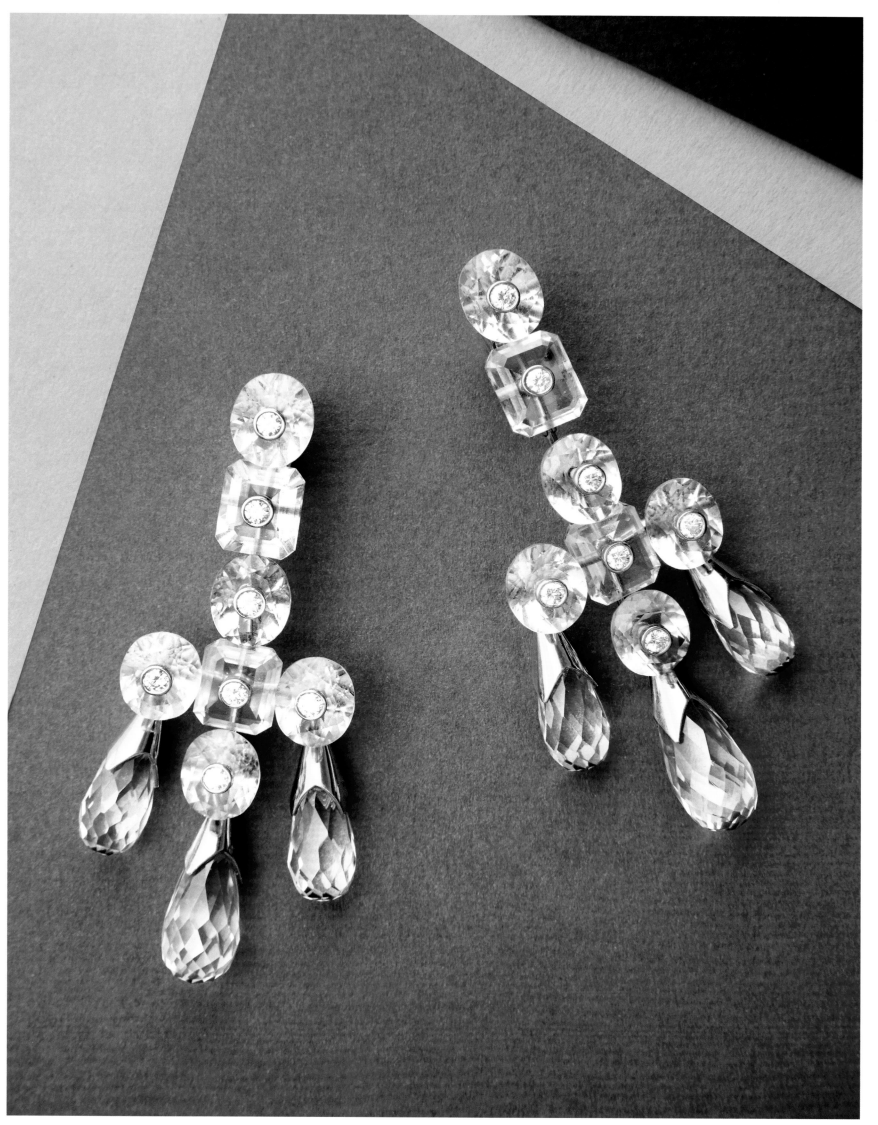

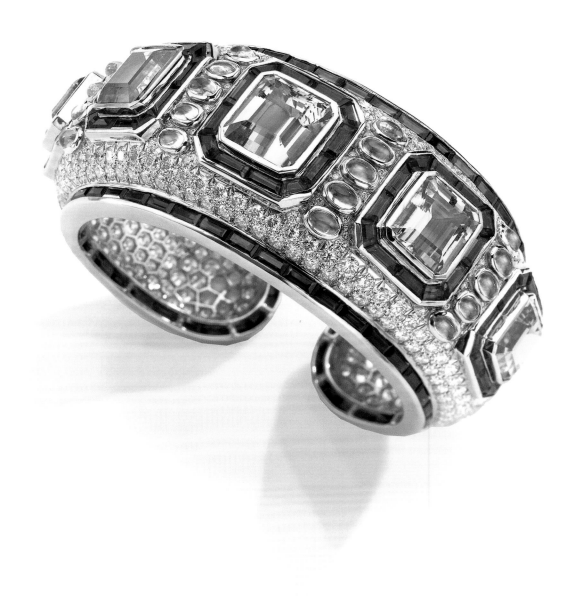

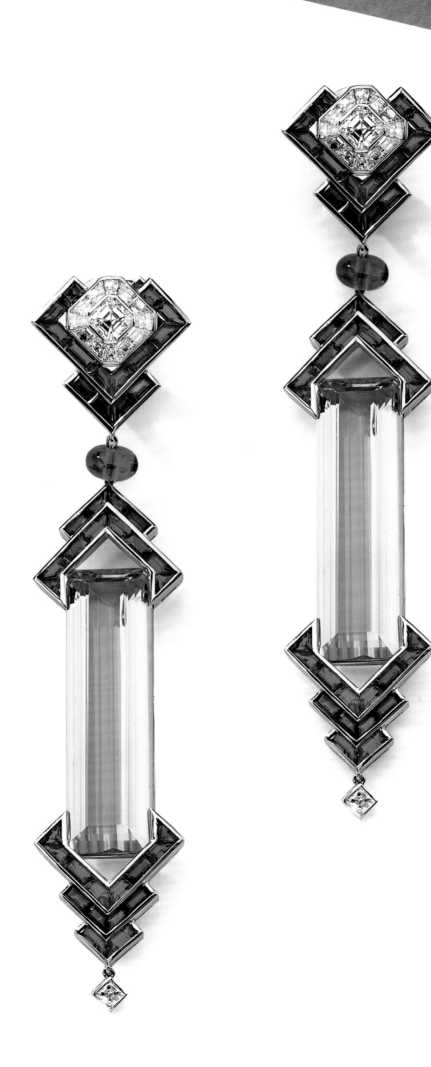

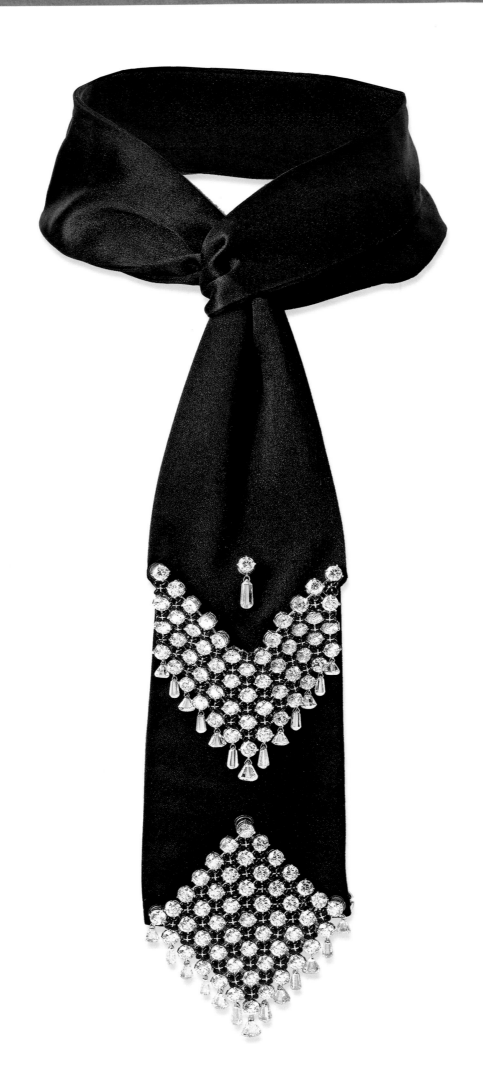

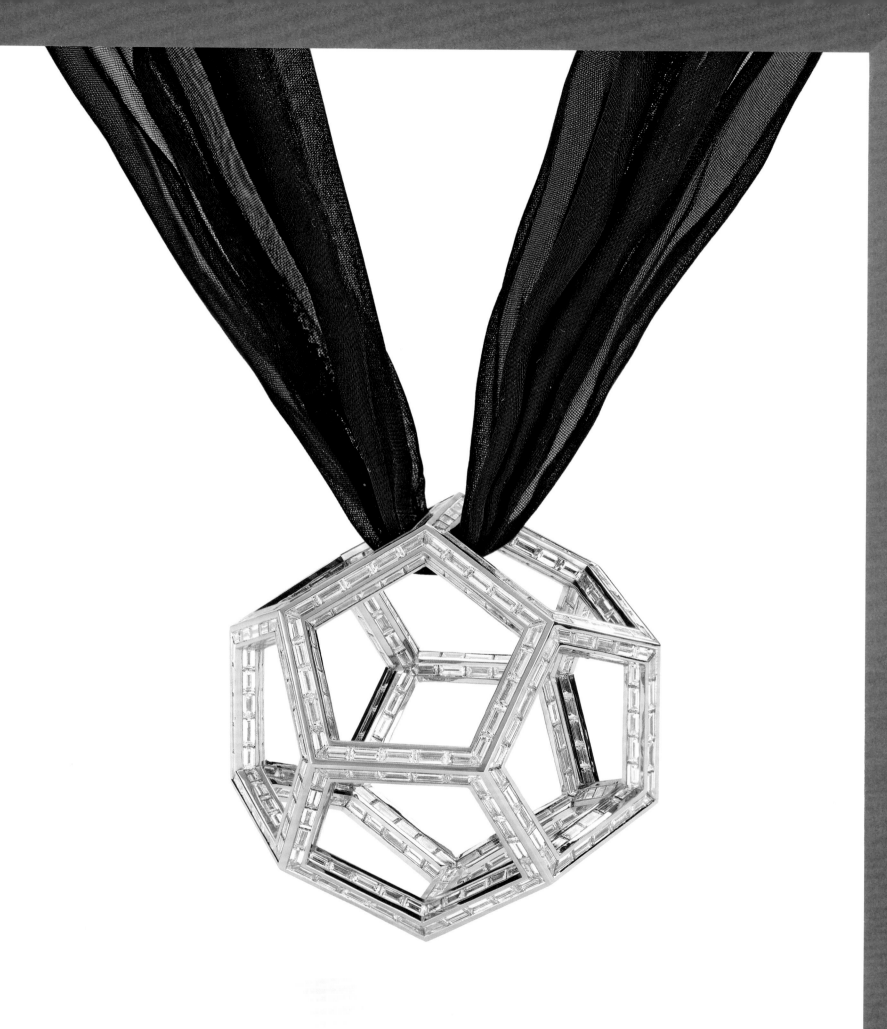

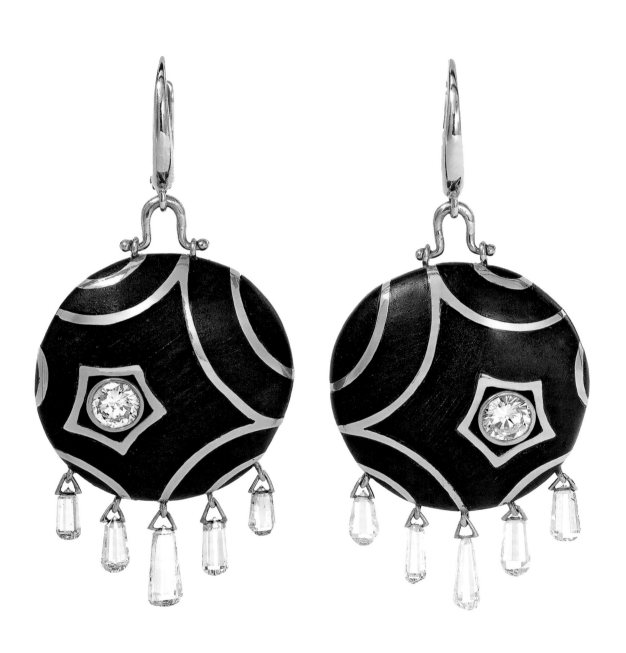

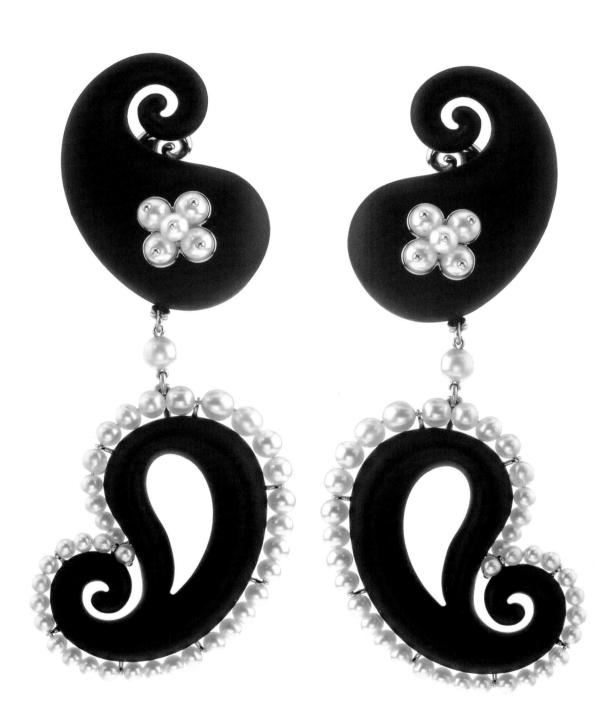

D. smith Aug 13th '7

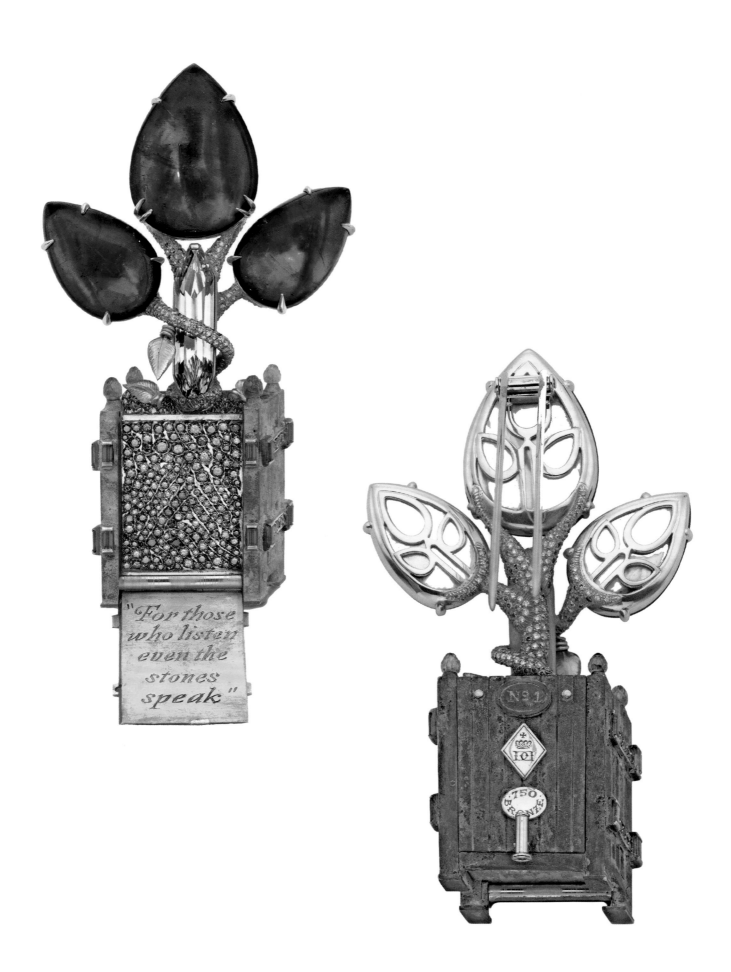

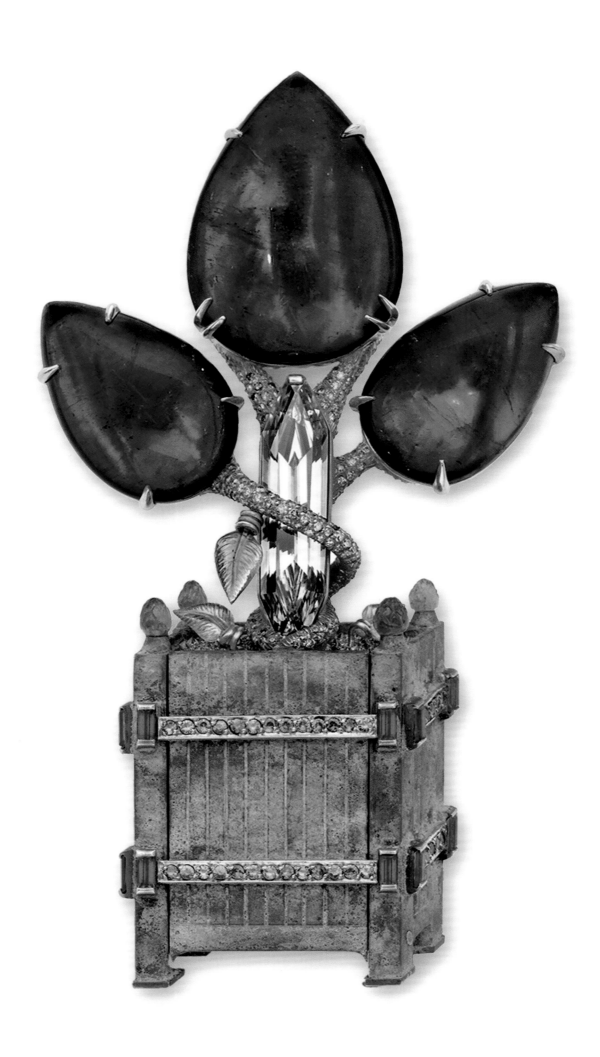

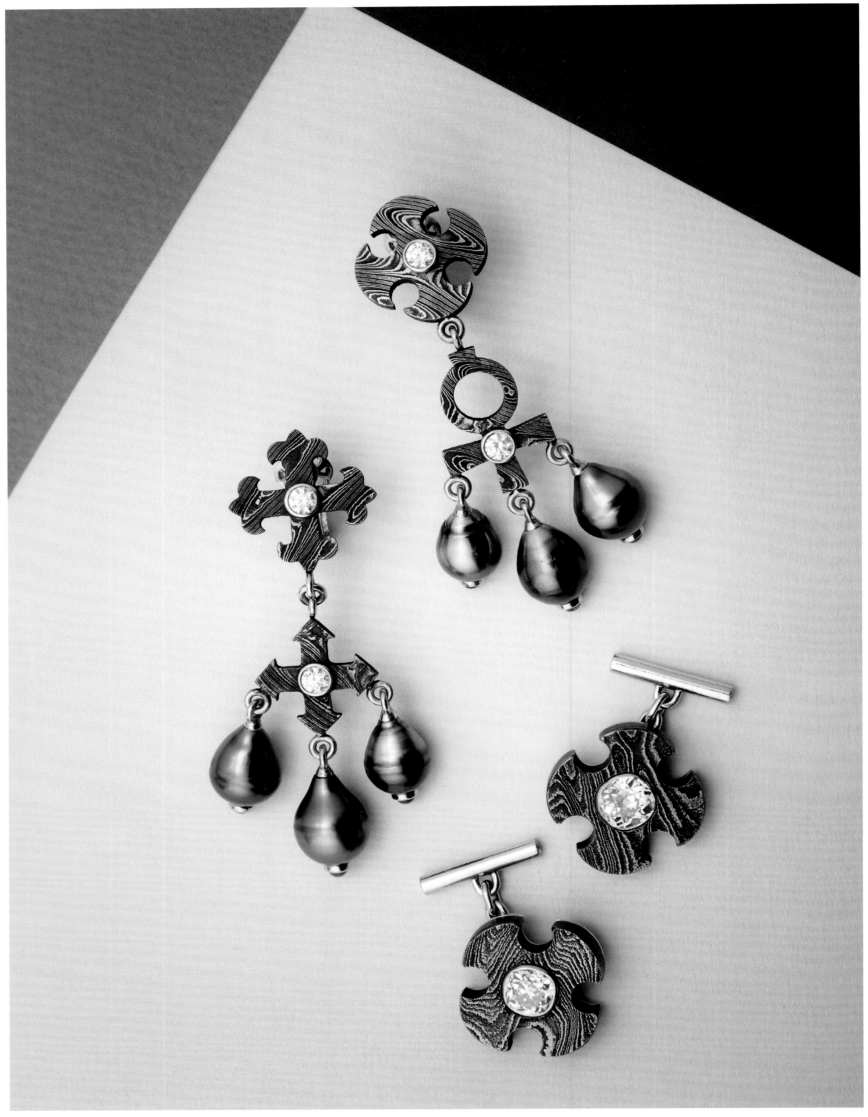

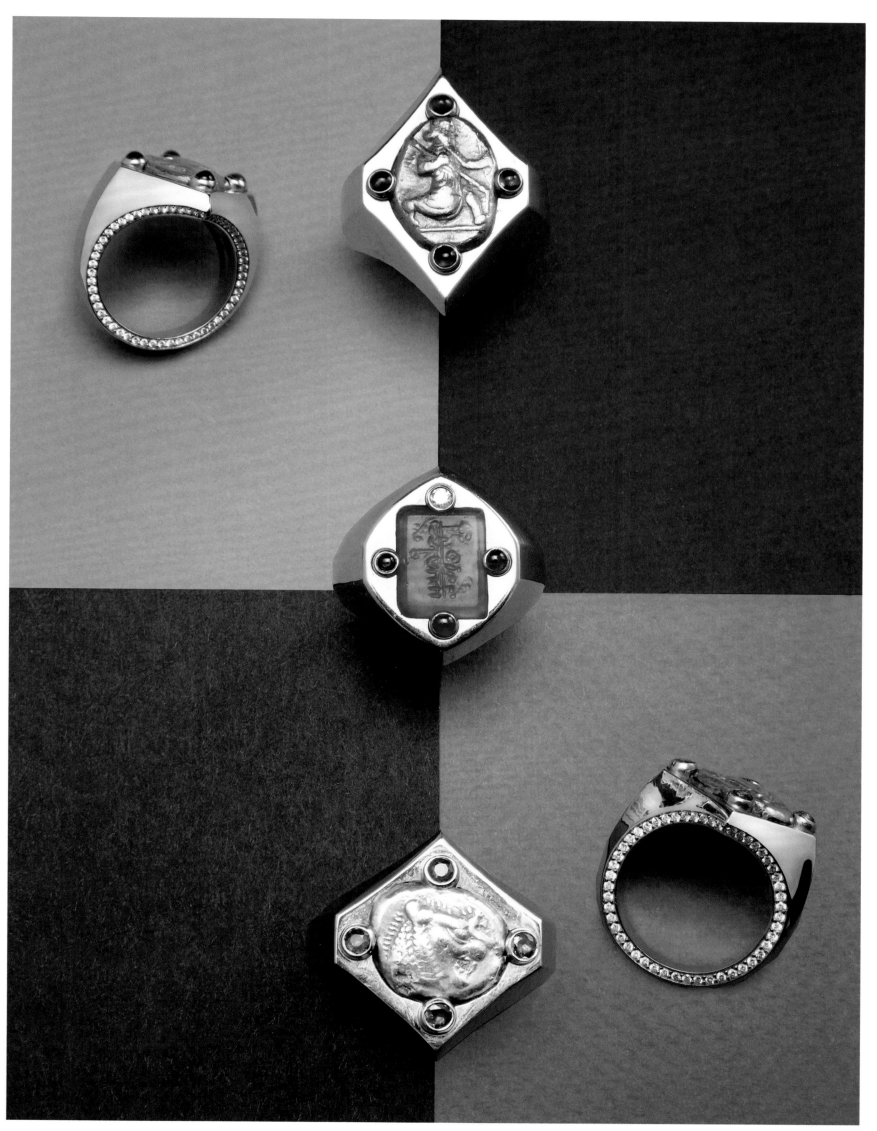

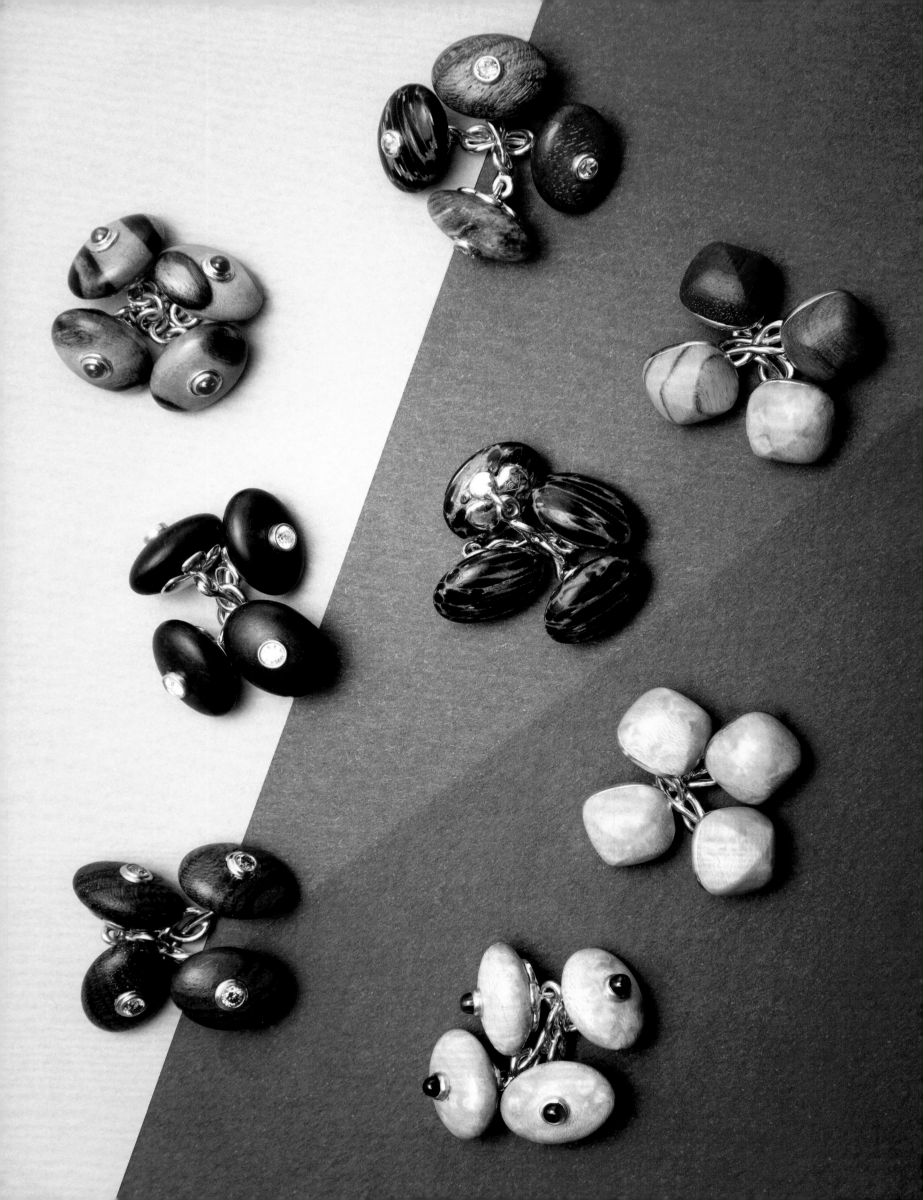

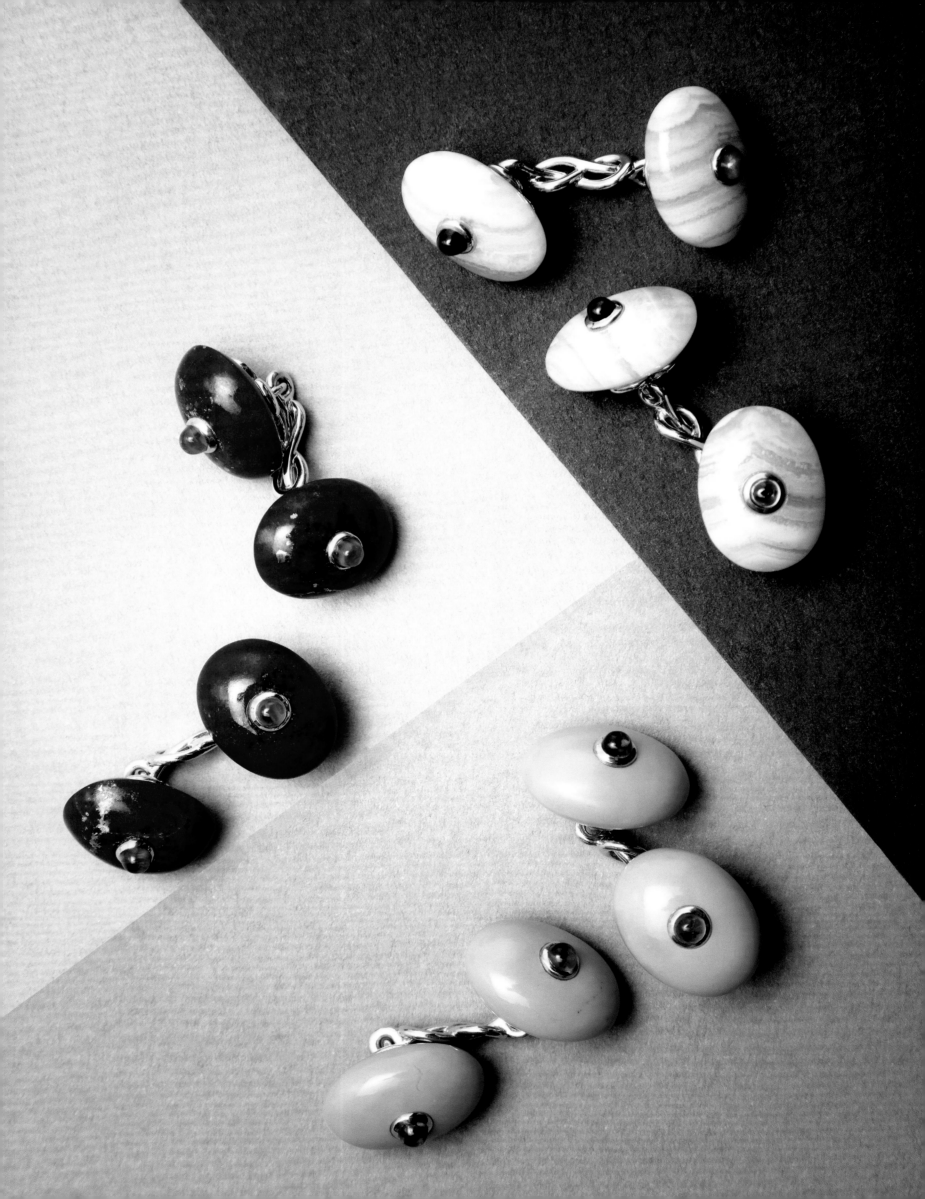

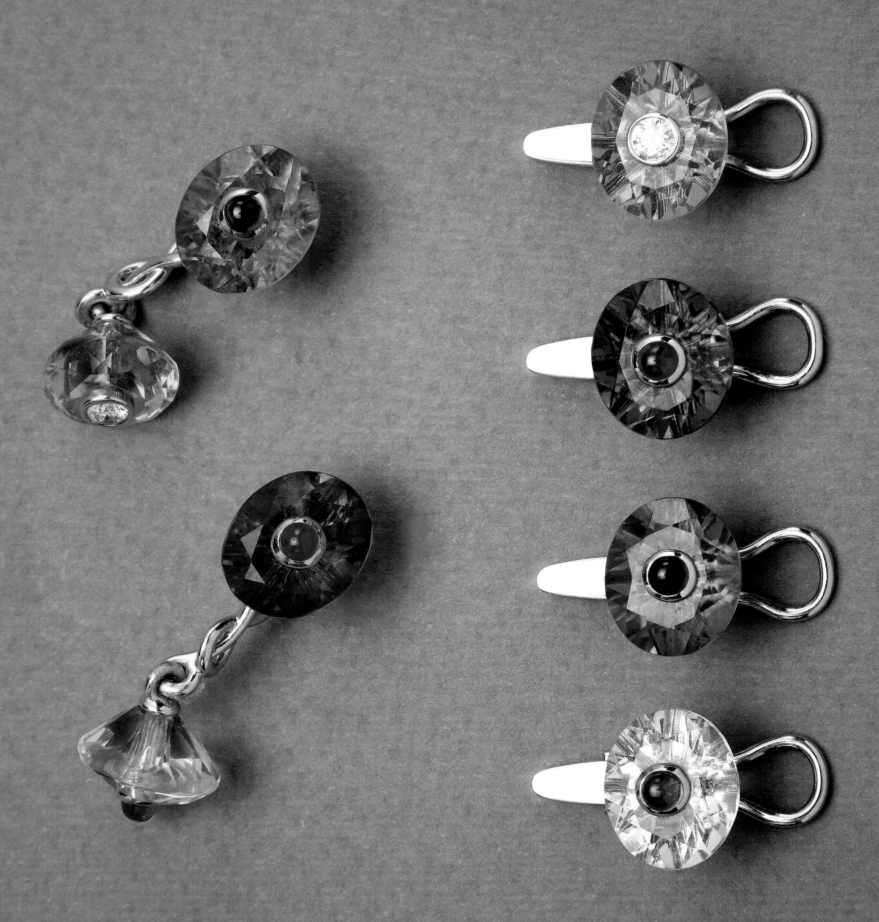

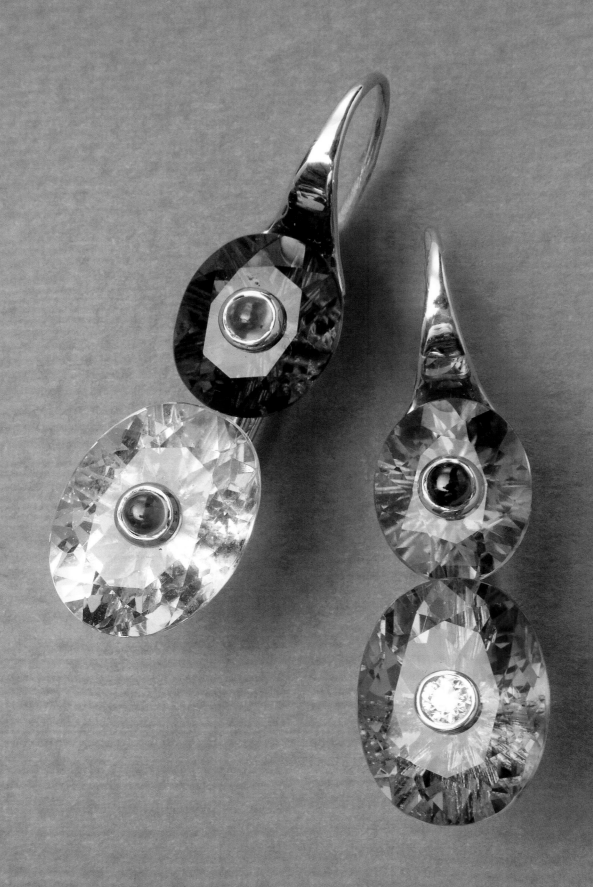

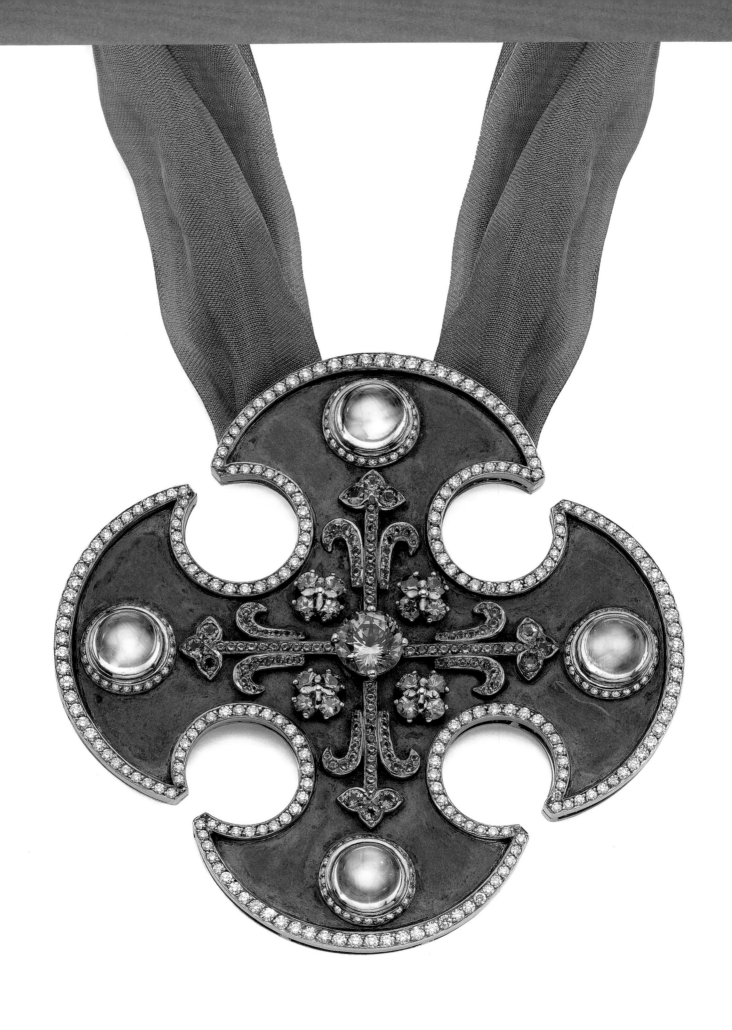

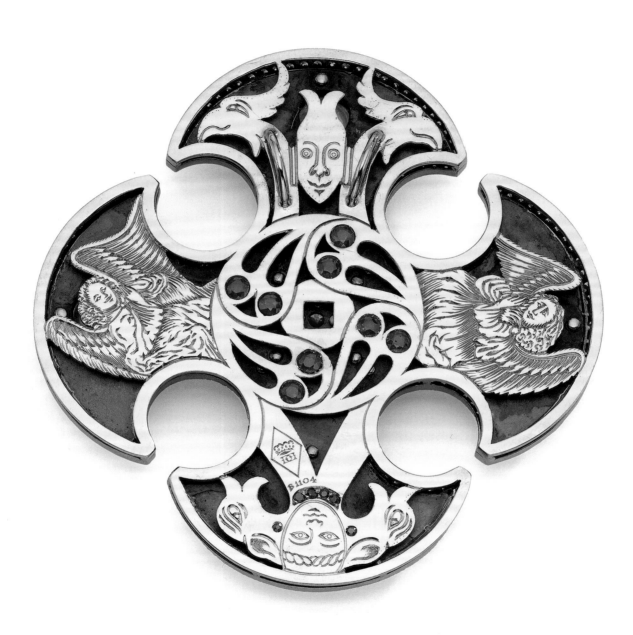

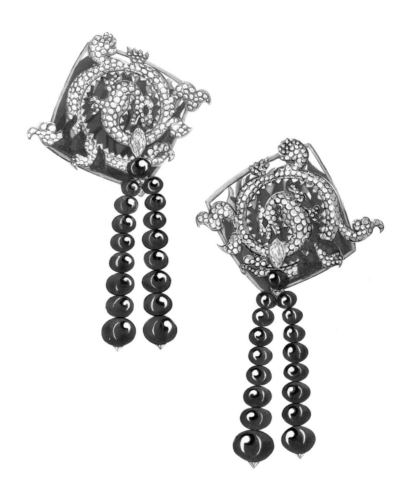

Di Modé 10 at 07

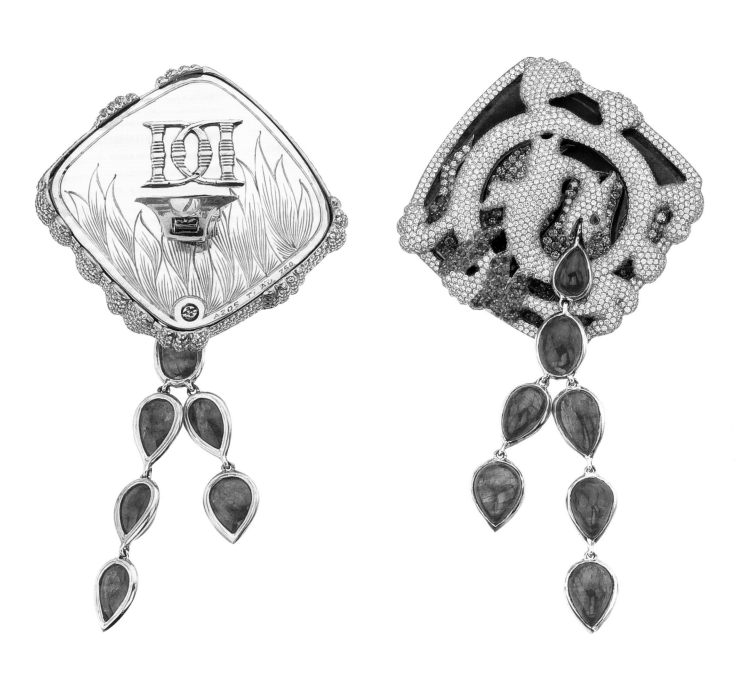

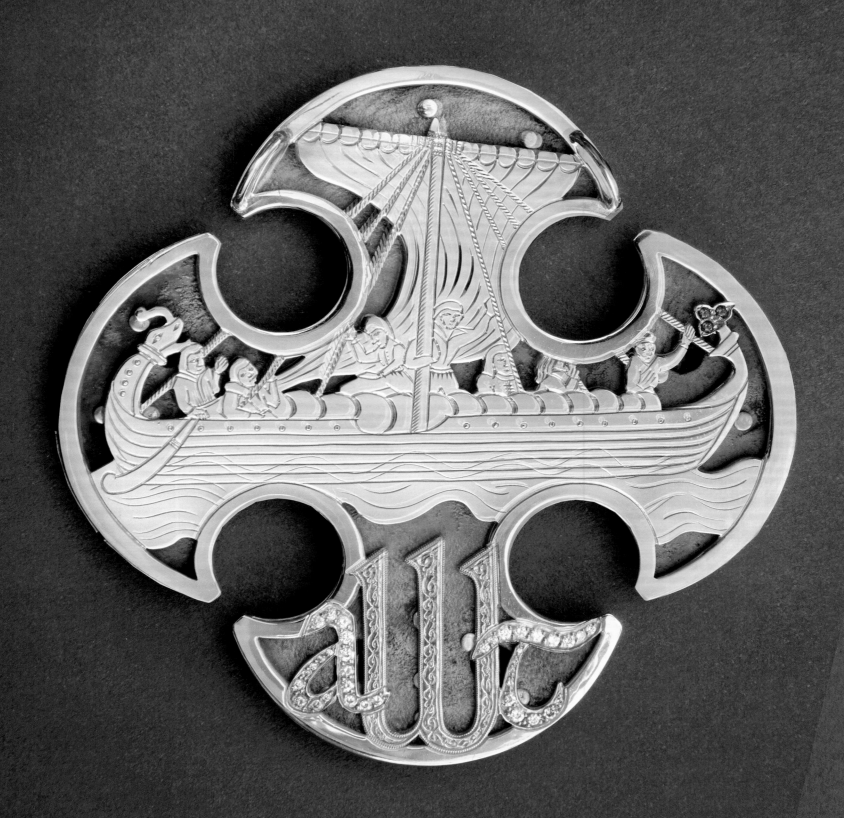

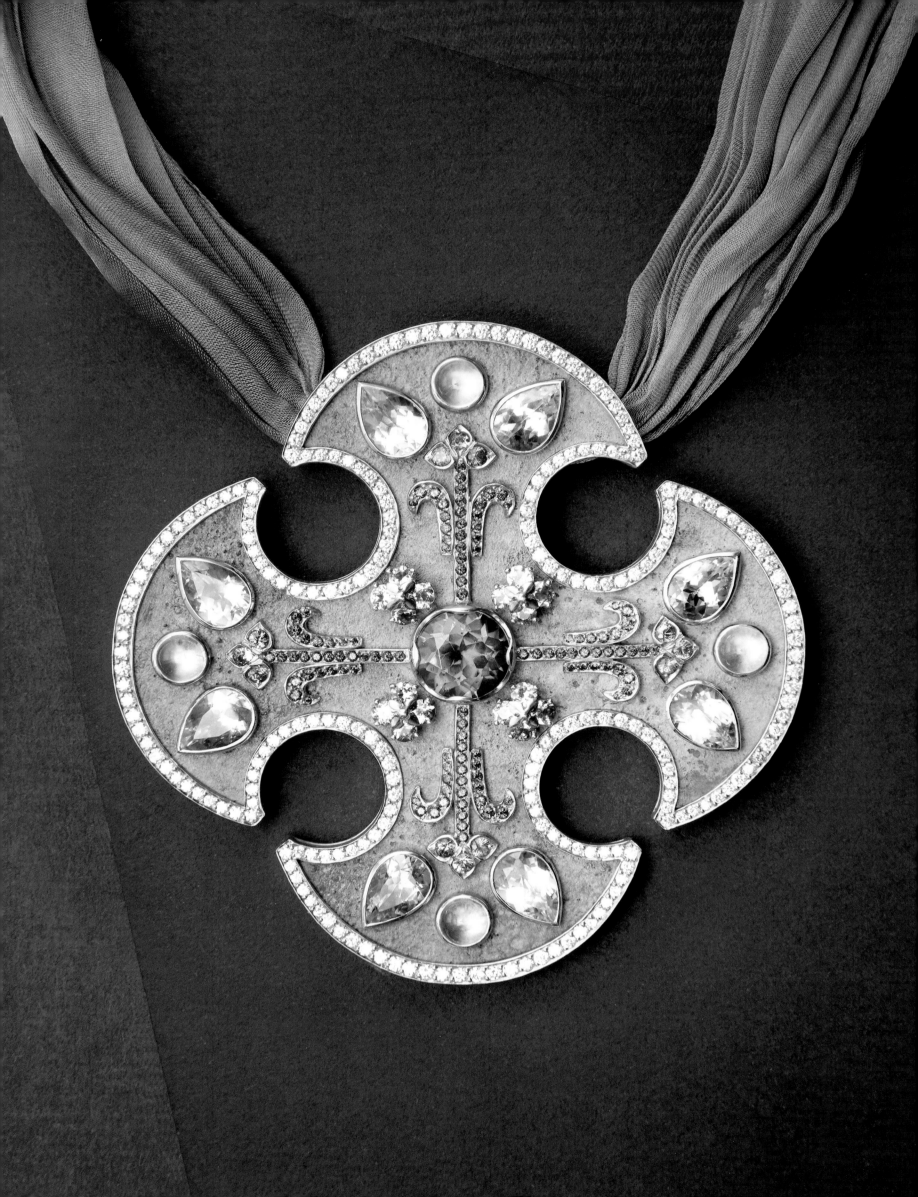

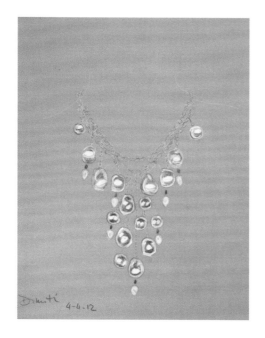

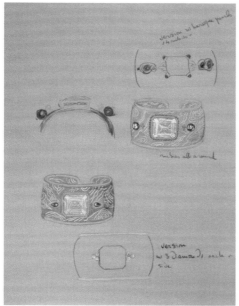

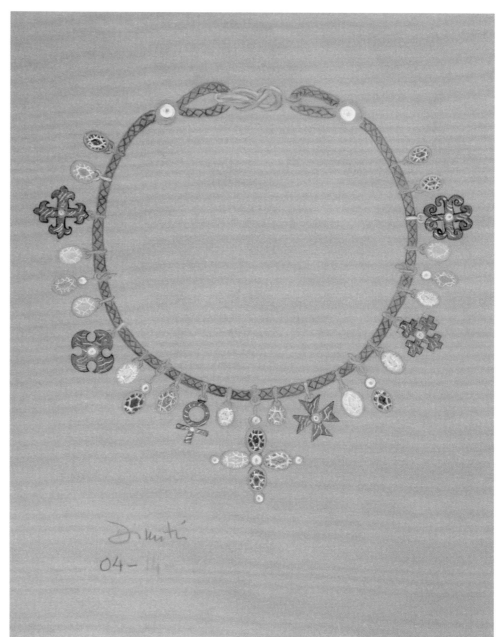

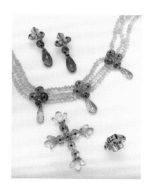

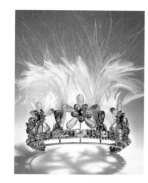

PAGE 4: A citrine found in the Demidoff mines in the Urals in the late eighteenth century and engraved with the Demidoff coat of arms and various cyphers of members of the family.

PAGE 10: A selection of citrine, diamond, and ruby jewelry all mounted in 18k yellow gold.

PAGE 187: Tiara topped with aigrette feathers with 18k yellow gold, citrine, green quartz, diamonds, and Tahitian pearls.

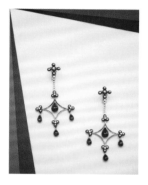

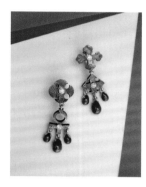

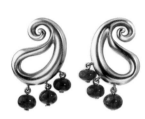

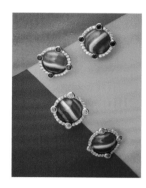

PAGE 188: The Polar Star Earrings in Burmese rubies and diamonds, mounted in 20k rose gold. Eight ruby drops weighing 24.09 carats and 34 beads weighing 17.24 carats.

PAGE 189: Medieval inspired cross earrings in Damascus Steel and 20k gold with diamonds and Burmese ruby drops weighing 26.74 carats.

PAGE 190: Satin-finish yellow gold (24k) and ruby bead paisley earrings.

PAGE 191: 18k yellow gold Carnelian ear clips set with diamonds, garnets, yellow sapphires, and mandarin garnets.

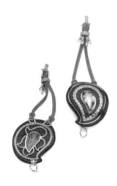

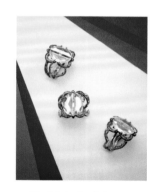

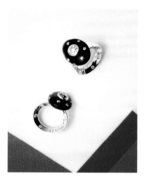

PAGE 192: Paisley cocobolo wood bracelet in 18k yellow gold and fancy color diamonds. The bracelet is set with a 13.12 carats paisley shaped briolette yellow diamond and pavéd front and back with 10.69 carats of pear and round yellow and orange diamonds.

PAGE 193: The Adinkra Symbol engagement ring, two half moon rose cut diamonds 2.39 carats and pavé of rubies.

PAGE 194: A black pebble and diamond ring with an old-mine diamond from a necklace of Queen Marie-José mounted in platinum with a few tiny round diamonds sprinkled around.

PAGE 195: The Bloodstone and Ruby Ring with a 2.05 carat hexagonal ruby mounted in 18k yellow gold.

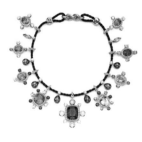

PAGE 196: Platinum, coral and diamond ring with in its center a round diamond of 1.36 carats of E, VS1 quality.

PAGE 197: The Beeswax Ring in 20k yellow gold, with round, briolette, and hexagonal yellow and orange diamonds (top); the Birthday Candle Ring in platinum and 3.00 carats of diamonds (middle); the Pink Candle Ring with 4.93 carats of pink diamonds (bottom).

PAGE 199: A pink sapphire bead necklace with 20k rose gold pebbles, set with pink and purple sapphires on one side and rubies on the reverse.

PAGE 200: The Explosion of Color Necklace. The center amethyst of 42.44 carats, originating from the Russian imperial mines, was part of a collection given by Tsar Alexander III to Queen Elena of Italy. Next to it is a collection of multicolor gems.

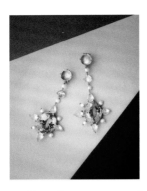

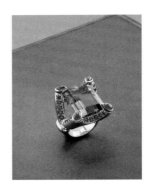

PAGE 201: Tourmaline, moonstones, and pearl ear pendants mounted in 20k rose gold; one pink tourmaline weighs 25.29 carats and one purple tourmaline weighs 19.65 carats.

PAGE 202: Nine amethysts that were part of the collection of Queen Elena of Italy, a gift of Tsar Alexander III of Russia.

PAGE 203: Rose gold, amethyst, and ruby ring.

PAGE 204: The New Look of Glamour rings: platinum and rock crystal with diamond center (middle); rose gold with amethyst, and ruby (right); and pink quartz and ruby (left).

PAGE 205: Morganite, diamond, and ruby ear pendants. Two Brazilian morganites, weighing 45.46 carats and 46.16 carats, mounted in rose gold and platinum with 5.25 carats of baguette diamonds and 5.93 carats of baguette rubies.

PAGE 207: A pearl sautoir made with an old, three-strand pearl necklace with ruby and diamond clasps to which we added six 20k rose gold crosses pavéd on one side with the diamonds and on the other side the rubies from the supplied clasps. We added ruby beads gold chains and leather cords.

PAGE 208-209: A paisley brooch in 18k rose gold, flexible and articulated, entirely pavéd with diamonds and rubies suspending a paisley motif with a pear-shaped center rose-cut pink diamond, weighing 4.36 carats, with a quote by Einstein engraved on the back.

PAGE 211: A bracelet of 20k rose gold, Burmese rubies, diamonds, and Damascus steel.

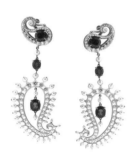

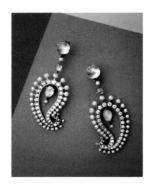

PAGE 212: Paiseley earrings in rubies supplied by the client, diamonds (5.66 carats), and natural pearls. Mounted in 20k rose gold.

PAGE 213: Moonstone, diamond (4.74 carats), and pearl paisley earrings mounted in dark gray gold.

PAGE 214: The Bubble Bath Ring in 18k white gold with a Kashmir sapphire of 3.26 carats and numerous round and briolette diamonds weighing 5.23 carats.

PAGE 215: The Rajasthan style bracelets, one in diamonds, the other in sapphire and diamonds, includes twenty-one oval diamonds (4.72 carats) and pavé work (weighing 24.09 carats).

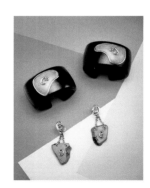

PAGE 216: Sapphire, moonstone and diamond earrings. Two cabochon drop shaped sapphires weighing 59.41 carats. Two cabochon moonstones weighing 8.12 carats and numerous round diamonds weighing 6.64 carats.

PAGE 217: The body of this sapphire ring is made with a block of turquoise mounted on 20k yellow gold, a sugarloaf cabochon sapphire of 9.41 carats, four cabochon emeralds, and numerous tsavorites.

PAGE 218: Bespoke necklace designed with three slabs of turquoise to which were added lapis lazuli beads and 18k yellow gold paisley motifs.

PAGE 219: Bespoke pair of ebony and 18k yellow gold bracelets made with turquoise slabs provided by the customer with added gold paisley elements. Turquoise and yellow gold 18k paisley earrings; turquoise supplied by the client.

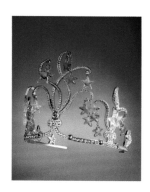

PAGE 220: Homage to Empress Sissi Tiara for the 2013 Vienna Opera Ball designed for Swarovski.

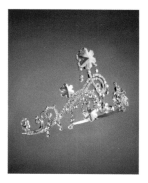

PAGE 223: The Snow Storm crystal tiara. Designed for Swarovski for the 2012 Vienna Opera Ball.

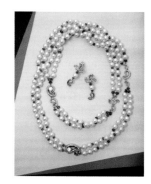

PAGE 224: A pearl sautoir and earrings made from a four-strand pearl necklace with a diamond clasp. We used all the diamonds of the clasp to pavé numerous different shapes and sizes, 18k yellow gold paisley elements, and added some emerald beads. It can be worn long or short.

PAGE 225: Limited-edition terra-cotta pendant by Picasso, mounted on rose gold with sapphires as a star and moon gold with leather necklace.

PAGE 227: The paisley pendant brooch in emerald, yellow diamonds, ruby beads, orange sapphires, and cabochon emeralds. In the center is a flat, portrait-cut emerald of 10.53 carats. Mounted in 18k yellow gold.

PAGE 228: A necklace of coral beads and coco-bolo wood, with paisley elements of diamonds, Mexican fire opals, emeralds, and gold balls.

PAGE 229: A necklace of carved emerald beads, greenish Tahitian cultured pearls, birds-eye maple wood with demantoid garnets and emerald and gold spheres.

PAGE 230: A 20k dress set with rose-cut diamonds, cabochon emeralds, emeralds, and small pavé diamonds.

PAGE 231: A 20k yellow gold dangling paisley ring with a pear-shaped rose-cut diamond and numerous demantoid garnets.

PAGE 232: Three Cross Rings: 24k gold with a 3.58-carat pink spinel (right); 20k rose gold and oxidized silver with a moonstone center of 0.88 carat (left); 24k yellow gold and oxidized bronze with a 2.81-carat tsavorite center (middle).

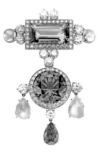

PAGE 233: A 15.52-carat heliodor, 30.79-carat peridot, 4.91 carats red spinel, diamond, and moonstone brooch, mounted in 18k yellow gold.

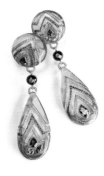

PAGE 234: The Flame and Fire amber earrings mounted in 18k yellow gold and set with rubies, yellow diamonds, garnets and sapphires; (28 carats of colored stones and 9.16 carats of diamonds).

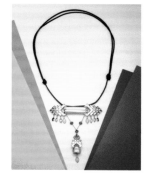

PAGE 235: A rectangular Heliodor of 25.17 carats and an oval one of 7.65 carats, mounted in yellow gold with diamonds, yellow sapphires, mandarin garnets and three ruby beads, on a red leather cord.

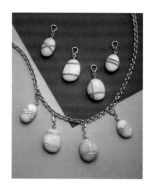

PAGE 236: A white pebble 18k yellow gold and diamond reversible necklace. The diamonds are from old earrings supplied for this project. The four pebbles have diamonds on one side and gold rope on the reverse. They are all detachable.

PAGE 237: Earrings made with Ancient Roman intaglios and one nineteenth-century cameo, supplied for this project, with diamonds added and mounted in 18k yellow gold.

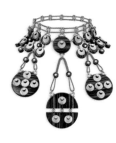

PAGE 239: Tribal Necklace in Makasar ebony, with 24k gold, 20k rose gold, and diamonds. The two side pendants detach to become earrings and the center one to become a pendant. Everything is held together with leather cords and gold screws.

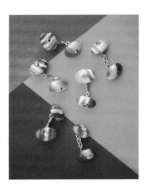

PAGE 240: A collection of striped orange carnelian cufflinks mounted in 18k yellow gold with diamonds or mandarin garnet centers.

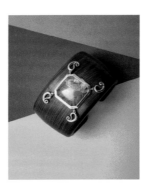

PAGE 241: Cocobolo bracelet with a cabochon rutilated quartz center and four loose 18k yellow gold paisley elements.

PAGE 243: Platinum, diamond, and sapphire medieval-inspired key pendant mounted in platinum. One cabochon sapphire (43.58 carats) and numerous diamonds weighing 11.33 diamonds.

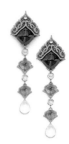

PAGE 244: The Arabesque Earrings, inspired by the dome of the mosque in Isfahan. Two sugarloaf Burmese sapphires (52.94 carats), four Ceylan sapphires (35.98 carats), moonstone, and white and blue pavé diamonds. Mounted in platinum.

PAGE 245: Platinum twig ring with a 43.58-carat free-form cabochon sapphire mounted with tsavorites on 18k white gold.

PAGE 246: Necklace with 131 larger diamond beads weighing 161 carats, tiny diamond beads weighing 23.36 carats, five Colombian emerald drops weighing 58.25 carats, and nine Burmese sapphire briolettes weighing 67.91 carats. Four pear-shaped diamonds, 4.28 carats.

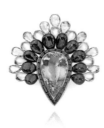

PAGE 247: The Peacock Brooch in aquamarine (44.50 carats), 5 emerald drops (38.25 carats), five sapphire drops (42.77 carats), moonstones, and nine pear-shaped rose-cut diamonds (11.93 carats). Mounted in platinum.

PAGE 248: Blue topaz (weighing 31.65 carats), diamond, emerald, and sapphire earrings in 18k white gold. Emerald beads (13.22 carats).

PAGE 249: Blue topaz and diamond chandelier earrings, mounted in 18k yellow gold.

PAGE 250: Bangle bracelet in platinum with five aquamarines (47.50 carats), moonstone (6.20 carats), diamond (31.19 carats), emerald (21.5 carats), and sapphire (22.5 carats).

PAGE 251: A pair of aquamarine, emerald, sapphire, and diamond ear pendants. The aquamarines weigh 39.44 and 37.41 carats.

PAGE 252: The Black Tie Necklace in diamonds and black enamel, mounted in platinum and silk satin. There are 102 round diamonds weighing 32.15 carats plus twenty-seven tie-cut diamonds weighing 7.42 carats.

PAGE 253: The Dodecahedron Diamond Pendant in 18k white gold set with 45.81 carats of diamonds. It hangs on a silver sash enameled in black.

PAGE 254: Ebony and diamond earrings mounted in 18k yellow gold with two round diamonds weighing 1/2 carat each and ten tie-cut diamonds.

PAGE 255: Paisley earrings with ebony, natural pearls, and 18k yellow gold.

PAGE 256: Hair ornament/brooch in diamonds, two natural drop shaped pearls and four pear shaped diamonds: two white ones, a fancy intense yellow, and a fancy pink one.

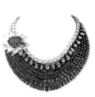

PAGE 257: The Knot of Savoy engagement ring with an old-mine diamond of 3.62 carats in platinum.

PAGE 259: Indian inspired emerald, diamond, sapphire and moonstone necklace. The left motif detaches to become a brooch with in its center a 41.39 carat carved Indian emerald.

PAGE 260: Platinum and emerald ring with two Colombian emeralds of 22.50 carats each.

PAGE 261: Platinum, emerald, and diamond ring with a 9.86-carat pebble-shaped emerald, pavé diamonds, and tie-cut diamonds weighing 9.15 carats.

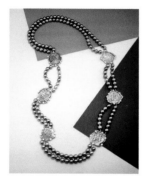

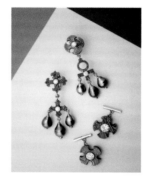

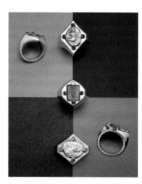

PAGE 262: Sixteenth-century Spanish silver coins, black Tahitian cultured pearls, and diamonds on one side, and multicolor gems on the other. Reversible bespoke necklace made with the sixteenth-century Spanish coins supplied for the project.

PAGE 265: Emerald Tree Brooch, inspired by the cachepots of the Orangerie at Versailles, in oxidized bronze and 18k yellow gold. The three emeralds weigh 79.65 carats; the octagonal baguette brown diamond weighs 7.36 carats. Demantoid garnets and diamonds.

PAGE 266: Damascus steel, 18k yellow gold, diamond and Tahitian cultured pearl earrings with Damascus steel, platinum and diamond cufflinks. Diamond weight 2.96 and 2.97 carats. Old-mine diamonds from a diamond necklace from Queen Marie José.

PAGE 267: Two Ancient greek coins mounted in 18k rose gold with emeralds and sapphires on the side and micro-pavé diamonds on the edges of the ring. An ancient Roman intaglio mounted in 18k yellow gold held by four gems.

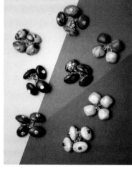

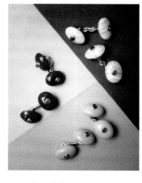

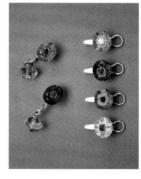

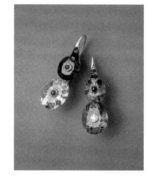

PAGE 268: A collection of 18k yellow gold wood cufflinks with rubies, sapphires, and white and colored diamonds.

PAGE 269: Blue chalcedony and sapphire cufflinks in 18k yellow gold; lapis lazuli and emerald cuff links in 18k white gold; 18k yellow gold, turquoise, and emerald cuff links.

PAGE 270: Tutti frutti dress set in citrine with diamond center, amethyst & ruby, peridot & sapphire, and blue topaz & emerald.

PAGE 271: Tutti frutti ear pendants: amethyst & ruby, blue topaz & emerald, peridot & sapphire, and citrine & diamond center.

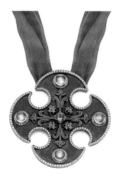

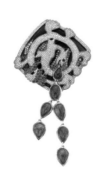

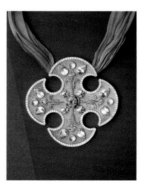

PAGE 272: Medieval-inspired cross in oxidized silver and 18k rose gold with lavender spinel center, four cabochon moonstones, blue and purple sapphires. The back of the cross (page 273) has rubies and a diamond frame.

PAGE 275: The Firedragon Earrings, inspired by a medieval pavement design, with 24.74 carats of pear-shaped cabochon rubies and three carats of micro-pavé diamonds.

PAGE 277: Medieval-style cross in 20k yellow gold and oxidized bronze. In the center is a 6.29 carats peridot surrounded by blue topaz, moonstones, diamonds, tsavorites, green spinels and pink sapphires. The back of the cross (page 276) has the initials of the client and his sons in diamonds and gold, and an image of William the Conqueror from the Bayeux tapestry.

PAGE 288: A green beryl found in the Demidoff mines in the Urals in the late eighteenth century and engraved with the Demidoff coat of arms.

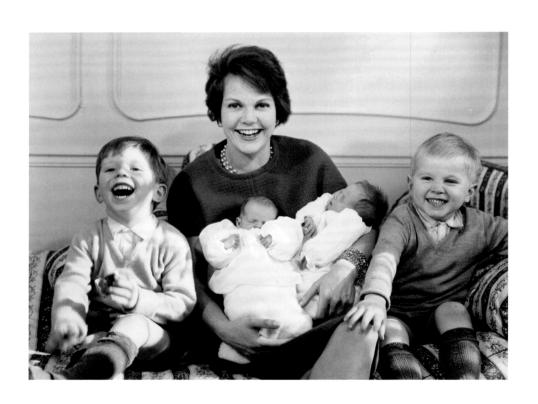

ACKNOWLEDGMENTS

The inspiration and the driving force behind *Once Upon a Diamond* are the jewels, the stories, and the lives of Prince Dimitri's past and present family members. Their remarkable and legendary gems, as well as the stories of the lives of these kings, queens, princesses, and grand duchesses, were passed down from generation to generation to become the spark that ignited Prince Dimitri's imagination.

In this very personal book, Prince Dimitri's stories allow us to shine a light on these extraordinary chapters in the history of the world. This is also the remarkable legacy that led him to create the fabulous and fanciful jewel creations that fill these pages.

A great debt is owed to Stefano Papi, who generously shared his historical knowledge, contributed his keen editorial mind, and whose many loans from his photographic archive are the reasons this book now stands on solid—and fascinating—documentary evidence. His role was invaluable and his support unwavering. This project could not have found a greater friend.

Mark Roskams wielded the skilled and sensitive lens through which Prince Dimitri's jewels shine. His artistic mastery, his technical expertise, and his unmistakable style ignite the fire in these jewels and gems, while his craft weaves romance and modernity into every frame.

We are grateful to Violetta Caprotti, as well as to the many institutions, historical archives, collectors, and friends and family members who shared their knowledge as well as photographic material: Albion Art; Arturo Beéche; SquareMoose; Cyrille Boulay; Boucheron; Archives Cartier Paris; Christie's; Hillwood Estate, Museum & Gardens; Mary Evans Picture Library; Padulo Privé; Roger-Viollet; Smithsonian National Museum of Natural History; Sotheby's; as well as Count Hans Veit zu Toerring-Jettenbach and H.R.H. Princess Maria Pia of Bourbon Parma.

Project Director Cristina Rizzo, whose aesthetic sensibility and collaborative spirit were the glue that made it all possible, led the team that brought to light this editorial project. Under her guidance, George Foreman brought his technical skills to render each jewel in their utmost splendor. Rizzoli's team, led by Daniel Melamud, were relentless in pursuing the utmost best in all aspects of this project from design to originality and historical accuracy.

Without these dedicated contributors, *Once Upon a Diamond* simply would not be . . .

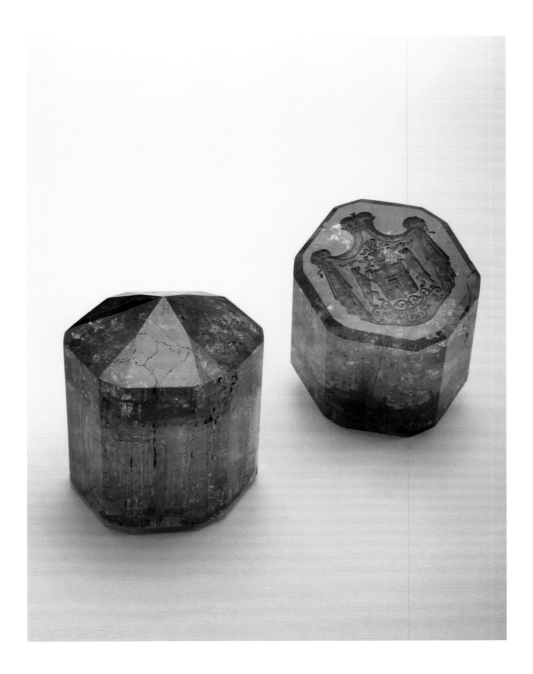

First published in the United States of America in 2020 by

Rizzoli International Publications, Inc.

300 Park Avenue South

New York, NY 10010

www.rizzoliusa.com

Copyright © 2020 Prince Dimitri

Text by Lavinia Branca Snyder

Photography by Mark Roskams

Art direction by Cristina Rizzo

Publisher: Charles Miers

Editor: Daniel Melamud

Design: Olivia Russin

Copyeditor: Tricia Levi

Proofreader: Elizabeth Smith

Production Director: Maria Pia Gramaglia

Printed in Italy

2020 2021 2022 2023 / 10 9 8 7 6 5 4 3 2 1

ISBN: 9-780-8478-6691-5

Library of Congress Control Number: 2020935915

Visit us online:

Facebook.com/RizzoliNewYork

Twitter: @Rizzoli_Books

Instagram.com/RizzoliBooks

Pinterest.com/RizzoliBooks

Youtube.com/user/RizzoliNY

Issuu.com/Rizzoli

All photographs by Mark Roskams except for the following:

© Agefotostock: 57, 59, 76, 87; © Albion Art Jewelry Institute: 67, 68, 71, 72, 75, 170; © Archives Boucheron: 102; Archives Cartier Paris © Cartier: 21, 25, 27, 29, 30, 32, 37, 38, 41, 42, 45, 46, 49, 51, 88, 94, 172; Courtesy of Archives Chiappe, Genoa: 167, 169; © Collection of Cyrille Boulay: 26, 28, 50, 60, 80, 82 (top), 83, 84 (all), 86, 98, 176; Courtesy of Christie's: 44, 53, 77, 162; Collection of Prince Dimitri: 17 (all), 18, 19, 22, 54, 55 (all), 56 (all), 63, 81, 82 (bottom), 85 (all), 92, 95, 96, 103, 104, 106, 108, 112–29, 132–45, 146, 147 (all), 149 (top), 155, 164, 168 (top), 173, 174; Collection of H.R.H. Princess Maria Pia of Bourbon-Parma: 149 (bottom), 150–51 (all), 179, 180–81, 183; © Photograph National Gem Collection, National Museum of Natural History, Smithsonian, 79; Courtesy of Stefano Papi: 16, 64, 89, 153, 161, 168 (bottom); © RMN – Grand Palais / Art Resource, NY: 177; © Roger-Viollet: 43; Courtesy of Diana Scarisbrick: 105; Courtesy of Sotheby's: 90, 91, 107, 109, 160, 166; Courtesy of Count Toerring-Jettenbach: 100; Photograph by Dario Tettamanzi, Courtesy H.R.H. The Prince of Naples: 156, 158, 178; Photograph by Hank Walker/The LIFE Picture Collection via Getty Images: 111, 159.

WEST
MIDLANDS

W ――――+―――― E

S

DITCH

ESSEX

COLCHESTER

HERTFORDSHIRE

WELWYN GARDEN CITY

LONDON

A Place for Me
Polly Braden & Sally Williams

50 Stories of Finding Home

Dewi Lewis Publishing

Foreword

A Place for Me tells the stories of 50 people living in Civitas homes. It is inspiring, moving and motivating to read about real people's lives, their challenges and their search for greater independence and opportunity that comes from having what we hope will be a home for life based in the community. What the stories tell us is we must never rest until everyone has a place that is appropriate and personal to them.

Civitas is the largest owner of specialist community-based properties for adults of working age in the UK that serves as a base for the delivery of expert care by professional organisations such as National Care Group who kindly acted as the joint sponsor of this new publication. Polly Braden and Sally Williams have been able to tell people's true stories and to use their expertise and passion for the people in the sector without any editorial restrictions or controls being placed on them.

Civitas is supported in this endeavour by its investment manager, Civitas Investment Management that has brought together a multi-disciplined team drawn from a variety of life and work experiences including social housing, the care sector, local authorities, real estate, asset and fund management all with the intention of delivering the best living environment that is possible for each resident as well as servicing the needs of Civitas' shareholders.

Our residents will typically have a lifelong care condition requiring substantial support. These are often young people with a whole life ahead of them who have often resided in hospital or other institutional settings simply because of the disability they experience and the lack of supply of suitably specified community homes.

Paul Bridge
CEO, Social Housing
Civitas Investment Management

Supporting people to enjoy full and active lives in the community within which they live is the cornerstone of good quality care. *A Place for Me* shows what can be achieved when the aspirations of individuals, who need support, during their lives, are put at the heart of planning solutions and where organisations work collaboratively to deliver solutions.

The desire to have a home we call our own is commonly held, but everyone is different and there is no single response to finding the right environment for an individual who may struggle to live with others or requires support to maintain their tenancy. However, even for those with the most complex needs, who have traditionally found the journey into independent living hard, this book shows we should never give up seeking solutions, even if at times it feels that the desired outcome cannot be achieved.

Social Care transformation means the demand for good quality housing and support will continue as, quite rightly, we aim to support individuals in environments that maximise their independence in the least restrictive way. To meet this demand, it is important that good practice is openly shared and all those involved work in a spirit of collaboration, ensuring everyone is aware of the amazing opportunities there are, and what can be achieved for individuals who perhaps for too long have been excluded from their communities.

National Care Group is delighted to be associated with this book and thanks all those who so willingly contributed to it.

Mike Ranson
Commercial Director
National Care Group

Introduction

There are 1.5m people with a learning disability in the UK, according to the charity Mencap. The National Autistic Society estimates that one in ten people are on the autistic spectrum. And a report from the Royal College of Psychiatrists says that one in 100 people will suffer from an episode of schizophrenia at 'some point during their life'. The pain and confusion of having a mind that doesn't work, in certain respects, in the way most other minds do, is felt by millions of people and their families.

Since the 1980s, there has been a drive to remove people once regarded as crazy and peculiar from impersonal, often Victorian, institutions and care for them in the community through a variety of options: living with friends and family, residential care, or supported homes, where trained support staff come to a person's home to help them live free and fulfilled lives.

Care in the community is a movement inspired by optimism, cost (long-term institutional care is generally more expensive), and human rights. All people should be treated as equals and supported to help them lead the lives they choose.

The number of people with a learning disability and/or autism in NHS in-patient units fell from 3,400 in 2012 to 2,055 in March 2021. Although this number has fallen, it is still a long way from the target set by NHS England in 2015 to halve the number by 2019. The same goal has now been extended to 2024. Community support for people with learning disabilities and autism is still 'totally inadequate', according to a recent government inquiry.

In the summer of 2021, photographer Polly Braden and I travelled throughout England and Wales to chronicle the lives of people too often over-looked: adults with learning disabilities and mental health conditions, living in the community. We visited day centres, self-contained flats in converted council blocks, house shares in family-style homes and a mansion in 4.5 acres. The oldest was 69; the youngest 23.

There were challenges. Some people's conditions meant an interview was not easy to sustain. I became even more aware of the importance of precision when asking questions. 'What have you got on today?' I asked a young man with autism, with a view to establishing his routine. 'Jeans and a T-shirt,' he replied.

The people in the pages of this book give us a valuable insight into how they came to live where they do, and the progress and setbacks along the way.

We learn about the damaging effects of living in the wrong place. And the transformation from being in the right one. In some cases, all it took was a change of staff. Carers may be seen as marginal by the outside world, but not to the people they look after.

Above all, the 50 stories in these pages show that home, for many, is not about bricks and mortar, or immaculate surfaces. It is about a feeling. Home is where people feel understood and accepted. As one person says of her move from a five year stay in a psychiatric hospital, to her supported accommodation: 'I love it here. I thought there was nowhere out there for me. Now, I want other people to know, there is a place out there for you.'

Sally Williams

Lord Nelson House, South Quay, Great Yarmouth, Norfolk

Situated on the waterfront of South Quay, in an historic part of the seaside town of Great Yarmouth, Lord Nelson House is a complex of 11 self-contained flats for people with learning disabilities, autism and mental health conditions. Formerly a 1970s local government office, Lord Nelson House opened in April 2019, with an additional floor, wider stairwell, and timber cladding.

There is always a member of staff based in the office on the ground floor, which is equipped with a desk and a bed. In addition, there is one-to-one support, which is pre-arranged as needed. People are encouraged to cook their own food and do their own shopping. They can get up and go to bed when they like, although they are prompted to try and keep to a routine. Some people are allowed to go out alone, and stay out overnight, but everyone must tell the staff where they are going. Pre-pandemic, people spent as much time as they wanted in each other's flats; now visits are limited to one person at a time. The only communal area is the courtyard to the rear of the building. There are plans for a summer house.

Stephen, 23

If you are late for an appointment with Stephen he will tap a finger on his invisible watch and say, 'What time do you call this?'

Stephen has attention deficit disorder (ADD) and autism and an unbound fascination for trucks and cars. Lord Nelson House is on the main road to the harbour and Yarmouth Power Station and Stephen likes to walk with his carer and count the trucks. He waves, they beep their horns. 'I love trucks,' he says. Stephen can also look at a pile of washing and calculate the weight. He says a load of 7kg is required for the washing machine to work effectively. 'If it's under-loaded it doesn't spin very well,' he explains.

He grew up in Great Yarmouth, an only child, and was orphaned in his early twenties. His father died of heart disease in 2015, when Stephen was 17; his mother of cancer nearly two years ago. Losing both parents was 'a complete and utter shock for him,' says Marie, service manager. The legacy of his father's death is a fear of getting fat. 'He'll put a whole meal in the bin rather than eating it because his dad died of heart disease.'

Stephen spent a year or so in a home that offered short-term care before moving into Lord Nelson House in July 2020. He studied at Easton College, in Norwich, where young people with learning disabilities are taught maths and English, as well as vocational skills. Stephen is way ahead verbally with his jokes and irony, but in some basic ways he is clueless. 'He'll trust anyone,' says Marie. About two months ago he invited someone he met on Instagram to his flat. 'He kept wandering downstairs and hovering by the door. I said, "What are you doing?" He said, "My friend is coming." "Your friend? Do you know them?"' Marie recalls. '"No," he replied. He comes across as incredibly articulate and understanding everything, but he doesn't fully understand the risks.' A few days before he went to the flat of someone he had just met on the street. Marie's job is about calibrating how much freedom to give. 'At the moment he's not allowed out on his own, but we're working on it.'

'Stephen is a night owl, often still up at 3am playing racing games on his computer. If someone beats him, he'll throw things, like the controller.' —Sherry, support worker

Willow, 28

Willow's real name is Charlotte, but she prefers 'Willow' after the character from Buffy the Vampire Slayer, the US television series; a shy computer geek, who grew to become a powerful and assertive witch.

Willow has Down's syndrome and learning disabilities. She can appear shy, which, in the same spirit as her namesake, is misleading. She has a hearing impairment in both ears and talks quickly. According to her grandfather, if she doesn't want to engage in a conversation; 'She will look away from you, believing that if she can't see you, you can't see her.'

Willow grew up in Great Yarmouth, with her single mother. When her mother fell ill, Willow was looked after by her aunt. She was in her early twenties when her mother died of a heart attack, aged 52.

In 2016, at the age of 23, Willow moved into Clarence Road, a supported living home, in Great Yarmouth. In October 2019, Norfolk County Council decided the home was 'no longer fit for purpose' and it was closed. Willow went into foster care, before moving into Lord Nelson house about a year ago.

At Lord Nelson House Willow has a carer come to her flat five afternoons a week, from 2pm to 4pm, to provide companionship and instruction in independent-living skills. She can dust and hoover, but needs help lifting hot pans and changing her duvet cover. Carers also take her out shopping, where she likes to buy clothes or colouring books. On Mondays, Willow goes to a day centre, where her schedule includes cooking and colouring. She has regular visits from her aunt and grandfather and before the pandemic, used to do work experience in a café.

'I have a strong character and like to make up my own mind about things', Willow told a review panel two years ago. One example of this was when she was at Clarence Road. A social worker, keen to promote independence, arranged for Willow to take a taxi to and from a social event on her own. The journey there was uneventful. But on the way back, Willow stopped the taxi and got out. She said it was too expensive and wanted to catch a bus instead. The taxi driver alerted social services who reported Willow to the police as a missing person. Thankfully, she returned safely later that night.

Now, when she is out and about, Willow has someone with her at all times.

'Willow's aunt introduced her to ABBA and she listens to ABBA on her ipod, ipad and DVDs. She turns it up very loud so she can hear it.' —Marie, service manager

Shaun, 25

'My stepdad used to support Norwich City and got me into them when I was ten or 11 – not my stepdad now, another one. I've got Norwich City shirts, and my grandad gave me a set of centenary stamps. I watch them play on Sky sports. I share my brother's account.' —Shaun

Shaun has moderate learning disabilities and ADHD. He is able to tell the time, read and write, and manage his money. He is open and engaging and when conversing says exactly what is on his mind. But his family set-up was chaotic and his mother felt it would be detrimental for him to stay at home.

'The system basically places people where there's space and as there wasn't any supported living in Great Yarmouth at that time, he went into residential care,' says Marie, service manager. She has known Shaun for over three years. From the age of 21 to 24 Shaun was in a home where his diet, bedtime routine and freedom were closely monitored. And yet he did not really need such intense supervision. His mental health deteriorated. More capable than those around him, he got less attention from staff, which left him feeling upset and frustrated. The pandemic heightened his feeling of isolation. 'They weren't even allowed to go out for a walk,' says Marie.

In April 2020, the Eastern Learning Disabilities team agreed that Shaun should be moved to a more independent setting.

In July 2020, he moved into a first floor flat at Lord Nelson House, along with a television, table football and a pile of board games. Shaun has gone from being a person who did not cook or clean, to someone who prepares and eats healthy meals at regular times each day and gets himself up and to his work on time. He volunteers in a local YMCA charity shop twice a week, pricing stock and working on the cash till. 'Hopefully I'll get a paid job soon, fingers crossed,' he says. 'I am trying to get early nights, because it does the world of good for me and I feel happier.' He knows local bus routes well and often travels on his own. His dream is to get the bus on his own to Norwich. He is very close to his mother and his brother and sees them regularly.

'He's a lot calmer and we're at the point where we can reduce his meds,' says Marie. He takes fluoxetine and resperidone for anxiety. 'We just need to be 100% certain. He's learnt he can fly and my worry is if he flies too soon, he could get taken advantage of.'

Gloucester Road,
King's Lynn, Norfolk

Gloucester Road is an 'enablement' home in King's Lynn, where people with a range of disabilities live with supervision in family-style homes. Situated on a quiet housing estate close to shops, bus stops, a supermarket and a pub, Gloucester Road is semi-detached with a drive and front garden. Inside there is an open plan kitchen and dining room, a sitting room, wet room, bathroom, and six bedrooms, including one for staff. The rear garden comprises a large patio, small lawn, flowerbeds and a blow-up paddling pool. It is currently occupied by one woman and two men, whose ages range from early twenties to late thirties. Staff work 24 hour shifts, sleeping on site, going to bed at 10pm. People take care of their rooms and do their share of chores and a notice board in the kitchen lists daily cleaning tasks. There are structured activities, such as a quiz night every Thursday and an informal nightly curfew of 10pm, when visitors need to leave in order for staff to go to bed.

From Gloucester Road people can progress to greater independence and minimal supervision at Wootton Road, a bedsit on the outskirts of King's Lynn.

James, 38

In the summer of 2019, James went on a Mediterranean cruise with his father. He can remember every place they visited: Barcelona, Marseille, Naples, and that Valletta is the capital of Malta. If you stand with him on the beach in Hunstanton, a seaside town in Norfolk, he will point out the lighthouse and the gothic tower of 'Boston Stump', a church in Boston, a village thirty miles on the other side of the bay. He can distinguish a barnacle from a whelk. However, reading does not come easily to him. Or cooking. He is getting better at not opening the oven too frequently to check if the food is cooked. But he will still expect a dish with a cooking time of half an hour to be ready in ten minutes. Five years ago, when he was cutting grass in the garden of his last care home, he mowed over the electric cable. 'It exploded. I wasn't allowed to do any mowing after that,' he says.

James has learning disabilities and autism. As smart as he is, he needs supervision. He grew up, the younger of two children, in King's Lynn. His parents separated when he was young and his mother re-married. He became estranged from his father. When James was 16 his mother was diagnosed with breast cancer and she died, two years later. He was not close to his stepfather and with no immediate family to care for him, he was referred to Kensington Road, a supported living house, in King's Lynn. He lived there for 15 years. When James was in his early twenties, his father made contact and the two are now close.

In February 2020, aged 37, James moved to Gloucester Road. He works two days a week as a volunteer with the British Heart Foundation, helping a driver collect donations. It is an opportunity for James to use his navigational ability. Before he sets off, he studies a map, locates the destination. 'And then I remember it,' he says.

James does not handle his own finances. Not because he is not able to budget – but his trusting nature makes him vulnerable to financial abuse. At his previous home a member of staff cloned his bank card and took money out of his account. James does not remember how much.

His dream is to live with his girlfriend in the bedsit in Wootton Road. They met in 2016. She is deaf and has learning disabilities and lives in residential care.

'It's a big step,' says Tara, the team leader (pictured with James on the previous page), 'but we would never rule anything out.'

'My dad is general manager of a garage in King's Lynn, which used to mend all the Formula One cars. In 2006 I met Martin Brundle, the racing driver, because he lives in King's Lynn, and he gave me a picture. I keep it in my bedroom.' —James

Sheila, 25

'I bought my mum a bracelet when I was 12 or 13. It took me ages to save up my pocket money. I keep it in a special box, along with a china plate mum used to keep on the wall.' —Sheila

On the morning of 28 February 2014, Sheila, then 19, went into her mother's bedroom to wake her up. Sheila was her mother's carer. 'I got mum her tablets and everything ready,' she says, now. But her mother did not move. She had suffered a fatal heart attack. 'I had to call the ambulance myself.'

Sheila grew up in King's Lynn, one of three children and the only girl. She and one of her older brother's were diagnosed with learning disabilities. Her father left when she was a baby and her mother's relationship with her second husband was fraught. 'He had anger problems and used to chuck things at my mum.' The relationship broke down when Sheila was in her teens. When her mother's health deteriorated Sheila was the only one at home. The brother with learning disabilities was living in a residential care home; the other had moved to Wales.

Since her mother's death, Sheila has lived in two supported living homes in King's Lynn: the Anchor and from the age of 23 to 24, Gloucester Road. 'She found it hard to understand what had happened, and to process her grief,' says Rachael, the registered manager, who has known Sheila for nearly three years. 'She'd cry and become withdrawn. She's not a big talker, anyway, but she became even quieter.'

She still has down moments about her mother. 'We can sense there's something wrong and so we sit and have a chat with her,' says Rachael.

But Sheila continued to progress. In August 2020, staff felt she was ready to be more independent and Sheila moved into a bedsit in Wootton Road. The first thing she did was paint her bed/sitting room purple and grey.

Support has dropped from 24 hours a day to 10 hours a week. But the office is just downstairs. 'And if she has any concerns, she'll send me a WhatsApp message, day or night,' says Rachael.

There was a minor blip a few months ago. Sheila was on the internet when her eye was caught by an advert by Snapfish, a company which prints photographs onto a range of objects, from birthday cards to cushions. Sheila ordered a premium canvas print of her aunt's dog, Milly. 'I ordered one and then got the urge to do more,' she says. She ordered six in total, which amounted to half of her weekly budget.

Sheila has now agreed to speak to staff when she shops online.

Meadowside, Tavistock, Devon

Meadowside is a large, Victorian, four-storey house situated close to the centre of Tavistock, a market town on the edge of Dartmoor. For 30 years it was run as a private residential care home, for people with long-standing mental health needs, many of whom had a diagnosis of paranoid schizophrenia. It had 11 beds, and most of the residents were long-term. Staff would cook a main meal every evening and a roast on Sunday. The atmosphere was 'happy' and 'relaxed', according to an inspection by the Care Quality Commission in 2016. 'People and staff appeared comfortable in each other's presence, interacting ... with laugher and light banter.'

In 2019 Meadowside was sold and re-designated to supported living. Six of the original 10 residents remained, as did five of the ten staff. While the building was being refurbished, residents were moved to a nearby care home. They returned in the spring of 2020. Meadowside currently has nine residents, and has broadened its remit to include learning disabilities. Between 8am and 8pm there are two members of staff on duty and one person works the night shift, from 8pm to 8am. An extra member of staff is on duty for nine hours during the day, for one-to-one support.

All the bedrooms now have ensuite bathrooms and the smoking lounge has been repurposed as a second kitchen. The main sitting room is open plan, with a dining area and French windows lead to a garden.

Residents are encouraged to do their own cooking and cleaning and to look after communal areas. They still have a roast cooked for them on Sundays.

Brian, 53

Brian's life has changed a great deal since Meadowside's move to supported living. For 27 years he had his room cleaned, his meals cooked and his washing up done. Today, however, he is cooking his tea of a burger and cheese sandwich, on sliced white bread. He puts the burgers in the oven and checks his watch. Brian spends a considerable amount of his day checking the time. 'I am lost without a watch,' he says. In a strange way, this means he is adapting well to cooking for himself, as everything is timed very carefully.

'Brian is probably one of our biggest success stories,' says Ryan, 33, the senior mental health support worker. He has known Brian for five years. 'He doesn't come to us and say, when's tea ready, like the others. We just sniff the air and say, "Brian's already done it."'

Brian was born in Plymouth, one of two children. His parents divorced when he was young and he lived with his mother. 'I haven't seen my dad for over 25 years,' he says, now. In 1993, he was living in a bedsit in Plymouth, training to be a mechanic, when he had a breakdown. He was admitted to Moorhaven, a psychiatric hospital in Ivybridge and diagnosed with paranoid schizophrenia. After a total of 12 weeks in Moorhaven, at the age of 25, he moved into Meadowside. 'I've been here ever since,' he says.

In recent years Brian has had no psychotic episodes or symptoms of schizophrenia. Medication is possibly containing the condition. Staff suspect his obsessive watch checking is OCD-related. He also suffers from chronic obstructive pulmonary disease (COPD), where the lungs become inflamed and damaged.

Brian has hundreds of DVDs and watches a film a day in his bedroom. He likes most genres, except musicals. He dislikes *Singing in the Rain*. He goes to the supermarket to buy food, but likes to have staff with him. 'Sometimes I get wobbly on my legs. I can't walk very far or stand for long,' he says.

Brian's new bedroom has an ensuite bathroom, but it is smaller, with only two plug sockets. His television, Blu-ray player, stereo, kettle, alarm clock and nebuliser are plugged into extension leads. He gets harried by staff to do his share of the cleaning: this week, it was two toilets and the sitting room. If he wants a cigarette, he has to go to the smoking shelter in the garden.

'To be honest I liked it the way it was before,' he says. 'Staff did a lot more things for us back then.'

'I've had about 100 watches and bought one for my birthday for £20. I didn't know it didn't have a second hand when I got it. I like to have a second hand so I can see the seconds ticking away.' —Brian

Carole, 54

'Staff from the other house got me a record player. I've had it about a year. My favourite music is Queen, Elvis and David Essex.' —Carole

Carole likes clothes, nail varnish and potato pie. She changes her outfit three times a day and has stickers on her chest of drawers to remind her what goes where: underwear, pyjamas, leggings, cardigans and so on. Her style is colourful with bold prints and patterns and her taste in music dates from the 1970s.

Carole has an historic diagnosis of learning disabilities and schizoaffective disorder, which is marked by a combination of schizophrenia symptoms, such as hallucinations or delusions, and mood order symptoms, such as depression or mania. She was previously sectioned in a secure hospital for six months.

Carole moved into Meadowside two months ago, after her residential care home in Yelverton, Devon, closed. It is a dramatic change for her. She is the only woman at Meadowside and in contrast to her previous home, is being urged to fulfill her potential and gain greater independence.

'If we were to leave her to her own devices all day, like they do in some supported living homes, she wouldn't have a clue,' says a support worker. 'She'd come in and say, is tea ready? We try to involve her as much as we can. But her focus is on her personal CD player at the moment.'

'My stepdad found a painting by my mum in the attic after she died. She painted it when she was in college training to be a nurse. My mum used to hide her paintings. She didn't want us to see them. I look at it and feel happy. She had a good life.' —Simon

Simon, 52

Simon arrived at Meadowside about six months ago, in a slump of depression. His relationship of twenty-odd years had recently come to an end. He had met his girlfriend at a supported living home in Buckfastleigh, Devon, when he was 30 and she was 25. He has learning disabilities, she has autism. Their relationship flourished and they even shared the same room at one point. But in the last few years things soured. Quarrels intensified during the pandemic. 'We had to stay indoors. She got stressed and I got upset.' It was agreed they should separate. 'I feel better now,' Simon says. Calm emanates from him. Occasionally he can still be a bit verbally aggressive. But it is short-lived.

Simon was born in Havant, Hampshire, the older of two children, to a factory worker and a nurse. It was an unhappy household. 'Dad kept shouting at me,' he says. His parents separated when he was six and he lived with his mother. She remarried and the family moved to Totnes, in Devon. He suffered hugely when his mother died in 2013, when he was 47, but he remains close to his stepfather.

Simon was bullied at his local school, because he could not follow the lessons. He was diagnosed with learning disabilities when he was young. 'My mum used to help me in the evenings.' He still has difficulties telling the time. 'I can do the o'clocks but not the bits inbetween.' He gets confused over coins and their value. 'I worry about money. I feel I haven't got any.' Staff will take him to the cashpoint so he can check his balance. 'Then I see I have plenty.' He left school at 16, but, he says, 'Mum wasn't very happy with me sitting around.' At 18, social workers referred him to the supported living home in Buckfastleigh, where he stayed for over 30 years.

His sense of liberty has expanded since leaving. 'Managers didn't like us going out like we do here. I like Tavistock. There's a lot more going on.'

Simon now has a bedroom on the ground floor. He chose dusky pink for the walls. He likes to watch *Dr Who*, is interested trains and goes for coffee at Bob's East End cafe (pictured left), in Tavistock market. He is very taken with the stall selling model railways. Staff 'never get cross' if he sleeps in beyond 8am. He finds Meadowside 'very homely.' 'I will be here for the rest of my life,' he says.

Mike, 69

'I like drawing birds, avocets, kittiwakes, choughs, peregrine falcons, gulls. It keeps my mind active and away from wickedness.' —Mike

Mike is not a great talker, he prefers to walk – through Tavistock and up the hill to the viaduct, or a four-hour tramp across the open moorland and granite of Dartmoor. When Mike was 17 and a patient at Moorhaven psychiatric hospital, when he was allowed home at weekends, he would walk from the hospital in Ivybridge to his home near Plymouth, a distance of some 12 miles.

Mike was born in a village in South Hams, the older of two boys and he believes, his mother's least favourite. 'I was always the villain,' he says, now. 'She didn't particularly like me for some reason.'

In 1969, aged 17, he was working as a carpenter and a joiner when he had a breakdown. 'It buggered everything up. I got depressed and sat in a chair and didn't want to go out.' There was also an incident with his mother. 'She used to get a wet towel and hit me on the legs and one day I pushed her over in the garden.'

He was admitted to Moorhaven where he was diagnosed with paranoid schizophrenia. 'I've got over it now. I take my medicine and I'm alright,' he says. Mike likes to come across as strong minded. He went on to work as a labourer and lived independently in Wales for some years, before moving to Tavistock in 2006.

In 2014, when he was 62, social workers referred him to Meadowside. 'They thought I needed a bit more help.'

He is interested in football and birds, but not in cooking. He mostly buys sandwiches and quiches from the supermarket. 'He doesn't like fire, even in an oven,' says Ryan, the senior mental health support worker. 'There is quite a lot of fear around fire and hot things.'

Mike invites slight awe from the other residents. He is always on the move, has a playful sense of the absurd and an extraordinary laugh. He can also get moody. Ryan's strategy is to talk to him about football, or they go to a coffee shop or out for a walk.

MEADOWSIDE, TAVISTOCK, DEVON

My Life

I am not saying I am perfect
In fact I am far from it
I am just saying I am worth it

Sometimes the world seems
a very dark place
But the staff at Clark House
are my saving grace

They are there when I am up
and there when I am down
Always smiles on their faces
and never a frown

V Hadbock

Clark House, Murton, County Durham

Clark House is a complex of 14 supported flats for people with mild learning disabilities, personality disorders and cerebral palsy, in the centre of Murton, a former mining town in County Durham. Originally a warden-run home for 'aged miners' who had never married or for widows who had to give up colliery houses, Clark House opened as a supported home in 1987.

It currently has 14 residents (including a woman from when it was an aged miners' home), whose ages range from 30 to 80. Six are in their thirties. Two are independent and require minimum supervision. There are up to eight staff on duty during the day and two at night.

There is a communal sitting room, where residents meet for coffee mornings and craft sessions on weekends. Other activities include a day centre and a Mencap club, where the charity runs classes in crafts and living skills. Families are allowed to visit as they please.

Hope (a pseudonym), 33

Shortly after 10am on a snowy morning in the winter of 2012, two policemen and two doctors knocked on the door of Hope's home in Consett, County Durham. Hope, then 24, was instructed to get in the car. 'I didn't even have time to get ready,' she says, now. Hope was sectioned. She was driven for an hour to a psychiatric hospital where she was detained in a locked ward. This was to be Hope's home for five years.

Hope grew up in Stanley, near Gateshead, in County Durham, the second of four girls. Her father worked in a fish and chip shop and her mother was a carer for Hope's grandmother.

When she was seven, teachers began to suspect she had mild learning disabilities and she was moved to a special school. At 16 she found a class for young people with learning disabilities at a mainstream college in Consett. But the size of the college was too much for her, and she dropped out after a year.

In 2009, aged 21, Hope left home and moved into supported accommodation in Stanley. She was evicted after two months. A resident hit her, and she gave him a shove. 'He went flying. He must have not been good on his feet.' She lasted two days in her second home. 'I got sexually abused by one of the lads living there,' she says. The third home was happier, and Hope settled down. But after a year or so, Hope broke down during a session with her counsellor. It transpired she was being groomed by a member of staff who had sexually assaulted her twice. 'I thought he was a friend,' she says.

By now she was in a fragile condition. 'I was a mess. Lashing out, kicking out, just really hurting people because everyone hurt me. I was constantly getting arrested and going to court.' She tried to take her life.

After being admitted to the psychiatric hospital in 2012, she was diagnosed with paranoid schizophrenia, emotionally unstable personality disorder, and post traumatic stress disorder.

Hope was not a docile patient. 'I was angry with the world, I was upset. I had no-one to turn to.'

She saw her mother once a month, but, she says, 'I didn't see my dad or sisters for nearly five years. I would just look at four walls, and think, what am I fighting for? There was nothing, just that feeling of being sad, vulnerable and lonely.'

In 2016, the hospital psychiatrists planned to transfer Hope to a high secure unit in Wales. But one consultant took her aside. 'She said, "If you take your medication, do your counselling sessions, you could be out of here. If you carry on, you'll be sent away." She changed my life.'

In 2017, only a year later, aged 29, Hope was able to move into Clark House. She lives in a one-bedroom flat on the ground floor, surrounded by her artwork and motivational quotes: 'Believe in yourself. You can do it!'

'My social worker said, "I'll find a good, safe place for you" and honestly, I love it here,' she says. She likes drawing, making things, baking.

Hope has a carer 24 hours a day. 'Sometimes she'll wake you in the night,' says Michelle, her support worker, 'because she's having flashbacks and needs reassurance and we get up and have a cup of tea.'

'I don't want people to go through what I went through, sad with no hope,' she says. 'I thought there was nothing out there for me, until I came here. Now, I want other people to know, there is a place out there for you.'

'When I first moved here, I wrote and drew a book called Devil Cat Meet Angel Cat. Both are me! Devil Cat felt scared at first but there were nice staff to help and welcome her. Slowly but surely Devil Cat turned into Angel Cat. Now Angel Cat is happy and more confident to go on adventures.' —Hope

Cornwall Court, Murton,
County Durham

Situated in Murton, a former mining town in County Durham, Cornwall Court provides supported accommodation for people with complex needs, including autism, learning disabilities, personality disorders, schizophrenia and drug and alcohol abuse. Originally a 1970s council block on the Cornwall housing estate (the name dates back to the copper and tin miners who migrated from Cornwall to the north east in the late 1870s), Cornwall Court is a two-storey L-shaped building with 17 one bedroom flats and four bedsits. Referrals are from psychiatric units, prisons, residential care homes and families.

The ratio is 11 staff to 21 people, including a support worker on night duty from 10pm to 7am. (There is currently only a core team of five staff due to staff shortages and illness.) There is a communal courtyard with wooden benches and surrounding trees. Activities include football, badminton, and bingo. Dalton Park, a new outlet with shops, cafes and supermarkets, is a four-minute drive away.

Ruth, 66

'Ruth is good at sewing and has a sewing machine, but in her previous home there were restrictions. It had to be risk assessed and she couldn't get it out when high-risk people were about. Here, she can get her sewing machine out when she wants and leave it out for two or three days. It's her choice.' —June, manager

On 18 January 2021, Ruth moved into Cornwall Court. For over forty years, Ruth had been in and out of residential care homes where she didn't have the freedom to decide when to eat or what to watch on television. At 66, Ruth finally had a key to her own flat.

Ruth has adjusted well. 'I don't find anything hard,' she says. But Ben, she adds, was a bit unsettled at first. Ben, a doll, has been Ruth's companion for years; helping her stave off panic attacks as well as providing a bridge between her emotions and the outside world. When one doll breaks, she gets another. They are always called Ben. 'Ben's my little favourite,' she says.

Ben, she explained, could not cope with the bath, as the previous home had a shower. He also resented the fact that other residents seemed to get more attention. 'He's a bit of a whingey baby,' says Ruth. 'But he's settled now.'

Ruth grew up, the fifth of eight children, in Bearpark, a former mining village, some three miles west of Durham. Her parents worked in Ransome & Miles, a ball bearing factory in Annfield Plain, a twenty minute drive away. Ruth was the odd one out. She found reading and writing difficult: 'If there's a long word, I have trouble spelling it out.'

She left school at 16 and attended a day centre where she learned to sew. Ruth moved into residential care aged 21, where she was diagnosed with mild learning disabilities. Apart from a few periods of staying with different members of her family, she thereafter lived in a succession of care homes, the most recent for 13 years.

In 2020, when Ruth was 66, she decided she wanted to live on her own, and asked her social worker to be moved.

Staff at the care home and Ruth's family were unsure. June, the manager of Cornwall Court, lists their concerns: 'She'd never lived on her own. There's no way she could manage on her own. She would go downhill.'

They pointed to a recent episode, where Ruth had lashed out and scratched a woman's face. It was one of seven or so incidents in the previous six months, and June believes the 'animosity' was caused by the strain of living in such a restrictive setting. 'She had no personal space. She'd go down to the kitchen and there was always somebody in there. She used to go to her room and sleep all afternoon. She doesn't nap here.'

June and Ruth's social worker championed the move to Cornwall Court. On 18 January 2021, a removal van drove through the gates, loaded with a single bed, sewing machine, clothes and several babygros.

The first time Ruth went to the supermarket she spent five hours just looking at the shelves. Food was always delivered to her residential care homes. She was told what to eat. Now she makes mince and dumplings, or spaghetti bolognaise in her slow cooker. A carer is with her for 33 hours each week to assist with cooking and shopping. Ruth does her own washing, cleaning and ironing. But dependency is a difficult habit to break. She still doesn't feel confident to go out on her own.

'She has dignity, privacy,' says June. 'She can shut the door, close her blinds, come and go as she pleases.'

June, 49

'I love my job,' says June, the manager of Cornwall Court. 'I would work seven days a week, because this isn't just a job, you're making such a difference to people.'

She is a great believer in the ethos of supporting people to live independently in the community. 'I've been in the world of care for 37 years and have seen a lot of older people put in institutions. Anyone who was "mad" was locked up…and left under the radar.'

'We've made such a difference to Ruth,' June continues. 'She was buzzing the day she got into the bath on her own. If things like that had happened when she was in her late teens, she could have been living on her own now. She might have been married.'

CORNWALL COURT, MURTON, COUNTY DURHAM

Ty Cwm Gwendraeth, Tumble,
Llanelli, Carmarthenshire

Ty Cum Gwendraeth is a nursing care home for people with complex physical and mental health conditions, learning disabilities, neurological illnesses and acquired brain injuries. Opened last August, on the site of a former community hospital, it is a complex of low-lying buildings with 49 beds organised into five units. These include a unit of eight for people with learning disabilities. Each unit is semi-autonomous, with its own kitchen, sitting and dining rooms, laundry, offices, and garden. The nursing home also has separate accommodation for those who find it hard to live amongst others. There is a full-time staff of 130 – including nurses, carers, psychologists, occupational and speech therapists. The main building, or 'social club', has a large hydrotherapy pool, gym and a 'club house' with a bar for soft drinks, an assortment of chairs and small tables, several sofas and a large pull-down projector.

Jon, 55

Jon was a project manager with a 27-year career in construction. He was practical, effective and good at maths. Around six years ago, he suddenly couldn't remember calculations for planning applications and paid the same bill twice.

'I thought, oh my God, he's got a brain tumour,' says Jane, 55, his wife, a retired district nurse (pictured with Jon). They went to see a GP who asked Jon to list the months of the year backwards. 'December, November...' answered Jon. He couldn't work out what came next. Nor was he able to draw a clock. 'All the numbers were bunched on one side,' says Jane. 'We went home that evening and cried. He realised there was something seriously wrong.'

Jon was diagnosed with dementia in September 2015. He was 49. The future they imagined together – retire by 60, buy a camper van, drive around Europe – was gone. Jane took a career break and with a modest inheritance from her father, bought a caravan and drove them around Scotland for three weeks. Jon also managed to walk his daughter down the aisle on her wedding day the following year, in 2016.

By September 2019, Jon's condition had worsened. His mood swings and bizarre outbursts were more pronounced. He lost any sense of danger and would try to get out of a moving car. He was hospitalised in a mental health ward for 17 months. 'He was constantly on his feet, looking for a way out,' says Jane. 'He had no concept of why he was there. He often used to think he was on a job. He'd move furniture as if he was clearing things out of the way.'

Jon moved into Ty Cwm Gwendraeth last February, but the home was in lockdown and Jane could not see him for three months. 'When I was able to visit again I saw a real improvement. He would lift his head up and make direct eye contact.'

Jon now lacks the motor control to feed or dress himself. He can walk if someone holds him, but he wears a protective head guard because he is prone to trips and falls.

Jane likes to sit close, stroke his arm, gently touch his leg. 'That's why I was so glad to be able to see him again, because he responds so much to the sensory, to touching, rather than words on a Skype call.' They have been married for 30 years. Before his diagnosis, 'it wasn't perfect but it was pretty good. We were a very close couple.'

'Jon was always a passionate supporter of the Wales rugby team. He has a lot of Wales Rugby Union tops because he used to buy a new one every time the team changed its kit. He'd wear them in the evening or weekends, and even now it's what he wears most days. It's a connection with what was important to him.' —Jane

Hilary, 66

'When Hilary was in her 40s she had a mid-life crisis: she dyed her hair red, got three tattoos and decided to do a degree in pediatric nursing. It took her three years. She fitted it around her job as a general nurse. There is a photo of us at her graduation ceremony. She keeps it in her bedroom' —Jeff

Jeff and Hilary lived in Swansea, south Wales, where he had been a postman for 42 years and she a nurse for 40. They had met at a dance when Hilary was training and were married a year later. Their children are now 44 and 43.

The first signs were subtle: Hilary left patients' notes out rather than filing them away; she would go on her usual morning walk to pick up her paper, forgetting she had already collected it.

Hilary was only 58 when she was diagnosed with dementia in 2013. 'We hoped the disease wouldn't take hold too quickly,' says Jeff, now 69. 'We hoped it would be slow.' He took early redundancy. They bought a caravan by the sea and a dog with a froth of white fur. 'She'd always wanted a dog,' he says.

But worse was to come, four years after the diagnosis. 'One day we came back from shopping in Swansea and I said, "Would you like a cup of tea, love?" I went to the kitchen, came back in and she looked at me and said, "Who are you?" She started screaming and hitting me. She thought I was a burglar,' he says. 'From then on she never wanted to be in a room with me, alone. She forgot I was her husband.'

Hilary spent six months in a residential care home in Swansea, where her condition deteriorated further. She started hurting herself and refused to eat. 'She'd hold her mouth tight shut. They didn't have enough staff to feed her, so I'd go up every day.'

Hilary moved to Ty Cwm Gwendraeth in December 2016. She has an ensuite bathroom, and a smart TV. Staff dye her hair and take her on trips – most recently to Folly Farm Adventure Park and Zoo. She is unable to dress herself, and has lost the basic faculty of self-care. Meals are a challenge and staff try to coax her with different foods, chopped small or liquidised. She has dropped from size 18 to size 10. She no longer speaks anymore. Jeff sold the caravan 18 months ago.

Before Covid, Jeff would visit her most days and spend hours with her. Currently he is allotted 45 minutes with her in the visiting area, at most twice a week. 'I can't talk to her when I do see her. I just hold her hand, that's all. She does pull me towards her, but I can't tell her what's been happening, or how the dog is, because I don't think she understands.'

St Gwynllyw Living Skills and Education Centre, Newport

St Gwynllyw is a day centre for people to learn and practice skills to help them in the future. Occupying a municipal site near a Methodist church, in east Newport, St Gwynllyw operates from two buildings: Cadoc is for people with complex disabilities and higher needs; Gwladys is for those with autism and mild to moderate learning disabilities. Established two years ago, the centre is open from 8.30am to 3pm and has a full time staff of 15, including educational leads, senior support workers and care staff who specialise in drama. Referrals come from families, the local authority, or local health board, and most are young, aged from 18 to 28. Some already live in supported living houses like New Station House, which is nearby; for others a move to supported living and greater independence is their aim.

Inside the décor is bright and cheery, with wipe clean surfaces and easy-access corridors. Facilities include two practice kitchens, and a utility training area with a washing machine, tumble dryer and ironing board to teach people in the basics of day-to-day care. There is an education zone with classes in literacy and numeracy, a workshop to learn basic DIY skills, as well as opportunities to trampoline, engage in sport and spend time in the music room, art studio and drama space. A 'snooze room' is also available.

Jeremy, 54

'Jeremy loves airplanes. It's in our family. My father was a
squadron leader in the RAF, mum worked as a plotter for the
RAF during the second world war and Toby served with the RAF
for six years. In 2017, Toby took Jeremy to the Red Arrows base
at RAF Scampton, in Lincolnshire. Jeremy met all the pilots and
saw the planes take off. He loved it! He has lots of Red Arrows
memorabilia, including a signed uniform, DVDS and a duvet
cover. The blinds in his bedroom at New Station House are in
the colours of the Red Arrows: red, white and blue.' —Sue

Jeremy is well known at St Gwynllyw, and not just because he attends three days a week. Staff and students know him from other day centres and respite care homes in the town. 'Newport is a small place for people with disabilities,' says his mother Sue, 74 (pictured with Jeremy) a retired principal officer for social services. 'They feel part of a community.'

Jeremy has quadraplegic cerebral palsy, a consequence of his birth. Where a normal pregnancy is 37 to 41 weeks long, Jeremy was born at just under 44 weeks. 'They wouldn't allow that today,' says Sue. 'Postmaturity' in pregnancy brings with it the risk of weight loss and poor oxygen supply, as the placenta may not function as well.

Jeremy's legs are more affected than his arms, and his left side more so than his right. In addition, he has learning disabilities, which cause him to have poor concentration. He needs help around the clock. He cannot get dressed and undressed without help and is unable to manage money or use public transport. As he gets older, he is deteriorating further.

As a baby, Jeremy was unable to suckle, and Sue had to feed him using a pipette, dropping formula milk into the corner of his mouth. He finally crawled at five years and stood with a walker at ten.

Sue went on to have another son, Toby, with her husband, but they separated when Jeremy was six. 'Toby has played a major part in Jeremy's life. Mum's been the carer, cook, cleaner, pick him up and sort him out, but Toby's been able to give him lots of fun.' Two subsequent marriages also ended in divorce. 'They couldn't cope with Jeremy,' she says, now. 'My son came first. End of story.'

Jeremy was educated at special needs day schools, and then went to day centres. He always lived at home. 'I was adamant he was going to stay with me as long as I could possibly manage him,' says Sue. She was diagnosed with breast cancer in 2013 (which is now in remission); and although fully mobile, had two mild strokes the following year and another earlier this year.

But four years ago, when Sue was 70, and newly divorced for the third time, Jeremy turned to her and said, 'Now I don't have to look after you anymore, I want to live with my friends.' Sue took a step back. 'I thought I was the carer, but for all his problems, he saw that as his role: he was looking after me.'

In 2018, aged 50, Jeremy moved into New Station House, where he lives with six people, some of whom were already friends. With the help of support workers Jeremy does his own dishes and puts his laundry into the washing machine. A carer drives him in his mobility car, to and from St Gwynllyw, where he likes doing drama and making music.

'I did everything to dissuade him from going into supported living,' says Sue. 'Everything! But he is so happy. They go on holidays, to concerts, to the cinema, on day trips, out to meals. I couldn't do that at my age. He has independence. He can choose what he wants to do and not be dictated by me.'

Andrew, 35

When Andrew was a toddler, he hardly slept beyond 3am. 'We'd come downstairs and watch Thomas the Tank Engine, over and over again,' says his mother, Gail, 65 (pictured with Andrew). A former retail manager, she is married to Tony, 65, a retired product supervisor at a chemical plant and who is now disabled after a brain haemorrhage. They live in Newport. Andrew is the youngest of their three children.

At seven, Andrew was only able to say two words: 'Thomas' and 'Gail' and would only eat mashed potato and crisps. He was diagnosed with autism that same year.

Andrew has an excellent memory. He can recall the ending of every episode of the BBC sitcom Only Fools and Horses but would have difficulty understanding the question if you asked him to tell you them. He is a fluent reader, but he is unable to cook or do his laundry and will wear a thick jumper on a hot day. However, he can appear more 'normal' than he is.

'Years ago, he walked into my mother-in-law's and said, "Nan, can I have sausage and chips, please?"' Gail recalls. 'She made them and he sat down and just looked at them.' She thinks Andrew overheard someone say it, as he often repeats words and phrases, without any apparent understanding of their meaning. 'He'll answer questions with the first thing that comes into his head,' she says.

Andrew was happy at his special needs primary school and thrived at a secondary school for autistic children. But he only lasted a month at a residential college for adults with special needs in Dorset. 'They couldn't handle him,' says Gail. He broke the bed by jumping on it and punched a hole in the wall. She suspects the school was taken in by his apparent competence and did not realise the extent of his limitations.

He moved back with his parents and two years later, aged 21, went to a local home for young adults with autism. Andrew had his own flat, but the care was inadequate. 'He'd be in dirty clothes. You could smell the BO on him. I'd ask the carers, "Why?" And they'd say, "He chose them."' Gail still agonises over why she let Andrew stay there for five years. 'I didn't think there'd be anything better. Now I realise I could have stopped it earlier.'

In 2015 he moved into New Station House where he has a large room on the top floor. He goes to St Gwynllyw two days a week where he likes to play football and rugby and watch films on the TV in reception. 'I don't worry about him anymore,' says Gail. 'He's the happiest he's ever been.'

'Andrew has to have the Mirror every single day. He either collects it first thing from the newsagents, or at the end of the day. He walks to the shop with one of the carers, then he'll go in and buy it and get the receipt. When he gets back, he takes it upstairs to his bedroom. He likes the news and sport best.' —Stacey, support worker

Shannon, 25

'I do Tik Tok dancing on Wednesdays with my other friends outside of St Gwynllyw. You have to scroll up and if you like the song, you click it and then you make up your own dance moves. I have a special [private] account. I don't bring my phone to St Gwynllyw because I'm supposed to socialise in here.' —Shannon

Shannon loves cheese, chips and gravy, clothes shopping and Justin Bieber. While almost everyone else listens to music when they get to St Gwynllyw in the mornings, Shannon watches cat videos. She has autism and severe learning disabilities and is aware of her shortcomings. 'I'm not good at money or time,' she says. 'I know what a ten [pound note] and a five is, but I don't know loose change.' Her mother, Kerry, a teaching assistant, worries this puts her at risk of getting ripped off. 'That's why I always get a receipt and Mum staples it in the folder.' Shannon tried to overcome her difficulties with telling the time during lockdown. 'I can tell one o'clock and two o'clock and that's it.'

She has an older brother and has always lived at home. Some people who come to St Gwynllyw are inward and reserved. But Shannon is outgoing. She likes to please those around her and is loving. She comes to St Gwynllyw daily and is delighted with everything: art – 'I've made elephants and bumble bees', cooking, gardening, cleaning and helping Mackenzie, the support worker (pictured with Shannon), with drama workshops. 'We're doing a summer show!'

Her dream is to share a house with friends. 'Like with boys my own age and girls my own age. People I can talk to, go out with and socialise. I really want to move to supported living. We've just got to find the right place for me.'

Stuart, 30

Stuart is a movie buff. He also likes animals. What sets him apart from his peers is the depth of his interest in them. For example, he knows which member of staff at St Gwynllyw has what pet. Laura has a springer spaniel called Winston; Gina, a boxer called Max and Lorna has a beagle cocker spaniel mix called Logan. Stuart asks many questions: what do you say to your dog? Does he lick your hand? Do you say good boy? Does he like sitting on your lap? Where does he like being stroked? His expression is one of utter focus. He holds up his hand and strokes the air as if imagining the feeling of fur.

Stuart has mild learning disabilities and autism. His mind works like an Internet search engine. 'He'll latch onto a subject, particularly animals, and if he hears something, he'll memorise it, but not necessarily understand what it means,' his mother, Suzanne, explains. 'It's a way of deflecting attention.'

Stuart lives in Newport, with his dad, Stephen, a steel worker and Suzanne, an assistant at an opticians. He has an older sister who also lives in Newport.

Stuart was diagnosed with autism as a child. 'He has a brilliant memory for certain things,' says Suzanne. When he watches a Harry Potter film, for instance, he will parrot the dialogue ahead of the actors on the screen. But he is not able to tell the time and has no idea how to cross a road. 'He'll never be able to go out on his own,' says Suzanne.

He has a set routine: the day centre on Monday and Tuesdays; St Gwynllyw on Wednesdays, where, in nice weather, he enjoys playing outdoor games. He brings a packed lunch, always with the same sandwich: marmite on sliced white bread.

On Thursdays Stuart goes to a class for adults with learning disabilities, and he has gardening club on Fridays. He has a support worker who takes him out two evenings a week, usually to the cinema. Before the pandemic, he used to spend one weekend a month at Centrica, a respite care home in Newport.

'I've talked to Stuart about moving into supported living, but he doesn't seem bothered,' says Suzanne. 'It would be a good thing – he's 30 now – so hopefully in the next couple of years.'

'Stuart is passionate about superheros. The other day we were working on sun safety and Stuart had to design a sunhat. His idea was a Human Torch sunhat. The Human Torch is a superhero from Marvel. His superpower is that he doesn't get hurt by heat or flames. His has a protective aura. So, Stuart's Human Torch sunhat will protect you from the sun.' —Ieuan, support worker

Heathfield Apartments,
Swansea

Situated in a four-storey building in a residential area close to Swansea city centre, Heathfield Apartments helps people who have been in care to become more independent, but within a supervised setting. There are 13 self-contained flats: 10 in the main house, two in a side building, and one in the 'summer house.' Communal areas include a lounge, coffee bar and Hobby Hut which runs art and yoga classes and other activities such as quizzes. There are six full-time staff on duty during the day – five support carers, and one activities coordinator – plus two at night. Their job is to help with everything from cleaning and cooking, accompanying people when they go into town, and dealing with any crises.

Paul, 48

'I'm not sentimental, the kind of person that gets attached to things. What happened in the past stays in the past. To be honest, I don't plan for the future either. I don't make plans for next week or the week after, because you just don't know what's going to happen.' —Paul

In February 2019 Paul was in the bathroom of his brother's flat, when he suddenly felt dizzy, and collapsed into the shower cubicle. Paul had been feeling odd for some months. He had had tremendous headaches, blurry vision and pain in his left hand. 'I didn't know if I was having a stroke, heart attack, or a nervous breakdown.'

He was admitted to hospital, where it was eventually determined that inflammation on his brain had caused a catastrophic stroke. He was paralysed down the left side of his body. 'I didn't think I'd ever walk again,' he says, now. 'I had a vision of me on a Zimmer frame for the rest of my life.'

Up until that point, Paul says, life had been 'excellent'. Boisterous and outgoing, he had his own flat near his brother and had worked in a variety of jobs, including being a postman and a sorter for Amazon. He liked going to the pub with 'the boys' and working out in the gym.

Following his stroke, Paul spent six and a half months on the neurological ward of a hospital in Swansea. He was then transferred to a neurological rehabilitation unit in Neath Port Talbot Hospital. 'They got me walking again. It was amazing. I was so chuffed.'

He moved into Heathfield Apartments 18 months ago, where he has had to adjust to his body not functioning as well as it used to. His sight, hearing and short term memory were all damaged by the stroke. 'I can't play snooker, pool, can't do darts.' If he tries to run, he collapses, owing to a lack of coordination because his brain cannot send the right messages

Where he used to lift 40kg in the gym, now he can manage 3kg. Picking up cups and coins with his left hand requires a lot of effort. He has been told he will never work again. 'I've worked all my life. I'd like to work, but it's not going to happen. That's the way it is.' He has received a lot of help, the most affecting from Katy, the activities coordinator. She plays Velcro catch ball with him, does jigsaws with him at home, and is by his side when he goes to the bank, shops, or gets his hair cut. She also tries to get him to cook, but he prefers take-aways. 'I was 12 stone when I went into hospital. Now I'm 19 stone!'

He says he is a different person: he wears glasses, no longer drinks and has surprised himself by doing guided meditations with the help of a wellness app. 'I always thought that stuff was rubbish!'

He has managed very well and is due to move into his own flat in two weeks.

Ty Newydd, Maesteg, near Port Talbot, west Glamorgan

Set in Maesteg, a former mining town in the Lynfii valley, Ty Newydd is a new, light-filled care home for people with multiple needs ranging from mental illness and learning disabilities, to long term conditions like Huntington's disease and neurological conditions. Opened last June, on the site of what was once a council-run care home, the two-storey building is well resourced with nurses and support workers as well as a management team, cooks, maintenance staff and a gardener who oversees the communal garden.

During the day, eight full-time staff (two nurses, four carers) are looking after 16 people who range in age from their 30s to 70 plus. There is additional one-to-one support available for those who require specialised care. One nurse and three carers are on duty at night. Each person has their own ensuite bathroom and accommodation is arranged in units of four, each with a sitting-cum-dining room and a separate quiet area. There is a communal sitting room on the ground floor and a chalet with a pool-table in the garden. People are encouraged to participate in activities – clean their rooms, wash up, do their laundry, garden, arts and crafts. There are regular trips which can include visits to the swimming pool or shops.

Gemma, 36

'I bought my first Minion after watching the film *Despicable Me* in 2012. I've now got a collection of about 50 small figures and eight limited edition figures. I don't want to take them out of their boxes because they lose their value. Their laugh is funny, they're really cute, they're bubbly. Minions are innocent.' —Gemma

Gemma is physically disabled and mentally ill and the two are interlinked. The middle of three children, she spent her early childhood in Barry, on the south coast of Wales. Her father was in the navy and her mother a carer. After her parents separated, her mother remarried and went on to have another child.

When she was 14, during a gym class, Gemma landed awkwardly on the side of her ankle, after doing a somersault. She thought it was a sprain and ignored the pain. She eventually saw a physiotherapist who referred her to an ankle specialist, who diagnosed a detached ligament.

In her early 20s, while working as an outdoor pursuits instructor in west Wales – 'my dream job' – Gemma had an operation to repair the ligament. Further surgery was required the following year, to remove fibre sutures from the previous procedure, and this led to a tremor in her leg (possibly as a result of nerve damage, but this is unproven). She went on to develop complex regional pain syndrome, prolonged pain and inflammation, which then spread to other parts of her body. This was treated with epidurals, spinal blocks and steroid injections.

Today, six years later, Gemma is wheelchair bound, and has a pump implanted in her body to deliver morphine. 'I'm in unbearable pain and agony,' she says.

She also suffers from reactive depression – 'I lost myself as a person' – and borderline personality disorder, a mental illness which gives her a tendency to experience intense feelings of paranoia and not have a clear sense of self. She describes her mental illness as a 'scar.'

She came to Ty Newydd last June, after being sectioned in a mental health and psychiatric hospital where she stayed for two years and three months. She likes it. 'They look after my mental health and physical needs,' she says. She goes shopping – Ty Newydd has a minibus with a tail lift for wheelchairs – on her last trip she bought a cream jumper from Primark and some flavoured water. She enjoys watching programmes like *24 Hours in A&E* and true crime thrillers. 'I always wanted to do criminology or forensics, but never thought I was brainy enough to do it.' She smokes about 30 cigarettes a day. 'In some ways smoking makes me less anxious, in some ways not.' She keeps Rizla papers and tobacco on her lap, as well as a hand-held mini fan and a bottle of Vimto squash with a thickener (to reduce the risk of aspiration). At night she sleeps with a blanket over her head. 'I hide under my quilt. I don't sleep properly, I can't switch off.'

TY NEWYDD, MAESTEG, WEST GLAMORGAN

Heather, 55

'Heather loves perfume, clothes, fashion. We used to spend loads of time going around the shops together choosing her clothes. I used to joke it was a big part of my working week. These things are still incredibly important to Heather. She spends a good deal of her money on clothes and has a large perfume collection. Before Covid, when the shops were still open, I bought her a bottle of La Vie est Belle by Lancome.' —Keith

Around nine years ago, a neighbour found Heather in the street, wearing a nightdress, with her bag packed. She said she was going to China. Looking back on the incident, Keith, 69, (pictured with Heather) her partner of more than 30 years, says he had sensed 'things were coming to a head.' Heather had had fixations before, like her fairy period when she decorated the house with about 3000 fairies. Keith found it endearing.

This was different. Heather had thought she was Chinese for some time. 'It became a complete and utter mania,' says Keith. The couple lived separately and when Keith next went to see her, she threatened to call the police if he did not go away. A day later, the neighbour alerted him. 'I walked into [Heather's] house and absolutely everything was in pieces, pictures, stuff ripped off the walls. She'd completely and utterly smashed her house up.'

Heather grew up in Hereford, with a twin brother, and an older sister. Her parents separated when she was in her early teens and the twins were split up: her father and brother went to live in Cornwall, while Heather and her sister moved with their mother to Wales.

After leaving school, Heather travelled widely as a nanny. But in her late twenties, while she was working for a Saudi family in London, she caught psittacosis – which is similar to a severe flu – from their pet parrot. The family left her to cope alone and Heather's mother eventually had to bring her home to Wales. The event precipitated Heather's first major breakdown.

In 1994, aged 28, she was admitted to a psychiatric hospital in Merthyr Tydfil, where she was diagnosed with bipolar disorder. Keith, then a director of public works for the local council, was a patient in the same hospital, suffering from depression and alcoholism. Fourteen years

her senior, they are polar opposites: he is bookish and 'thinks far too much' and she is outgoing and instinctive, but there was an emotional connection. 'She is the love of my life, no question of that,' he says.

He was discharged after four and a half months; Heather, after three. She was subsequently re-admitted three months later, establishing a routine that continued over the next few years. 'As I got myself back together and was more capable of keeping an eye on her, I was able to keep her out of hospital as far as possible,' says Keith.

After 10 years of relative stability, Heather was advised by her doctor to stop taking clopixol, an antipsychotic injection. 'She started losing contact with reality,' Keith says. Heather became convinced she had a Chinese mother after seeing black and white photographs of her father on National Service in Hong Kong. 'She constructed this whole narrative, and it just reached a crescendo, like something had snapped in her.'

In 2013 Heather was hospitalised in a psychiatric unit. Later that year, she was moved to Tan-yr-Allt Lodge, a care home with 26 beds near Swansea, where she remained for seven years.

Last year, the staff and Keith decided Heather would benefit from being among more able people, as she was mimicking the neediness of some of the older residents.

Keith visits her once a week from his home in Abedare, 30 miles away. They go to Wetherspoons for a panini. Her sister is also a regular visitor. 'She is still crippled by anxiety, has lost most of her self-confidence and needs help with absolutely everything,' says Keith. 'But the hope is that in a new environment with slightly younger people, and more potential for freedom, she can be brought out of being so helpless.'

TY NEWYDD, MAESTEG, WEST GLAMORGAN

Thorne House, Thorne, near Doncaster, Yorkshire

Thorne House is a residential home for adults with mental health problems, learning disabilities, and autism. Originally built for a prosperous brewery owner in 1899, the home has a grand country setting in 4.5 acres, and yet is only a two minute walk from the town centre. Opened by Autism Plus in 1987, it supports up to 18 people across five apartments, each with a communal lounge and kitchen. There is also a quiet room on the first floor. A staff of 61 work full time shifts (from 8am to 3pm, and 3pm to 10pm) and 22 work part time. Eight staff are on duty every night. Care is mostly one-to-one, though some people require two carers.

Homely in style, there are no set times for meals or bedtime, however some people like fixed times as they need routine. The central ethos is for care to be as unrestrictive as possible so people can 'live their best lives.' People are encouraged to choose what they want to eat, wear and do. Where appropriate they go on walks, day trips, to the cinema and learn musical instruments. Everybody at Thorne House is on a 'deprivation of liberty safeguard' authorisation, which means that they are supervised constantly and are not free to leave on their own.

Katie, 33

'About four years ago, Katie started to become really frustrated, upset and angry. Her younger sister who lives with us had just had a baby and Katie's psychiatrist suspected Katie was broody. He suggested we get a baby doll. You can buy kits for 'reborn dolls' which are very lifelike and I made Annabel from scratch. Katie buys baby clothes and equipment from the charity shop. It can feel awkward walking in the town with an adult who is carrying a doll. You do worry what people will think. My husband struggled with that. But you have to accept this is part of Katie's world. It's really helped her. Every year she'll say can I have another one? She's got six or seven now.' —Julie

Katie was diagnosed with learning disabilities at five and with bipolar disorder at 20. But it wasn't until she was sectioned at 24 that her mother, Julie, 51, (pictured with Katie) finally understood the cause of her daughter's distress.

'I asked for an autism diagnosis when she was seven,' she explains. As a young child, Katie had an extremely limited diet, and would only eat yoghurt with no bits for days at a time. Her speech, which had appeared to develop normally, started to regress. 'Everyone said no, she couldn't possibly be autistic, because she was a girl.' Boys outnumber girls with autism by 4 to 1. 'So you just put it to the back of your mind.' But as Katie got older, her destructive behaviour intensified. She would sit down in the middle of busy roads and refuse to budge. She would explode into a rage in the supermarket. Two placements in residential care broke down, the first after nine months – 'She refused to go,' says Julie – the second after four weeks. She would throw things at staff, bang her head against a wall, make herself sick. Julie was called in to help. 'It was apparent that she needed more help than any of us could offer,' says Julie. A director of a charity, she is married to Andy, an engineer. Katie is the oldest of their three children.

Katie was sectioned in 2012 and stayed in the hospital for 15 months. 'It was the best thing that could have happened,' says Julie. The team did some assessments: 'Katie is bang in the middle of the autistic spectrum.'

Julie says her first reaction was guilt. 'She was made to come with us for clothes shopping, food shopping, big family holidays on planes and boats. Whatever we were doing, Katie was part of it. You suddenly think, wow, that must have been such a sensory overload.' Katie is exquisitely sensitive to crowded spaces, fluorescent or flickering lights and noise. Everything she hears and sees is amplified. 'We had done all these things not knowing that it was making it worse. That was the light bulb moment for me and my husband. We had to stop making Katie fit in our world and learn to join her in hers.'

Julie found Thorne House by searching online for residential homes that specialised in autism. She was immediately struck by the family-feel. 'I just felt we belonged. I met a lot of people like Katie.'

Katie has been at Thorne House for seven years. Occasionally she will still lash out at staff but is much calmer and understands herself more. 'She'll ask for medication to calm down if she needs it,' says Julie. The key to the success compared to Katie's other residential homes is 'Katie is understood and loved,' Julie says. Before moving to Thorne House, Katie would never go to the hairdressers, overwhelmed by its lights and noises and smells. Now she goes regularly and loves to try out different hair colours – purple, red, green – and even allows staff to straighten her naturally curly hair. 'Katie's world is here,' says Julie.

Chris, 36

Chris has high-functioning Asperger syndrome: he is rational, methodical and engaged. For example, he had been given the job of auditing the first aid boxes in Thorne House to check they were complete. But he found the job frustrating, because the checklist of supplies; the plasters, eyewashes, wipes and so on, were not in alphabetical order. 'I was going back and forth and by the end my eyes were a bit warmer and hotter and more tired than normal,' he explains. He has now reorganised the list alphabetically.

He likes to learn new things, but admits he can become overwhelmed by his own mind. He recently bought a guitar and started having lessons. Soon after he got a clarinet and a violin, too and signed up for lessons in those instruments as well. 'Because he's learning them all at once, he gets upset because he's not learning as fast as he wants to learn,' says Kelly (pictured with Chris), a social care support worker who has worked at Thorne House for 11 years.

Chris was diagnosed with Asperger Syndrome as a teenager. He has spent most of his life in hospital and residential care. He came to Thorne House nearly ten years ago after trying to live independently. Chris has a tendency to hoard. He wanted to keep the box a new hoover arrived in recently, even though he did not have a purpose for it. 'If we weren't around to say, you need to get rid of this, there wouldn't be room to walk into his living room. And that's what happened when he lived on his own,' says Kelly.

Chris also suffers from anxiety. A ten-minute walk can easily take three hours as he is constantly stopping to check he has not forgotten or dropped something. One of Kelly's roles is to walk behind him and confirm he has everything. 'Then he's quite happy to carry on.' But perhaps the hardest thing for Chris is the tension between his intellectual ability and his condition. He knows the difference between what he is and what he might have been. 'I've got all the aspirations of my brother: wife, kids, car, house, career, lots of friends. But unfortunately, that's just not what life's got in store for me.' This can lead to periods of depression. 'Sometimes I have to shut myself away for a few days and work through it on my own.'

'I play chess nearly everyday either against a computer or on the internet. Chess can teach you things like strategies, discipline, strength of character, tactics, thinking skills. I'm not the best player, but I am not the worst either.' —Chris

Shon, 54

Shon has Asperger syndrome and thinks in an extremely literal way. He recently withdrew £50 from an ATM because of the sign saying 'free cash withdrawals' and he assumed the money was free. Similarly, when a shop assistant offered him 'cash back' after buying a packet of cigarettes, he nodded and asked for £10. Sean is bright, he did well at school, but began showing signs of bipolar disorder aged 18. 'He collapsed and went inward on himself,' says Theresa Lees, manager of Thorne House. He spent many years in hospital and residential care before moving to Thorne House 13 years ago. He is now the gardener, paid to work 16 hours a week.

'This is a picture of my motorbike. I don't have it anymore. I sold it. But I like to show people what I'm capable of.'

THORNE HOUSE, THORNE, NEAR DONCASTER, YORKSHIRE

Matthew, 26

'Matthew loves watching children's programmes like Tom and Jerry, Horrid Henry and Spongebob Squarepants. If he finds something funny, he'll keep rewinding and watch it again and again. It could be [one scene for] ten minutes.' —Sharon

Sharon remembers very clearly the day the police put her son in handcuffs. Matthew was 19, and at a day centre for adults with learning disabilities. Exactly what happened is largely unknown, because Matthew has never been able to explain. He was in the recreational room at the centre, when he became distressed and upset. Matthew's way of communicating those emotions is with violence. He lashed out at a member of staff. The centre called the police. By the time Sharon arrived, Matthew was in a small cage in the back of the police van, with his hands cuffed behind his back, shouting "Mum, Mum!" 'I said, "It's ok, Matthew, Mummy's here. Get in the car, we're going home."'

Matthew was born 19 months after his sister, and Sharon instinctively knew there was something different about him. As a baby, he cried continuously through the nights and continued to do so for three years. As a toddler, he would not mix with other children in the playgroup. He would kick the front door if he wanted to go out. His speech was poor. Sharon's husband, a forklift driver, was not able to help as he often worked nights. She became depressed and overwhelmed and says she was devastated when Matthew was diagnosed with autism, aged six. 'You grieve for a child you thought you had and [then discover] you hadn't.'

Sharon tried every form of education – a local primary school until Matthew was 10; a special school for children with moderate difficulties; another for those with more severe. But none worked out. 'We had to pick him up a lot,' says Sharon. Matthew did not like queuing or moving classrooms. He would take against certain children, especially if they were 'loud and screechy.' His outbursts would escalate to the point that staff felt unable to handle him.

As Matthew grew larger, he became stronger. 'I've had a lot of injuries, he's kicked me, bitten me, pulled my hair out. Once it's over, he doesn't realise what he's done.' In 2017 Matthew was sectioned after a violent episode in a local gym, during a visit with two carers. He stayed in hospital for seven months. Sharon searched for a residential placement and found Thorne House, where he now lives, coming home to the family home in Beverley every third weekend.

Three years on, Matthew still needs help in every aspect of his life – eating, personal care, managing his money. But he has become easier to care for. When he arrived he needed two members of staff; he now has one.

'The staff really understand Matthew and know his tiny triggers. Like if you say, "It's fine," he'll get touchy. For some reason he just doesn't like the word,' says his mother. Matthew likes the space and peace at Thorne House. His bedroom is on the top floor, in the old servant's quarters where he has a radio, DVD player and a TV subscription to Sky and the Disney channel.

Most striking is his attachment to Billy (pictured jumping, with Matthew), who is non-verbal and is in the next-door bedroom. They eat together and sit together in the cinema and on the bus. 'They don't have eye contact. They don't speak to one another. But they're the best of buddies,' says Sharon.

Park House Barns,
Ampleforth, north Yorkshire

Set in five acres on the edge of the Ampleforth College estate, Park House Barns is a social enterprise for people with autism and learning disabilities, who are paid to make artisanal chocolates or grow organic fruit and vegetables. These are then sold to farm shops, restaurants and businesses.

Opened in 2014 by the charity Autism Plus, the initiative is underpinned by the principle that employment has a positive impact on people's health and wellbeing. Referrals come from families, schools, social services, day centres and mental health teams. There are typically six people on site at any one time, all getting paid. There are also attendant volunteers. Some people who work there are living independently; some are in supported accommodation.

Getting people to the centre can be a challenge owing to its remote location in the Howardian Hills. The studio is not a commercial enterprise, but it has industrial standard equipment and produces premium grade chocolate. Clients include Fenwicks and North Yorkshire Moors Railway, which serves Park House Barn chocolates in the Pullman Dinning train.

To date, Park House Barns has equipped 20 people with key skills to help them become more independent.

Jonny, 24

Jonny works two days a week in the chocolate studio, where he pops chocolate buttons out of plastic moulds and fills gift boxes with assorted centres. The best-selling chocolate is salted caramel, but Jonny says his preference is for 'the ones with alcohol in'; like the whiskey, or gin and lime, truffles.

He started as a volunteer in 2018 and was offered a paid job last year. He is dropped off by family. 'The money goes in my bank. I'm saving up to get something lovely for my girlfriend.' They met at Easi Works, the day centre for people with learning disabilities and autism, in Easingworld.

Oliver, 31

Oliver is the lead horticulturalist in charge of a large vegetable garden with poly tunnels. The most recent crops are strawberries, pumpkins, beans, cabbages and onions. One of his most time-consuming tasks is watering, which can take up to three hours a day. This is partly because there is no hosepipe (this is being addressed), but also because of Oliver's highly focused interest.

Oliver has high functioning autism. He has a degree in creative writing and performance acting from York College. But following his graduation he was unable to find paid work. His mother heard about Park House Barns, and suggested he volunteer. He began in 2015, and he was offered a job a year later. He works four days a week and travels there on his moped.

'When you do an exam, you have to wait weeks to get the results. Here the results are tangible. You can just see it. It's like a distinction or A plus.' —Oliver

PARK HOUSE BARNS, AMPLEFORTH, NORTH YORKSHIRE

Ashcroft Lodge, Thorne,
near Doncaster, Yorkshire

Tucked off the main road in the town centre of Thorne, Ashcroft Lodge houses six people with autistic spectrum disorders. Originally a B&B, it was bought by the charity Autism Plus in 1995 and converted into two connected areas. The Lodge, at the rear of the property, caters for complex needs and has four bedrooms; the Cottage at the front has two bedrooms, for people more able to look after themselves. Modifications include wider doors and wet rooms. Communal areas include a galley-kitchen with a 'chill out' sofa, sitting-cum-dining room with a TV, and a paved garden.

Ashcroft Lodge changed from a residential care home to a supported living home in 2018, but residents were not moved out, and life in the home continued much the same as before. Carers work a rota of seven-hour shifts from 8am to 10pm, which involves everything from cooking and cleaning, to tying shoelaces. There is at least one member of staff per person in the Lodge during the day and one person on the night shift. Extra staff are deployed as required. There is no rigid routine, not even for meal times. Residents can go to bed and get up when they chose, though some have to be awake at a certain time to take their medication. Families are allowed to visit whenever they like and for as long as they like. Three men and one woman live in the Lodge; two women in the Cottage.

Paul, 46 and Sarah, 56

'Paul loves to look at photographs of his family, but he likes to hold them and they get scrumpled up. James saw an advert for personalised photo placemats and thought they'd be perfect. They have cork backing and they're bomb proof. Paul can hold them, but he can't break them. He adores them.' —Sarah support worker

Paul has autism, learning disabilities and noctural epilispy (when seizures only occur at night). He is not able to speak, but 'I think he understands a lot,' says Sarah, who has cared for Paul for 11 years. And unlike many with autism, Paul has no difficulty with eye contact. It is a big part of the way he communicates. Sarah has learned to decode his expressions. 'He has beautiful green eyes,' she says. 'When he wants something he'll do a "Lady Di flutter."'

Paul grew up in York, the youngest of three boys, and his parents' only biological child. Paul's father, an accountant and his wife adopted Michael six years after they married; James was adopted the year Paul was conceived. It turned out they could have a baby after all. It was a difficult labour, a breach delivery and Paul suffered from a lack of oxygen. An apparently healthy baby, Paul never talked and as he grew, his disabilities became more apparent. He was diagnosed with autism aged 10, and educated at a residential special school. He moved into Thorne House at 18, before graduating to Ashcroft Lodge in 2004, at the age of 28.

Last June, Paul was rushed to hospital with acute pancreatitis. 'One minute he was watching snooker. The next, boom! He collapsed,' says Sarah. He was taken into intensive care and the consultant said it was touch and go.

He pulled through and returned to Ashcroft Lodge in October, but his weight has dropped by 20 per cent and he has lost the use of his legs. 'He was bed bound for so many months, his ligaments have shortened,' Sarah explains. He now needs to be lifted in a hoist and requires two carers full time. 'We need to build up his core strength so we can get him to stand. I'd love to see him racing up the corridor again like he used to.'

Paul is fascinated by cars, trains, planes. His father used to take him on trips to RAF Linton-on-Ouse where they would watch the planes take off. The two were close, but his father died in 2009. 'I'm now trying to surrogate myself into that position,' says James.

For 25 years, Sarah worked in the pub trade, including four years as the landlady of the King George near Doncaster. 'I like banter and I can talk to anyone,' she says. Over the course of her career, she served everyone from the late actress, Diana Rigg – who ordered champagne – to 'Fred, who had a tenner in his pocket to last the week.'

But price rises and the smoking ban meant pubs were not the same for her anymore. 'It just got to the point where I thought, I've had enough,' she says, now. A friend who worked as a manager for the charity Autism Plus, suggested she apply for a job as a support worker. 'I put in my application and got the job and wish I'd done it years ago,' she says. 'The people are special because they're so different. Even though they can't communicate with us, they are such good souls. We don't do it for the money. The money is not good at all. It's just to help them. One of my young men wears the same clothes religiously. I finally got him in a Christmas jumper for Christmas Day. His mum cried. He was still wearing it in March, mind you, but that didn't matter.'

When Paul was so ill in hospital, Sarah and her team of ten continued to look after him, even though he was not officially in their care at that time. He was distressed by the machines, and the consultants; by all the wires and procedures. 'We couldn't leave him. He was scared. He didn't understand what was happening.'

Paul was discharged after two months, but he was not able to return to Ashcroft Lodge as Sarah did not have the training needed to lift him in a hoist or to do the nursing care. Instead he was placed in a series of temporary homes, with a different carer in each one. Sarah was desperate to get Paul back to Ashcroft Lodge and so with the help of two trainers who were qualified in moving and handling people, she learned how to look after him. 'We're supported living. It's not hospital care,' Sarah explains. 'We're trained to lift furniture, not people.' Within ten weeks Paul had returned. 'We wanted to be able to bring him home, because at the end of the day Ashcroft Lodge is his home,' she says.

Darran, 30

'Darran loved watching Fireman Sam videos as a baby and this was knitted by a friend of my mother-in-law's when he was about 18 months old. He had it before he got ill and I think it's a memory he's retained from childhood. He always sleeps with it at night, like he did as a baby.' —Vilma

Darran has autism, learning disabilities and severe epilepsy, where the risk of Sudden Unexpected Death in Epilepsy (SUDEP) is a grave concern. He has a carer 24 hours a day and two for when he is outside the home. 'We have rescue medication on us at all times, in case he has a seizure,' says his carer Sarah.

The oldest of three boys, he was born in Doncaster to Darran, a glazier (his father shares the same name) and Vilma , a bank clerk. Darran was advanced as a baby, already walking at seven months, but contracted viral encaphalitis as a toddler. He started having fits, sometimes as many as 90 in one month. The consultant said he would be lucky to live to be ten years old. 'From then on we always felt we were on borrowed time,' says Vilma.

When he was 18, Darran went to Thorne House where he would stay a few days a week to give his parents a break. But Vilma worried about the stairs. 'I wanted him to have a room on the ground floor,' she says. He moved to Aschcroft Lodge six years ago.

Darran used to go home to his parents roughly every other weekend. Covid-19 meant he wasn't able to see them for over a year. There were tears and pleas. He missed Christmas and his 30th birthday, but these events were celebrated for him at Ashcroft Lodge.

However the upside is that Darran has lost seven and a half stone. 'To be honest he was really spoilt at home and got everything he wanted,' says Vilma. 'We just gave into him because always, at the back of our mind, was the thought, this could be the last time we see him.' He was not on a strict diet at Ashcroft Lodge, says Sarah. 'Just fill up on veg, not as many potatoes, steady with bread, fizzy pop and carbs.'

Darran is more mobile and recently went six weeks without a seizure, the longest period ever, which they think is directly related to weight loss. He also now has more choice with clothes. When he was size XXXXXL with a 62-inch-waist, he was restricted to wearing joggers and sweatshirts from Jacamo, the oversized men's clothing brand. Now he is a size XL, with a 40-inch-waist, he wears skinny jeans and shops at Next, JD Sports and Matalan.

Bradmere Day Centre, Thorne,
near Doncaster, Yorkshire

Bradmere is a day centre for adults with autism, learning disabilities and mental health problems. It aims to develop 'life skills' and 'confidence', through a variety of activities: drilling and sawing in the woodworking room; weeding and watering in the garden, or simply playing with building bricks and Lego.

Bradmere operates from a light-filled building that was once part of a stable block for Thorne House, a stately home built in the late 1890s (and repurposed in 1987 as a residential care home for 18 people.) The centre has a full-time staff of ten – learning support workers, programme facilitators, a driver and a team leader. It is used by 40 people in all, though only about six are present on any one day. They either live at home with relatives, or come from care homes within a five-mile radius. The day tends to start at 9am and finishes at 3pm.

Jonathan, 46

Jonathan has autism and mild learning disabilities and is not able to function independently in many areas of his life, but he has the extraordinary ability of immediately knowing what day of the week any date falls on, for years back. He moved into Thorne House on 28 February 1992. A Friday.

He comes to Bradmere three times a week, from Wildwinds, his supported living house in Thorne. Situated opposite a Sainsbury's, he prepares his own packed lunch the night before. 'I normally have a chicken sandwich with some picallili, some crisps, and an apple, banana and yoghurt.'

'I like watering the flowers and plants and doing things in the woodwork room.'

Duncan, 58 and Julian, 44

Julian used to work as a night club DJ. 'I vowed that if I'd not made a million by the time I was 30, I'd get a normal job. I didn't. And the job centre sent me to an interview as a support worker. I fell in love with it from day one.' He has worked at Bradmere for ten years.

Julian runs the sessions in the woodworking room and garden. He has worked with Duncan, who has autism and only a few words in his vocabulary, for eight years. Duncan visits Bradmere three times a week.

'I'll demonstrate once and then he'll copy. Sometimes I have to guide his hands on the drill otherwise he'd just keep going.'

Richmond Rd, Hollinsend Rd, Welwyn Rd, and Gleadless Ave, Sheffield, South Yorkshire

There are four supported homes within a five-minute drive of each other in Birley, south east Sheffield. All are family-style houses, close to shops and a 15-minute ride on the tram to the centre of Sheffield.

Richmond Road has four bedrooms and is currently occupied by three men aged 37 to 57; Hollinsend Road has three bedrooms and is home to three men aged 29 to 30; Welwyn Road has three bedrooms, occupied by three women aged 31 to 48; and Gleadless Avenue has two bedrooms and is home to two women aged 25 and 42.

Each house has a communal kitchen, sitting room, dining room and rear garden. Richmond Road has a summer house in the garden and a ramp for wheelchair users was installed in 2018. However, internal doors have yet to be widened to accommodate them. A member of staff is present 24 hours a day in Richmond Road, Hollinsend Road and Welwyn Road. Gleadless Avenue does not have night staff.

Suzanne, 25

Suzanne's mother had two children by the age of 16, each fathered by a different man. Social services removed both babies; first her sister, and then at 10 months, Suzanne. 'I feel angry that no-one took me off her sooner,' says Suzanne, now.

Suzanne traces many of her problems back to her mother's neglect. She suffers from depression, anxiety and post-traumatic stress disorder (PTSD). She is more forgiving of her father. 'He wanted the best for me, but didn't know what to do.' He died in March 1998 when Suzanne was two.

Suzanne and her half-sister grew up in Leicester, living with their aunt and her two children. Suzanne was severely bullied at her secondary school. 'I had a speech impediment, I didn't have the latest fashion and I was on the chunky side.' At 14 she moved schools and was much happier. She went on to do a Btec in animal care at a sixth form college.

In 2016, when Suzanne was 20, her aunt moved to Malta, and she went to Sheffield College to study media production. She dropped out after the first year. A friend who lived in the same student block died suddenly. 'She just dropped dead. I lived below her and heard a thud from her room but thought nothing of it.' She still blames herself for not doing more. 'I could have given her CPR. I might have saved her.'

She stayed in a YWCA in Sheffield for a year and in 2018, aged 22, moved into Gleadless Avenue. Suzanne has a stalwart character and carries herself with self-assurance, but admits she has 'dark moods' and is attracted to fantasy as a form of escape. She plays Dungeons & Dragons, a fantasy role-playing game, with friends on Tuesdays. She is a long-standing fan of Harry Potter. 'He had loads of father figures and I wanted one of them to be mine. I wanted a Dumbledore.' Today, she has several Harry Potter-themed tattoos, including a Hufflepuff badger.

She tries to walk to the shops at least once a day, just to get out, and goes to church on Sundays, but she spends a great deal of her time in her bedroom listening to music or watching films on Disney Plus or Amazon Prime. 'One day I'd like a job, but at the moment when I try to do too much I get really stressed out.' She is on anti-depressants.

'I feel safe here,' she says. 'Staff don't restrict me, they encourage me. Just knowing that if I do have a dark moment there is somebody I can talk to.'

'Once a week I play Dungeons & Dragons with friends in a theatre in Sheffield. You need a character sheet for each player and a number of polyhedral dice. The dice are sold in sets, and I've got 43. My favourite set uses a Harry Potter font.' —Suzanne

Dan, 36

For Dan to see an object clearly, he has to be no more than eight inches away from it. He is partially deaf and has a poor short-term memory. When he arranges to meet his mother, he relays the details to a carer straight away, in case he forgets. His most noticeable quality, however, is his use of language, particularly irony. Being rushed to hospital in a critical condition when he was 26, for example, was 'fun'.

Dan was born in Sheffield, an only child to John, a dangerous goods handling agent for DHL and Julia, a Marie Cure nurse. When she was pregnant, Julia became infected with toxoplasmosis while clearing the garden. The parasite is transmitted from the faeces of infected cats. As a consequence, Dan was born with hydrocephalus, a build-up of fluid in the brain, which caused permanent brain damage. At the age of one, he had a shunt surgically implanted in his brain, to drain away the excess fluid.

Dan was educated at special schools and when he was 18, he spent two years in Coventry, at a residential college for young people with disabilities, where he did media studies. In 2008, when Dan was 23, he moved into supported accommodation in Burton-on-Trent, in Staffordshire, where his parents then lived.

The home was run with a relaxed attitude, and staff were only on duty during the day. One day in November 2011, Dan's shunt failed and fluid started to build up around his brain. This can be fatal and it was the intervention of his parents that saved his life; they drove him the 50 miles from Burton-on-Trent to a specialist hospital in Sheffield. The experience left Dan feeling 'jumpy' and vulnerable. 'It was supported living, but I wasn't supported at night,' he says, now.

In 2012, Dan was joined by Quentin, a guide dog. 'You could call Quentin my brother,' he says. The labrador slept on Dan's bed and helped eradicate some of his tension.

In early 2020, his parents returned to live in Sheffield and that August Dan moved into Richmond Road. Here, help is always on hand for him, which he says is a big relief. A member of staff sleeps in the office near his bedroom and a list of symptoms of a blocked shunt is pinned to the office wall.

'I didn't know about adult Lego until somebody told me about it. Mum bought me my first one, The White House, in 2020. I've bought the rest – San Francisco, London, Dubai. I did want Tokyo but I'm not too happy about the price – £54.99. That's what I do now, build.' —Dan

Quentin retired with arthritis in 2019 and lives with his parents. Dan hopes to get another guide dog, but even so he will not be allowed out without a carer, in case he gets lost. He likes to listen to audio books; anything from crime thrillers to military history. He supports Sheffield Wednesday and goes to matches with his father or his support worker. He is interested in airplanes and has a large painting of a Spitfire above his bed.

In 2011 he tried to join the armed forces, like his father, who had been in the RAF. 'I wanted to do something for my country,' he says. '"No, thank you", was the response,' he reports. 'But I've found another way of giving back,' he says. Last year, he raised £232.50 on a sponsored walk for Guide Dogs for the Blind.

RICHMOND ROAD, SHEFFIELD, SOUTH YORKSHIRE

'I just love to build Lego. It's the building I like more than the finished object. I don't build in the evenings. [He sings] Build...build...build.' —Peter

Peter, 30

Peter has lived at Hollinsend Road for nine years and his bedroom is a tiny, cave-like space crammed with all the evidence of his passions: the Lego kits balanced precariously on shelves, the collection of large trucks and cranes, the half-eaten packet of strawberry flavoured laces thrown on the bed.

'Behind the castle is Pikachu!' says Peter, pointing to a chaotic jumble of Harry Potter Lego kits and Pokemon characters. He emanates such enthusiasm it is sometimes quite hard to understand what he is saying.

Peter grew up in Stockbridge, near Sheffield, the third of four children. He has mild learning disabilities and ADHD and went to special schools until he was 16. He then went to a college in Grimsby, where he enrolled on a basic skills programme for students with learning disabilities. His parents separated when he was in his teens and he lived with his mother. He moved into Hollinsend Road when he was 21 and has clearly made it home.

He has a packed schedule: Mondays, Tuesdays and Thursdays are spent at Newfields, a day centre, where he makes bird boxes, garden tables and planters out of wood; Wednesdays and Fridays, he is at Enable, another day centre, where he strips down and renovates cars, under the supervision of a mechanic. He sees his mother two weekends a month.

He is able to catch the tram to the day centre by himself and make his own packed lunch. But he needs help with his laundry and cooking. He is not allowed into Sheffield on his own. 'I just need people to prompt me,' he says.

Shelly, 33

Shelly has cerebral palsy, a condition which affects muscular coordination. There is nothing wrong with her mind, but her movements are fidgety, jerky. She is able to walk and talk, but it requires huge energy and focus. Nonetheless, she sees herself as an independent adult, who makes her own decisions. 'Even though I've got a disability I want to make the most of what I've got, because at the end of the day I am just like you.'

Shelly was born in Sheffield, the middle of three girls, to Mick, a tool maker, and Bridget, a shop assistant. Bridget had a normal pregnancy, but when she went into labour she was looked after by a trainee midwife, who seemed not to realise that Shelly was in a breach position. She was then starved of oxygen as the midwife struggled to deliver her.

'Dad said mum should sue the hospital for malpractice, but she said, "I'm not unhappy about how Shelly has turned out and I don't want to make any money out of the NHS,"' Kay, Shelly's older sister, recalls.

The family lived above a baker's shop in Birley, south east of Sheffield. When Shelly was six, her parents separated, but her father only moved to the next-door estate.

Bridget had been told her daughter would be 'a vegetable'. She set out to prove them wrong. She treated Shelly like her other daughters. 'Shelly walked with a frame and when she fell over, mum would say, "Leave her, she can get up on her own,"' says Kay. Shelly confounded expectations.

After going to a special school when she was four until she was 18, Shelly then went to a residential college for young people with disabilities, in Mansfield, Nottingham. 'It was absolutely brilliant,' she says.

When Shelly was 25, her mother was diagnosed with lung cancer and 18 months later, she died. 'One of the last things my mum said was, "I don't want Shelly moving away." We're like one big family around here,' says Kay. Shelly could have moved in with either of her sisters, but, she says, 'I wanted to live as independently as possible, but I still wanted that connection with my family.' By chance, a family friend was selling their home in Welwyn Road, and with Shelly in mind, contacted a housing association and asked if it would be suitable to buy as a supported home. In 2016, aged 27, Shelly moved in.

Kay, who works in a respite care home, lives two minutes away and Allison, her younger sister, who works in retail, lives two minutes in the other direction. Her father lives about ten minutes up the road. 'Shelly is central to everyone's lives,' says Charlotte, her support worker (pictured with Shelly).

Shelly has a bedroom on the first floor and goes up and down the stairs on her bottom. She goes to a day centre four days a week. A minibus picks her up at 7.30am and drops her back at 4pm. Staff cook her evening meal.

She likes *Coronation Street* and bowling and goes to bed at 7pm. 'She is proud of her walking but prone to falling, especially when she gets tired,' says Kay. 'So she goes upstairs with her ipad to watch soaps in bed.'

'I like to do colouring by numbers on my ipad.
You press the number and it colours the picture.
I don't like to be rushed.' —Shelly

Lancaster Avenue is a supported living house for women with mental health conditions such as schizophrenia and personality disorders. Many are former in-patients of psychiatric hospitals.

Set in a large, detached Victorian house in a residential area of London, it has 12 bedrooms, each with an ensuite bathroom and two also have a kitchen. Communal areas include two sitting rooms, a kitchen and the rear garden. There are currently 11 women, whose ages range from their 20s to 60, looked after by a team of eight staff. Two people are assigned to the morning shift, from 8am to 3.30pm; two from 2.15pm to 9.45pm and two from 9.15pm to 8.15am. An occupational therapist and a psychologist visit the home one day a week.

Lancaster Avenue is seen as a stepping stone to life in the outside world. Women are helped to cook, budget, clean, self-medicate. People can come and go as they please. However, the women are expected to sleep at the house at least four nights a week. The maximum stay is five years.

Millicent, 37

'I've just got the keys to my flat. It's lovely. It's got a sitting room, kitchen, washing machine, fridge, single bed, shower room. I've made a long list of things I need for the kitchen. So far, I have an oven glove, tea towel and four drinking glasses.' —Millicent

In 2018, at the age of 34, Millicent moved into Lancaster Avenue after spending three months in a psychiatric hospital.

Millicent grew up in Brixton, the only child of a single mother, who worked as a sales assistant. After leaving college at 18, where she studied IT, Millicent became a sales assistant too, which she enjoyed, particularly working with designer brands.

On 9 September 2009, Millicent had been working in an upmarket department store in London, for three months. At some point during the day the manager asked her to get a pair of women's trousers from the stock room. To reach them on the rail, Millicent stood on a stool. But she lost her balance, fell back, and banged her head on a brick wall.

An assessment at the A&E of her local hospital concluded she was suffering from whiplash. Her injury made it painful for her to move and she did not return to work. Millicent pinpoints this as the start of her breakdown. 'I got stressed,' she says, now.

After she stopped working, Millicent became increasingly withdrawn. 'I stayed indoors; I didn't want to get out of the house.' Her relationship with her mother deteriorated. In 2010, she was diagnosed with psychosis.

When Millicent arrived at Lancaster Avenue, she was in poor physical condition. She shut herself away in her bedroom. 'She never used to speak to anyone. Just go to her room,' says Danah, the deputy manager.

'She had this mistrust of everything and everyone. It was part of her mental illness. Paranoia.'

'I was always sleeping,' remembers Millicent. 'Then I started coming out of my room, doing artwork, watching TV and films with people, or going out for walks.' Gradually, the home helped to build up her sense of self-worth again.

'Staff are always here' she says. 'They support you, check everything is ok.' Millicent also worked hard developmentally and physically. 'I take my medication [which includes Clozapine, an antipsychotic drug, and sodium valproate for mood swings], buy clothes and don't wear the same thing all the time.' Before the pandemic, she worked on the reception of a day centre, where people did art, gardening and knitting.

She likes M&S ready meals and breakfast TV. She goes to appointments on her own and manages her money. The psychosis has receded, and she is no longer so withdrawn.

'She's acquired this new-found confidence,' says Danah. 'We've had some people here say mean things to her, and she'll walk away and report it to a member of staff. She'll do everything the right way. Whereas someone else would just shout back.'

Millicent has made so much progress she is ready to leave and move into her first flat. 'I'm not scared,' she says. 'I feel ready. I am happy to go.'

Kayeisha, 31

In 2019, when Kayeisha was 29, she went for her father so aggressively she had to be wrestled to the ground. Kayeisha looks back at that time with terrible regret. 'If only I could change...' She exhales. 'I go to church,' she says of her principled upbringing. 'It got really bad. I was sick.'

Kayeisha grew up in London, the younger of two children. Her father was a plasterer and her mother, an administrator. She was bullied at her secondary school, a girls' comprehensive. 'There were the popular girls, the not so popular and then the neeks,' she says. She was considered a neek: someone to be mocked and avoided. She was slow in lessons and had to catch up in extra classes after school. She suffered from social anxiety: 'I was a loner.' She had mood swings and at times she felt detached from the real world. 'I felt stressed in my head.'

Kayeisha left school at 18 and enrolled in a local college. Here, she was diagnosed with learning difficulties and schizophrenia. She was put on Clozapine, an antipsychotic drug.

In January 2017, aged 26, Kayeisha had a baby boy with her 'sort-of boyfriend,' whom she had met four years before. He has Asperger's, and a controlling personality. 'Looking back, even though he's the dad, I wish I'd found someone else to have a baby with.'

Kayeisha and her son lived with her parents, but she was 'glued' to her boyfriend and would come home late. Her parents accused her of being irresponsible and not appreciating the enormous amount they did for her child. Tensions rose, Kayeisha's illness accelerated and in an agitated psychotic state, she attacked her father: 'It's weird, I tried to hurt him.'

She ran out of the house and handed herself in to the police. She was held in a cell for 24 hours, and then admitted to a psychiatric unit, where she was hospitalised for several months. In August 2019, at the age of 29, she moved into Lancaster Avenue.

The Kayeisha you see today is completely different to the one that arrived two years ago, says Danah. She is more confident, especially with cooking. 'People smell these gorgeous smells coming out of the kitchen and she's the focus of attention.' Kayeisha has come to realise that she is not defined by her illness. Her boyfriend is out of her life, she is reconciled with her parents and sees her son most weeks. But as she gets better, she has clearer insight into her condition. 'Though I am happy here, looking back on the reasons I moved here makes me feel bad. I just wish I could be with my son every day.'

'I'm good at cooking. I do stewed mackerel in a pot, chicken in the oven, cheese bake, spaghetti bolognaise. I just feel healthier when I cook. It makes me feel good. I don't mind cooking for people here, but sometimes I feel they take advantage.' —Kayeisha

Situated in Headless Cross, once a village in its own right, and now part of Redditch district, Forge Mill offers the chance for people with disabilities and health problems to live with supervision in one-bedroom flats. Opened in October 2020, the site consists of eight flats in what was the Forge Mill pub, a building which dates from 1870, set back from the high street, and six further flats in a new-build, two-storey apartment blocks to the rear. There, the first-floor flats have Juliet balconies, with large glass doors overlooking the courtyard, bound by railings for safety. Fifteen people, aged from 18 to 70, are looked after by 10 staff who work from a portakabin in the courtyard. A button in each flat activates a phone in the office. Four staff are on duty at night. Residents have keys to their own flats and are given support with cooking, shopping, studying, working, socialising – with the objective of independence. The only communal area is the courtyard, where there are group activities such as football, basketball and dance classes. Those who are more capable are allowed to come and go as they please. Families are always welcome.

David, 33 and Lauren, 30

'David and Lauren chose their engagement ring from
F. Hinds, a jeweller in Redditch. We threw a surprise
engagement party for them at Lyn's house at Christmas.
David went down on one knee in front of friends and family
and proposed to Lauren officially. It was lovely. If everything
goes fine, they'll get married in a few years.' —Lynne

David and Lauren's love story began over three decades ago, when their mothers met at a Down's syndrome support group in Redditch. Lynne, a housewife married to Jasper, a car paint sprayer and panel beater, was 37 when David, their first and only child, was born in 1987. At no point during her pregnancy was the possibility of Down's syndrome discussed. 'I was shocked, but we soon came to terms with it,' says Lynne, now. 'We'd been trying for a baby for ten years, so when David arrived it felt like a bonus.'

Three and a half years later, in 1991, Lyn joined the same group. A store manager then married to a digital film editor, Lauren was the first of their three children. Lyn was 25 – young and fit. 'Having a baby with Down's wasn't something I ever thought was a possibility.'

The two mothers became friends. However, their children did not meet until 2001, when they went to the same special needs school. David was 14; Lauren, 11. Their friendship deepened at Redditch College, which has a course for special needs students, where they studied from ages 16 to 25. Both went on to have a relationship – with other people.

About three years ago, the mothers met up for coffee and soon established that David and Lauren were single. Their dream was for their children to live independently and they knew neither would ever move out on their own. They saw a life where David and Lauren could set up a home together. 'So, we encouraged the relationship,' says Lyn. 'I invited David around to our house for tea on that Saturday.' The following Monday evening Lauren and David went to Special Olympics, a weekly sporting initiative for people with special needs. When Lauren came back, she said to Lyn, 'David's got a new girlfriend.' 'I thought, "Oh crumbs, who's that?"' she recalls. 'And she said, "It's me."'

The couple got engaged at Christmas in 2019, and soon expressed a wish to have their own flat. Lyn and Lynne spoke to social services and in October 2020 Lauren and David moved into Forge Mill. It was exciting for the staff too. It was the first time a couple had moved in together. They marvel at how well 'Romeo and Juliet' are doing. 'They won't be having children,' says Lynne. 'They wouldn't be able to look after a child, so they're on contraception. Besides, neither want a family.'

Their first floor flat is clean and tidy. Lauren is very orderly. 'I went up the other day and Lauren had her head in the oven, cleaning it out. She'd have never done that before,' says Lyn. The mothers live about ten minutes away and drop by most days. Lyn helps plan menus for the week and shops for ingredients. Lynne ferries them to activities.

Lauren and David make their own breakfast and then wraps for lunch. 'I do ham, salad with tomatoes, cheese and spicy mayo,' says David. 'I am different to Lauren. She likes normal mayo.' Staff oversee their cooking in the evening. David also needs help crossing the main road outside. 'He's not confident if there's lots of traffic about,' says his mother.

David has a black belt in Kung-fu and goes to a weekly class. He goes to day centres three times a week and also works a couple of hours a week cleaning tables in a coffee shop in Redditch. Lauren goes to a day centre four days a week. She likes Zumba and dancing.

'Since they've moved in [together] they've grown so much in confidence,' says Lyn. 'They absolutely love it. It's the perfect setting for them.'

Jack, 31

Jack is autistic and has many extraordinary abilities. He is highly creative and skilled at making masks, drawing cartoons and computer animation. He has an excellent memory for dates and is able to look at a blueprint for a building and immediately visualise the design. He likes to organise CDs, DVDs, VHS tapes, not alphabetically, but according to his own idiosyncratic system.

But crying babies and crowded places can be unbearable. 'He'll cover his ears and rock back and forward and say, "No, no, not again",' says Sarah, the team leader, who has been Jack's carer for five years. He speaks with a flat intonation, and he does not like to go to new places on his own. When he gets excited, he will jump up and down and swish and flick the 'wand' he made from a bamboo stick covered in address labels. 'He doesn't like people to think he needs support, but he loves being in supported living,' says Sarah.

Jack was born in Worcestershire, the second of four children to Barry, a consultant engineer, and Jo, a housewife. The earliest symptom was his delayed speech. When he was two and a half, his parents took him to be assessed and he was diagnosed with autism. 'It never crossed my mind there was anything wrong,' says Jo.

Jack was educated at special needs schools and between the age of 19 and 22, he was a residential student at Derwen College, a specialist college for young adults, near Oswestry in Shropshire. After leaving Derwen, he moved into supported housing and over the following eight years, shared a house with three other young men, first in Bromsgrove and then Redditch.

This March, Jack moved into Forge Mill. He lives in a ground-floor flat, fully equipped with the contents of his parents' holiday home in Devon, which they sold a couple of years ago. He likes the space and peace of having his own place. 'Sharing a house, there is always a nuisance,' he says. He cooks his own meals, like spaghetti bolognaise and pasta and meatballs, and clears up afterwards. For breakfast, he alternates between toast with peanut butter and Crunchie Nut Cornflakes. He has an espresso coffee machine.

Jack works as a volunteer in local charity shops three days a week, cataloguing CDs, DVDs, books etc, and is probably the most able person at Forge Mill. Nonetheless, many things remain elusive. 'He wants a girlfriend, a paid job and a happy family,' says Sarah.

Last year he broke up with his girlfriend of ten years, who he met at college. They saw each other every other week and spoke on the phone daily. But she has special needs and is likely to always live at home with her parents.

'All of his brothers and sisters are married. He sees that life and he wants that life,' says Sarah. And that life, she believes, 'is 100% possible for him.'

'I cuddle my Pikachu plushie every single night. Pikachu became my all time favourite Pokemon [character] when I was nine. I've had this Pikachu since 2018. My sister got it from Amazon for my 28th birthday. I had my first Pikachu plushie for Christmas 1999. But sadly, I gave it to someone else in Summer 2001. It's a long story.' —Jack

Pedmore Walk, Oldbury, west Midlands

Originally a children's home, then a care home for adults with severe learning disabilities, Pedmore Walk became a supported living home for people with autism, mild learning disabilities and mental health illnesses in 2014.

Situated in a residential area south of Oldbury town centre, the two-storey house has a garden and conservatory. Inside, the building has been divided into six flats; each with an open plan kitchen/sitting room, bedroom and bathroom. The current residents are men, aged 21 to 47. Staff work from a shipping container in the front garden and care is one-to-one. One member of staff is on duty at night, based in the communal conservatory. The ethos is choice. People are supported, but they can shape their own days, with activities like bowling, or going to the cinema. A small block of shops is within easy walking distance and there are good transport links to the centre of Oldbury, Birmingham and Wolverhampton.

'Josh is a fan of horror films. His ground floor flat is filled with silicon masks and boxed action figures like Chucky from *Child's Play* and Jason the unstoppable killing machine from *Friday the 13th*. I think he likes to act the big brave one. "Oh, you're scared. I'm not." He will only watch a horror movie if he has someone with him.' —Bernie, deputy locality manager

Josh, 25

Josh was evicted from his last care home in Warwick, in September 2019; an incident led to him being surrounded by six police and three police cars. When Josh describes what happened he focuses on the manager. 'She thought I had a knife and because I was really angry I went like this' – he punches the table – 'and then she phoned the police.'

'He didn't have a knife,' explains his mother, Michelle, now. 'When I got there, I hugged Josh and he calmed down. They didn't know how to handle him.'

Josh was born in Warwick, to Steve, a hospital maintenance engineer and Michelle, a senior early years educator. The older of two boys, he was diagnosed with moderate learning disabilities and autism aged four and with dystonia, aged eight. The neurological movement disorder causes muscle spasms and contractions and means Josh lacks coordination on his left-hand side.

Josh went to local schools until he was 12 and then moved to a special needs school where he remained until he was 18.

In 2017, when he was 20, 'things were getting tense in the household,' Michelle explains. The boys fought, which put the family under a great deal of strain. They managed to place him in a local care home. 'It was a chance for Josh to have some independence.' The care home had 15 individual flats, a mix of men and women, all with varying degrees of mental and physical issues.

'Not many of the staff knew about autism or learning disabilities,' says Michelle. More than once, Josh became violent and aggressive. His way of expressing anxiety is to harm himself or hit things, like walls. 'They'd call the police over quite petty things', says Michelle, 'like pushing past staff.'

When he left after 18 months, Josh was sent to the only place available: Pedmore Walk. What was meant to be a stop gap is now permanent. Two years on, Josh seems to be more secure and more grounded than ever before. 'I really like it here because all the staff are lovely,' he says.

Josh has help stripping his bed, doing his laundry and cooking. He is not steady enough on his feet to take hot food out of the oven.

Josh is infatuated with Michael Jackson and has the whole outfit: wig, hats, jackets, shoes. Some days he will play Billie Jean at full blast, on repeat, for hours. He sings along and copies the dancing. His support worker will say how well he's doing, 'and move the chairs out of the way, so he doesn't trip over,' says Bernie O'Reilly, deputy locality manager. Bernie describes Josh as 'intense' and 'polite', with 'lovely manners.'

Josh's schedule for the week is written on a board in his kitchen-cum-sitting room: Monday, local shopping centre; Tuesday, bowling; Wednesday, cleaning, laundry, gaming; Thursday and Friday, gym (he didn't go); Saturday, walk in local area; Sunday, home. He watches films three evenings a week with Simon, who lives upstairs. Their cut-off time is midnight.

Josh's weight has increased in recent months. Bernie suspects the medication and lockdown is to blame. 'He said he wanted to go to the gym to lose weight, but he won't actually use the equipment, he'll sit on his phone. But he tells his dad, "Dad, I've been to the gym today." "Well done, Josh!"'

Bernie believes in being direct. 'The other day he said to me, "I wish I didn't have learning disabilities." I said, "I wish you didn't either. But you have and you're really addressing it well."'

Claudius, 60

Six years ago, Claudius was a security patroller for National Car Parks (NCP). His role was to protect railway stations and prevent crime. He would monitor the platforms at Coventry and Wolverhampton stations on a shift pattern of two days, two nights. 'You'd see people trying to break in the cafes at three in the morning, trying to take their lives, running across the tracks.' Claudius knew all the train timetables and would help passengers with directions, to Coventry cathedral, for example, and the best places to get a taxi.

'There was a lad that used to come to Coventry station regularly. He had learning disabilities and was a very nice guy. He liked to see what was going on from day to day. He knew me by name and we'd talk about football and horse racing. He had a good bond with his carer. And I thought, that's what I want to do.' At the age of 57, Claudius retrained as a carer. He started working at Pedmore Walk in 2019 and is Josh's favoured support worker. 'It's good to see Josh happy and doing well. In my other job you'd see a whole mix of good and bad, but here it's about helping and that's what I wanted to do.'

Claudius has three children, 10 grandchildren and one great grandchild. His wife died of cancer just before the pandemic.

'Working at Pedmore has really helped with my grief. Everyone has been very supportive – even Josh.'

PEDMORE WALK, OLDBURY, WEST MIDLANDS

Cornflower Close, Colchester, Essex

Set in a quiet, residential cul-de-sac in Colchester, Essex, Cornflower Close is a comfortable five-bedroom, red-brick house with a garden that used to belong to a family who ran a home beauty salon business. It still has a jacuzzi in the bathroom. Opened in 2019, it is home to four men, aged 38 to 49.

The set-up is like a house share: individual bedrooms with a communal sitting room, craftroom, kitchen/dining room and garden. Joe heads up the team of six carers who work on rotas of up to 12 hours (the care ratio is 3:4 during the day; one carer is on duty at night from 8pm to 8am), supporting the housemates to cook, clean, hang out washing, as well as taking them to activities and medical appointments. There are no set times for getting up or going to bed and no fixed menu or time to eat. Families are free to visit them whenever and they are always free to go home.

James, 37

Joe, 29

James may be able to read only a few words, but he can detect even the tiniest change in his environment. A new duvet cover, a crease in an ironed vest; anything unfamiliar can unsettle him. When James was born his head was smaller than normal. The consultant diagnosed microcephaly and said his brain had not developed properly: 'If he lives for three years it will be a miracle.' His mother, Roz, a secretary and her husband, Keith, a tailor, had been trying for 16 years to have a child and they loved James unconditionally. 'He's ours. We will take care of him. We will fight for him.'

James is talkative but has a very short attention span and poor coordination. He is not able to cut up an apple, for example. He is prone to destructive outbursts because of his anxiety, and has scoliosis, a curvature of the spine. He takes daily medication, including Risperidone to control his anxiety. At one point he was on an anti-depressant, but Roz said it made him sleep too much. (She still thinks he is on too many drugs and is discussing this issue with team leader, Joe, his doctor and the community nursing team).

James moved to Cornflower Close in 2019. It was a big worry for Roz and Keith. For 19 years James lived in Jameson's, a care home for 16 residents near Colchester, coming home every other weekend. When Jameson's changed hands, the new owners saw it as an opportunity to move James to a more independent setting. 'We were scared,' says Roz. She did not even dare change the colour of his curtains for fear of an outburst.

But the move has been smoother than she imagined. 'He's calmer,' she says. He washes up, which he never did before. Most of all, his world is ordered and predictable. James often asks different carers the same question – what's for tea? who's on tomorrow? Being told the same thing and seeing the same people reassures him. This helped when Keith died last year. James and his father were very close. James has a portrait of him in his bedroom. Sometimes he takes 'daddy' downstairs so he can join James for dinner. With life on a firm footing, James is more able to venture out and try new things, like Zumba, which he now does one afternoon a week.

When Joe was 16, he cared about fast cars and designer trainers. He now understands how satisfying small things can be: James clearing his plate away or being prodded by Peter – something Peter only does if he really trusts you. 'Working with vulnerable people has opened my eyes to what matters in the world.'

It started as a holiday job at Jameson's, peeling potatoes and washing up in the kitchen, when he was 16. Then he did some work experience and when he left school, the manager asked if he'd like a job as a carer.

Joe has cared for James and Peter for 15 years. He moved with them when Jameson's was sold.

Here at Cornflower Close, 'there's time to sit down for coffee and have a chat. That is huge. You can look beyond challenging behaviour and work out what's causing it.'

Jameson's institutional structure meant that people ate at set times; had tea and coffee at set times; Peter even had a set hair cut: a number 3 (hair cut down to 3/8 of an inch), done by a visiting barber.

'It was always a massive performance. A bribe of a Mars Bar helped but Peter would still get very upset.' When they moved, Joe set a goal: Peter would have his hair cut in a barber's. He started working towards this in February 2019, by taking Peter with him when he got his own hair cut. By mid-October, Peter agreed to sit in the barber's chair. Comforted by a toy car – a present from the barber – and background music, for the first time ever Peter had his hair styled in a salon. 'It's individual. Not institutional. He'll say, "Look!" And he'll rub his hair because he's proud of it.'

'When James got his motorbility car, he wanted to have a nodding dog like his parents had in their cars. His mum had one called Sandy; his dad, Sammy. His is called Rupert.' —Joe, team leader

'Radios are massive for Peter. He's got about 20. He keeps
them on a little shelf and at the side of his room. He'll
change the dial until he finds a song. He'll listen for a bit and
then change it to something else. He's really good at it. His
favourite song is *Giant* by Rag'n'Bone Man. He also likes
Elvis Presley – from listening with his mum – and anything
he can dance to. Peter likes to dance.' —Joe, team leader

Peter, 45

By temperament, Peter is very gentle and accepting. But around 17 years ago, he started 'playing up.' He would throw his toy cars out of the bedroom window of his care home. 'He was bored,' says his mother, Christine. 'He'd run outside to pick them up again. It gave him something to do.' She also found out he was 'drugged' with what she believed to be unnecessary medication. 'When I found out I moved him to Jameson's.'

When Christine was eight months pregnant she fell ill with what she thought was flu. It was cytomegalovirus, a virus which can cause serious abnormalities if it crosses through the placenta and infects the developing baby. The virus damaged Peter's optic nerve and his mental ability.

'Imagine a black space with little pinpoints of light,' she explains. Peter 'sees' by joining them together. 'He'll pick up a Smartie from 10 yards away but will bump into a lamp post.' He has little language; you cannot have a normal conversation. But he understands most of what you say. The only medication he takes now is for hayfever.

Peter was diagnosed with congenital cytomegalovirus when he was three. 'By the time I found out it was almost a relief,' says his mother. 'I thought I was just being a neurotic mother.' Her husband's reaction was: '"Put him away". He didn't want to know.' They divorced soon after and he never saw Peter again.

Christine dedicated herself to finding a place where Peter would be safe and happy. He first went into residential care at 18. 'He needed a life without me, and I needed to get money to look after him and make sure we had everything we needed.' She is 72; the two are very close. 'I'm not saying I worry about it 24 hours a day, but it's always there – what happens when I die?'

Initially, Christine was not keen on moving Peter from institutional care to live in a home in the community. 'The community doesn't want people like Peter. The community doesn't want handicapped people etc. But at Cornflower Close, he's in a protected envioronment because when he goes out he's with his carers.'

Peter's life is fuller, outside and in. Although Peter and James both lived at Jameson's for 14 years, they never really had much contact with each other. They certainly did not regard themselves as friends. Now they say good morning to each other, eat breakfast together, link arms on the sofa while James watches TV. When it is time for bed, Peter turns to James and says, 'Good night, my mate.'

Coppice Lodge is a residential care home for people with learning disabilities, autism and complex needs. A red brick, semi-detached building on a housing estate in Kidderminster, it has six bedrooms (one ensuite), two bathrooms, two sitting rooms and a dining room. The rear garden, which has a paved terrace, flower beds and a wooden swing seat, is within earshot of the Severn Valley steam train, which runs from Kidderminster to Bridgnorth. Five men, aged from 46 to 80, are looked after by 14 staff; a core team of five are on duty during the day, with two at night.

The ethos is to support choice, regardless of the disability. People are encouraged into sensory play such as blowing bubbles in the garden. There are also trips to the swimming pool, garden centre and local pub.

Matthew, 46

In 1974, Brenda and her husband Graham learned of a mixed-race baby that was up for adoption. They lived in Kidderminster, Worcestershire, where Graham, now 81, was a postman and Brenda, 78, a housewife. They had adopted their first son, John, as a baby, five years earlier.

Brenda admits she had reservations about adopting Matthew. 'I was afraid I would feel some sort of deep-rooted racism. I'd always thought I had no prejudice against anybody. Was this the test? Then I thought, I'll know as soon as I see him whether it's right or it's wrong.'

Matthew's biological mother is white, his father is Jamaican. His mother delayed having Matthew adopted. 'She wanted the father to see him first,' Brenda says. 'She hoped he might change his mind and say, "Let's get married." Apparently, he said he was proud to have fathered a son, but marriage was not for him.'

Brenda and Graham collected Matthew from his foster carers on 8 January 1975. He was three months old. 'Graham was enamoured with him and couldn't wait to get him home. I was happy being a mum of two children. But it took me about three months to say "I love you" and mean it,' says Brenda.

The family fell into a routine and Matthew was 'as good as gold.' But he was slow to speak and by two and a half had lost the little language he had. He was hyper and couldn't concentrate. He was referred to the hospital for an EEG – a recording of the electrical activity of the brain – and subsequently diagnosed with frontal lobe atrophy, a reduction in the size of the frontal lobe; the part of the brain responsible for functions such as language, cognition, behaviour.

'It was just words to me,' says Brenda. 'We loved Matthew by then. Nothing was going to change that.' Matthew has never recovered any language. He developed a pattern of behaviour which continues to this day: happy and smiling and mostly docile; or extremely agitated when he has been up all night. 'I've known him go for three nights without sleeping,' says Brenda. Matthew's passion is eating. 'He's put some silly things in his mouth,' says his mother. For example, the pet goldfish. 'He thought it was a carrot. He loves raw carrots and he put his hand in the bowl, and went, gulp.' He also has violent outbursts. 'I've been sat in an armchair and he's grabbed my arms and pulled me across the room.'

Matthew attended a day school for children with learning disabilities from the age of six to 18, and then he went to a day centre five days week. In 2001 at the age of 26 he moved into Coppice Lodge. He was diagnosed with autism when he was 29.

Matthew is known as Miss Daisy because he likes being driven around in his mobility car. He has two carers looking after him during the day and one person at night. 'They really do try and do things with him, but his concentration is so limited,' says Brenda.

He used to come home for an overnight stay one day a fortnight. But now, he only visits for a few hours once a fortnight and is accompanied by two carers. 'I'm afraid we can't manage him anymore,' Brenda admits. But Matthew is very settled at Coppice Lodge; 'the staff seem to understand him.' Brenda and Graham have no regrets. 'Matthew can be really difficult, but we've also had loads of fun.'

'Matthew likes the feel of catalogues and magazines.
It started with him flicking through the pages of an Argos
catalogue when he was little. It got really battered and dog-
eared and we tried replacing it. But he'd only accept ones
with glossy paper. Argos have stopped doing catalogues,
so he has ones from Wickes instead.' —Brenda

Walnut House, Welwyn Garden City, Hertfordshire

Situated in a former council block, in a leafy residential area close to Stanborough Park in Welwyn Garden City, Walnut House comprises 12 self-contained flats for people with autism and mental health conditions. It is aimed at those who no longer require close supervision, but still need attention and advice. Referrals are from supported and residential homes and Hertfordshire mental health service. There are currently 12 residents; three women and nine men, whose ages range from early 20s to 60.

Staff are always on site (three during the day, one at night), based in a Portakabin in the car park to the rear of the building. There is a summer house/smoking lodge, a communal kitchen and a community café, a converted shipping container with a glass front, mint green walls and a La Spaziale espresso machine. Opened in 2019, with the aim of giving residents work experience, the cafe is currently closed due to the pandemic, but is still used for meetings and social activities, such as chess club, arts and crafts, bingo, quizzes, music appreciation and tea and coffee mornings. Residents are free to come and go as they please.

John, 30

John is acutely sensitive to the touch and texture of food. He loves the crunchy, sweet sensation of Ben and Jerry's cookie dough ice-cream. And he loves melted cheese, because it is warm and comforting. But cold cheese gives him the creeps. The same is true of uncooked meat. 'I struggle with the sliminess. If I'm cooking chicken, one of the support workers has to cut it up. But eating it is fine.'

As a newborn baby, John lived in Ruislip, Hillingdon, where his father was a photographer and his mother, a baker. She already had two grown-up children from a previous relationship and she chose to leave John's father when John was three weeks old. 'They weren't compatible. It was a night and day relationship,' he says.

John and his mother moved to Wantage, in Oxfordshire, but not for long. 'I lost count of the times we moved. Life was not very fixed,' he says. At school he found it hard to relate to the other children: 'I had no idea how to act.' At secondary school, he was perplexed by the other boys' interest in page three girls. 'They'd open the Sun and go, "Phwoor, isn't she fit?!" I just saw it as a picture.' The boys called him 'gay'; he describes himself as 'asexual.'

John dropped out of school at 15. 'My mother wanted to move and anyway I'd had enough of the constant bullying.' He went on to take his GCSEs at a college in Uxbridge, in west London, where they now lived. He was diagnosed as having autism spectrum disorder when he was 16. He also suffers from depression and anxiety.

In 2012, when John was around 21, his mother decided to move to Spain. By now John was under the care of the Hertfordshire local mental health team. His mother asked if they could find a place for John. He spent a year in a supported home in Stevenage, before moving to Hill End 2, a supported home for six young men with autism and mental health conditions, in St Albans. In October 2019, aged 28, he moved to Walnut House.

John is discomforted by the outside world. If he ventures out – to go to the local park, or to a restaurant – it is never without a member of staff. 'I couldn't cope on my own, because of the stress and anxiety.'

'My last place had thin walls and you couldn't get away from the noise,' he adds. 'Whereas here, in my flat, I'm on my own completely.'

'I have a rescue cat called Ozzie. He's had a rough life and is very scared and timid. He's a house cat and never goes out. He just doesn't want to. He's scared of it.' —John

WALNUT HOUSE, WELWYN GARDEN CITY, HERTFORDSHIRE

'I'm determined to get good at drawing because if I get good
enough, I plan to self-publish my own comic books. Then I'll
be able to really look back and say I did something with my
life. If I'm not good enough the world will chew me up and
spit me out. It's a dog eat dog world.' —Max

Max, 27

Max has a laser-like focus. He is teaching himself Japanese and says he feels more comfortable with computers than people. 'I talk at people. I've always had problems with social skills.'

Max grew up, the oldest of three boys, in Bishop's Stortford in Hertfordshire, where his father was a dentist. 'I was a terrible child, always having tantrums and fighting,' he says, now. He was diagnosed with autism when he was five. He also has a history of bipolar disorder and anxiety.

In 2003, when he was nine, his parents separated, and he lived with his mother in Ware, east Hertfordshire, for a year or so, before moving back to Bishop's Stortford, where he lived with his father and went to the local secondary school. 'I was literally the most unpopular child in the whole school,' he says. 'None of the kids liked me. I was always being victimised. I try and black out a lot of those memories.'

In 2012, aged 18, he attended Cambridge Regional College, a further education college in Cambridge, where he studied IT for a year, and then switched to film and TV. But towards the end of the course, he fell apart. 'I just broke down in the classroom and started crying. I'm ashamed to admit I do cry very easily. It was the climax of a lot of things. I was under a lot of pressure. I just couldn't cope anymore.'

The college told Max to take a month out. He never returned. He saw a psychiatrist and aged 19, moved into Hill End 2. 'That is the moment my life started to come together,' he says. 'I had a lot of proper help. I learned how to do things for myself, like cooking and shopping.'

In 2017, aged 24, Max was well enough to progress to living at Walnut House. His flat is ordered and clean, with an angle poise lamp and neatly stacked books: graphic novels, history books, and one on dating. 'I haven't really used it much,' he confesses. 'I don't know where to start.' He likes drawing, playing computer games and going to comic conventions. He travels on his own. 'My ideal night in is a Chinese takeaway and an episode of *Dr Who* – the classic *Dr Who*, not the modern, because that's so bad.'

Max has one regret. 'If I could live my life all over again, I would study art from the very beginning. I did subjects I didn't enjoy just to make other people happy, like geography.'

Glossary

Adult day care centres
Adult day care centres provide people who live at home with practical skills, the opportunity to socialise and take part in activities. Run by experienced staff, they can be funded by councils, the voluntary sector or private firms.

Asperger syndrome
People with Asperger syndrome see, hear and feel the world differently to other people. Asperger syndrome isn't associated with learning disabilities or speech problems that many autistic people have, but there may still be learning difficulties and problems understanding and processing language. Many people who fit the profile for Asperger syndrome are now being diagnosed with autistic spectrum disorder instead. The shift acknowledges that it is almost impossible to draw clear dividing lines among these diagnoses.

Attention deficit hyperactivity disorder
ADHD is a neurodevelopmental disorder characterised by inattention, hyperactivity and impulsivity. Although people with ADHD may have difficulty sustaining concentration, many also have the ability to 'hyperfocus' on a task, topic or subject they find interesting or rewarding.

Autism
Autism is a lifelong developmental disability which affects how people communicate and interact with the world. It is seen as a pervasive disorder because it affects almost every aspect of behaviour, as well as sensory experiences, motor functioning, balance, the physical sense of where your own body is and self awareness. Learning disabilities are not part of autism per se. Because symptoms may occur to any degree, autism is defined as a spectrum that includes varying severity of different symptoms.

Bipolar disorder
Bipolar disorder (previously known as manic depression) is a mental health problem that can cause a person's mood to swing from extreme high to extreme low. People may also experience psychotic symptoms.

Borderline personality disorder
Borderline personality disorder (BPD) is a mental health disorder that impacts the way people think and feel about themselves and others. It includes self-image issues, difficulty managing emotions and behaviour and intense but unstable relationships with others. It can be a very broad diagnosis which includes a wide range of different experiences.

Cerebral palsy
Cerebral palsy is any disability caused by damage to the cerebrum before birth, immediately afterwards, or in the first three years of life. It comes with a broad range of possible impairments which include developmental delays, problems with speaking, weak arms or legs, uncontrolled movements, walking on tiptoes.

Down's syndrome
Down's syndrome is a genetic disorder caused by the presence of all, or part, of a third copy of chromosome 21. It is usually associated with some level of learning disability, physical disability, as well as medical issues such as heart defects and thyroid disorders.

Hydrocephalus
Hydrocephalus is a build-up of fluid in the brain. The excess fluid puts pressure on the brain, which can damage it. If left untreated, hydrocephalus can be fatal. There are three main types of hydrocephalus: congenital (present at birth); acquired (develops after birth) and normal pressure (usually only in older people).

Learning disabilities
Learning disabilities are disorders that affect the ability to understand information, use spoken or written language, do mathematical calculations, coordinate movements, or direct and focus attention. A learning disability happens when a person's brain development is affected. It may be caused by a mother becoming ill while pregnant; having problems during birth (resulting in inadequate oxygen getting to the brain) and illness or injury in early childhood. A learning disability can be mild, moderate, or severe.

Psychosis
A psychosis is a mental disorder in which the individual's ability to think, respond emotionally, remember, communicate, interpret reality and behave appropriately is sufficiently impaired so as to interfere grossly with the capacity to meet the ordinary demands of life.

Residential care
A residential care home provides accommodation, care and support for those who need help with daily life. They are designed for people who do not need 24-hour nursing care but are unable to live independently. The size can vary from smaller homes with as few as one resident to larger homes accommodating as many as 250 people. The care home provides residents with a bedroom, meals, housekeeping and laundry services, as well as 24-hour support from a trained team. Facilities are often shared between residents, such as bathrooms, dining room and kitchen. Residential care homes are regulated by the Care Quality Commission (CQC) in England, or Care Inspectorate Wales (CIW). They can be run by local authorities, private businesses, or charity and voluntary organisations.

Respite care
Respite care is when a person is looked after by someone else, to give the carer a break. Respite care options range from getting a volunteer to sit with the person for a few hours, to a short stay in a care home.

Schizophrenia
Schizophrenia is a serious mental illness marked by hallucinations, delusions, bizarre behaviour, emotional withdrawal and lack of motivation. The prevailing view of schizophrenia is that it is a variety of illnesses, many of which have a genetic factor that causes a chemical imbalance in the brain. Childhood environments that includes stress, may, however, help to trigger the illness.

Sectioned
Being sectioned means a person is judged to be a danger to themselves and to others and in need of emergency hospitalisation, whether they agree to it or not.

Supported living
Supported living is for people who do not want to live in residential care, but are finding it difficult to cope independently. Trained support staff come to a person's home to provide help and supervision. There are different models of support homes, from family-style shared houses to self-contained flats. In some cases, staff sleep on the premises overnight. Unlike in residential care where the same person or organisation is responsible for the cost of the care and the accommodation, in a supported home a specialist housing agency (for example, a housing association) owns the property and contracts out the care to another provider. People who live in the home are tenants, responsible for their own bills and cost of living. To afford these, the person may be entitled to a wide range of benefits, including housing benefit (those in residential care cannot receive housing benefit). Supported homes are not regulated by the Care Quality Commission, but any care received is regulated. Supported homes can be provided by the local council, charities, or run by commercial companies.

Acknowledgements & Thanks

A Place for Me is a group enterprise, and we are grateful, first and foremost, to the individuals and families who agreed to be photographed and interviewed. *A Place for Me* would not exist without them and we are fortunate to have found people who gave up their time so generously.

We are indebted to the care providers, charities and housing associations who opened up homes to us, and made helpful introductions; and to the support workers who shared their insights and helped us secure interviews. Their tireless assistance and devotion to the people they care for is profoundly heartening.

It is impossible to acknowledge everyone who participated in this project, but we would like to give special thanks to the following:

Lord Nelson House
Marie Roberts

Gloucester Road
Rachael Marriot
Tara Rye

Meadowside
Hayley Lynch
Ryan Kearney
Daryl Quarry

Clark House
Michelle Hutchinson
Lesley Cowley

Cornwall Court
June Huntley

Ty Cum Gwendraeth
Paula Lewis
Jane Smith
Jeff Bolch

St Gwynllyw day centre
Chris Lake
Sue Giblin
Gail Love
Stephen and Suzanne Craig
Kerry Humphreys

Heathfield Apartments
Katy Phillips

Ty Newydd
Keith Castrey
Lesley Newcombe

Thorne House
Theresa Lees
Kelly Laybourne
Sharon Pinder
Julie Adamson
Jayne Wilcock
Lindsey Scott

Park House Barns
Phil Kiernan
Graham White
Philip Bartey

Ashcroft Lodge
Sarah Barton
Vilma Hughes
James Smith

Bradmere day centre
David Evans
Julian Gill

Richmond Road, Hollinsend Road, Welwyn Road and Gleadless Avenue
Sharon Smith
Charlotte Holmes
Kay Pinder
Allison Pinder

Lancaster Avenue
Danah Smithen

Forge Mill
Sarah Meah
Lynne Francis
Lyn James
Jo Deakin

Pedmore Walk
Bernadette O'Reilly
Michelle and Steve Smith
Kady Hanson

Cornflower Close
Chrisine Kalisher
Roz Fincham
Richard Mason
Joe Steel

Coppice Lodge
Abi Crompton
Brenda and Graham Turley
Dean Ashby

Walnut House
Emma Clynes
David Callan
Laurence Fanning
Keeley Denham

Finally, we would like to thank Paul Bridge and Jamil Mawji for commissioning and championing the project and Georgina McGuinness for her unflagging support. We are grateful to Martin McGrath for his brilliant imagination, patience and skill in creating this book; and to Vicki Reid for her empathy, humour, close reading and ability to find coherence in chaos. Lastly, we are deeply indebted to Matthew Rhys Thompson. *A Place for Me* would have been an entirely different book without his understanding of the project, and his skill behind the camera and the wheel.

Polly Braden is a documentary photographer whose work features ongoing conversations between the people she photographs and the environment in which they find themselves. Highlighting the small, often unconscious gestures of her subjects, Polly particularly enjoys long-term, in-depth collaborations.

Sally Williams is known for long-form features and reportage. Her work has taken her across the world, and into the heart of people's lives – from Peshmerga fighters in Iraq to surrogate mothers in Ukraine to fishermen in Mozambique. She is published regularly in the Guardian, Daily Mail, the Telegraph and the Times magazines, amongst many others.

First published in the United Kingdom in 2022 by
Dewi Lewis Publishing
8 Broomfield Road, Heaton Moor
Stockport SK4 4ND, England
www.dewilewis.com

© 2022
for the photographs: Polly Braden
for the text: Sally Williams
for this edition: Civitas

Design: Martin McGrath Studio
Copy Editing: Vicki Reid
Colour reproduction: Manish Patel, Metro Imaging
Assistant photographer: Matthew Rhys Thompson
Print: EBS Verona

ISBN: 978-1-911306-83-2

Civitas Social Housing is dedicated to investing in social care housing and healthcare facilities. We provide social homes for life and create value by enhancing lives.

National Care Group is one of the UK's leading providers of care and support services to vulnerable adults. Its mission is to enable those it supports to live a full, rewarding and happy life through careful planning processes focused on each individual's needs, which allows them the opportunity to achieve their full potential and live as independently as possible within their community.